R GABRIEL **THE MARS VOLTA** 10cc THE WO

ESIS GOODBYE MOTEL AM ICE

DENAMEIS:MILO *Disco Biscuits* **XT** CO

F AND THE EXTREMES **ETHNIX** WISHBONE AS

MARSHALL **QUATERMASS** GENTLEMEN WITHOUT

E STAR *slow earth* CATHERINE WHEEL **UNO**

THE ALMIGHTY **THE OFFSPRING** POWDERFING

OGRAM THE DEAD O.A.R. **GRAVY TRAIN** SYD

RAGGA AND THE JACK MAGIC ORCHESTRA AL ST

EY UMPHREY'S McGEE **TOE FAT** VITALIC **STYX**

OSE PENDULUM **DEEPEST BLUE** *JUNG YONG-HW*

IKE RUTHERFORD **AUDIOSLAVE** MACHINERI T

CHARD WRIGHT **JOHN McLAUGHLIN** KAN W

alan parsons **PINK FLOYD** PETER GABRIEL TH

NBERRIES RIFF RAFF **GENESIS** GOODBY

AN **FOREIGNER** YOURCODENAMEIS:MILO *Disco*

ES **VILLAINY** BILLY KARLOFF AND THE EXTREMES E

ABILITY BROWN **QUATERMASS** GENTLEMEN

KER THE STAR *slow earth* CATHERINE WHEEL

TROSE **THE ALMIGHTY THE OFFSPRING** POWDE

NBOW PROGRAM THE DEAD O.A.R. **GRAVY TRAI**

MAN RAGGA AND THE JACK MAGIC ORCHESTR

EY UMPHREY'S McGEE **TOE FAT** VITALIC **STYX**

OSE PENDULUM **DEEPEST BLUE** *JUNG YONG-HW*

IKE RUTHERFORD **AUDIOSLAVE** MACHINERI T

CHARD WRIGHT **JOHN McLAUGHLIN** KAN W

XTREMES **ETHNIX** WISHBONE ASH *Voodoo*

L **QUATERMASS** GENTLEMEN WITHOUT WEAPONS

w earth CATHERINE WHEEL **UNO** BE BOP DE

Kant's four questions:

1. What can I know? (epistemological)
2. What should I do? (ethical)
3. What can I hope? (religious)
4. What should I wear? (important)

THE GATHERING STORM

THE ALBUM ART OF
STORM THORGERSON
WITH HIPGNOSIS AND STORMSTUDIOS

• • • •

INSIGHT EDITIONS

San Rafael, California

THE GATHERING STORM

A QUARTET IN SEVERAL PARTS

• • • •

Compiled by StormStudios

Design by Peter Curzon and Silvia Ruga

Text by Storm Thorgerson

It is customary to dedicate books to the children,
thus Adam, Bill, Georgia and Mabel and their children,
if they ever bloody have any.

Many thanks to Rosie and Donald, and Libby and Tibor for their support.
Thanks also to Theron and to San Francisco Art Exchange.

FIRST PUBLISHED BY DEMILO ART AND STORMSTUDIOS 2013.
BOOK DESIGN BY PETER CURZON, SILVIA RUGA AND STORM THORGERSON.
TEXT BY STORM THORGERSON WITH PETER CURZON AND DANIEL ABBOTT.
ESSAYS BY AUBREY POWELL, ANDREW RAWLINSON, ADRIAN SHAUGHNESSY,
RODDY BOGAWA AND SCOTT ROWLEY.
COPY EDITING: MARCELLA EDWARDS.
TYPIST: JOAN RAPHAEL-LEFF.
RESEARCH: CHARLOTTE BARNES.

SEVERAL IMAGES FROM THIS BOOK CAN BE PURCHASED AS FINE ART PRINTS VIA:
WWW.STORMSIGHT.CO.UK

. . . .

INSIGHT
EDITIONS
PO Box 3088
San Rafael, CA 94912
www.insighteditions.com

Find us on Facebook: www.facebook.com/InsightEditions
Follow us on Twitter: @insighteditions

Published by Insight Editions, San Rafael, California, in 2015.

Library of Congress Cataloging-in-Publication Data available.

ISBN: 978-1-60887-678-5

Insight Editions
Publisher: Raoul Goff
Co-publisher: Michael Madden
Acquisitions Manager: Steve Jones
Executive Editor: Vanessa Lopez
Project Editor: Dustin Jones
Production Editor: Rachel Anderson
Production Manager: Jane Chinn

ROOTS of PEACE REPLANTED PAPER

Insight Editions, in association with Roots of Peace, will plant two trees for each tree used in the manufacturing of this book. Roots of Peace is an internationally renowned humanitarian organization dedicated to eradicating land mines worldwide and converting war-torn lands into productive farms and wildlife habitats. Roots of Peace will plant two million fruit and nut trees in Afghanistan and provide farmers there with the skills and support necessary for sustainable land use.

Manufactured in China by Insight Editions

10 9 8 7 6 5 4 3 2 1

FoReWoRD

"WHAT IS THE USE OF A BOOK", THOUGHT ALICE,
"WITHOUT PICTURES AND CONVERSATIONS". *

WELL, my advice when opening this book would be to stand well back and read the small print. That's what Storm would ask you to do when looking at his work. At first glance, his pictures appear one dimensional, but look twice, and the interpretation becomes quite different, as realities are juxtaposed. 'Spooky', as Storm would say. Lift the inspection hatch and you'll discover a world of illusions, visual puns, conundrums and strange narratives, often set in a surreal landscape occupied by people and objects carefully composed in seemingly impossible situations.

IMPOSSIBLE? Not so – scale and realism is everything to Storm – it is the real McCoy. Observe a man by the sea pulling a twenty-foot-high ball of string, or a giant eye peering ominously over a naked shoulder in some parched badland. Thirty telegraph poles in a straight line with people sitting cross-legged on the top of each one, or five hundred hospital beds spread across a beach, not to mention two hundred red footballs in the dunes of the Sahara desert. A thirty-foot high pile of suitcases in the shape of a man's face. An underwater ballet, performed in a corporation swimming pool, or two elegant ladies wearing cerise onions for ball gowns. For sheer enormity, try two huge stone statues the size of the Easter Island figures facing each other, yet divided by Ely Cathedral in the distance. Be prepared to be very surprised.

*EXTRACT FROM *ALICE'S ADVENTURES IN WONDERLAND* BY LEWIS CARROLL.

THE ideas are extraordinary, but the execution is even more so. Storm insists on creating real and living sculptures for each of his projects, and sets them in real time. Everything has to be built and photographed in situ to a size determined by the idea. No fakery, no Photoshop, or no deal. That is his stipulation, and he sticks to it. Budget permitting, of course; but then again money has never been his prime motivation, and sometimes, and rather alarmingly, he has thrown his fee to the wind just to get the job done. Admirable, you might say, but I say Admiral. For he is an Admiral, one to be admired, a supreme commander, flying under his own flag of StormStudios, subordinate to no man or company. He is an inventive leader, an originator of schemes and dreams, and a prolific designer. (Does he never stop?)

STORM expects of others the same dedication under fire that he himself exhibits. And there is plenty of flak around I can tell you – Storm by name, Storm by nature.

DURING our time at Hipgnosis we steered the ship together for some fifteen years. In the beginning, however, he was my mentor, showing me the skills of photographic design, such as perspec-tive, composition, collage and montage, dark room techniques, and, most importantly, how to use a camera. These lessons have never left me and even though we were both young and inexperienced it seemed effortless for him to conjure up an end-less stream of ideas, plundering and pillaging his subconscious, no matter what the project. I had a vision to build a company. He had the intelligence to create an art house. And that's exactly what Hipgnosis became.

HIPGNOSIS eventually begat StormStudios. I charted a different course and went off to make films. We parted company and Hipgnosis quietly ceased operations. Storm continued doing what he liked to do best – playing the creator of images – and, by a series of fates, a new outfit ap-peared with a fresh bunch of loyal and willing hands to run different aspects of StormStudios. There's Peter Curzon, Lee Baker, Daniel Abbott, Jerry Sweet, Rupert Truman, Laura Truman, Silvia Ruga and Charlotte Barnes. Under Storm's bullish guidance, for the past few years this team of artisans have helped him discover new and wonder-ful horizons, and a casual enquiry as to, 'How's it all going', might be met with, 'Oh, Peter's in Japan de-signing a cover for so and so', 'Where's Jerry then?'

'Ah, he's driving to Berlin to set up an exhibition', 'And Lee?' 'Lee's scanning a new series of fine art prints', 'Rupert?' 'In Dubai shooting a photo for what's his name'. It's endless and relentless, and Storm's output never ceases to amaze.

THE great furniture designer Eileen Gray, once said that, 'to create one must question everything'. She must have seen Storm coming, and certainly for Storm's clients it has never been easy. As a lateral and fearless thinker, for Storm, the presentation of ideas is like a game of intellectual charades, with a few clues as to the meaning of the work thrown in every now and again. More often than not the images may be unrelated to the original brief, and so it becomes a marathon task to interpret what has come out of Storm's head. His slogan is 'a good idea is a good idea', so it will always withstand scrutiny, no matter the product. In other words, a good image will sell anything on its own merit. It's been tried and tested on many a rock star. Some hated it. Paul McCartney for one. Others played along, like Peter Gabriel, who enjoyed the mind games and the banter. For the most part, having been put to the test and lived to enjoy the resulting artwork, most clients have remained steadfastly attached to Storm. The proof is in the pudding, and the association with Pink Floyd, for example, has lasted nigh-on forty years.

STORM – always late, nearly always forgiven; full of quips, some not always appreciated; far too clever for his own good, but with a crazily gifted mind; revered by many, upsetting a few; rarely compromising, always fighting to the end, and wearing obstruction down in the belief in his own work – has rarely lost his way. This intensity has probably cost him his health, and so is it any wonder that rock managers, corporate lawyers, gallery owners, fine art dealers, printers, publishers and record companies cross him at their peril. Resolute, resilient, and very demanding, with an energy beyond Olympian standards, the boy done good. This book is a testament to a life given over to the workplace. The work shy need not apply. Do not read this book if you are of a nervous disposition, and some of the images it contains may frighten the children, because fulfilled dreams are made of this.

. . . .

Aubrey Powell (Po)

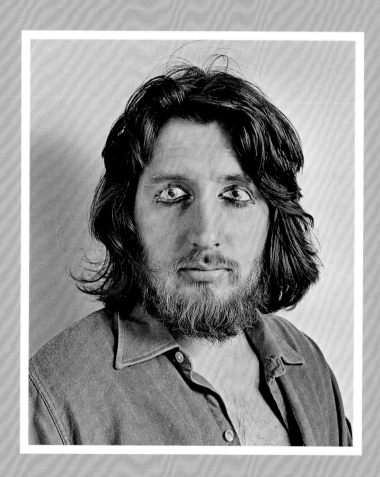

This book was intended to be a quartet of decades, but like the great Douglas Adams trilogy in 4 parts, this is a quartet in several parts. This is in order to include the end of the 60s when I started designing and the years after the noughties when we continued working.

• • • • • PREFACE

HAVING AN EGO THE SIZE OF A SMALL PLANET IS NO EXCUSE FOR EXCESS SO I won't use it. Suffice it to say that in the absence of huge demand from elsewhere I was . . . err . . . obliged to do this book myself. First proposed by an Italian publisher, the **COLLECTED WORKS** was then unproposed without ceremony and demoted till now, resurrected before it's too late and whilst circumstance permits.

I'M fond of fonts and creative typography, but I'm fonder still of imagery, thus all covers, posters and singles within have been stripped of numbers, logos and titles and represented in their unassuming nakedness.

THE images are sourced from original scans and artwork where feasible and are prepared and printed in the best quality attainable in these dark economic times.

COLLECTED WORKS implies completism, but more than one volume would embarrass my normally robust ego, so a degree of editing has occurred, there also being quite a few pieces I'd rather forget than remember.

THE order derived from an article I wrote a year ago, and struck me as fitting not only in terms of the work, but also in terms of the changing technology of music reproduction – viz. vinyl/cds/downloads – hence four decades it is. Four being the 'number', though not strictly chronological in each decade. Such strictness I find burdensome if not irrelevant – one's design progress, or not, is unlikely to develop like that.

I APOLOGISE for not putting image text next to the pictures to which they refer. This is very irritating I know, but I wanted the book to be clearly a picture book as opposed to having picture/text, picture/text . . . I hope, dear reader, you can live with this.

IT is not that important, but I have never been sure how to categorise or describe our work accurately. It is design, but not graphic design only; it is photographic, but not photography only; it is surreal, but embedded strongly in realism; it is not photo-realism but done with very real things. It is idea-driven but much concerned with the look of things. It is commercial for sure and not fine art, but still artistic, or so we'd like to think. Any bright ideas? Please put on a postcard and send it to the prime minister.

Storm Thorgerson
London, October 2012

• • • •

Acknowledgements, which are numerous at the end, apologies now – any errors or omissions are the sole responsibility of the author, my good self, and I deny them completely.

WHEN PO AND I STARTED HIPGNOSIS IN 1968, WE WERE YOUNG AND STUPID BUT

also unfettered and we didn't care where we might derive imagery. We had both been at film school and were inclined to scenarios, so GRAVY TRAIN (right) was a lonely station, a dwarf and a dummy waiting for a train that never comes, and not a gravy train.

A SAUCERFUL OF SECRETS (opposite) was like a chocolate box, a collection of our favourite things at the time, marbling, signs of the zodiac, **Doctor Strange**, planets, infrared film, etc . . . 'Groovy' things as we called them then, which makes me slightly embarrassed to recall, although I always liked the type, by David Henderson, who is, in fact, the model of IN THROUGH THE OUT DOOR (pg21), and suggests that the name Pink Floyd carried on endlessly around the world and was captured in a portion on the album cover.

AT Hipgnosis we were also fond of surrealism, partly because it is easy to render in photography. It was also the early days of our use of collage. QUATERMASS (pg 14) tried to echo the dominant keyboards with a slightly grand vision from a horror film, where prehistoric monsters attack the modern city, VOICE (pg 14) as influenced by Dali's mouth-like couch, and TOE FAT (left) I believe gained a notoriety due to its ugliness, a vision of faceless horror executed by vignette, and part of our experimental approach, mostly because we didn't know any better. UMMAGUMMA (pg 15) is a photographic rendition of a graphic picture about infinite regression, often used in books about perception. In this case it was executed in photography and consisted of a picture hanging on a wall, which shows a room in which a picture on a wall hangs, which shows a room in which hangs a picture on a wall. I think this is a seminal piece for me and it still weaves a little of its perceptional magic today.

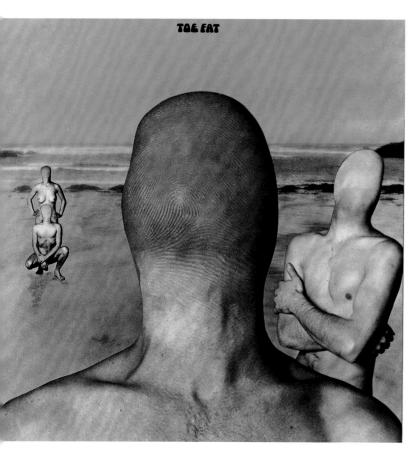

Toe Fat, *Toe Fat (1970)*

↑ Gravy Train, *Gravy Train (1970)*

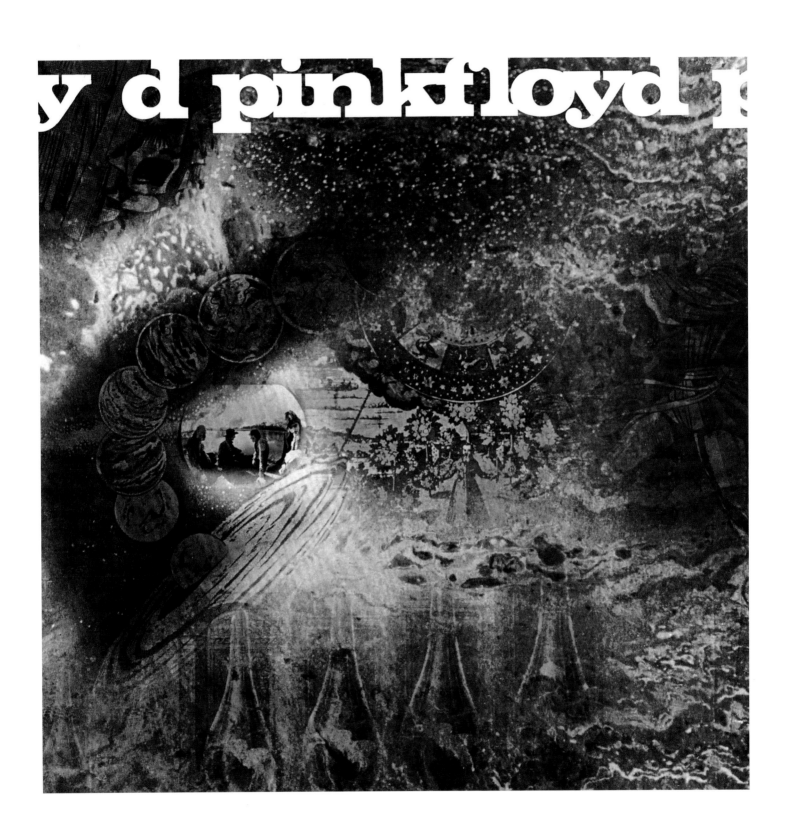

Pink Floyd, *A Saucerful Of Secrets (1968)*

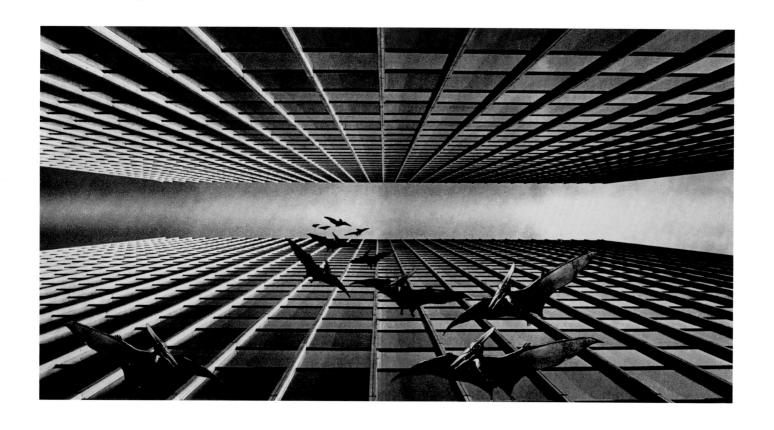

Quatermass, *Quatermass (1970)*

Capability Brown, *Voice (1973)*

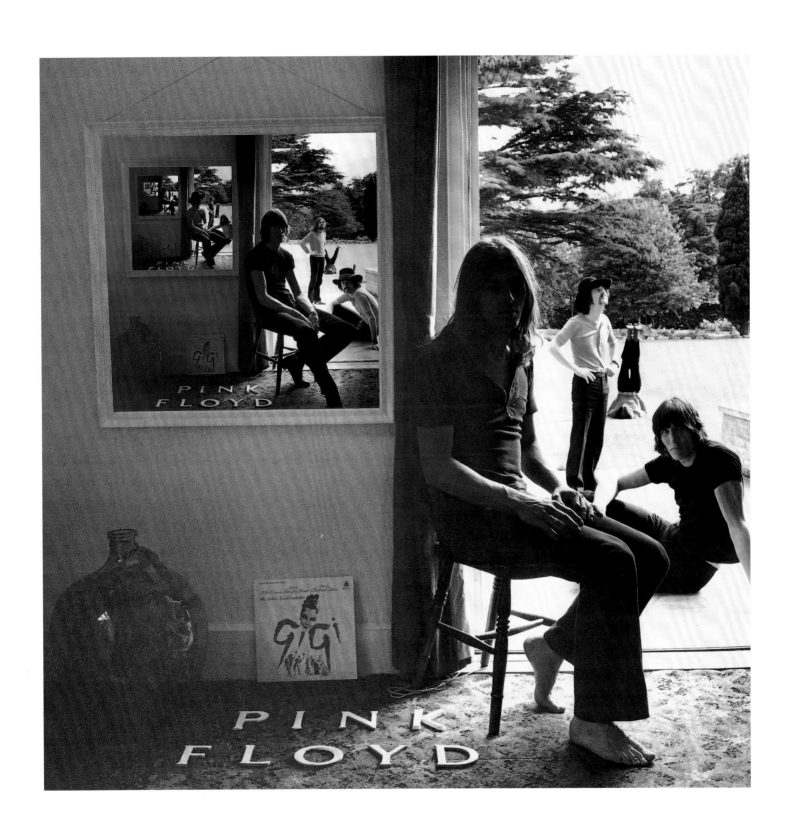

Pink Floyd, *Ummagumma (1969)*

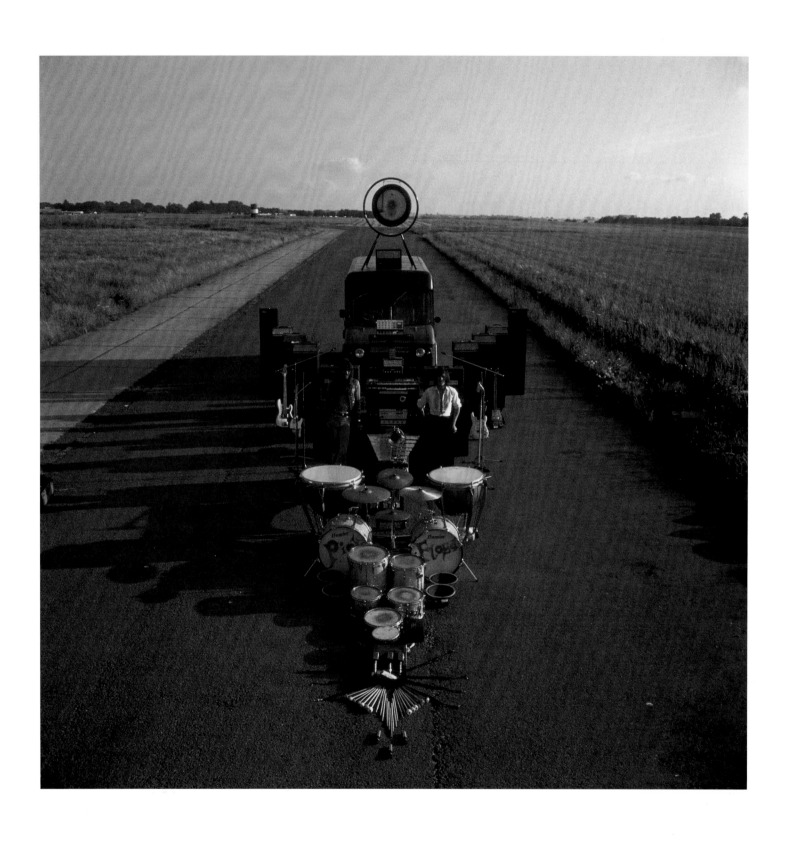

Pink Floyd, *Ummagumma*, Back Cover *(1969)*

70s

HIPGNOSIS

Hipgnosis comprised
Aubrey Powell, Peter Christopherson and Storm Thorgerson

● ● ● ●

MY first album was Benny Goodman. I'd heard his trio on another record and wanted more of it. I was 15 and I didn't know that he had a big band as well. When I got the record home, I discovered that the whole of Side 2 was big band stuff – and I didn't like it. So I did the typical 15-year-old thing: I deliberately scratched Side 2 – a huge, heavy scratch that started at the edge and spiralled into the centre. Then I took Benny back to the shop. "This record has a scratch on it," I said. The manager, a tall man with thick blond hair swept back, took the disc out of its sleeve and glanced at it. "We'd never sell a record in this condition," he said, handing it back to me. No refund. And I've never come round to Benny Goodman's big band.

LONG-PLAYING records were quintessentially physical. If you had a favourite track, you could pick up the needle and place it in the right groove – a delicate operation but it bonded you with the record. Everything was in your hands.

OF COURSE, plastic has its drawbacks. I once kept a John Cage record next to the airing cupboard. The heat warped it and gave it excitingly wavy edges. Perhaps John would have been happy with what this did to his music–but I wasn't. Another lesson learned.

FLICKING through albums in a shop was a pleasure. They were exactly the right size, and what we were looking for in a cover, though we didn't know it, was an instant connection with what was inside it. (The name and the image – probably the oldest duo in human history.) But boy, those images could be cul-de-sacs. I mean, they just didn't go anywhere. They were mostly shots of the performers. In practically every case, a chicken – or hey! A cow – would have done just as well. Into this world of careful, safe arrangement came a man with ideas. Images as ideas. Images and ideas as ways into other worlds – worlds that could be ours. He was on the beat: clean and crisp. He was behind the beat: throwing the straight into relief. He was ahead of the beat – and he wasn't looking over his shoulder. He was one Storm Thorgerson (Hipgnosis) just as well.

THE question has been put: Is commercial design art? Well, these terms – 'commercial', 'design', 'art' (let's leave 'is' out of it) – are all a bit tired, aren't they? I propose to leave them squabbling among themselves and just take off, whistling, with my lunch in a bag on a stick over my shoulder, like Dick Whittington.

THE images you have here, boys and girls, are way beyond the usual confines of space and time. The things that are being done fall somewhere between the unlikely and the impossible. There are close-ups and distance shots. The faces are often crumpled or distorted. Some of the scenarios are weirdly straight (The Cortinas (pg 50), The Broughtons); others are straightforwardly weird (the de Chirico-inspired *Wish You Were Here* (pg 28/29)). Could any two images be more different than *Technical Ecstasy* (pg 23) and *The Winkies* (pg 73)? This is style that precedes reality and makes it like unto itself.

GO 2 (pg 59) is possibly unique in record cover design. (It's been pilfered since but the results are wet and weedy.) No graphics, just words – but words like no other. "If you've read this far then you're TRICKED but you wouldn't have known this unless you'd read this far." And: "At least we're telling you directly instead of seducing you with a beautiful or haunting image that may never tell you." This may sound, or look, like a subversion of Storm's very aesthetic. But it's actually very neat. (How many people have united the double bind and seduction?) His images weren't mere images, either. They didn't just present themselves – they invited us in. Freedom and subversion eternally linked. We like that.

IT doesn't matter how it's done. Simplicity (*Atom Heart Mother*) and complexity (*In Through The Out Door*) go forth hand in hand. So do the 'natural' (*Wish You Were Here* – the diver (pg 44/45)) and the 'contrived' (*Deadlines* (pg 30/31)). The girl in Trees' *On The Shore* (pg 22) – what's she doing, exactly? We know what the swimmer in the sand is doing – we can see it – but the same question applies: what is he doing? Argus's helmeted figure (pg 27) and the naked man on *Going For The One* (pg 56) both inhabit the same world despite the fact that there isn't a single element in common. Except one: they come from a common imagination. They body forth the form of things unknown. The front cover of *How Dare You!* (pg 32) could easily happen, but the back cover couldn't. Part of life and beyond life – where are we in all this? Answer: 'This' is also 'that'. 'Here' is also 'there'.

STORM likes dramas; that is, moving through worlds with their dimensions and horizons. That's all worlds do: unfold and pull us in. That's why our lives have all the qualities and dimensions that a world has – and I mean the pulse, the cadence, the weight and grain; all those massed banks of colour, feasts and banquets, and there in the distance a 'storm' is stirring. It looks as if it's coming our way – but we're inside it. We always were.

TRUE, some of those images are high fantastical. They can be visions, confabulations and fictions. You know – love and transgression. This is the hum and everything flow of the world, brimming, bright and large. We find the boundaries dissolving. To and fro goes the way – and we're on it, you and me. We're all rather strange and wonderful. All this happens while we're flicking through the covers in a store. And we haven't heard a note yet.

• • • •

Andrew Rawlinson

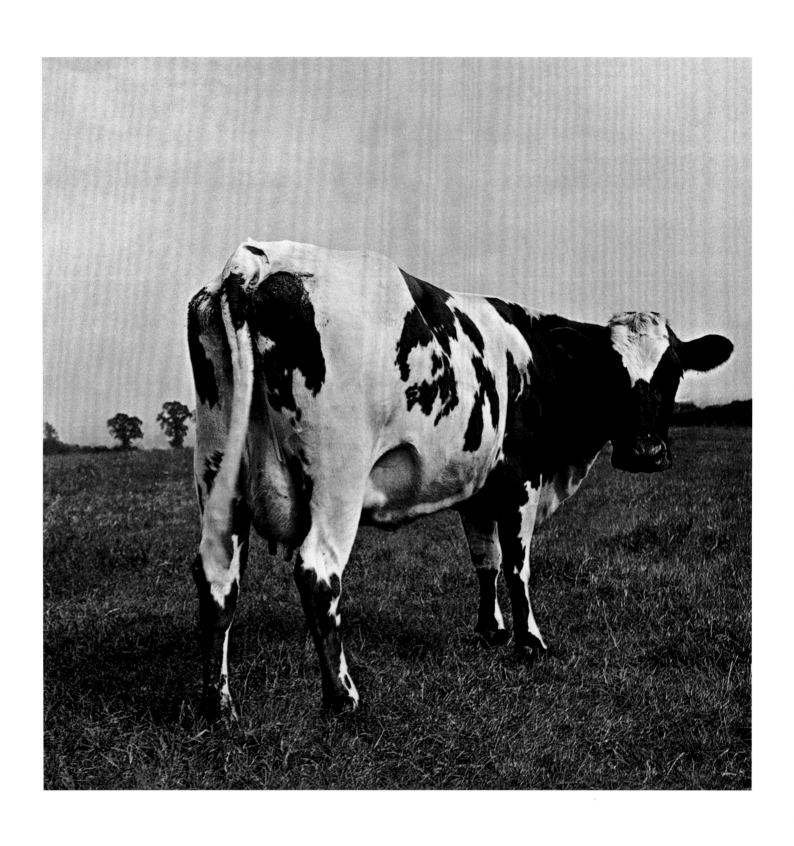

Pink Floyd, *Atom Heart Mother (1970)*

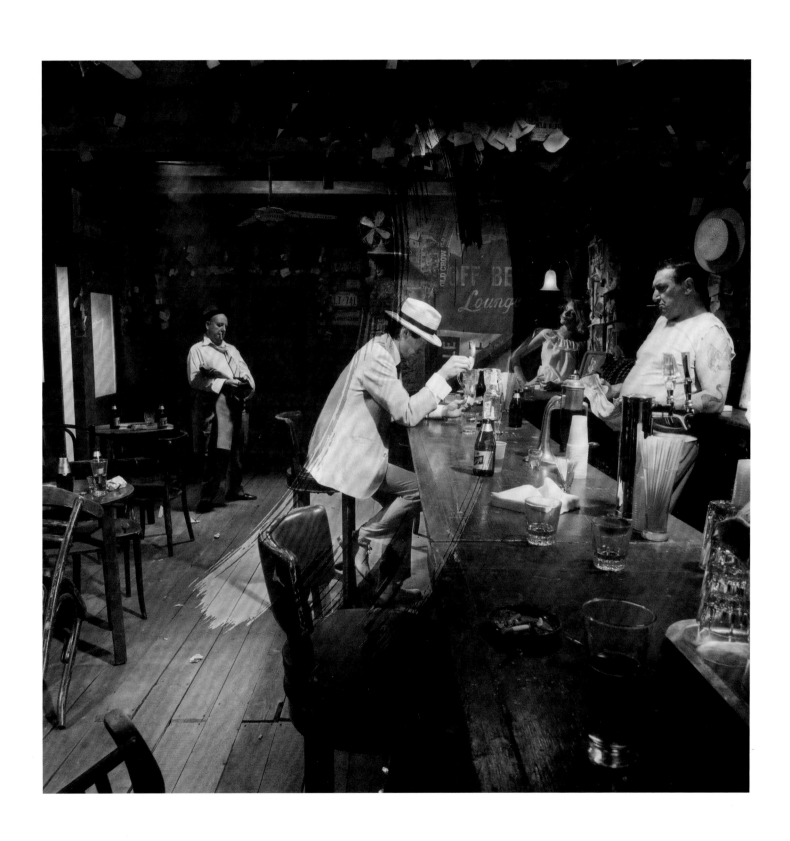

Led Zeppelin, *In Through The Out Door (1979)*

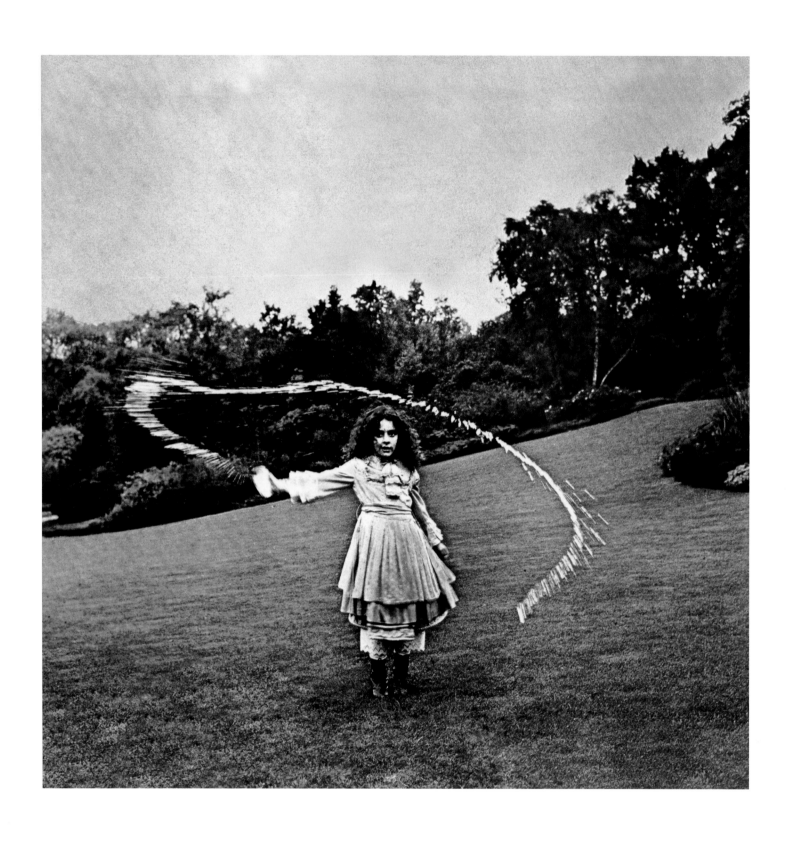

Trees, *On The Shore (1970)*

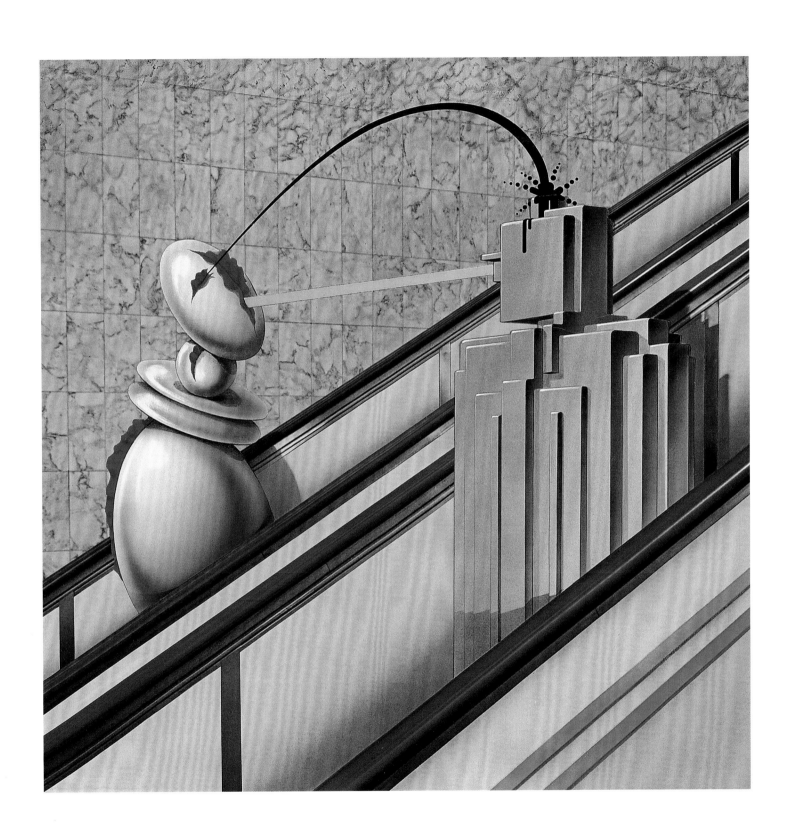

Black Sabbath, *Technical Ecstasy (1976)*

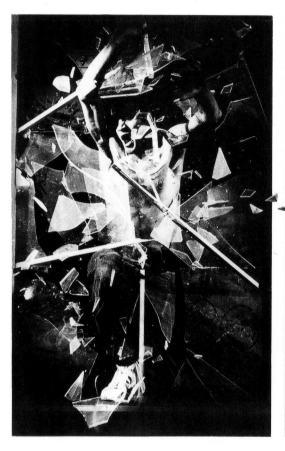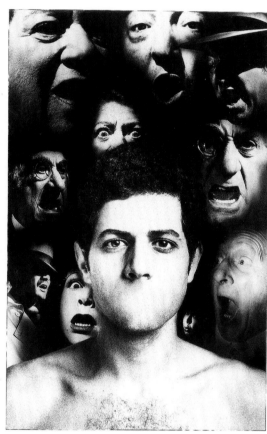

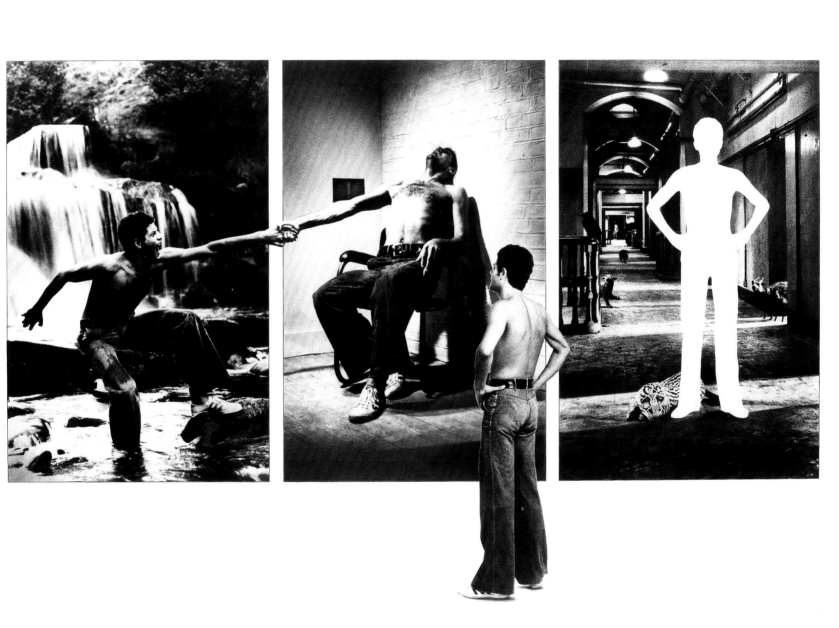

Genesis, *The Lamb Lies Down On Broadway (1974)*

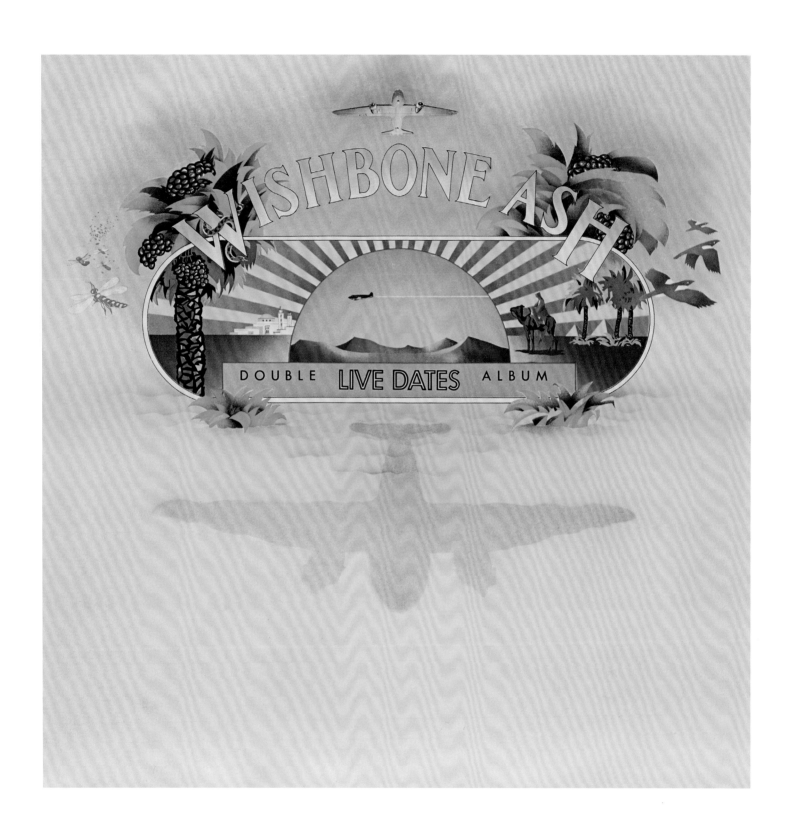

↑ Wishbone Ash, *Live Dates (1973)* | Wishbone Ash, *Argus (1972)* →

OUR GOOD FRIEND JOHN BLAKE HAD SUGGESTED THE THROWING OF WATER FOR Trees' **ON THE SHORE** (pg 22), on, I believe, an imaginary shoreline created in the mind of the thrower. Simple, weird and magical, we freely borrowed the idea, being amoral in such matters, and decided on a little Victorian girl in a formal garden as being even more 'enchanted'. What you see is what you get, though the colouring is by hand, not colour film.

PINK FLOYD'S **ATOM HEART MOTHER** (pg 20) was a stroke of good fortune much to the label's disgust. 'Why a cow?' they shrieked, 'What's the point of a cow?' they yelled, which is missing the point altogether. I was looking for a non-cover . . . what would be unexpected in a record shop? And my good friend John Blake came to the rescue again and said 'a cow', and I immediately pictured it in my mind, a text-book cow, a bog standard cow, as irrelevant as it could be and cheap; it worked a treat, the band laughed, the record went number one, and the label never mentioned it again.

THE image for **TECHNICAL ECSTASY** by Black Sabbath (pg 23) came directly from the title, not the music, which is unusual, but in this case, irresistible. I envisioned immediately two robots (Technical) in an ecstatic exchange. Passing each other on the elevator, falling in love at first sight and exchanging fluids unashamedly. The artwork was an interesting mix of drawing and photography, what fancy people call mixed media.

THE **LAMB LIES DOWN ON BROADWAY** by Genesis (pg 24) was a tale set up a bit like an opera, so we invented scenes from a story, reminiscent of a comic strip but photographic not illustrative – I think the man stepping out on the far right panel to review his journey was what did the trick. It was executed in black and white because in effect it was easier, but I think also an artistic preference.

ARGUS (below) features an ancient – possibly Roman – soldier and a flying saucer. It was an attempt to represent a new band who wrote about legend and stories from the past, the old and the new. Apparently Jimmy Page was fond of this design and he approached us to do **HOUSES OF THE HOLY** (pg 68/69).

TALKING of Led Zeppelin . . . a few years later they asked us to do **IN THROUGH THE OUT DOOR** (pg 21) which was described as a fresh approach to the rock-blues, like a fresh lick of paint, or a duster across an old window pane . . . which happens to look through to an old New Orleans bar for the 'blues', which Po found on a visit to New Orleans. We built a replica set in London and it was fantastic, a three-sided set which we should have shot on film, in retrospect, but, regrettably, we did not. The artwork was made in sepia, and the brush stroke was in colour. It was a beautiful piece, even though I say it myself, all six versions, which were the view points of the six habitués of the bar.

LIVE DATES for Wishbone Ash (opposite) is based simply on the design for date boxes. I particularly like the shadow of the airplane. It is deftly illustrated by Colin Elgie.

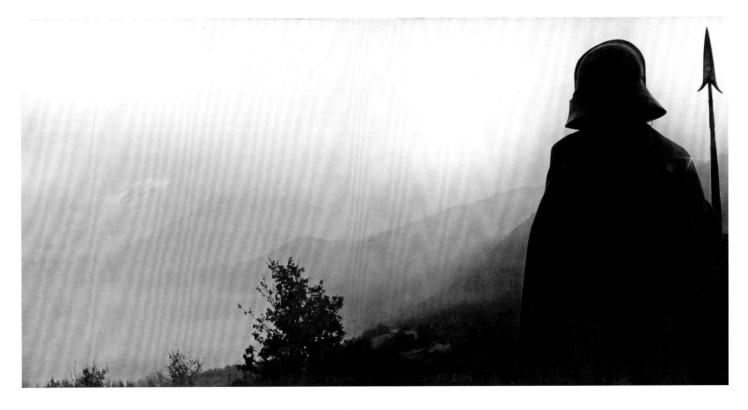

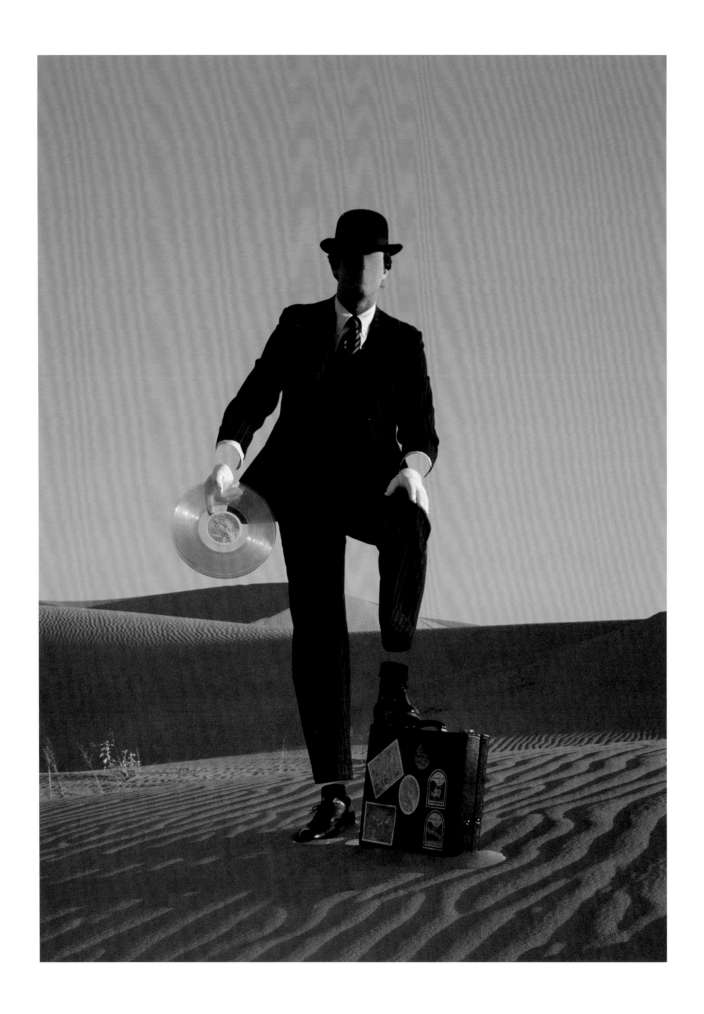

Pink Floyd, *Wish You Were Here (1975)*

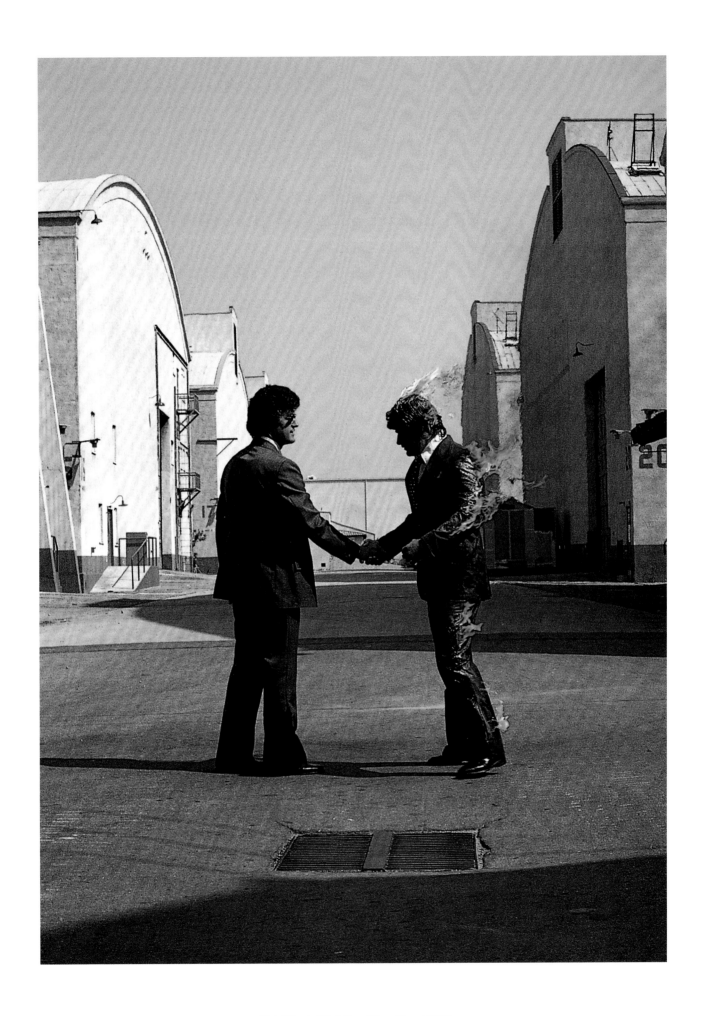

Pink Floyd, *Wish You Were Here (1975)*

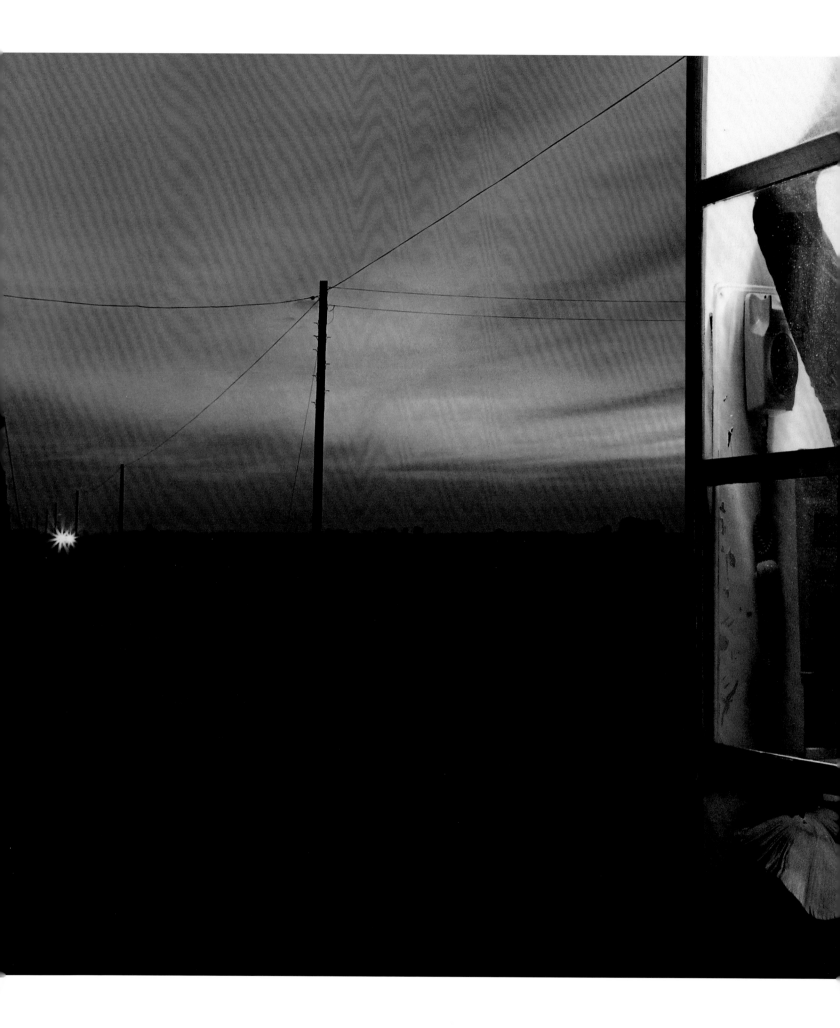

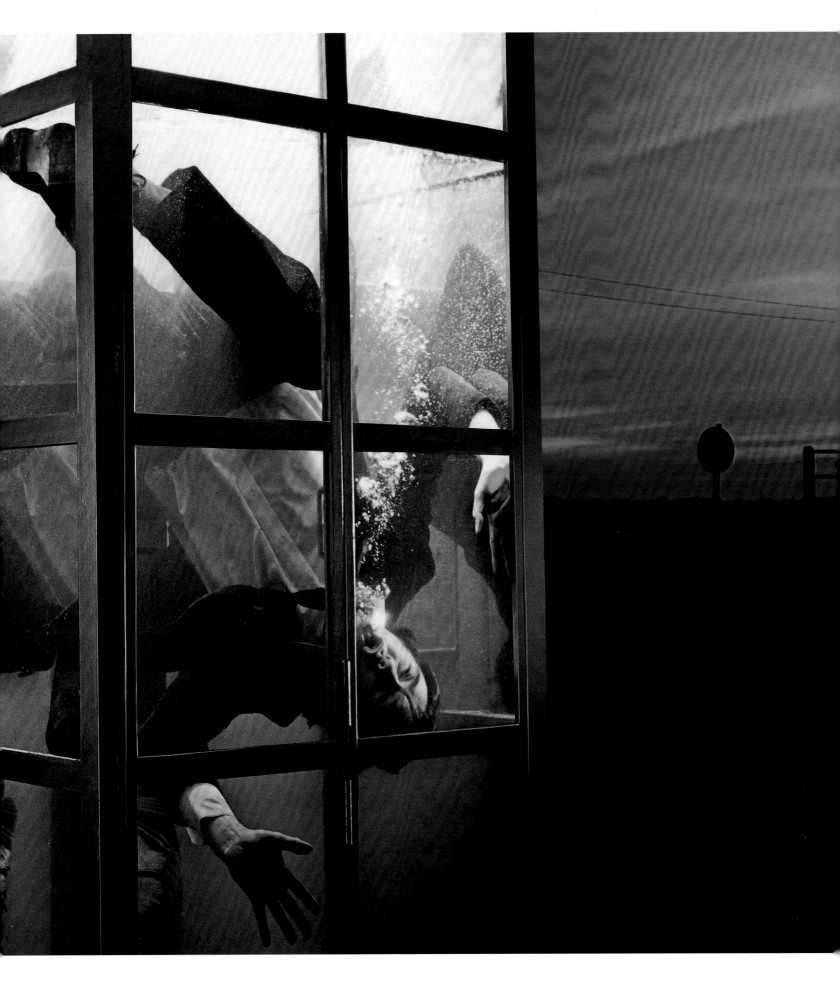

Strawbs, *Deadlines (1978)*

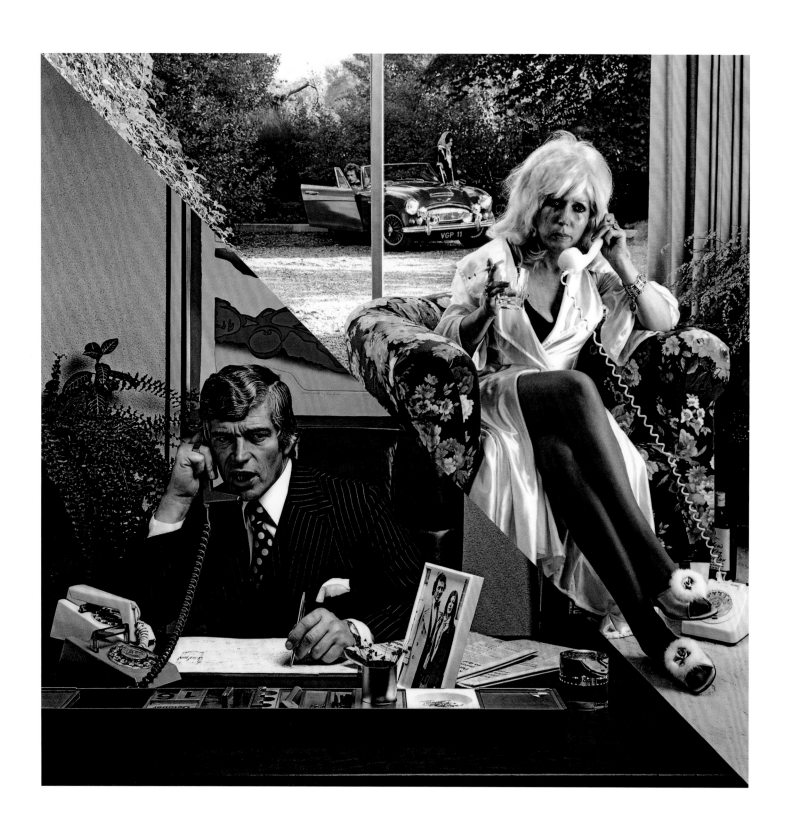

10cc, *How Dare You!* (1976)

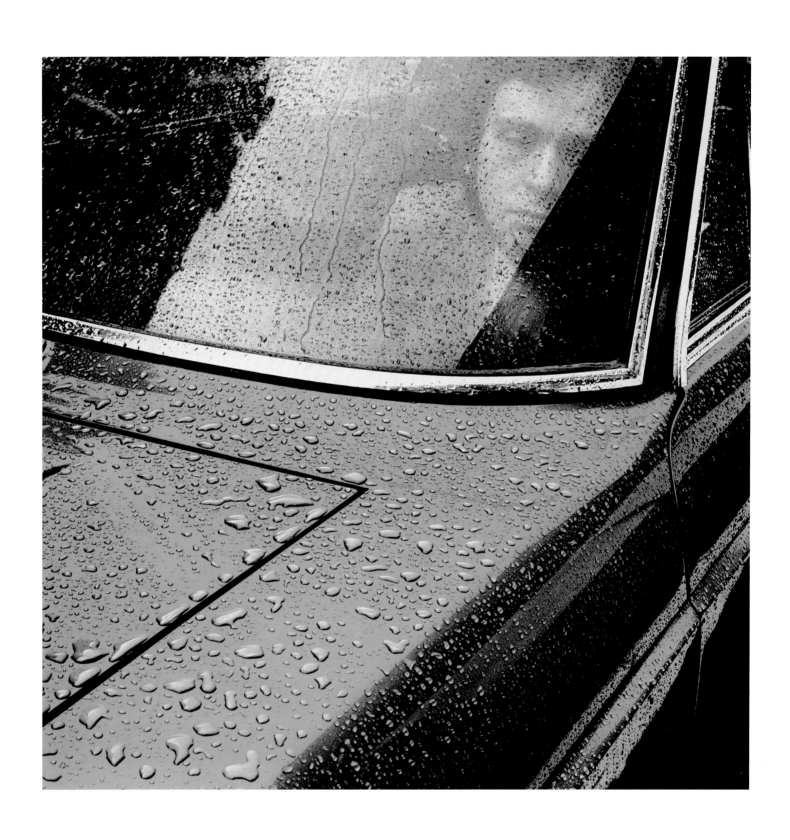

Peter Gabriel, *Peter Gabriel 1 (1977)*

IT might be considered unfashionable or even marginally shameful, but some of the work I've done I really like, and **WISH YOU WERE HERE** (pg 19/20) is certainly one of these. As a piece of packaging/design/idea/photograph I can't imagine doing better. After **THE DARK SIDE OF THE MOON** (pg 39) it was permissible to return to imagery and **WYWH** is very image-led, partly surreal, partly quirky, and partly mysterious. It was based on a theme of absence, particularly of Syd, and secondly of the band's commitment. It was hard to focus on the matter in hand after the success of **DARK SIDE.** First up was the diver, as a postcard, sent I thought from a resort back home saying **WYWH** but meaning nothing of the sort. The man on fire is probably not there, because he is not responding and the man in the desert, after 'Have A Cigar', is a faceless businessman in an obviously surreal style.

DEADLINES for the Strawbs (pg 30/31) derives from the title, as if a still from a film wherein the helpless victim, late with his deadline, was drowning in a remote telephone box. This was very difficult to do since the water pressure made the glass break until we put extra strengthening around it. Scary.

HOW DARE YOU! (pg 32). Being strongly connected, we came up with this idea of telephone and telephone conversation without actually knowing that there were two songs on the album about telephones. The conversation between a business man and his neglected but drunken wife is diagonally divided like it used to be in the old movies. In the background is a story about another couple, although not clearly stated, providing a little intrigue. These were very much the sort of games that appealed to 10cc as much as the filmic approach.

WHILST I sat in a cab in a central London traffic jam the incessant rain falling on the cab next to me formed droplets that would wobble and vibrate on the idling engine. It looked cool to me, and so on Peter Gabriel's first solo album, **PETER GABRIEL 1** (pg 33), we stuck him in a car, drenched it with a hose and took a snap. It was all done in about ten minutes, but it was much loved by fans and by Peter himself. The car is a Lancia Flavia, but the color is added. I think it is the simplicity and the furtiveness of Peter that makes this picture, although I've never really understood its appeal because it is just a picture of a man in car.

LASTLY, for the moment, is Led Zeppelin's **PRESENCE** (opposite). This is one of my favourite designs – a combined effort between me, George Hardie and Peter, and I never in my wildest dreams thought that Led Zeppelin would take it, but Robert has said on film that he regards this cover and the music as having the best synchronicity. Po has a great story about when he presented our ideas for **PRESENCE** to the band in Munich; he put the object to one side while showing the other design, but the band didn't know that the object was a facsimile made with black velvet. Fortunately, Po was not too clear either, and this turned out to be extremely apposite, for Jimmy and Robert discussed the implication for some time, then realised that if they spent so much time, a fan would have spent much longer. They embraced the design, which is quite complex and kitsch-looking – no shadows or moulding on the object suggest a lack of 3D reality – in fact this is a funny-shaped hole and not there at all, really, which is why it is called **PRESENCE**.

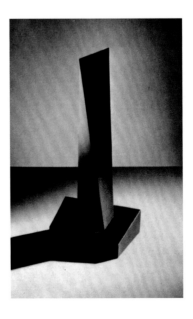

Led Zeppelin, *Presence (1976)* →

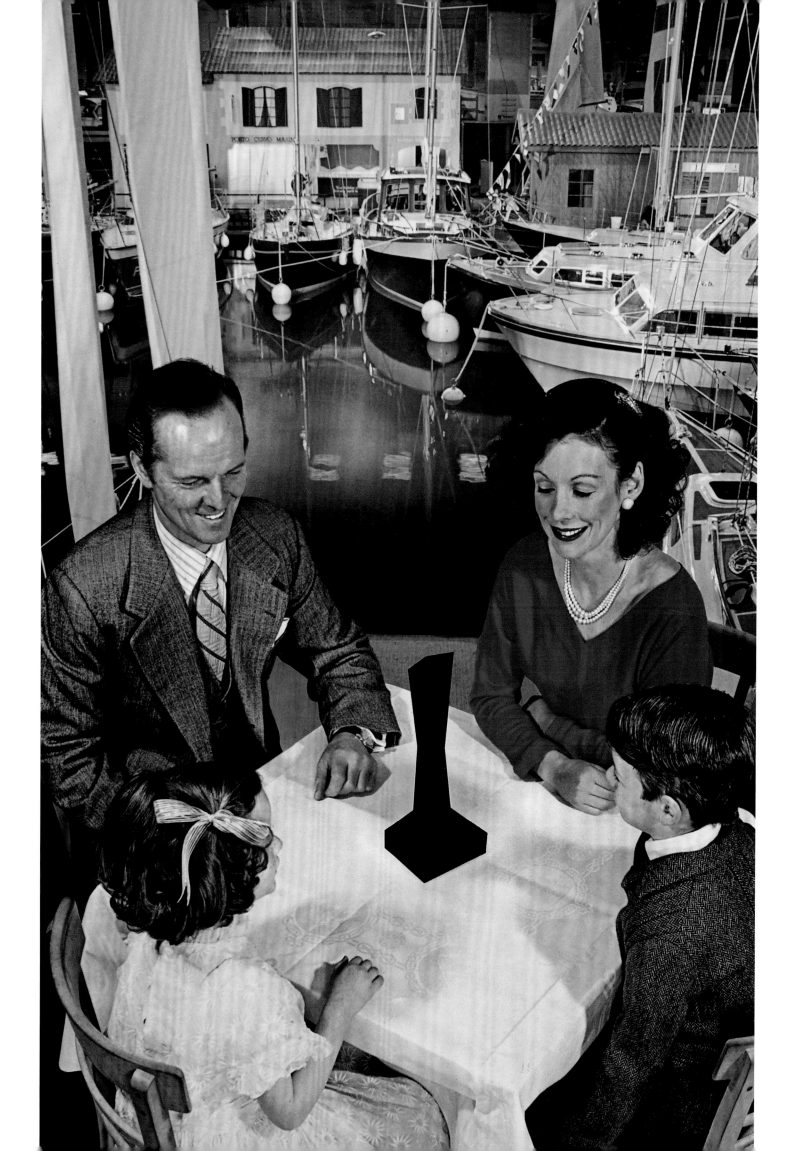

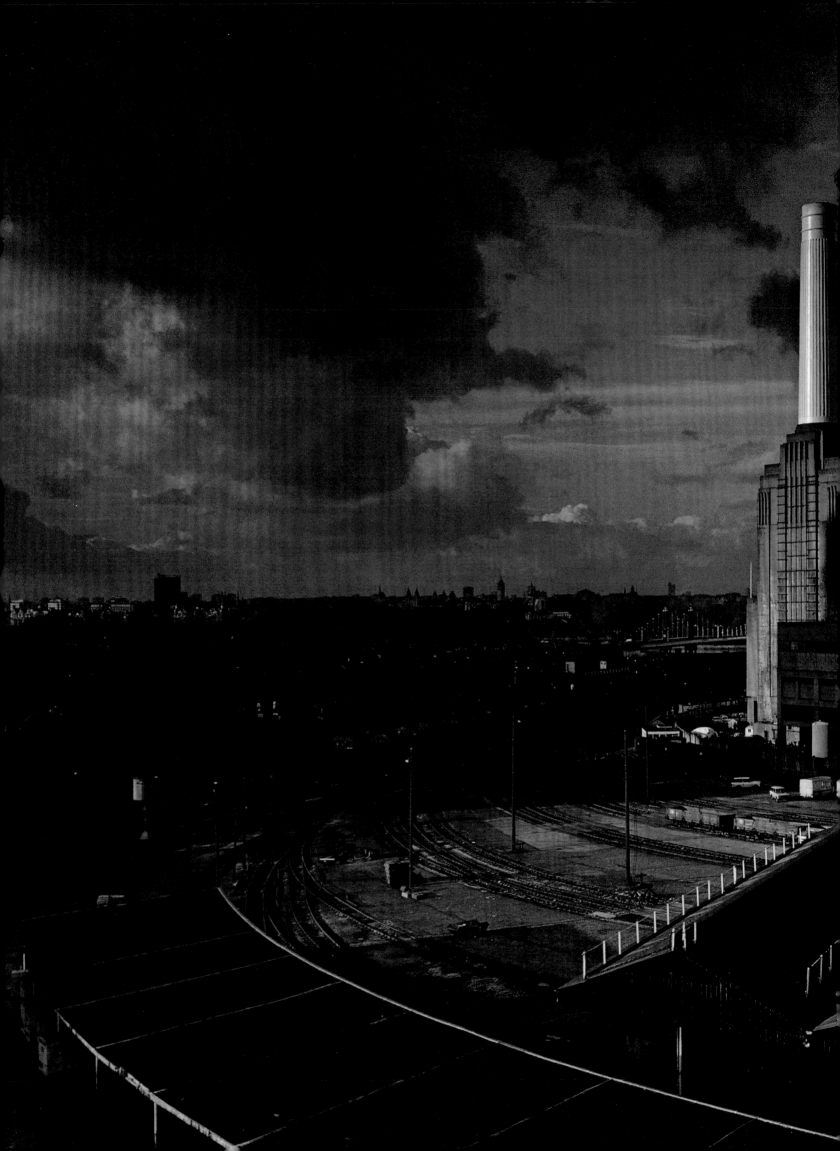

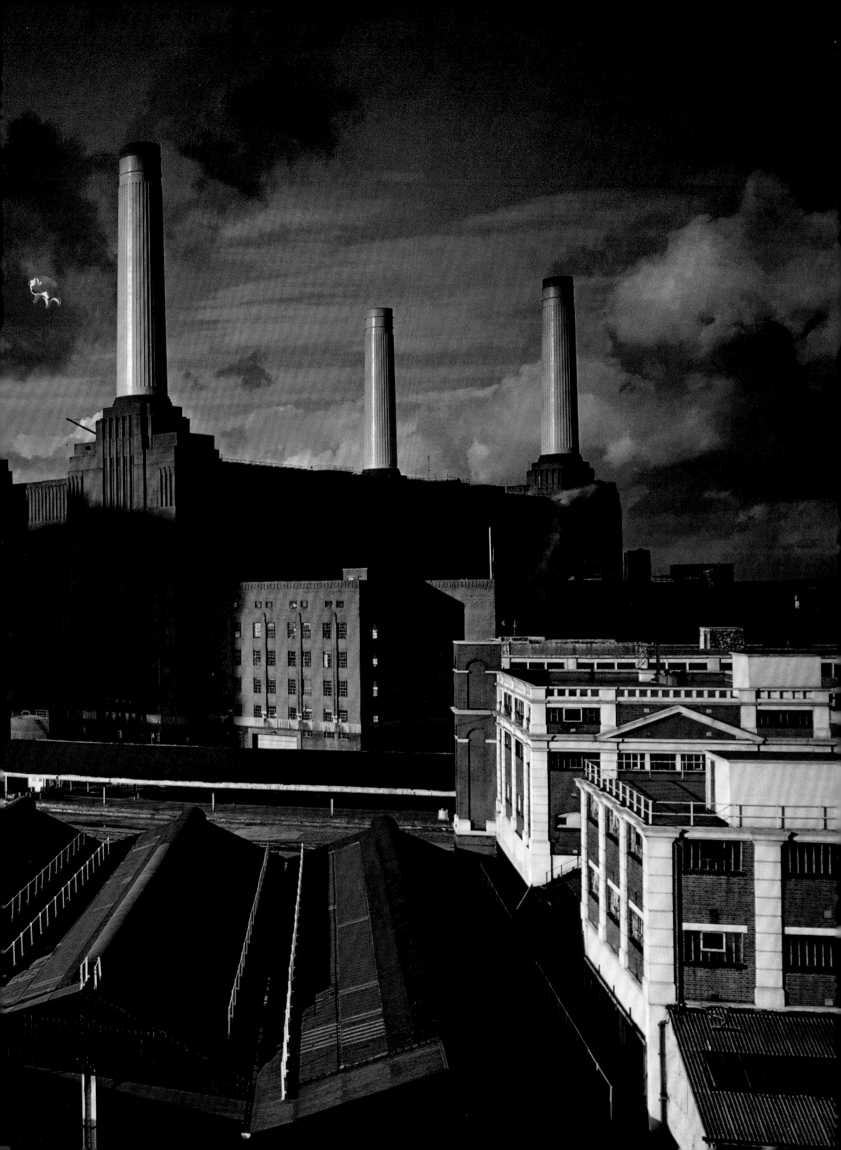

ANIMALS (pg 36/37), with the infamous pig, is a well-documented story of intrigue and escape, as the pig tore free of his mooring and ascended into the air lanes of Heathrow Airport to be sighted by alarmed pilots. It appeared as a headline in the British national newspapers. The pig above Battersea power station was Roger's idea, and I think it has worked very well both artistically and historically.

THE DARK SIDE OF THE MOON (opposite). I mostly wanted to write about DARK SIDE, which I think has been clinging to me for 40 years, not that I mind. The late Rick Wright – bless him – challenged me in an extremely annoying fashion to design something graphic, not pictorial. I said 'I don't do graphics, I do images'. He said, 'Well, make a change'. I protested. 'Are you a man or a mouse, Storm?' And he walked away smiling. I was so pissed off, I did it. Thinking that we had not as yet represented the light show, a central feature of a Floyd performance, on other covers, I thought I should do something about light. I saw a picture of a prism and its spectrum on a book cover in a book shop, which reminded me of a textbook picture of refraction, which we are all taught at school. This prism refracted into a spectrum belongs to everybody, it's a quality of nature, but by rendering it as a graphic, against black, it turns into a design which seemed to fit the album to a tee. The album sold a staggering 45 million and possibly imprinted me in the minds of many, and became one of their beloved possessions I should imagine. It is the black that does it. Like other artists, I have revisited this design many times, because its mixture of simplicity and universality makes it amenable to different media, be it stained glass, photographic form, illustrative form, made out of fruit or even words. The iconic nature perseveres. Our most recent experiments with oily liquids (see front cover), have worked a treat, if not better than the original.

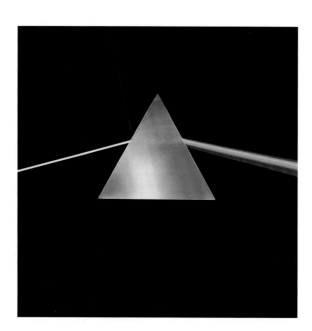

← Pink Floyd, *Animals (1977)* | ↑ Pink Floyd, *The Dark Side Of The Moon 20th Anniversary (1993)*

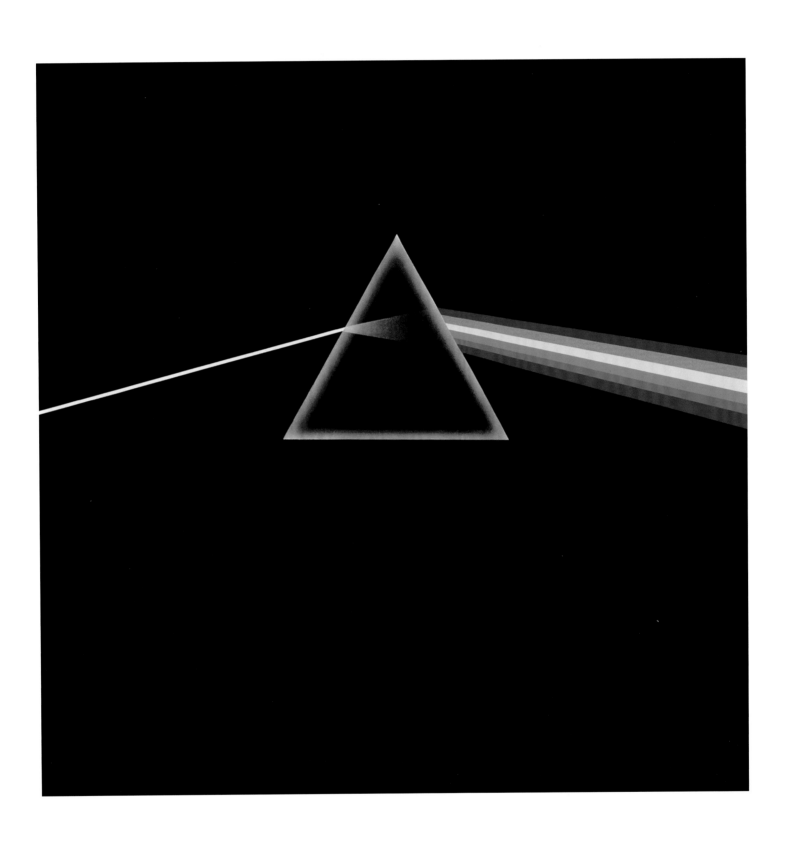

Pink Floyd, *The Dark Side Of The Moon (1973)*

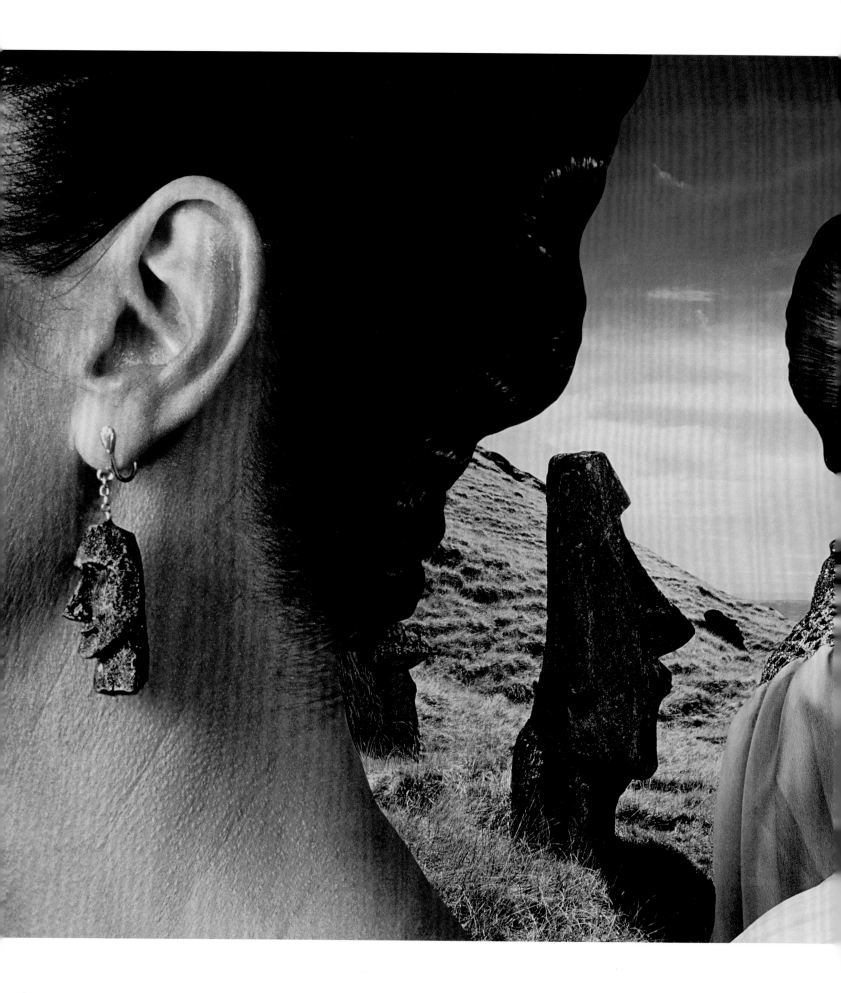

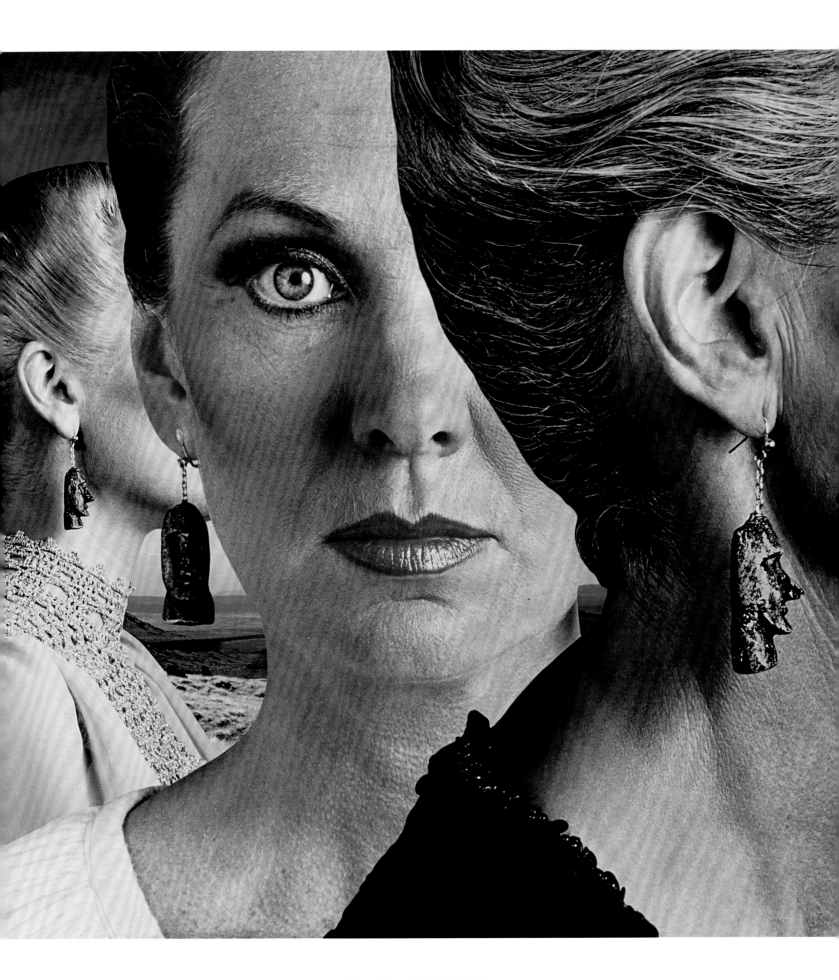

Styx, *Pieces Of Eight (1978)*

STYX, **PIECES OF EIGHT** (pg 40/41). I thought this was a risky idea to submit to an American prog rock band, since its origins were rather obscure, but I believe both the band and the record label enjoyed it as much as we did. Instead of featuring attractive young ladies with curves and pert breasts, as was often the case in rock 'n' roll, I thought it would make a change to photograph mature women, say in their late 40s/early 50s. Why can't they be as attractive as young tottie? The band must have said something to me about tourism, metaphorically speaking, so my mature ladies became tourists and I imagined a small party of them from a midwest town taking a package holiday to the Easter Islands. They have bought earrings as mementoes and are wearing them at some tea party, not necessarily looking at the Easter Islands' heads in the flesh. They were more interested in shopping than in archaeology. More interested in the semblances of life than the life itself. The artwork is a simple collage recopied to remove the joint lines; the ladies were shot one by one. Not literally, of course.

THE NICE's **ELEGY** (opposite), is another seminal piece for me and Po, as well as Ummagumma. Standing at the edge of the Sahara (Fort Mammid) looking at a meaningless and inconsequential line of red plastic balls as the sun set was extraordinary – it was for us a great moment, a moment of tranquility and strangeness.

ELEGY taught us two very important things; firstly, that an extreme idea presented badly can still become a thing of beauty, a piece of land art where the line of balls might stretch on forever, maybe as far as Cairo because you don't know otherwise. It is visible, maybe, from space, like the Great Wall of China, or so we like to believe. The second thing is that in the small and inconsequential world of album covers, the likes and dislikes of musicians are paramount. If the musician likes some idea, even if it is preposterous, the idea has a chance to be executed despite fiscal restraints. Which is how the record label probably viewed Po and me, who insisted on going to the Sahara, and not Camber Sands.

• • • •

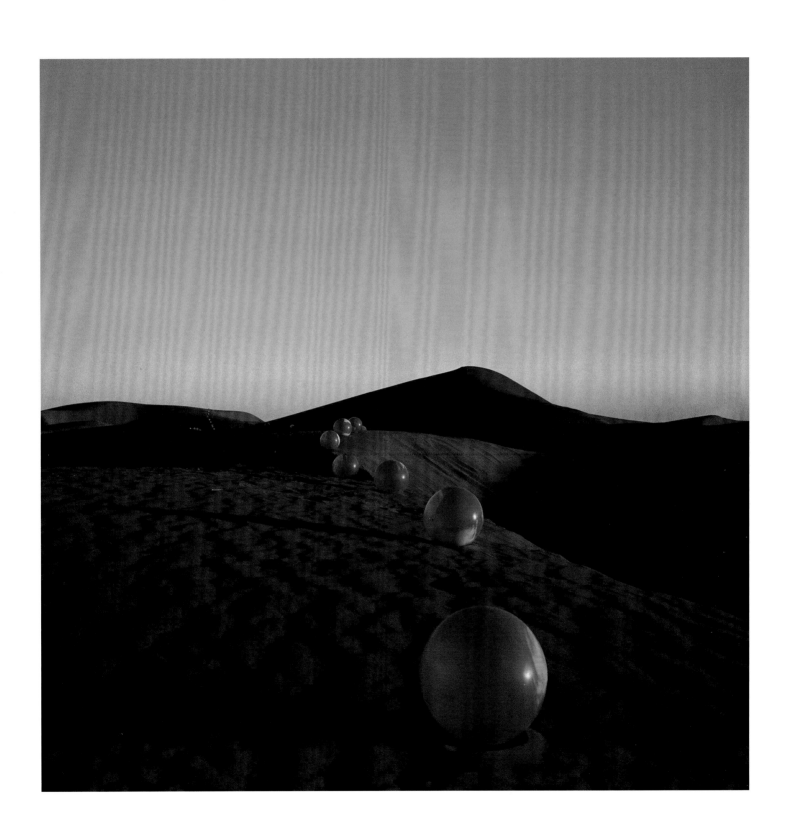

↑ The Nice, *Elegy (1971)* | Pink Floyd, *Wish You Were Here (1975)* →

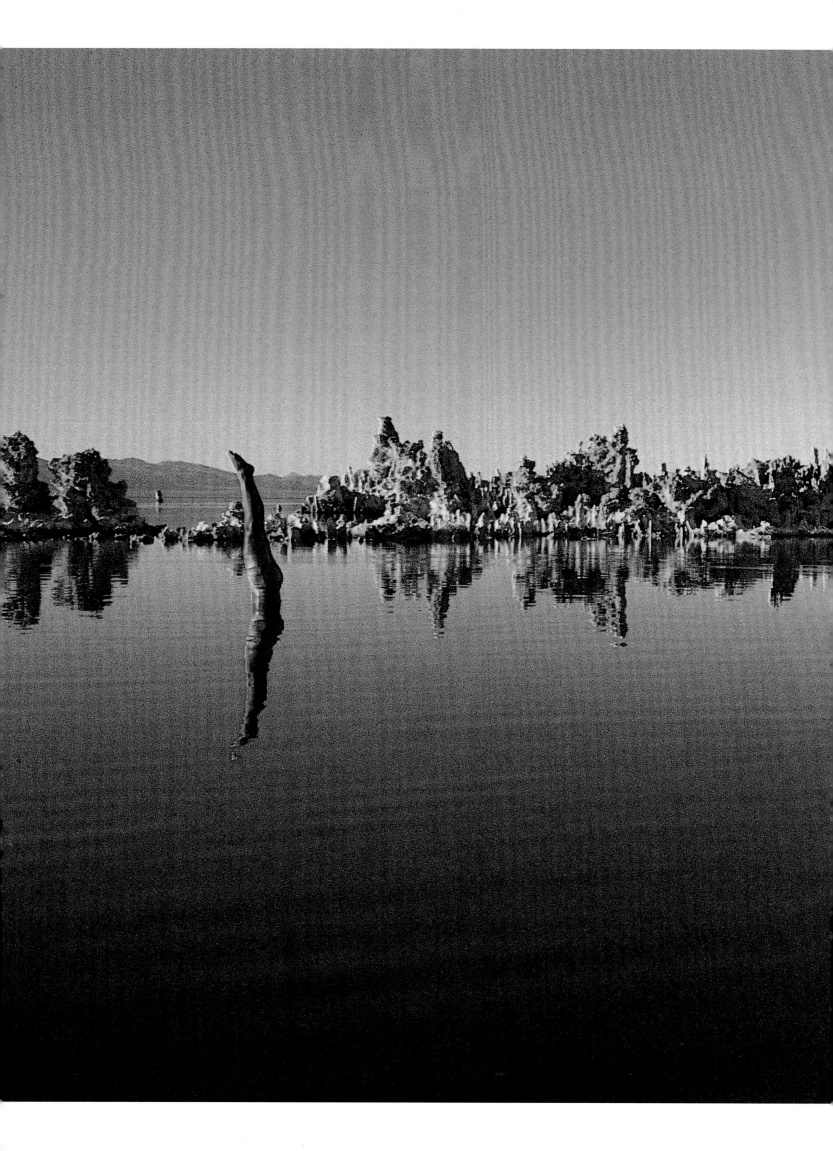

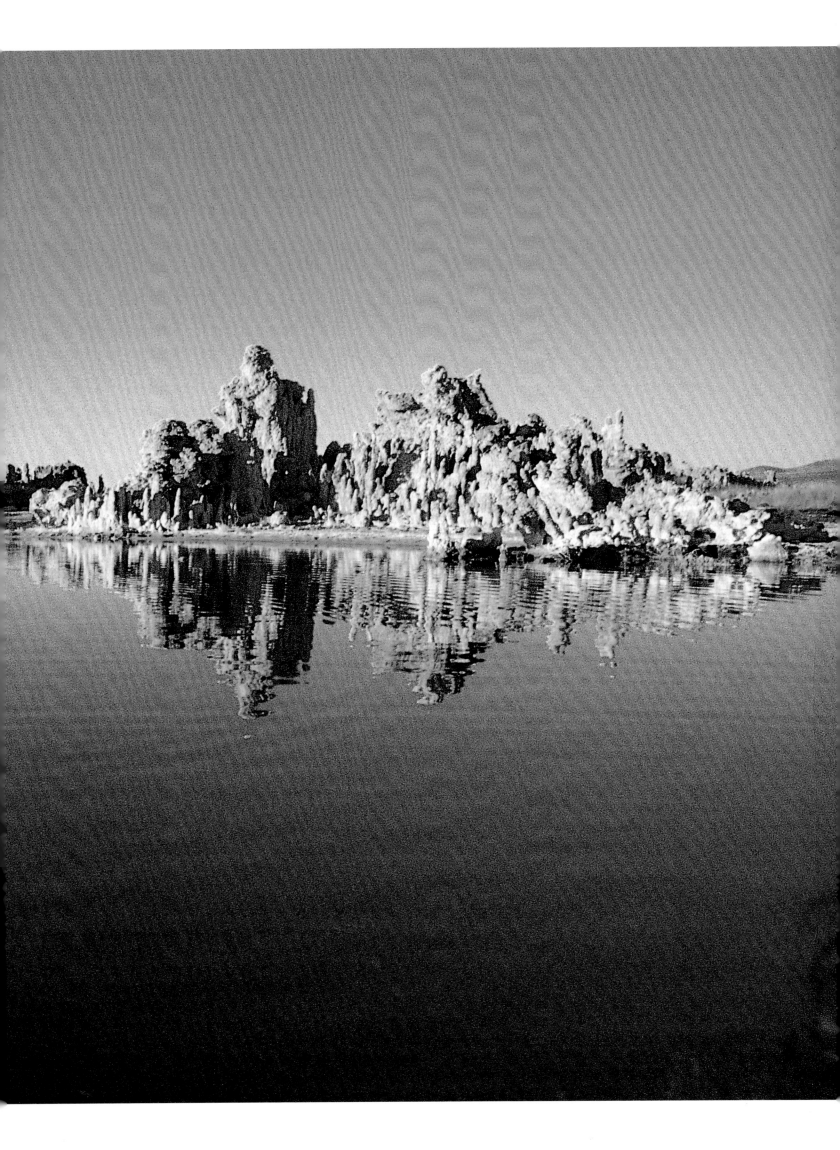

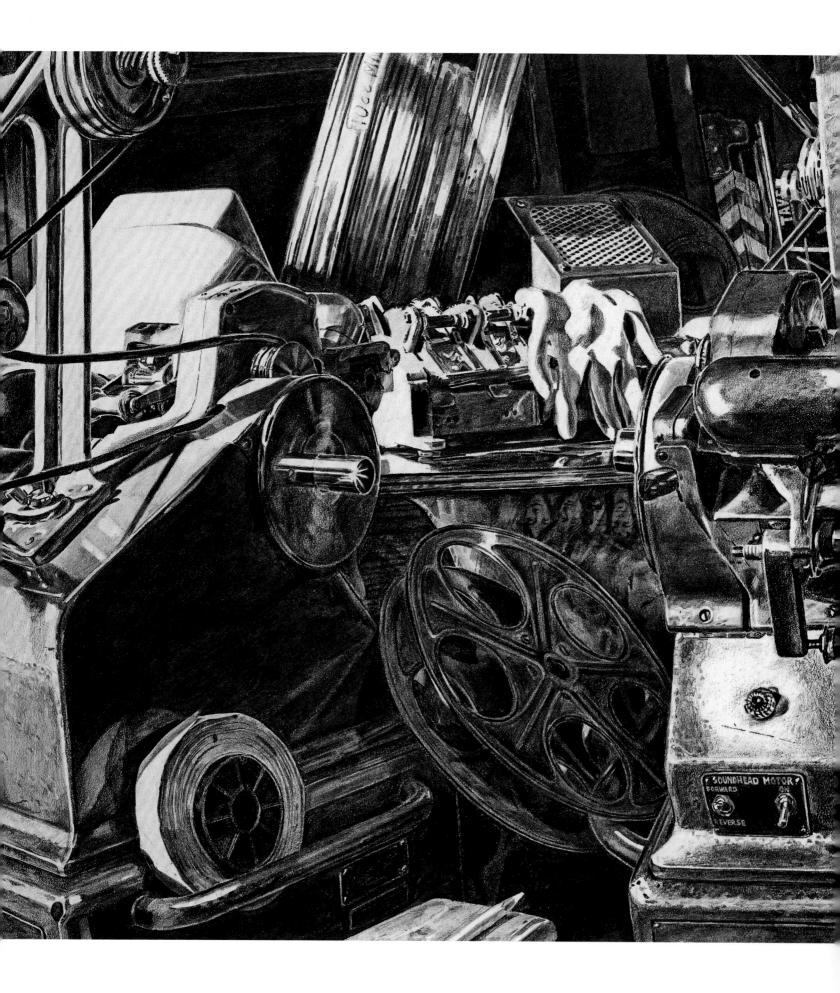

10cc, *Original Soundtrack (1975)*

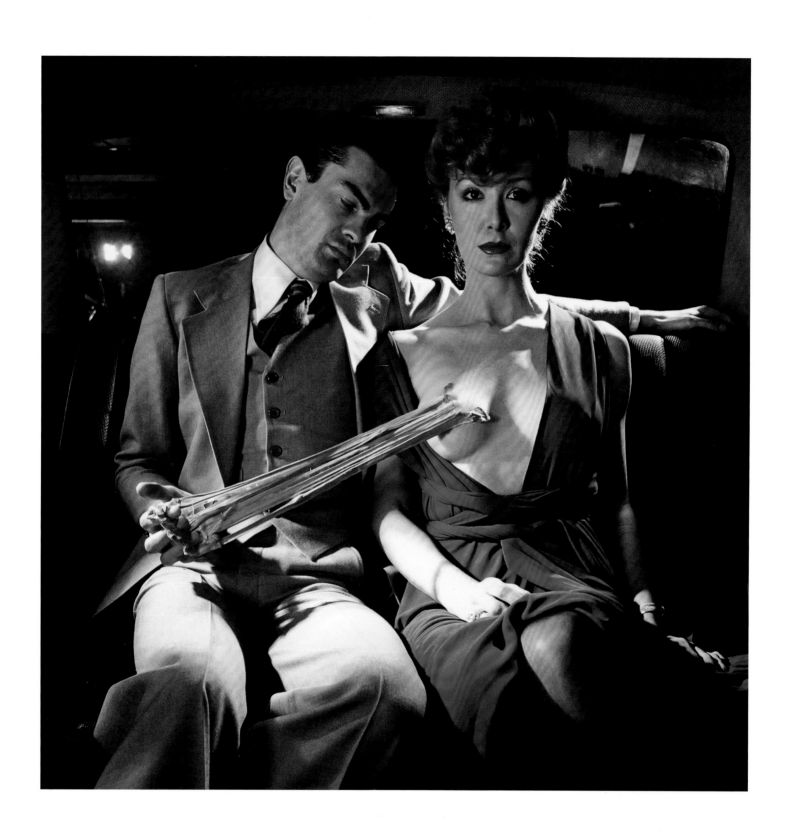

↑ Scorpions, *Lovedrive (1979)* | 10cc, *Deceptive Bends (1977)* →

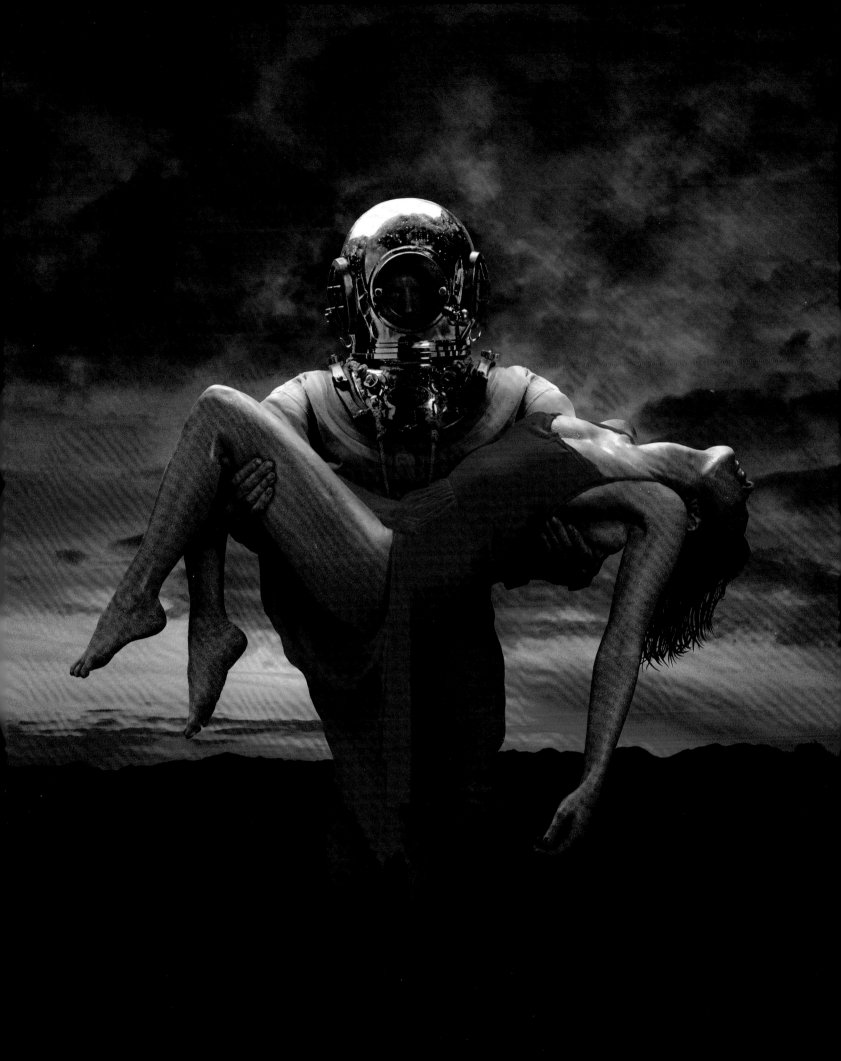

THE Diver for Pink Floyd's **WISH YOU WERE HERE** (pg 44/45) was an idea about absence, i.e. no splash, but it was elevated from its simple origin to a thing of great elegance with a photograph taken by Po at Lake Mono in California. A simple thought turned into a compelling image – its atmosphere is so peaceful that I personally find it restful just to look at it. And it's real, a man is doing a yoga headstand in a cradle, embedded on the floor of a lake and holding his breath for 3 minutes whilst the ripples died away.

THE music of 10cc often alludes to film. By their own admission, they are dead keen on movies, and feel that this enthusiasm pervades their music, especially on **THE ORIGINAL SOUNDTRACK** (pg 46/47), which is music for a film that has not been made. Editing is common to both film and music, and I remember that at film school the old equipment used for cutting celluloid was sort of attractive and busy – this simple notion as a photograph was a bit dull, but it was completely changed and elevated by turning it into an exquisite pencil drawing, care by our dear friend Humphrey Ocean.

TWO pieces of near cheesecake but again completely different. In later years I always felt that **LOVEDRIVE** (pg 48) for Scorpions was a bit crude. We see a couple returning from an opera in the back of a limousine. She indulges the man's peculiar obsession with chewing gum. Since it does not harm anyone, she puts up with it stoically, love is a peculiar thing and they're in the car. Hence **LOVEDRIVE**.

DECEPTIVE BENDS for 10cc (pg 49) is much more complicated – it's a fantasy not of mine or of yours, dear viewer, but of the diver who emerges from the depths too quickly and endures the bends, one of the effects of which is hallucinations, and his hallucination is of course egocentric; he is the best diver ever and has rescued the damsel in distress from the black lagoon and its nasty inhabitants. It's all in his mind and he is deceived – it is just a hallucination.

← The Cortinas, *Defiant Pose (1977)* | ↑ Fabulous Poodles, *Unsuitable, Rough (1978)*

THE CORTINAS, DEFIANT POSE (opposite). When the Punk movement swept across the UK in 1976, and Johnny Rotten wore t-shirts saying 'I hate Pink Floyd' we thought that our days were numbered, but I always liked this design for The Cortinas, which sums up in a fairly unattractive way the existential state of play between offspring and parents. I always considered this to be the heart of Punk although I think they thought they were railing against authority or the status quo.

AN episode in my continuous struggle to break free of two dimensions is the idea I had for Fabulous Poodles' UNSUITABLE, even though I think the rough (above) is much better than the finished thing, I imagined a man worried or perplexed, his face crumpled with anxiety with edges, raised bits and shadows, which of course you can't have in a 2D photograph, but here it is folks! See it and disbelieve me. We took a picture of Marcus, cut off his head, crumbled it and then placed it back on the original photo at his neck. Then we re-photographed it. It takes a worried man . . .

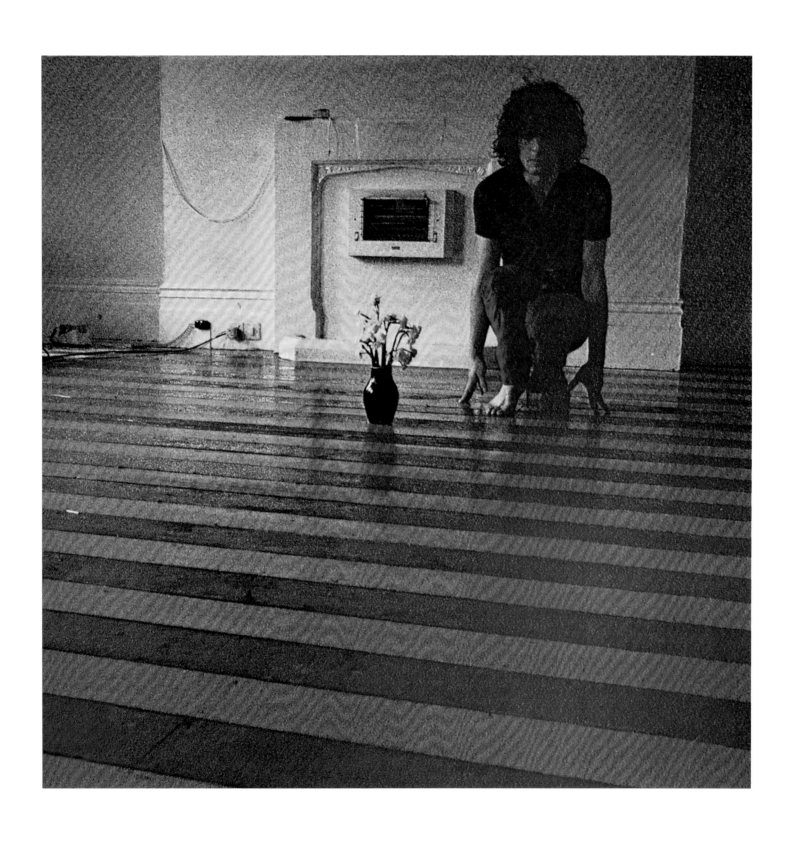

Syd Barrett, *The Madcap Laughs (1970)*

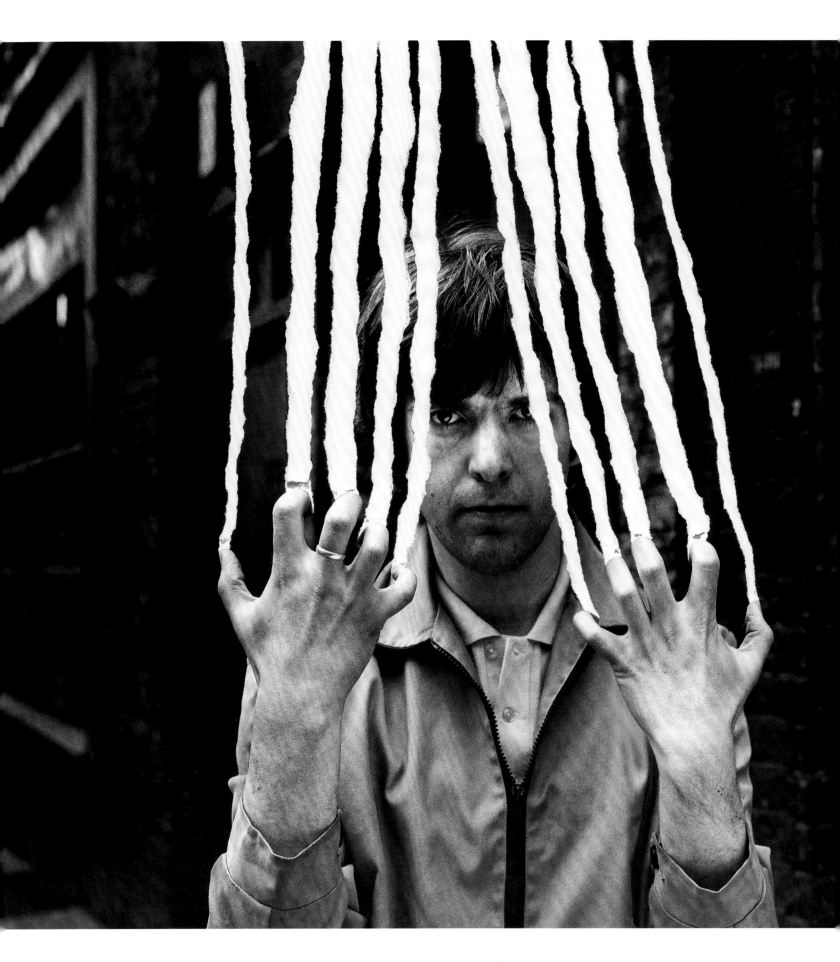

Peter Gabriel, *Peter Gabriel 2 (1978)*

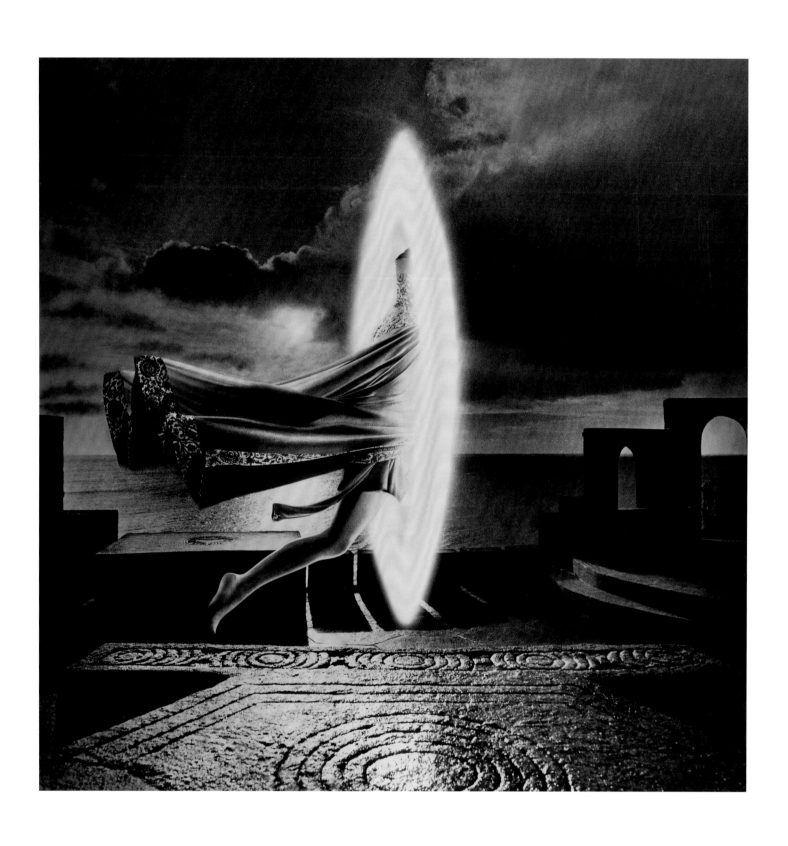

Al Stewart, *Past, Present And Future (1973)*

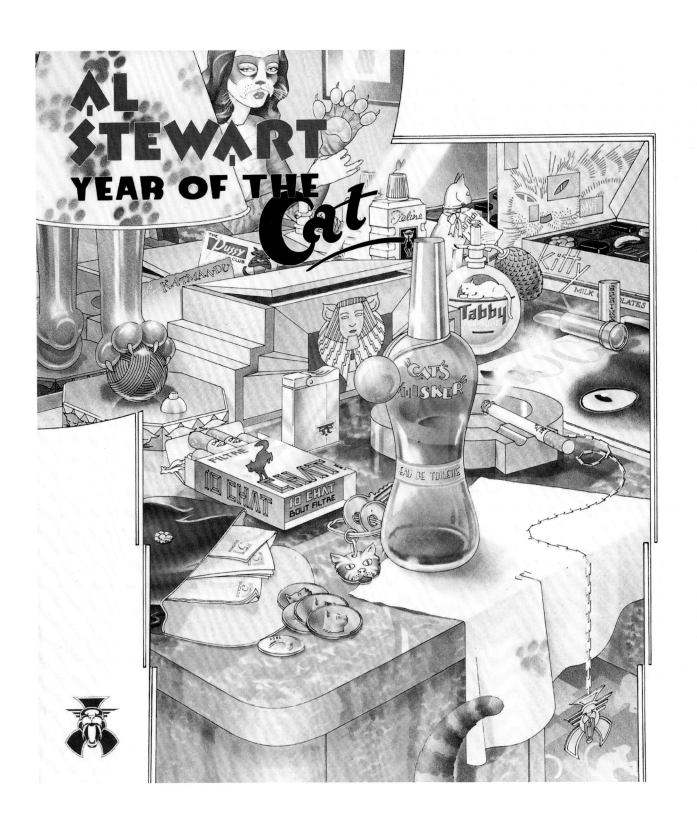

Al Stewart, *Year Of The Cat (1976)*

SYD BARRETT'S solo album cover for **THE MADCAP LAUGHS** (pg 52) was a very quick picture taken in his flat. I think he painted the floor boards especially for us. I didn't ask, I just took a quick picture and that was it. He was a beautiful boy but it all went sadly wrong.

ONE of the constraints of photography is that it is only two-dimensional, unlike installations, sculptures or dancing . . . therefore there is the occasional desire to break free and at least pretend to be three-dimensional, although you cannot actually break free. For Peter Gabriel's second solo album, subtly called **PETER GABRIEL 2** (pg 53), we suggested a sort of 3D illusion where his hands stretch out from the surface of the photograph to became real and scratch the surface of the picture from which the hands emerge. Obviously impossible, dear reader, but a little game we thought might be enjoyed for it's illogicality. Besides the graphic elements and the need to take a portrait, I don't expect anybody to believe it, only to entertain it through suspension of disbelief. It is certainly more interesting, we think, and Peter too, than a straight portrait. It was photographed in black and white in the back alley of Denmark Street, where we had our studio.

ANOTHER solo artist we worked with was Al Stewart, who was completely different both musically and in terms of the cover. The cover for **THE YEAR OF THE CAT** (pg 55) was an illustration by Colin Elgie based on a notion of everything being cat-like or showing cats. **PAST, PRESENT AND FUTURE** (pg 54) is based upon the idea of a time tunnel whose entrance appears as a disc of light through which our figure steps. Derived from **Doctor Strange**, the location is the Minack Theatre in Cornwall.

MOROCCAN ROLL. Brand X were a jazz-rock outfit featuring Phil Collins for whom we worked several times (see opposite and page 75). **MOROCCAN ROLL** was such a great title to work with. We envisaged a man in an Arabic town being watched and probably about to be mugged or rather 'rolled', and sent out of town. Such are the connections in Brand X's music and its cosmic undertones that our picture suggests a deeper meaning, by its graphic overlay, the configuration of participants is a key presumably of some underlying truth. Photographed in Tunisia, not Morocco . . . naturally.

YES, **GOING FOR THE ONE** (below), uses a similar graphic line overlay but for a completely different reason, in this Kundalini. We got into trouble with Yes because they thought the cover was about being gay, I'd like to point out that gay people have the same Kundalini point as non-gay people.

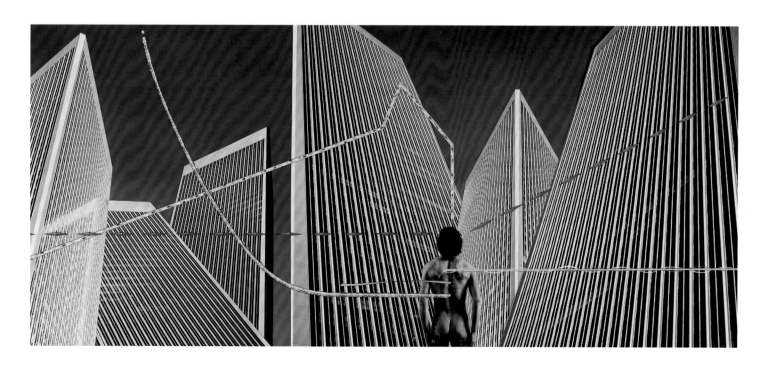

Yes, *Going For The One (1977)*

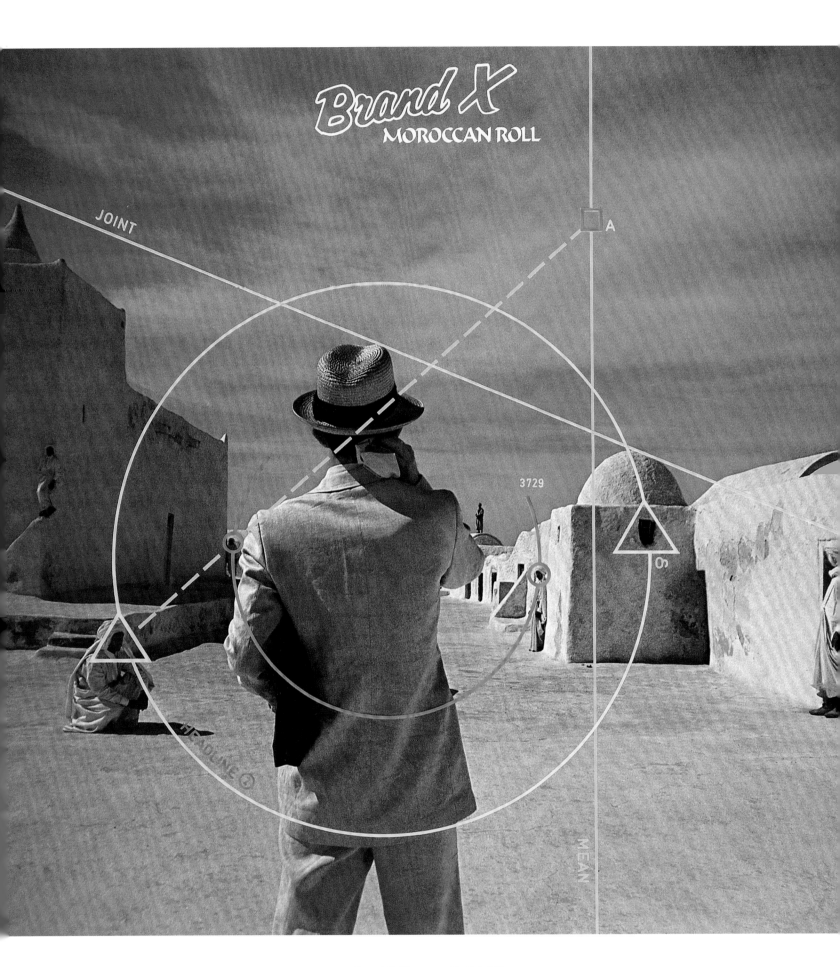

Brand X, *Moroccan Roll (1977)*

Be Bop Deluxe, *Drastic Plastic (1978)*

This is a RECORD COVER. This writing is the DESIGN upon the record cover. The DESIGN is to help SELL the record. We hope to draw your attention to it and encourage you to pick it up. When you have done that maybe you'll be persuaded to listen to the music - in this case XTC's Go 2 album. Then we want you to BUY it. The idea being that the more of you that buy this record the more money Virgin Records, the manager Ian Reid and XTC themselves will make. To the aforementioned this is known as PLEASURE. A good cover DESIGN is one that attracts more buyers and gives more pleasure. This writing is trying to pull you in much like an eye-catching picture. It is designed to get you to READ IT. This is called luring the VICTIM, and you are the VICTIM. But if you have a free mind you should STOP READING NOW! because all we are attempting to do is to get you to read on. Yet this is a DOUBLE BIND because if you indeed stop you'll be doing what we tell you, and if you read on you'll be doing what we've wanted all along. And the more you read on the more you're falling for this simple device of telling you exactly how a good commercial design works. They're TRICKS and this is the worst TRICK of all since it's describing the TRICK whilst trying to TRICK you, and if you've read this far then you're TRICKED but you wouldn't have known this unless you'd read this far. At least we're telling you directly instead of seducing you with a beautiful or haunting visual that may never tell you. We're letting you know that you ought to buy this record because in essence it's a PRODUCT and PRODUCTS are to be consumed and you are a consumer and this is a good PRODUCT. We could have written the band's name in special lettering so that it stood out and you'd see it before you'd read any of this writing and possibly have bought it anyway. What we are really suggesting is that you are FOOLISH to buy or not buy an album merely as a consequence of the design on its cover. This is a con because if you agree then you'll probably like this writing - which is the cover design - and hence the album inside. But we've just warned you against that. The con is a con. A good cover design could be considered as one that gets you to buy the record, but that never actually happens to YOU because YOU know it's just a design for the cover. And this is the RECORD COVER.

XTC, *Go 2 (1978)*

Montrose, *Jump On It (1976)*

Montrose, *Jump On It*, Back cover *(1976)*

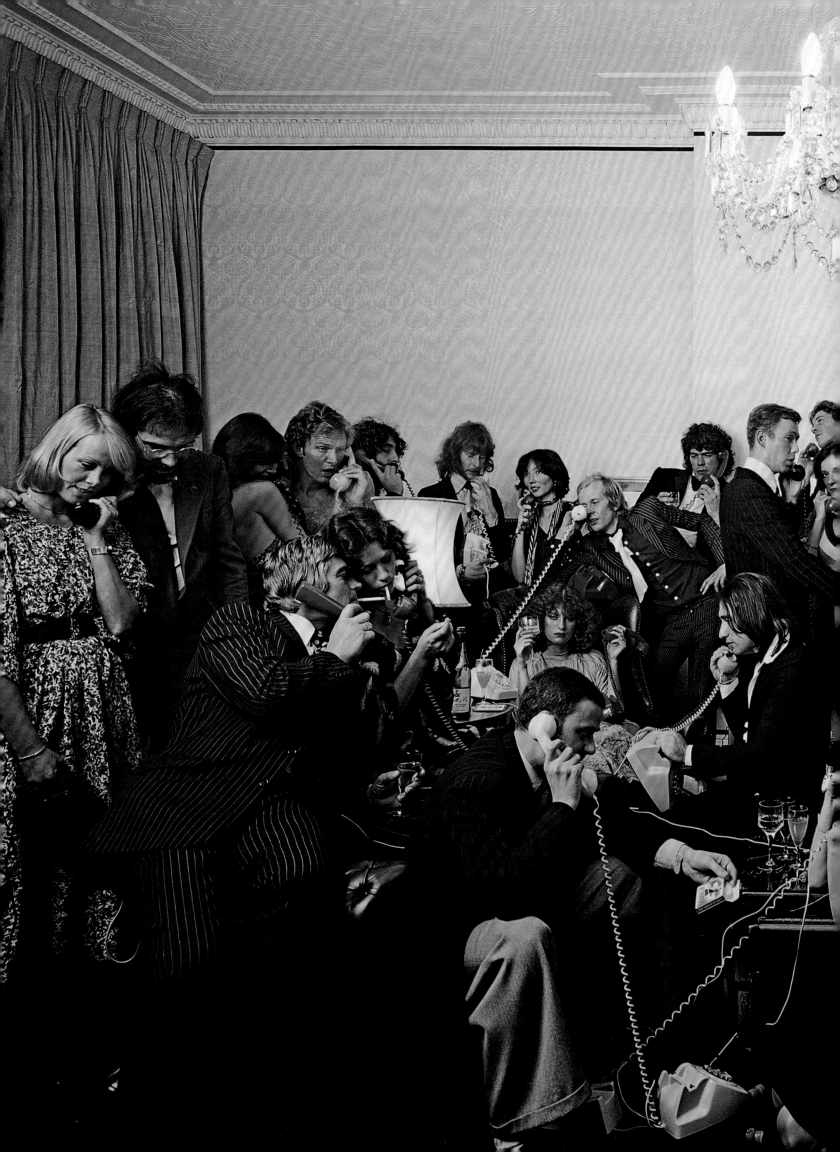

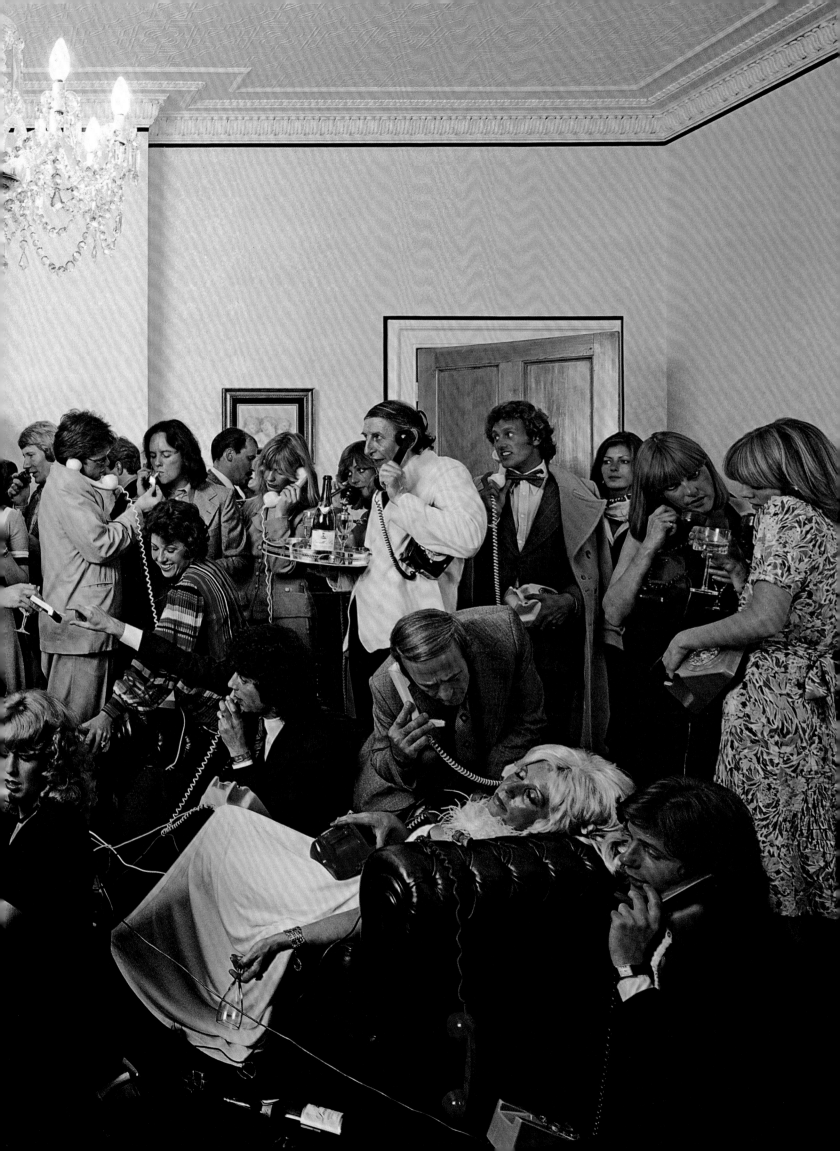

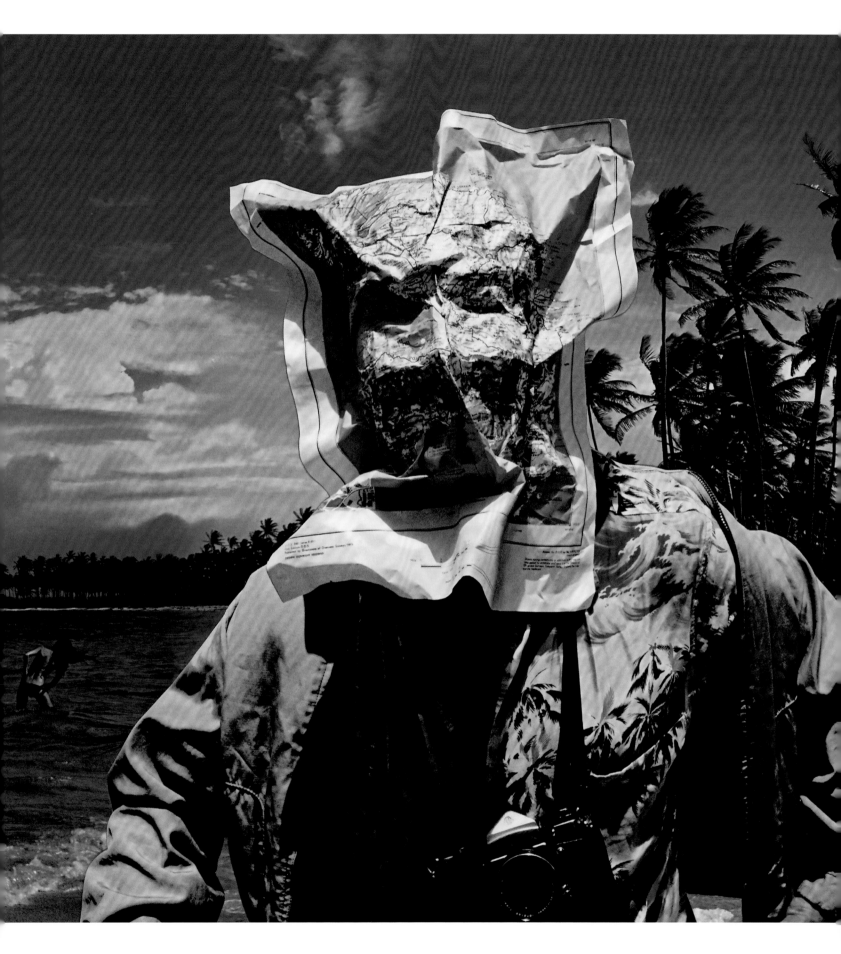

← 10cc, *How Dare You!*, Inner spread *(1976)* | ↑ 10cc, *Bloody Tourists (1978)*

BE BOP DELUXE were a band much concerned with style and abstraction so, for **DRASTIC PLASTIC** (pg 58) we designed a geometric pattern of colour, which is also a place, namely a kitchen with red floor, white sideboard etc. The tones of yellow are in fact thrown paint, which was a favourite pursuit of ours. It doesn't mean a lot, though I enjoy the shapes and colour.

THE cover for XTC's **GO 2** (pg 59), on the other hand, has a lot of meaning but a little style. I was attempting to present type in the most unstylish way as possible, in this case from a typewriter white on black, and that's all. Certainly cheap enough. I don't imagine many people read it, but once they did they had spent time on that and already succumbed to the conceit, which is trying to persuade you to read it because that's the objective of an album cover, in some people's minds. In effect it is explaining a trick whilst it is trying to trick you, but of course only the intelligent reader doesn't bother with its indulgent frippery.

MONTROSE from Canada subtly entitled their album **JUMP ON IT** (pg 60/61) and we tried hard to represent the likely allusion in a detached way as possible – hot subject, cool rendition. Warm human subject presented geometrically, this is a hand-coloured picture involving sepia toning and a red dye.

WE never realized how much 10cc were into telephones until we designed **HOW DARE YOU!** (pg 62), their 4th album, on which there was a song about telephones – 'Don't Hang Up' – where the telephone is a good metaphor for the interconnections both in film and in music. Our party where everybody is on the telephone is of course absurd, but interesting psychologically: why not talk on the phone if you can't talk to each other? And also historically: where are the mobiles? The band is in there somewhere, if you can find them, but they are probably on the phone.

SAVAGE EYE (below) is a simple picture of a knowing wink, whereas **BLOODY TOURISTS** (opposite) is a much more complex affair, where a map, which the tourist might need, is blown into his face. So firstly he can't see where he is going because that which he needs is obscuring the view, and secondly the paper wrapped around his head resembles a mask, not Venetian exactly, but still a mask. The tourist cannot see where he is going because he is merely passing through a Caribbean idyll, not caring to be there much because the map is blocking his view. As much as it might in life. A similar theme to Styx (pg 40/41) but presented in a different fashion, shot on location by Po, who was waiting for an aeroplane. He says he jumped over a private fence, took the picture, jumped back over and took the flight.

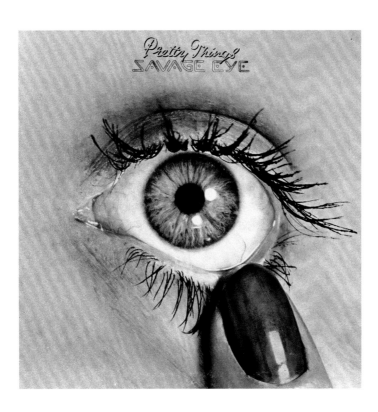

Pretty Things, *Savage Eye (1975)*

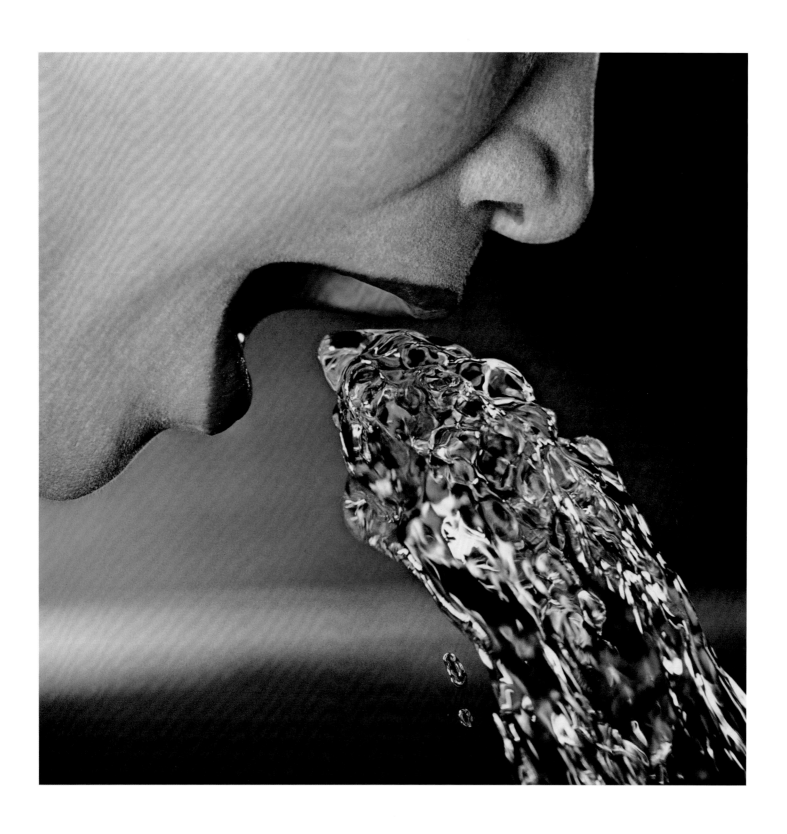

Ashra, *Correlations (1979)*

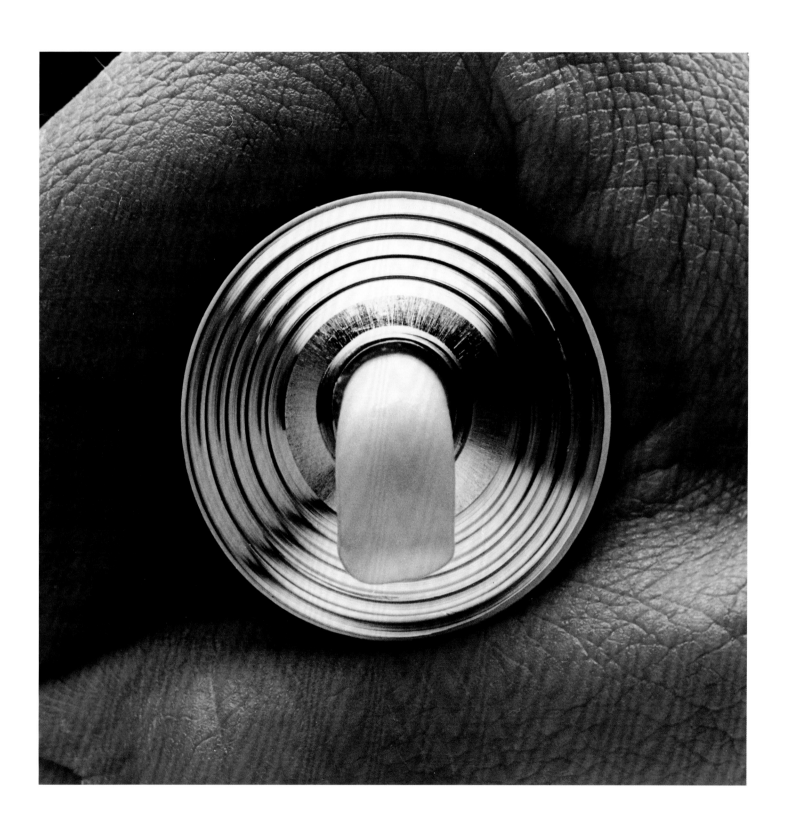

↑ String Driven Thing, *Keep Yer 'And On It (1975))* | Led Zeppelin, *Houses Of The Holy (1973)* →

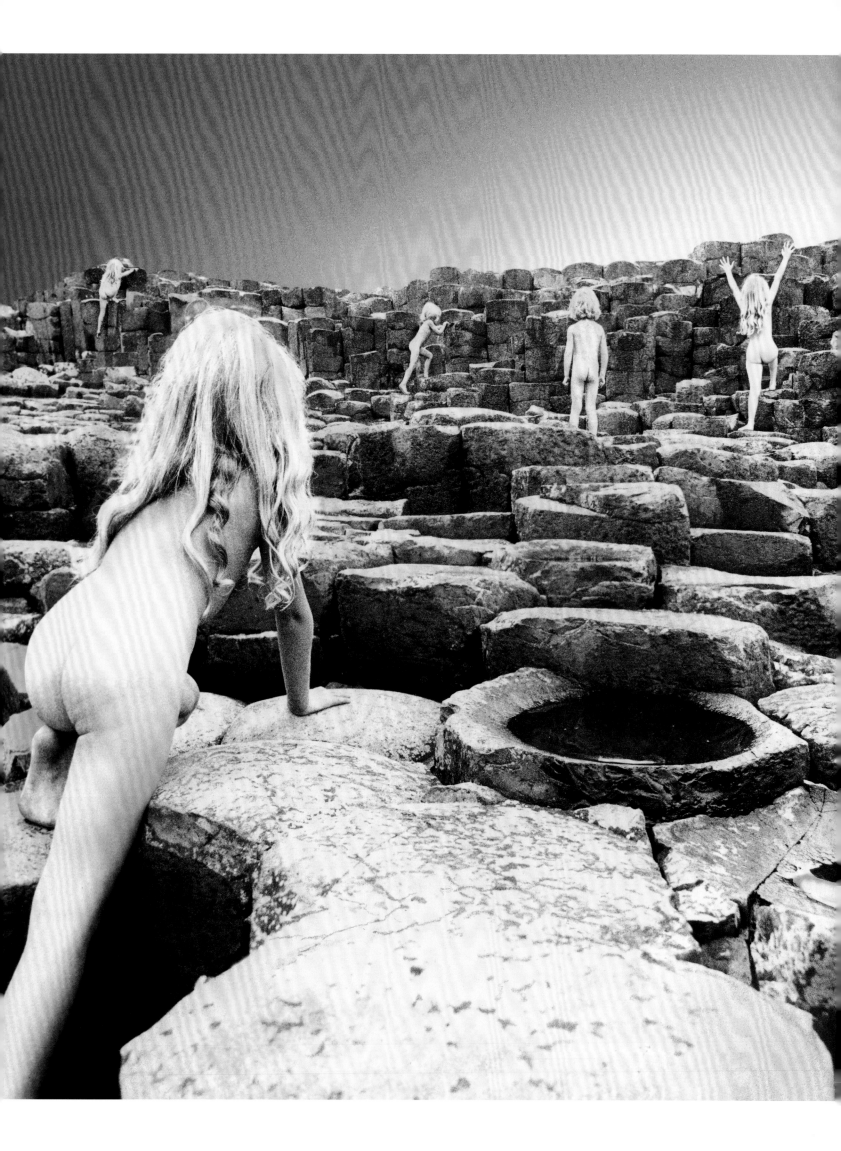

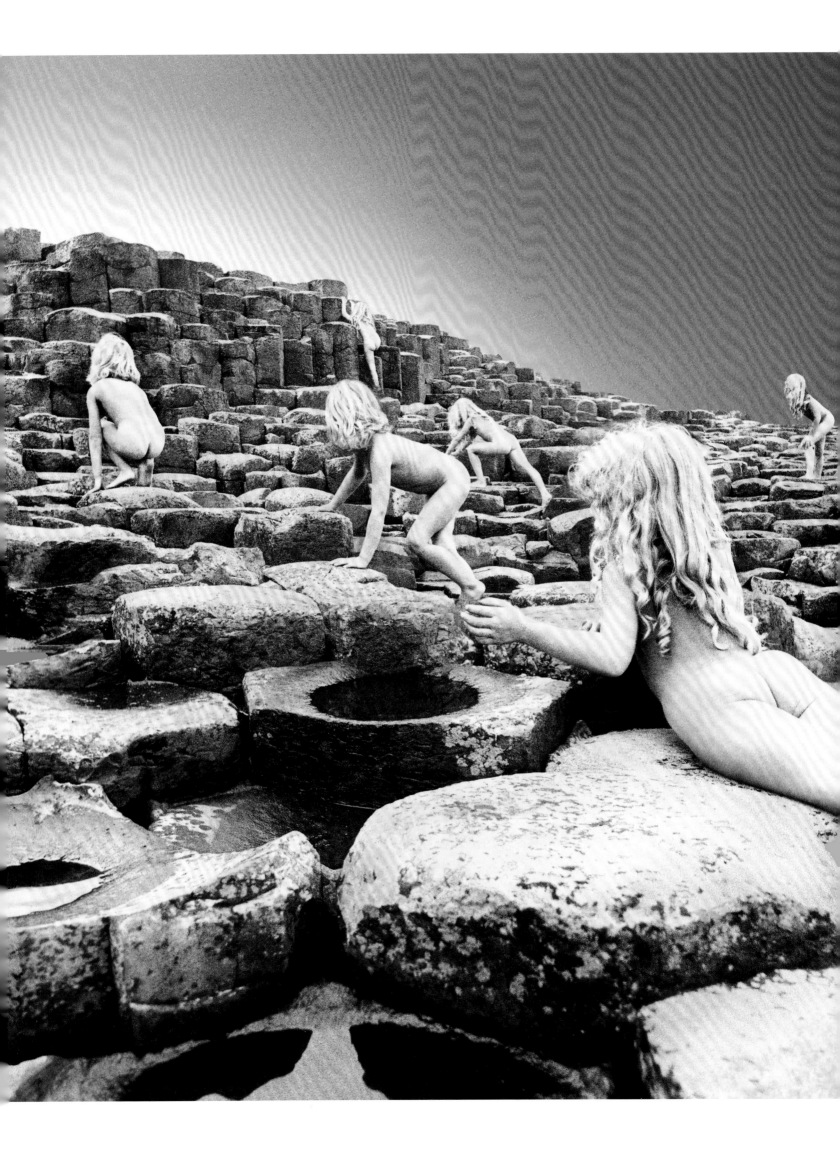

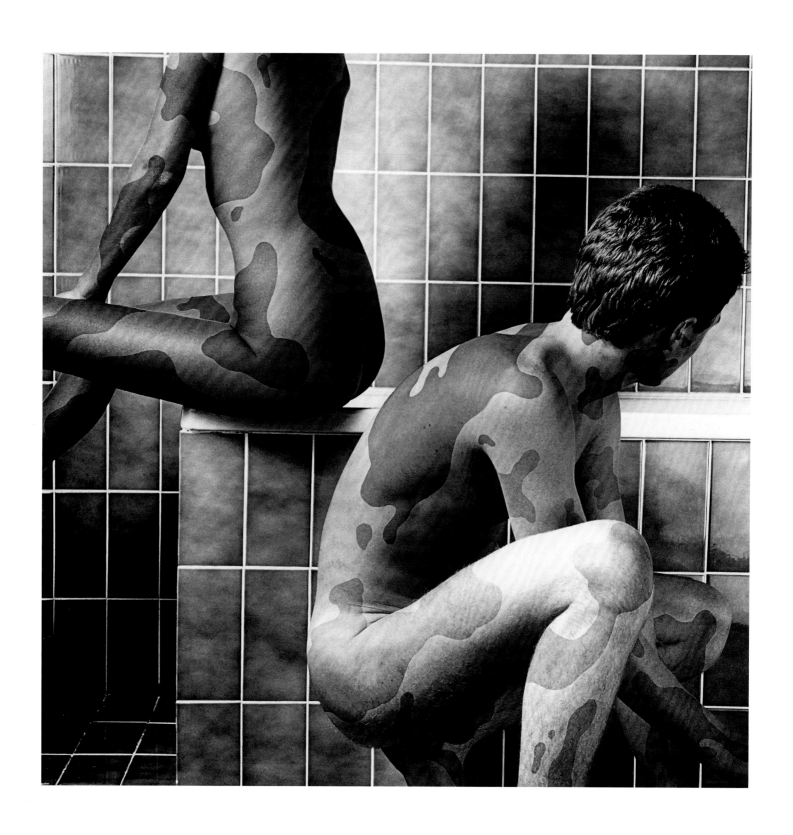

Godley and Creme, *Freeze Frame (1979)*

ASHRA'S CORRELATIONS (pg 66), like Peter Gabriel's CAR and String Driven Thing's KEEP YER 'AND ON IT, is an observation of life – a woman drinking from a water fountain. What you see is water, like ice: no trickery here. The shape is natural but highly suggestive. Once I held an auction at which this picture was very popular. It was bought for a nine-year-old girl who described it as the best picture in the world. Nine years old?

FROM the divinely simple to the divinely complex. String Driven Thing's album was called keep your hand on it – KEEP YER 'AND ON IT (pg 67). It was rather suggestive, I thought, so I took an observation from real life – brushing teeth in the morning – which had graphic and sexual connotations. It was just a hand squeezing a tube of toothpaste, very simple, very everyday, but perhaps unexpected when close-up.

HOUSES OF THE HOLY (pg 68/69) was altogether a different kettle of fish. Led Zeppelin were enormous, even their name could send a shudder. They were viewed as divine in some quarters, revered as the greatest rock band ever, so what could be visually large enough? I took an image from a science fiction book, called Childhood's End, by Arthur C. Clarke, in which the children of Earth come together,

'fuse' and leave the physical plane in a tower of fire. Sounded big enough to me. The location was suggested by Robert Plant. The Giant's Causeway in northern Ireland is made of hexagonal rocks and already imbued with spiritual meaning. The children are climbing up the rocks towards a brightly coloured sky where they will meet and transmogrify. The end of children, very spiritual, positive and optimistic, ironically.

Because the weather was awful, the picture was taken in black and white and hand-coloured by Philip Crennel. The hand-colouring was fastidious, bit by bit, brightly coloured, like pointillism, and it took some weeks to complete. Po showed it to the band from the back of his car in Victoria Station, where a small crowd had gathered. The children were naked only to emphasise their impending rebirth, but of course it was read as paedophiliac in Oklahoma and Spain and subsequently banned, which the band enjoyed as much as the cover itself.

THE image for Godley and Crème's FREEZE FRAME (opposite) was an idea by Peter. Piebald people, people whose skin markings separated them from normal people, who are possibly alien, possibly diseased or genetically wrought. Either way they are outcasts bathing in the privacy of their bathroom and we can see their bodies. The markings were made by using a matt to alter the exposure time.

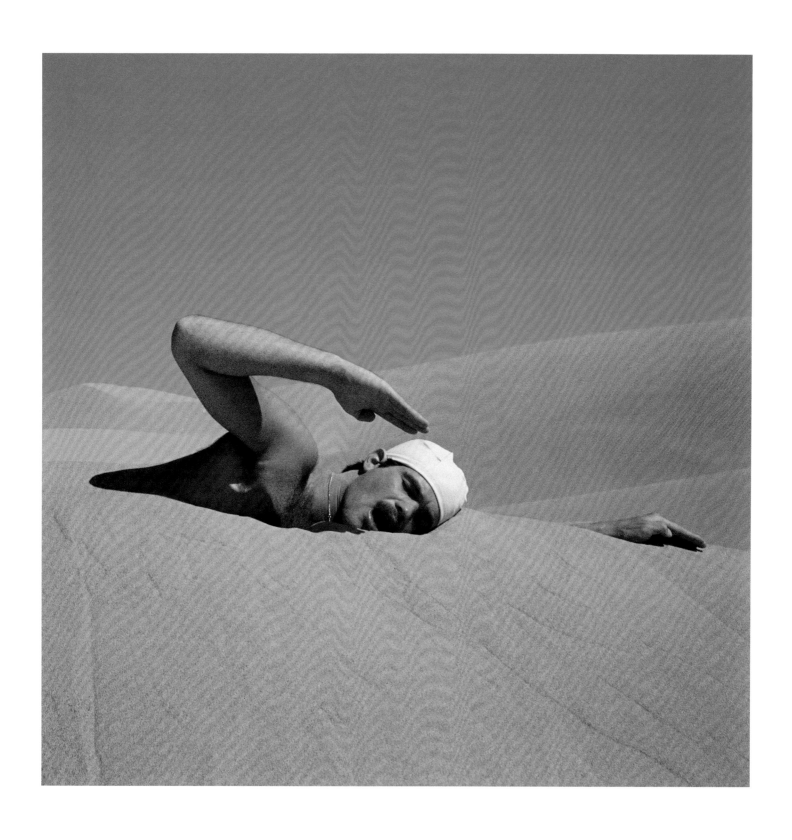

Pink Floyd, *Wish You Were Here (1975)*

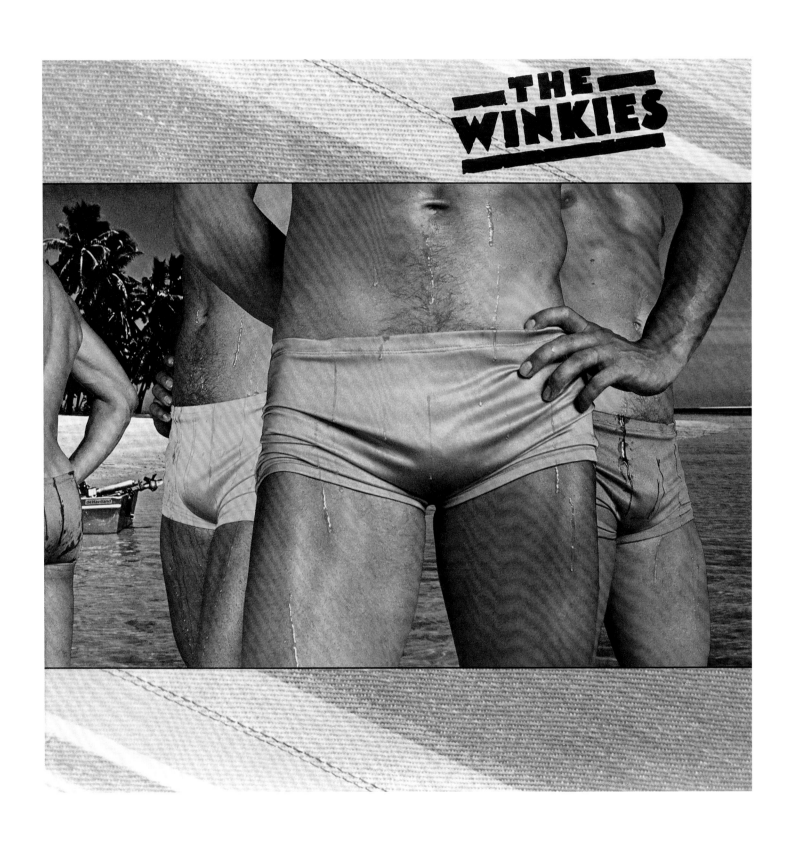

The Winkies, *The Winkies (1975)*

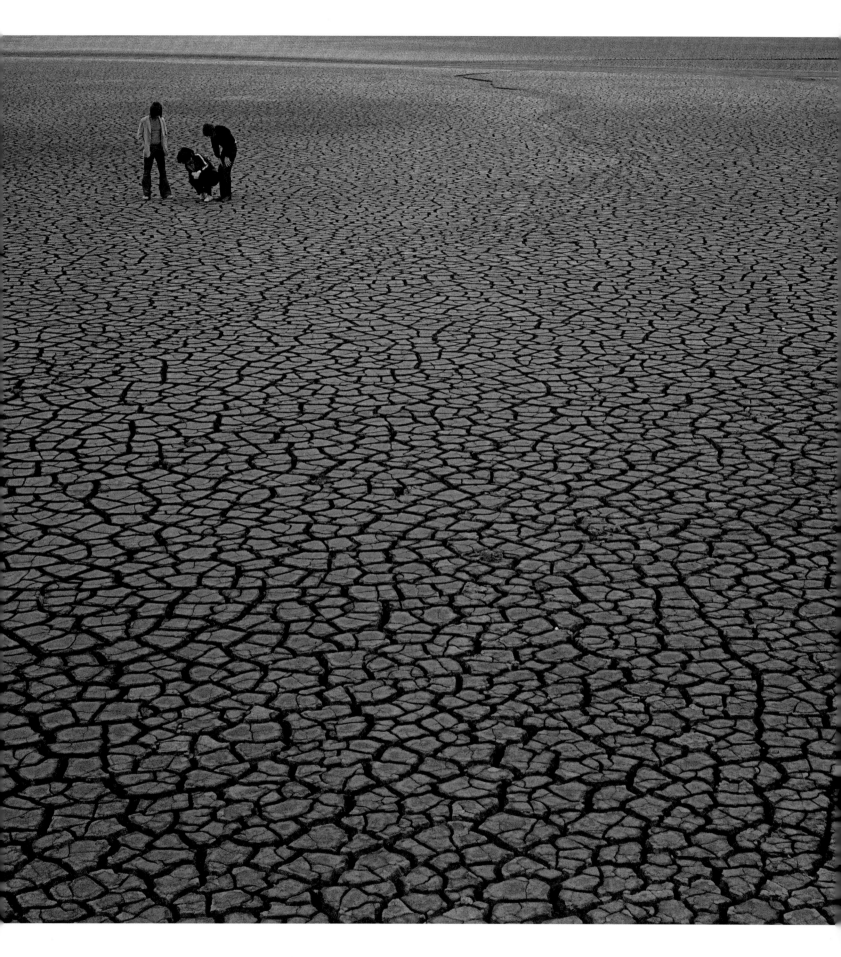

Marvin, Welch and Farrar, *Second Opinion (1971)*

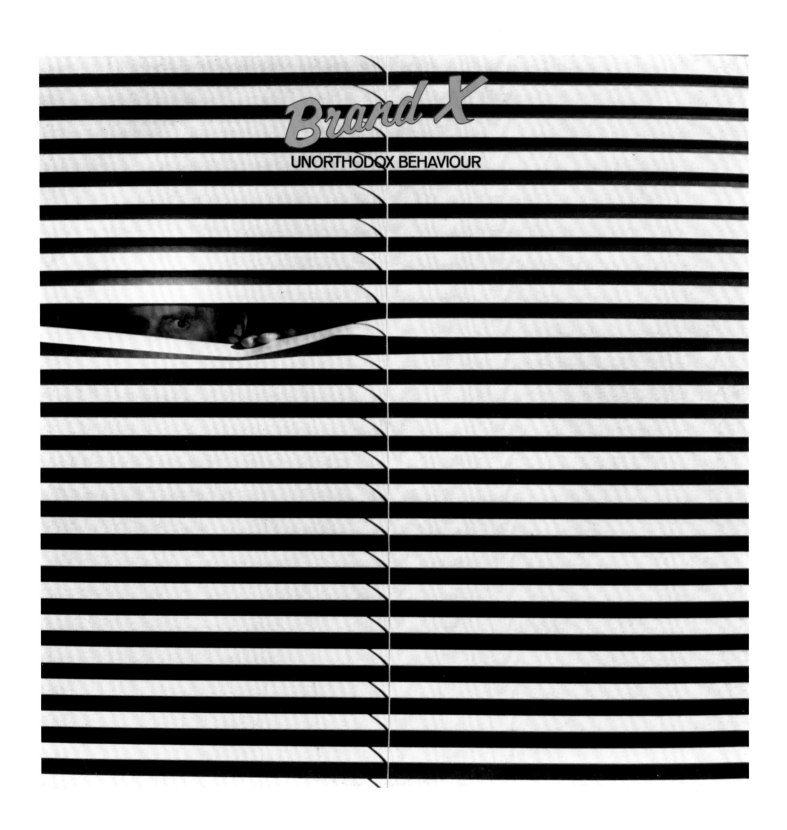

Brand X, *Unorthodox Behaviour (1976)*

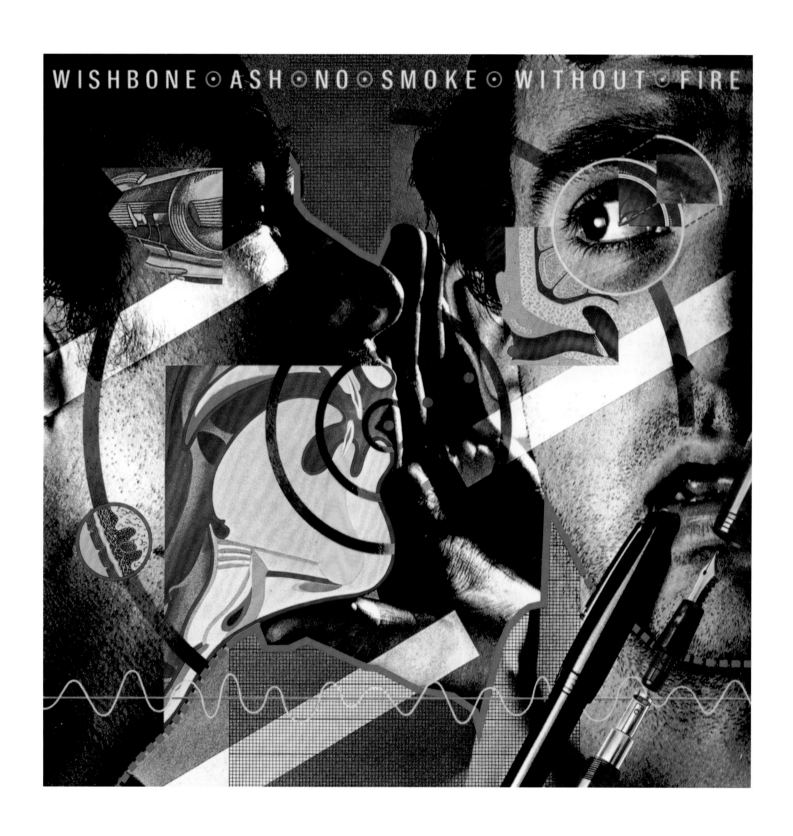

Wishbone Ash, *No Smoke Without Fire (1978)*

Heavy Metal Kids, *Kitsch (1976)*

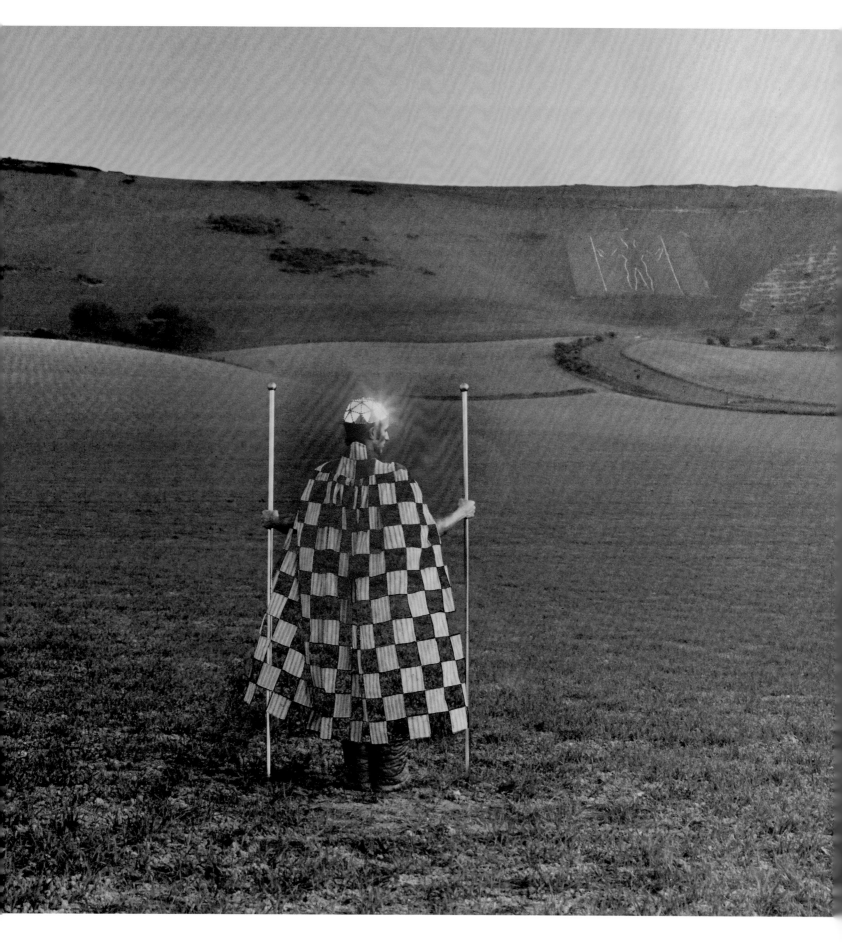

Uno, *Uno (1974)*

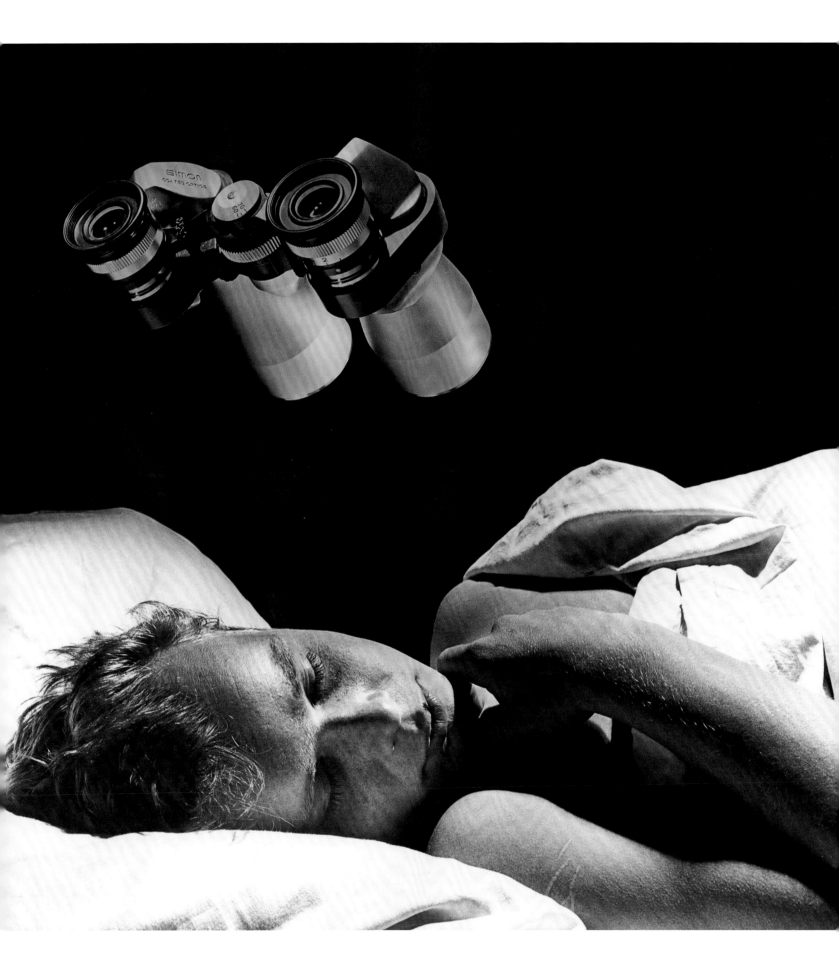

Foreigner, *Silent Partner* - Unused *(1979)*

THIS is a picture taken in the Yuma Desert, California for Pink Floyd's WISH YOU WERE HERE (pg 72). It is known as 'The Meaning of Life' picture since it appears so pointless. Maybe the swimmer was so keen that he swam from the sea straight up the beach, the crazy bastard.

THE WINKIES (pg 73) is a childish name for rude parts, and the album's cover was a blatant attempt to show the obvious in an obscure way – a bulging lunch box rather than naked genitalia. The added drops of glycerine lend a pubescent air – pubescent being rather hairy and insubstantial.

THE image of a window blind with strings gave me the obvious graphic virtues of a blind plus all its foibles, though the man in our picture for UNORTHODOX BEHAVIOUR (pg 75) is not only peering like a pervert, but he is also breaking the graphic lines. Very simple.

THE design for NO SMOKE WITHOUT FIRE (pg 76) by Wishbone Ash came from the title, but it was too boring on its own, so cross-sectioning the act by a cut elevation seemed to me to make it more interesting. I have always been fond of cut-aways since I was a kid and we had The Eagle comic.

SILENT PARTNER (pg 79) is about surveillance. I really like this vision of very close surveillance, as if the binoculars were spying on the boy's dreams. This was for Foreigner, but they didn't like it, thinking the boy looked too gay. I always thought the idea was kind of spooky since the binoculars allow you to read their intentions before they did anything.

THE most amazing thing about SECOND OPINION (pg 74) was this mud flat; it might have been in Africa but it was in fact in Yorkshire. The cracked mud desert was in Middlesbrough, on the Tees Estuary; nobody ever believes me.

HEAVY METAL KIDS' KITSCH (pg 77) is a sort of scenario about the future, about prognostication; whereas UNO (pg 78) is a picture of a past visitation based on the Long Man of Wilmington who is carved in the rocks and his real life counterpart has come to pay a visit.

It's an interesting parallel between Uno, which is about the past and Kitsch, which is about a premonition of the future.

80s

IN TWO PARTS

Storm continued to design album covers with HIPGNOSIS until 1983,
but for the remainder of the decade he worked for himself at STd-ICON –
to best reflect this the 80s have been divided into two parts accordingly.

· · · ·

IF a decade is defined by its haircuts, then the 1980s must rank as an epic failure: Poodle-haired, Spandex-clad rockers, Margaret Thatcher's ball of spun steel, truck-stop mullets (usually worn with sleeveless denim jackets) – these monstrosities define a decade that has become known as the 'designer decade' but which we now recognise as a period of stylistic gross-out and tastelessness on an heroic scale.

THE eighties were full of things that seemed smart at the time but which are now recognised as garish and superficial. It was the first truly modern decade (which means that we now call it the first post-modern decade). Politicians told us that the end of the Cold War presaged a life of global harmony; they promised a post-industrial world where we would all have well-paid jobs in the service sector. Sleek estate agents (indistinguishable from the sleek politicos who peddled the same message) told us that universal property ownership would turn us all into plutocrats. Global technology corporations (the makers of personal computers, cell phones and VCR machines), offered us a silicon-utopia, courtesy of the microchip.

BUT instead of utopia, we ended up with a world obsessed with celebrity, branding and greed. Our heroes were weather girls, TV soap stars – anyone who stepped into the magical frame of the TV screen was likely to become a figure of public obsession. In the 80s, City financiers (in truth, spivs and bandits) became Masters of the Universe. We defined people by the brand of wristwatch they wore and the car they drove. But most of all we admired people for their dexterity with a small rectangle of plastic – the credit card. The kingfisher-flash of shiny plastic in a chic restaurant was a sign of status. It was the equivalent of driving a Rolls Royce in the 1950s, except this time, loads of people could flash the plastic.

POP music too was infected by the 80s virus. Up until then, pop had been a relatively authentic form of artistic expression. I say relatively because pop music has always had its manipulators, exploiters and fraudsters. But from the 60s onwards, there was a sense in which pop music was a genuine upsurge of artistic and cultural activity unlike anything that had gone before. It seemed genuinely classless and democratic. Anyone could be a pop star – of course, it helped if you were good looking, had musical talent, and a sharp manager – but it wasn't obligatory.

YET in the 80s, when everything acquired a value, it was inevitable that pop music couldn't be

left to idealistic young people with guitars or cheap synthesisers and signed to idealistic indie record labels; like everything else, it had to be conglomerated. Most of the indie labels that burst into existence in a firestorm of creative energy in the 1970s slowly fell into the hands of major labels. The music business became the music industry. Power coalesced in a group of five major labels, each driven by shareholders and pension funds (some of these giant corporations even had interests in munitions).

ALL of this meant that a new breed of record company executive emerged. In the 80s it was still possible to deal with people at record labels who still actually liked music. But they were an endangered species. Rather than dealing with someone who had played in a band, you were far more likely to be hired by someone who had been trained in marketing at Unilever or Pepsi, and anyone earning a living as a record cover designer at this point was beginning to find life difficult. Album cover design became a marketing department concern, and the heavily styled (and retouched) artist portrait was the album cover's default setting.

OF course, some sleeve designers ignored all of this corporatisation. Storm Thorgerson behaved throughout the 1980s much as he had done in the previous decade – that is, with a piratical disregard for record company marketing conventions and their accounts-department mentalities. ('Do you think you could make the type bigger? And could you retouch the singer's paunch? Oh, and while you're at it, could you reduce the cost of the photo shoot?')

UNTIL 1983, Thorgerson functioned as part of Hipgnosis, but after that he operated under his own name. As before, he worked closely with bands who continued to see audacious record sleeve design as an essential component of a record's release. Looking at Thorgerson's sleeves from the 80s, we can see that not much has changed from the great days of the 70s, arguably a high water mark for cover art. The icy finger of the record company marketing department appears astonishingly absent from his work. We see the continuing absence of photographs of artists and plenty of Thorgerson's trademark symbolism: imagery that usually hints at derangement and psychological upheaval.

WHEN he did use an artist's photograph, he was incapable of playing it straight. Peter Gabriel's album *3* (pg 99), which spawned two of his biggest hits 'Games Without Frontiers' and 'Biko', featured a weird melting-wax portrait that made the handsome Gabriel look like a burns victim. As he notes: 'we did the sleeve with Storm again, Hipgnosis and he introduced me to these things called [Krimsographs], I think. There was a photographer called Les Krims, who discovered that if you take a Polaroid and squash it you can get the colours to run, and we used to doctor them with different objects – burnt matches and coins and fingers and all sorts of things – and it was a lot of fun because you had to get the timing right, but you got some wonderful effects out of the distortions.'

OTHER sleeves from Thorgerson's 1980s period saw him exploring more familiar territory. The cover for the 10cc album *Look Hear?* (1980) has a picture of a sheep sitting on a psychiatrist's couch on a beach. We can assume that the shoot wasn't done in Margate or Eastbourne. It looks as if it was shot in St. Lucia or Antigua, and knowing Thorgerson's appetite for authentic locations (and his taste for locations designed to upset record company finance departments), it was most likely shot in the Caribbean.

Thorgerson has said: 'The band asked for "something different". I never really have a clear idea of what that expression means . . . I thought it was more engaging to ask a question and between us we came up with "are you normal?" Anyway, the question led to the idea of normality and what could be more normal than a sheep, and they all tend to follow each other. But to be normal you'd need a lengthy dose of psychotherapy.'

THE sleeve for Ellis, Beggs & Howard's *Homelands* (pg 109) has a quasi-anthropological appearance. A quintessentially eighties band (albeit with a name more suited to a firm of provincial solicitors), the group were short-lived, and if they are remembered now it is only for the sleeve of their one official album release. According to Thorgerson: 'We devised three totems or masks (for the three band members), which Keith Breeden (Scritti Politti, The Mission, ABC) then proceeded to make from old boilers and motorbike parts – contemporary sculptures from scrap metal, suggestive of both modernity and ethnicity.'

BUT as usual, it is Thorgerson's work for Pink Floyd that seems to elicit his boldest and most ambitious responses. The cover for *A Momentary Lapse*

Of Reason (pg 104/105), the band's thirteenth studio album, features 800 hospital beds placed on a beach. The beds are real, and were painstakingly arranged on Saunton Sands in Devon. Even in that distant, pre-Photoshop era, the beds could have been faked. But fakery was rarely part of the Thorgerson methodology: if something could be done for real, that was how he did it. Nearly two and a half decades later, he's still at it: still insisting on doing it for real. He uses computers, but you sense that he's only happy when he has a team of people building something improbable and downright contrary in an exotic location. It's an odd way to behave in the era of postage-sized JPEGs for album covers on iTunes, and record company sleeve design budgets that would cause a hamster to starve. But it is the Thorgerson way: dogged, selfish and egotistical. But also shot through with genius. You have to be dogged, selfish and egotistical to do what Thorgerson does: and it helps if you are shot through with genius. The good news is you don't have to look like a member of A Flock Of Seagulls.

• • • •

Adrian Shaughnessy

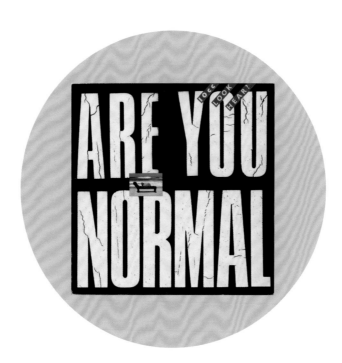

80s

HIPGNOSIS
1980 — 1983

Hipgnosis was
Aubrey Powell, Peter Christopherson and Storm Thorgerson

. . . .

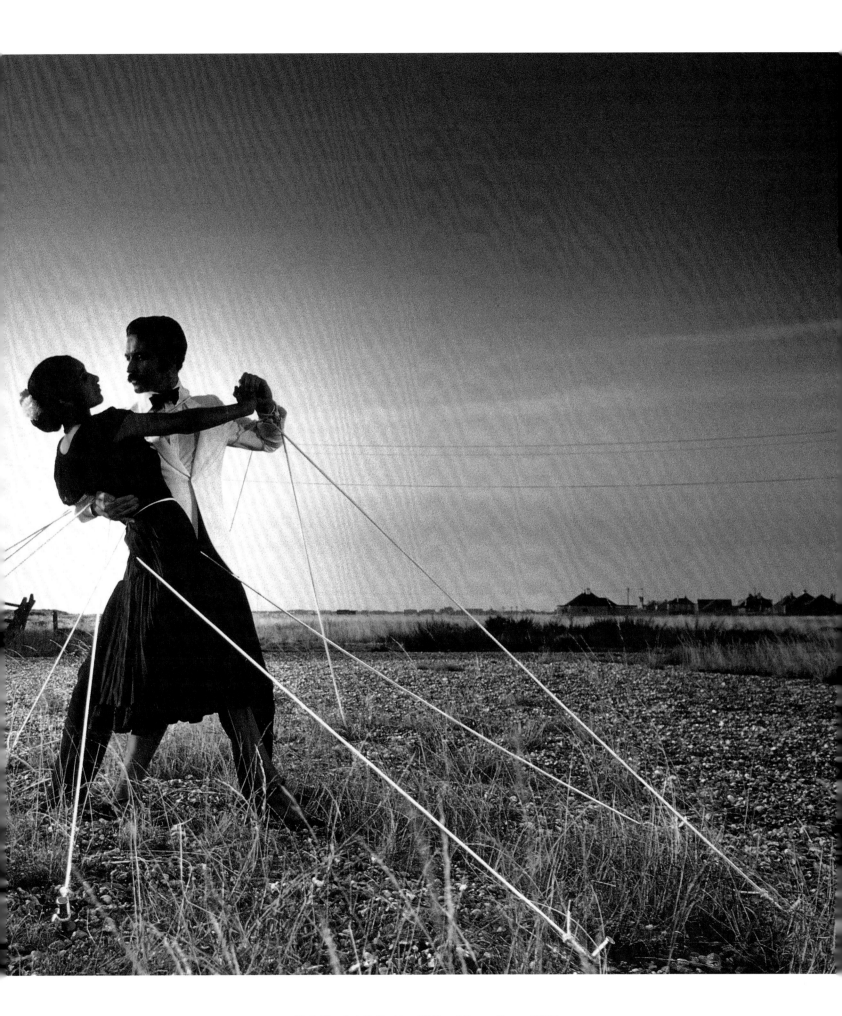

Pink Floyd, *A Collection Of Great Dance Songs (1981)*

John McLaughlin, *Music Spoken Here (1982)*

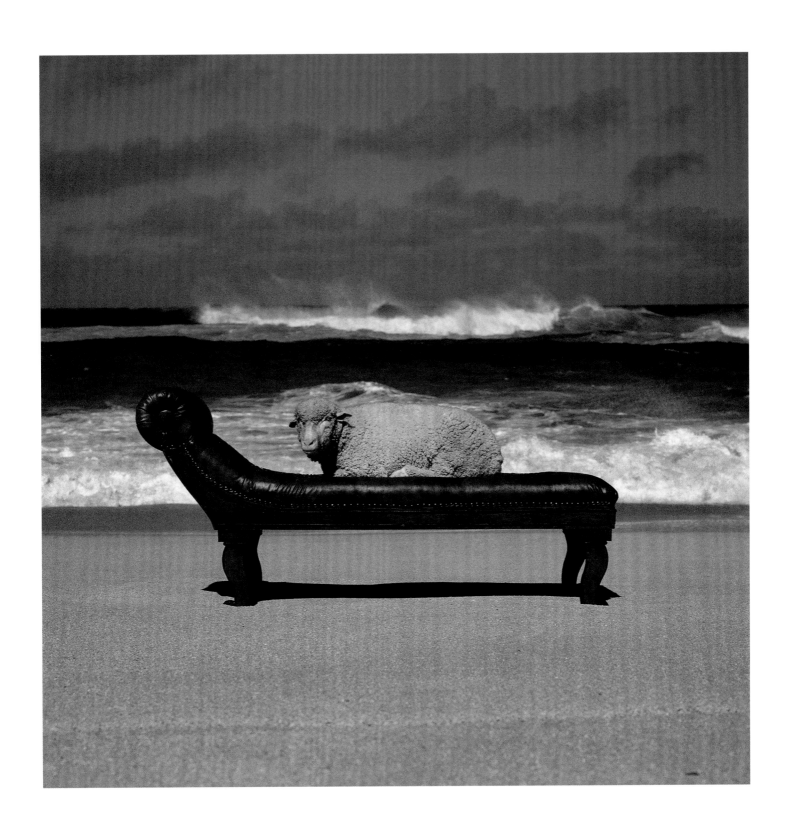

10cc, *Look Hear?* (1980)

Mike Rutherford, *Smallcreep's Day*, portrait *(1980)*

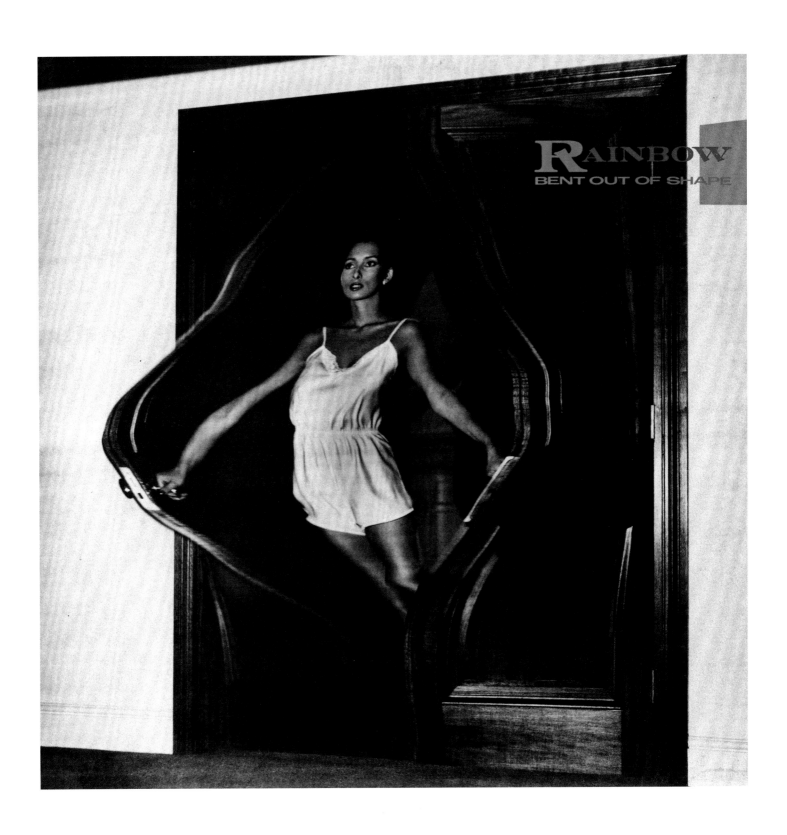

Rainbow, *Bent Out Of Shape (1983)*

FOR SOME REASON BEYOND COMPREHENSION OR EVEN COMMON SENSE PINK FLOYD agreed to a compilation album, **A COLLECTION OF GREAT DANCE SONGS** (pg 86/87), whose theme was unclear but seemed a collection of up tempo numbers. I suggested that it was like a collection of dance songs by James Last or Mantovani, which obviously it was not, any more than the picture is about dancers. Rather, it is a picture of dancers, but dancers who cannot dance. They are arrested in a frozen moment of movement by ropes, like those of a tent, and the trick here was to use elastic ropes which tightened as the couple spun into a dancing pose. It was photographed in one of our favorite locations – Dungeness – with the help of a chromo filter and a delightful sunset. David said 'Alright, I'll take your tatty picture'. I think Roger didn't like it at all, any more than he liked the record. But we like it and my wife likes it, so do I care?

I MET John McLaughlin through the Labèque sisters who are a pair of classical pianists from France. I think one of the them was 'going out' with John at the time. John described his music as varied and not easily categorized, moving from jazz to classical, from Spanish to psychedelic, just good music. Hence **MUSIC SPOKEN HERE** (pg 88). The music was not able to be categorized. like a square peg in a round hole. So that is what we did, by building a little wooden game like skittles. And John is trying to put a square peg in a round hole. On the back cover is a similar picture involving a measurement device and a piece of string, and John is trying to work out how long the piece of string is, not literally of course, but metaphysically as is John's nature.

10CC asked that I do something different for their album **LOOK HEAR?** (pg 89). Different from what I normally do? Different from what they had before? Different from all other record covers? So I suggested simple text accompanied by an image, but this time the image would be very small, not large, as I would normally do. The band particularly liked the image, not least because it was going to be shot in Hawaii, much to the label's irritation. The simple text would appear on the album cover, on t-shirts, singles, posters, etc. and would ask straightforward questions like 'Are you able?' 'Are you normal?' What can be more normal than a sheep having therapy to help make it more normal than it already is, set against the sea, a symbol of the raging unconscious. The high rollers were in Hawaii not Brighton, which is the bit the record company didn't like. Po was clever enough to ring up Hawaii to know if they had sheep, which they did, but not couches, which he had specially made. With the help of Valium and dogs he kept the sheep on the couch and took a great photograph.

I ACTUALLY thought that our portrait for Mike Rutherford's **SMALLCREEP'S DAY** (pg 90) was original, if ever one can be original. It's a sort of simplified Jackson Pollock photography where the dripping effect is achieved by flicking developer upon the developing bromide – thus the picture only appears where the developer lands. This is a quite difficult operation to do in colour so we did it in black and white and then hand-coloured the splashes, both a punk and painterly artwork, but rendered in photography. Mike is in there, somewhere.

Just because we are egofied this does not necessarily mean we are impervious to technology. **BENT OUT OF SHAPE** (pg 91), and a few years later **IN THE SPIRIT OF THINGS** (pg 108), used a remarkable photo system called Slit-scan, care of Derek Burnett. It makes slices of light in the same exposure as it captures the motion as the motion is performed. **BENT OUT OF SHAPE**, where the bent door frames are caused by the doors opening and the slit scan catching it as it opens, is a very fine and controlled procedure where the light moves across the body as the body moved across the space.

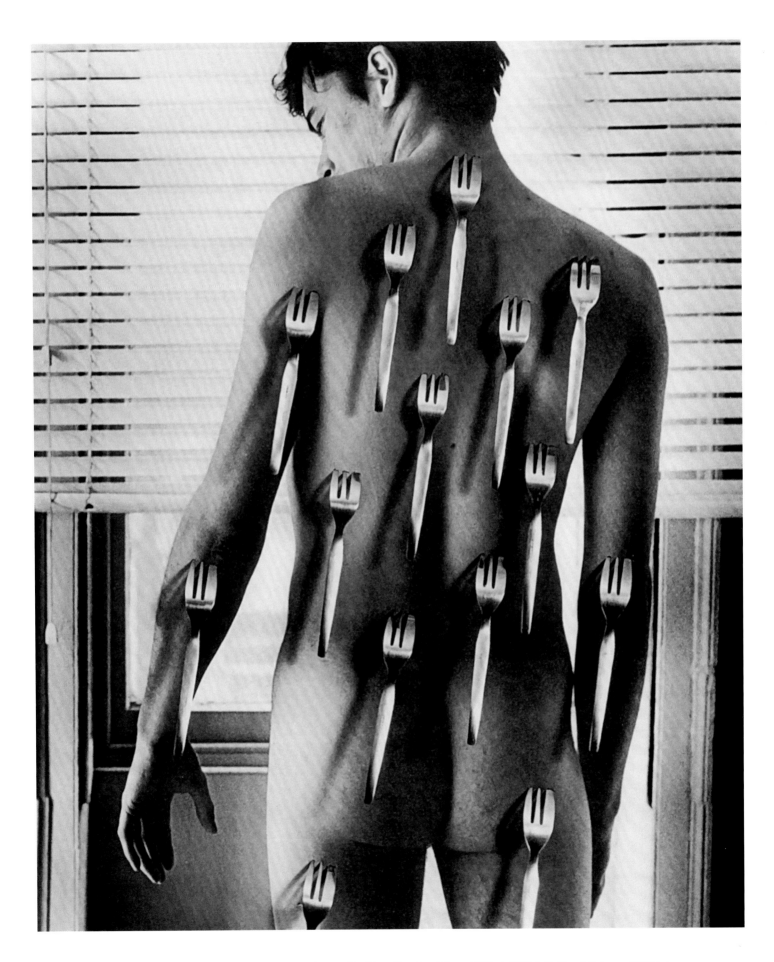

Creative Review calendar, *November - A Penny For Your Fawkes (circa 1982)* | Riff Raff, *Vinyl Futures (1981)* →

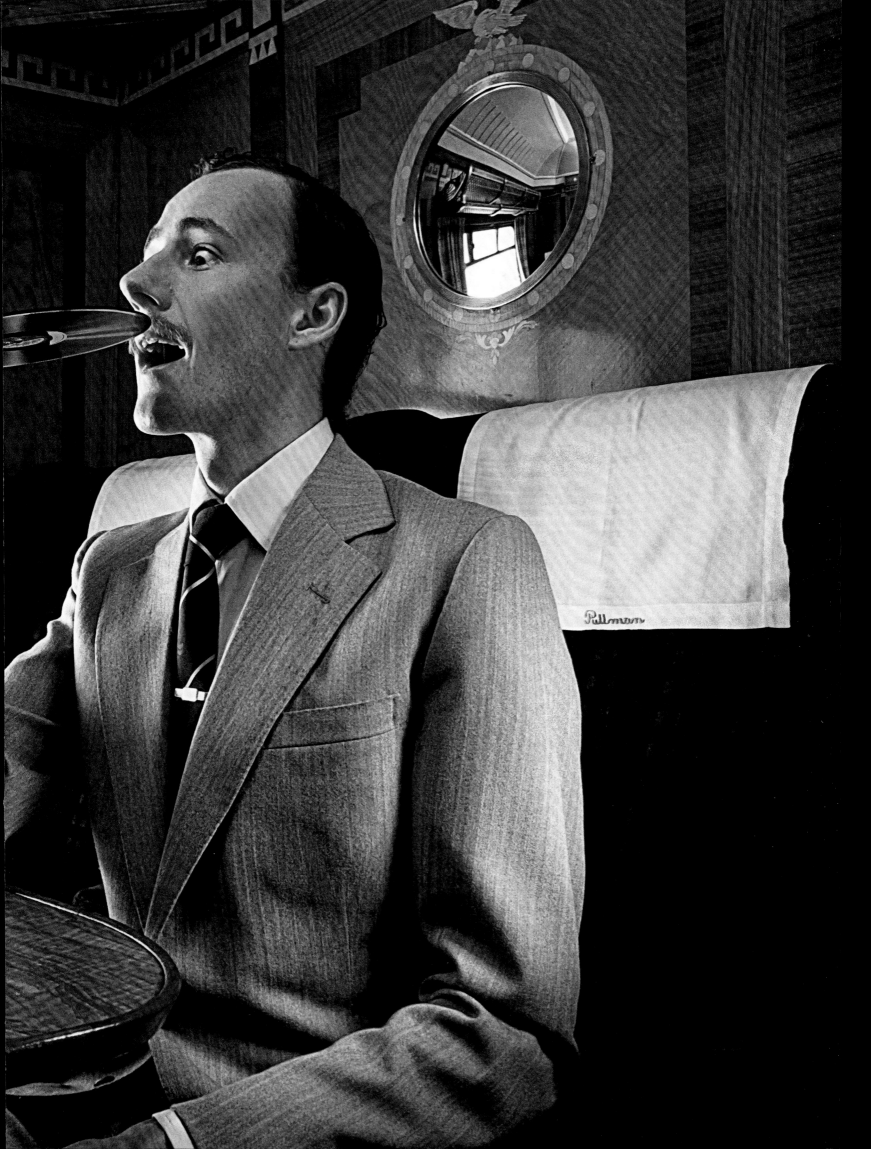

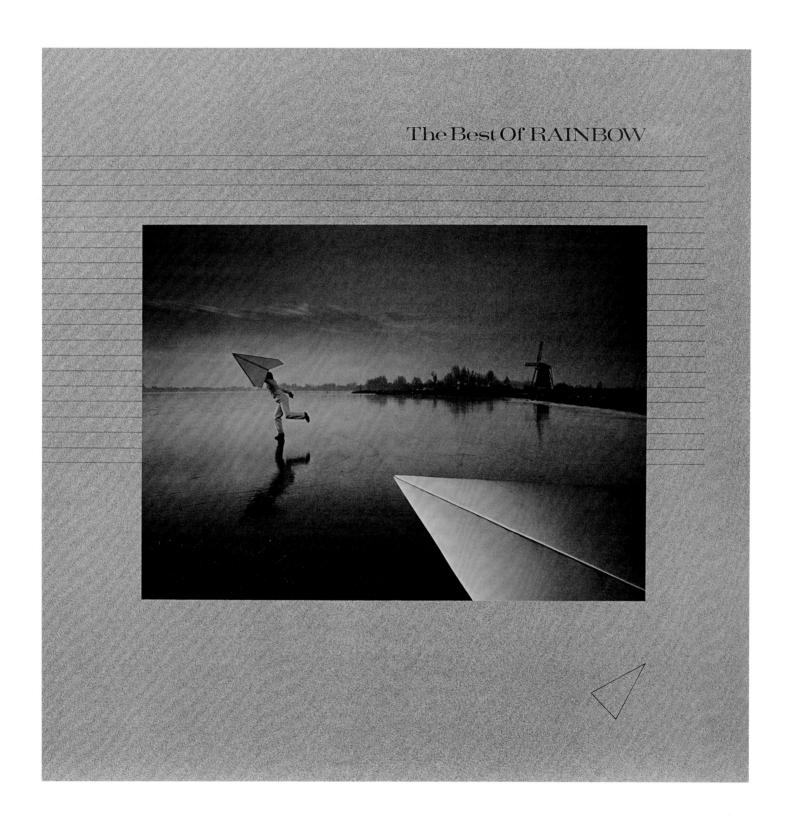

↑ Rainbow, *The Best of Rainbow (1981)* | Rainbow, *Difficult To Cure (1981)* →

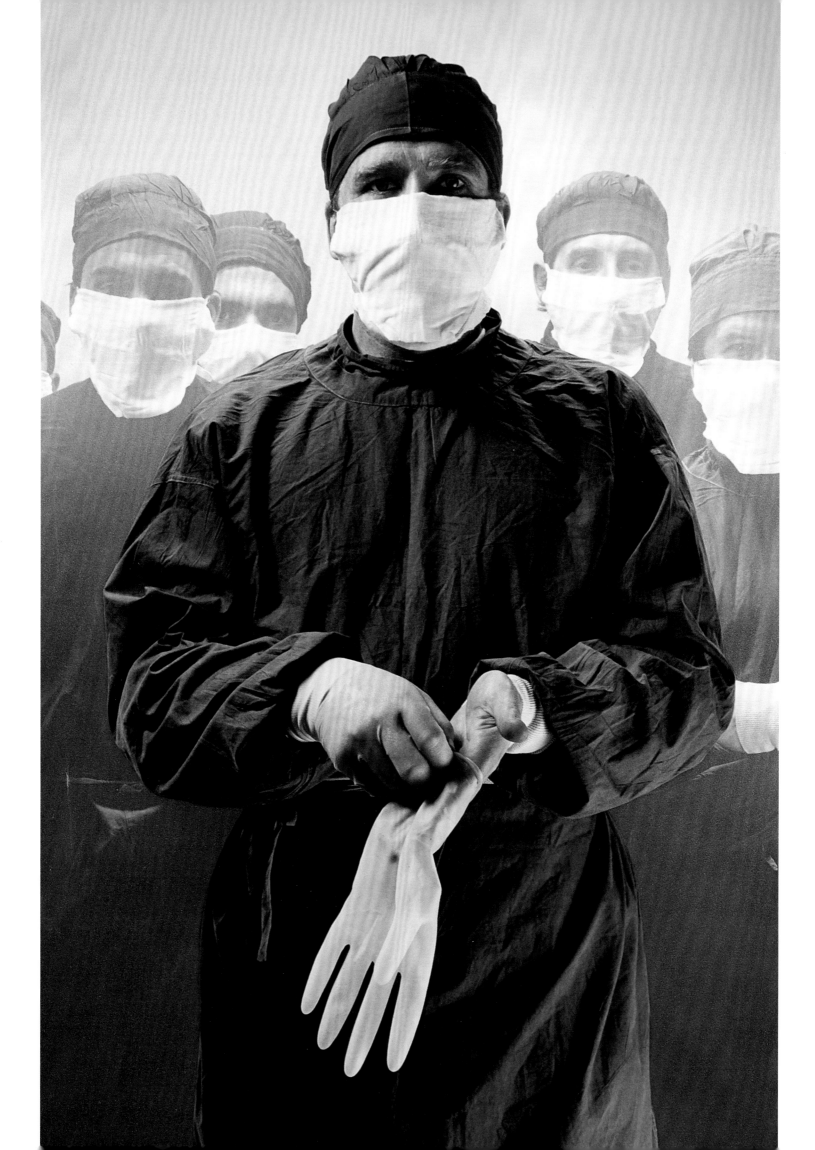

↑ Billy Karloff & The Extremes, *Let Your Fingers Do The Talking (1981)* | Peter Gabriel, *Peter Gabriel 3 (1980)* →

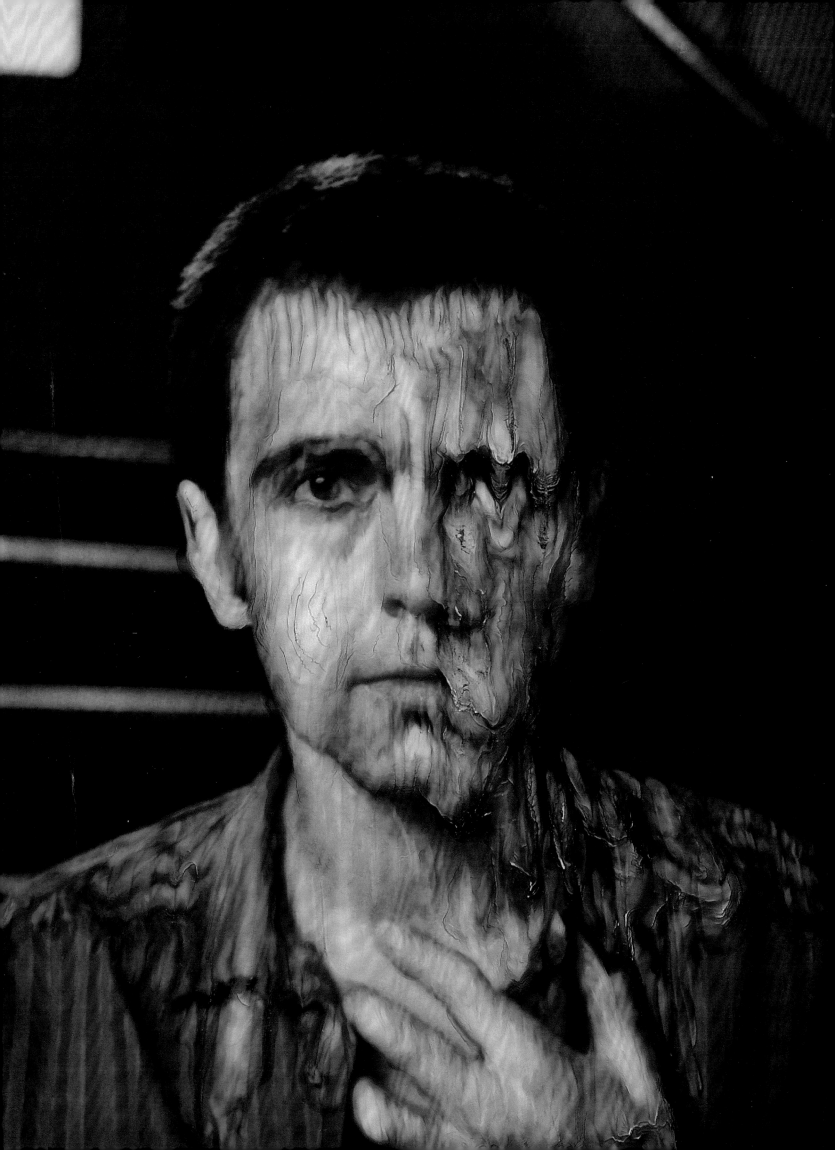

A PENNY FOR YOUR FAWKES (pg 93) is a tromp l'oeil which I did for a friend for his calendar and this was for November. I thought the effect was quite clever because what one does is to take a life-size picture so it looks like a real back – but is only a photo, and you bury the forks in the photo.

I think the idea for Riff Raff, whose album called **VINYL FUTURES** (pg 94/95) was very much about our friend, Peter Moon, whose face was full of character. He had huge eyes, so I saw him doing something bizarre, like eating a record in the carriage of a train which is travelling into the future. I love it! It makes me smile, and it intrigues me. Peter Moon has never recovered.

T HE late and much beloved Peter Christopherson had the idea for the cover of **THE BEST OF RAINBOW** (pg 96) about ice from a lake he had seen in Holland. I added the dart to imitate what the figure was doing. I just think it's a very pretty picture – why a heavy rock band liked it I had no idea.

R AINBOW wanted something slight odd and slightly menacing and so a picture of a surgeon might fit the bill (pg 97). It is an odd image because you cannot see who it is exactly behind the masks, and it is menacing because what they're going to do is cut you up. This is a gang of surgeons posing for a group photo, but it is not innocuous like a club of geography teachers. I very much liked the leader of the team being 'forward' where, by spraying a little white over the back figures, knocked them back a little. These are boys who'd deal with anything however **DIFFICULT TO CURE**.

T HE second album for Billy Karloff, **LET YOUR FINGERS DO THE TALKING** (pg 98), comes from an observation in the street where this guy walked past me with his outrageous check: check shirt, check tie and check suit. Not a vision, but an observation. We decided also to run the cover in four different colours because one could use the same black plate and simply change the black for blue or red. Spare no expense, huh?

I HAD a dream about Peter Gabriel in a house of wax. There was a fire and, because of the heat, he had a dripping face. All he said was: 'I don't mind being in your dreams so long as you're not in mine'. The technique used in Peter's 3rd album, **PETER GABRIEL 3** (pg 99), was invented by Les Krims, where you take a Polaroid and push the chemicals around while the image is developing.

B Y way of a change, **EYE IN THE SKY** for Alan Parsons (below) is a simple graphic nabbed from an Egyptian symbol called the Eye of Horus, the ultimate eye in the sky. We simply made it gold and embossed in a pale green background – I think it became their best-selling album, although this was certainly nothing to do with the cover design.

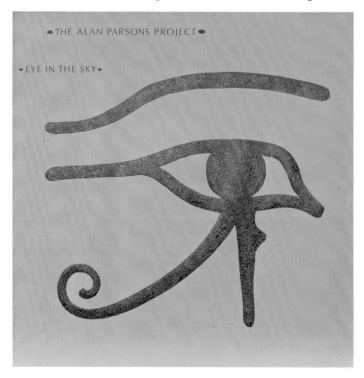

↑ The Alan Parsons Project, *Eye In The Sky (1982)*

80s

STD-ICON

1984 — 1989

STd-Icon consisted of
Colin Chambers, Andrew Ellis and Storm Thorgerson
and later Peter Curzon

• • • •

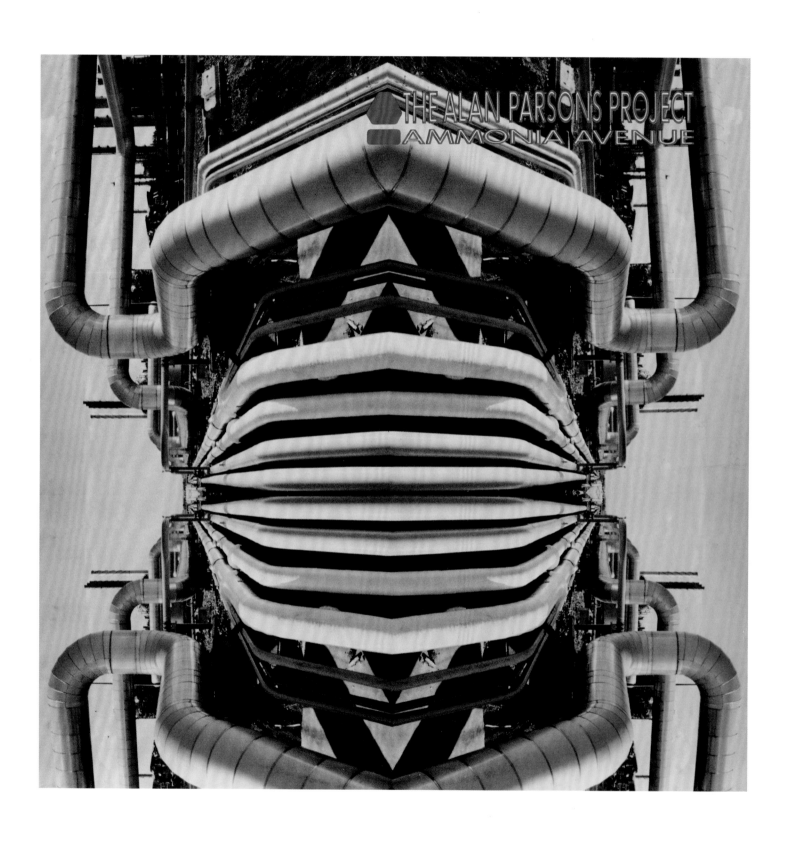

The Alan Parsons Project, *Ammonia Avenue (1984)*

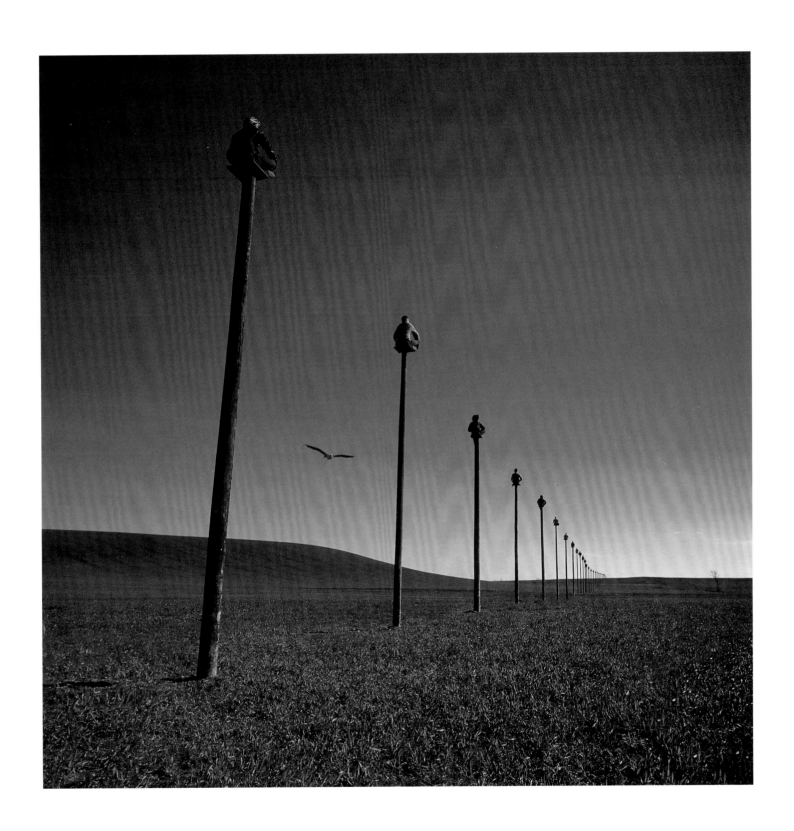

↑ Gentlemen Without Weapons, *Transmissions (1988)* | *Pink Floyd, A Momentary Lapse Of Reason (1987)* →

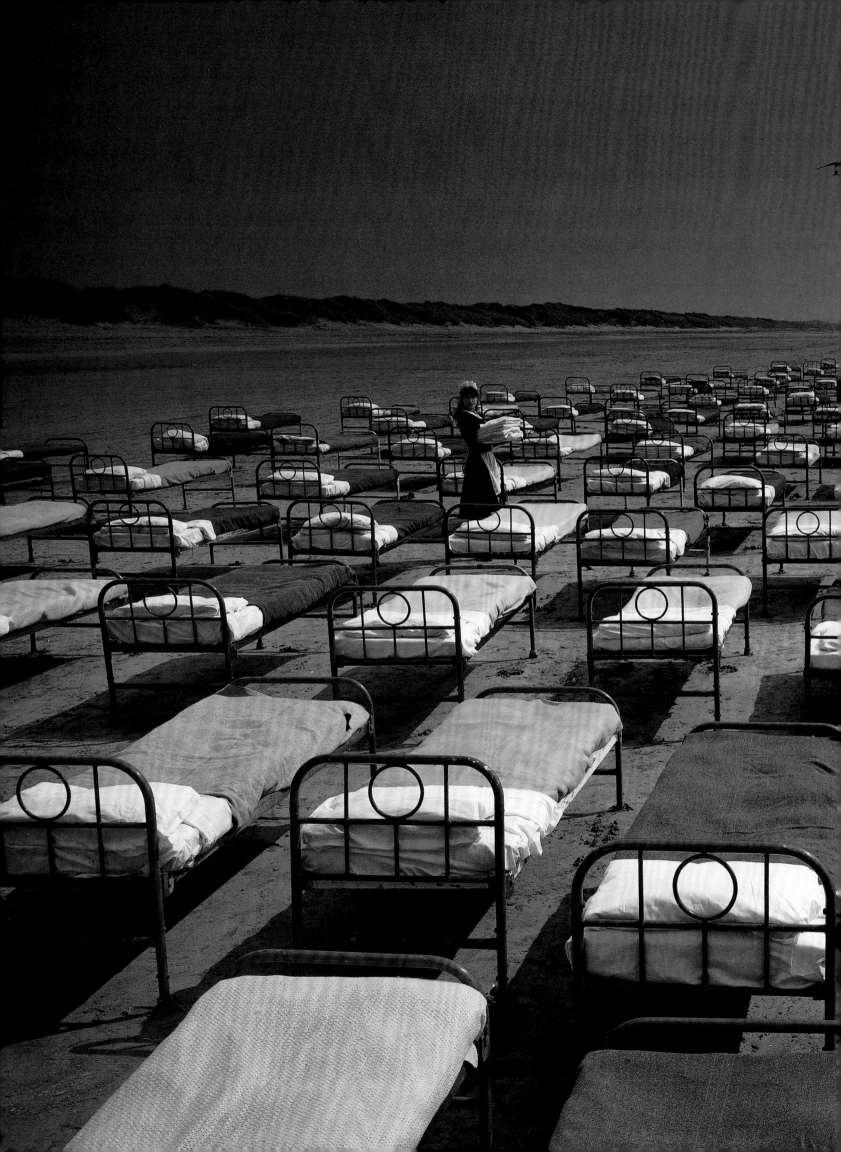

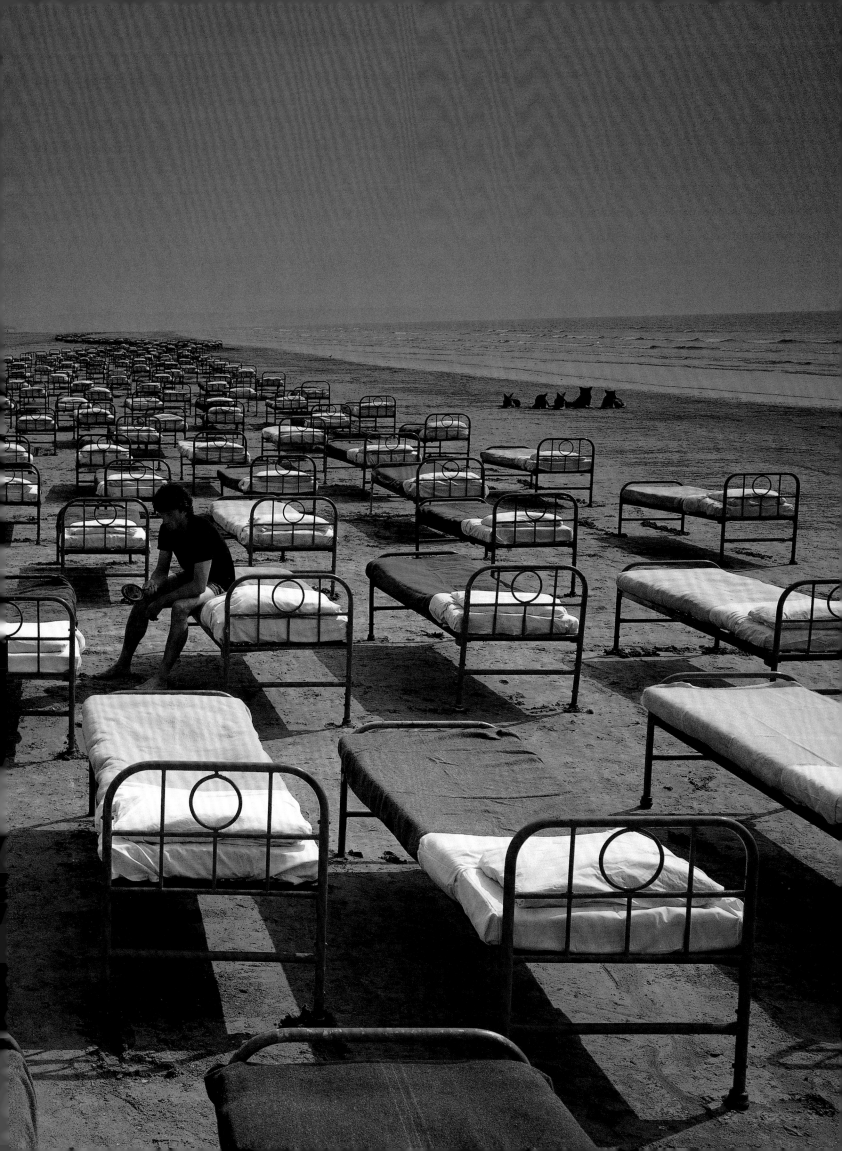

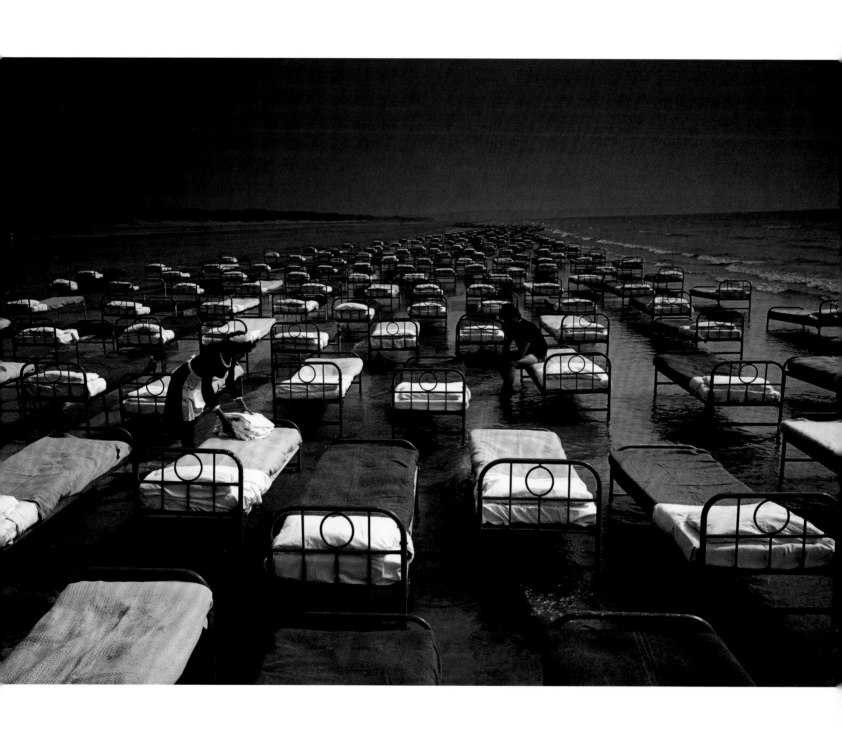

Pink Floyd, A Momentary Lapse Of Reason, 'Wet Beds' (1987)

I THINK Alan Parsons became preoccupied with the bio-chemical industry and how big and how important it is. I couldn't think of anything for **AMMONIA AVENUE** (pg 102) until I saw this picture of pipes, which seemed, if you duplicate it, to become a face, a sort of evil face, some kind of mechanical devil. I think it was quite effective but not very interesting . . . the subjects that Alan likes to tackle are always interesting but ironically don't always inspire an imaginative image.

AN unlikely trio, namely Kenny Young (who wrote 'Under The Boardwalk'), Vic Coppersmith-Heaven (who had produced The Jam), and Nick Glennie-Smith (from The Bleeding Heart Band and numerous film scores), came together to form Gentemen Without Weapons, what might be described as an eco band who worked in a charitable manner and who were particularly interested in preserving the rainforest. They wrote the song called 'Spirit Of The Forest' which featured a set of famous performers. For their album **TRANSMISSIONS** (pg 103) I envisioned a line of elevated people whose placement made for more effective transmission. They were placed on poles above the ground to avoid local interference. This was the most difficult job I have ever done because the telegraph poles were extremely heavy, and the ground was very soft due to incessant rain. In addition the farmer doubled his fee the night before. Sitting upon the little platforms on top of the pole was not in fact so difficult, and most of what you see is real: a line of telegraph poles stretching as far as the eye can see. It was photographed in Cambridgeshire with Tony May and his trusty house of blood, on colour film in the days before digital.

THE idea for this extravagant installation of beds – approximately 700 wrought-iron hospital beds on Saunton Sands beach, Devon – came from a line in a song on the album called 'Yet Another Movie', which spoke, so David said, of a room with a single bed in it in a Greek villa overlooking the sea. I changed this to many beds upon the beach outside the window, both a mad and excessive idea, **A MOMENTARY LAPSE OF REASON** (pg 104/105 and opposite), to say the least, but it rained on shoot day, which obscured the view, as only the English drizzle can. We had to do it all again two weeks later – transport the beds in articulated trucks and carry each bed down the cliff onto the beach, and to make each individual bed with bedding. Not, of course, that I lifted a finger personally, being the ponce wallah. There were thirty people and several flat beds arranged in the shape of a river – river bed – and we took many pictures involving a man looking at a mirror of himself, and a French maid who was making up the beds. The microlight in the sky is there for 'Learning To Fly' – another song in the album, as are the dogs for yet another song called 'Dogs'. All in all a secondary lapse of reason. It might not have rained but the tide came in so fast that I didn't even see it. Our PA said 'turn around!' and there it was, lapping the bed legs . . . quite a sight, really, and quite lunatic, both difficult and expensive – please don't ask me, because I wouldn't tell you anyway.

KANSAS, **IN THE SPIRIT OF THINGS** (below). The idea for this cover was how to represent the younger spirits of two older people, whose love was now dried up but whose previous (younger) love had been fresh and vibrant. The older selves are indifferent and separate, too disenchanted to make reparation.

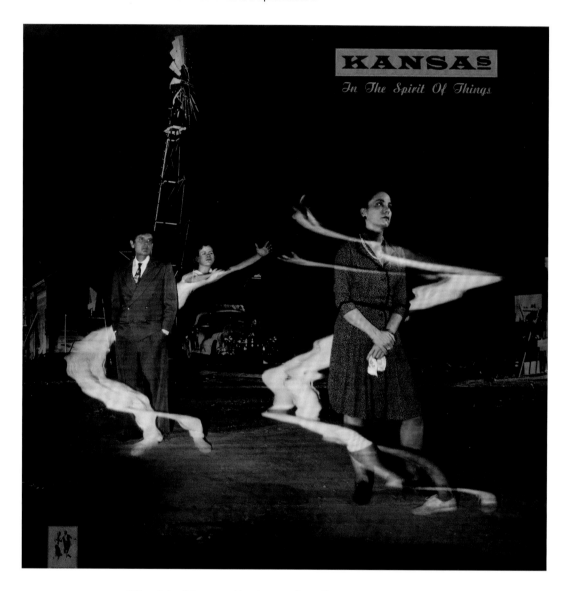

I liked the idea, and in theory the Slit-scan technique that we had used at Hipgnosis for **BENT OUT OF SHAPE** (pg 96) was very suitable, it's just that the exterior location, that the band had wanted, screwed the whole thing up, especially the central issue of lighting. The technique required that the older figures remain completely still during a time exposure to produce a sharp image, which is a much easier task sitting on stools in some interior bar or café in the day, rather than standing outside in the middle of the night, freezing their butts off.

Kansas, *In The Spirit Of Things (1988)*

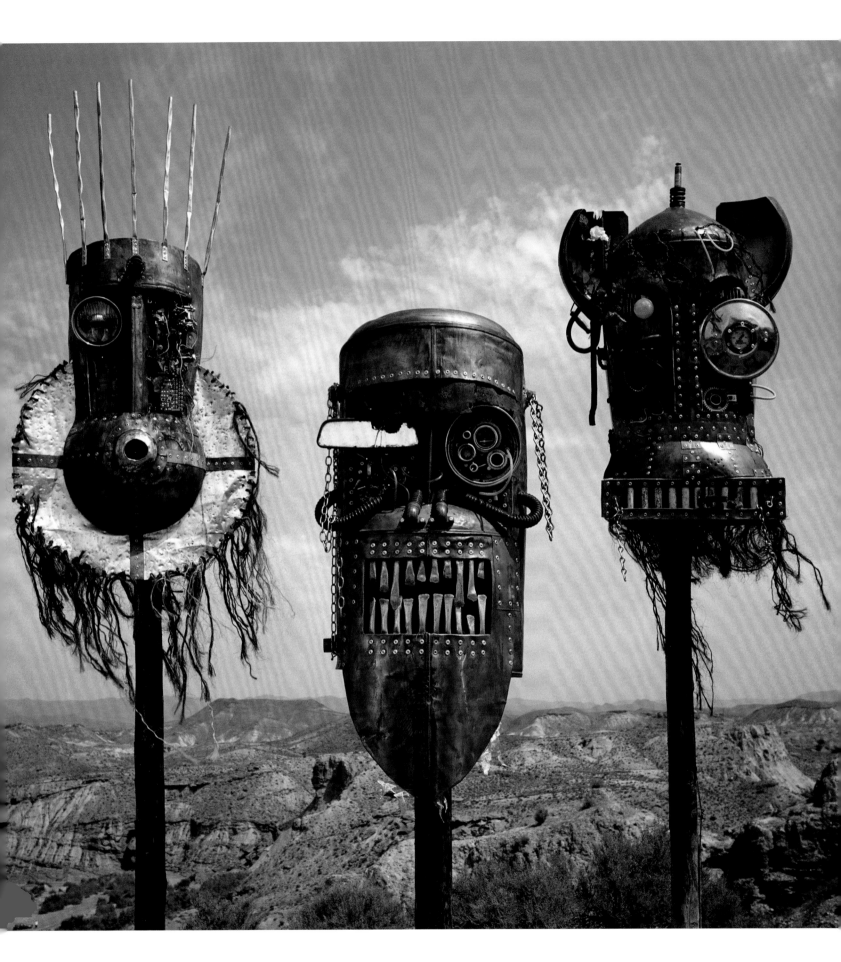

↑ Ellis, Beggs & Howard, *Homelands (1988)* | Pink Floyd, *Delicate Sound Of Thunder (1988)* →

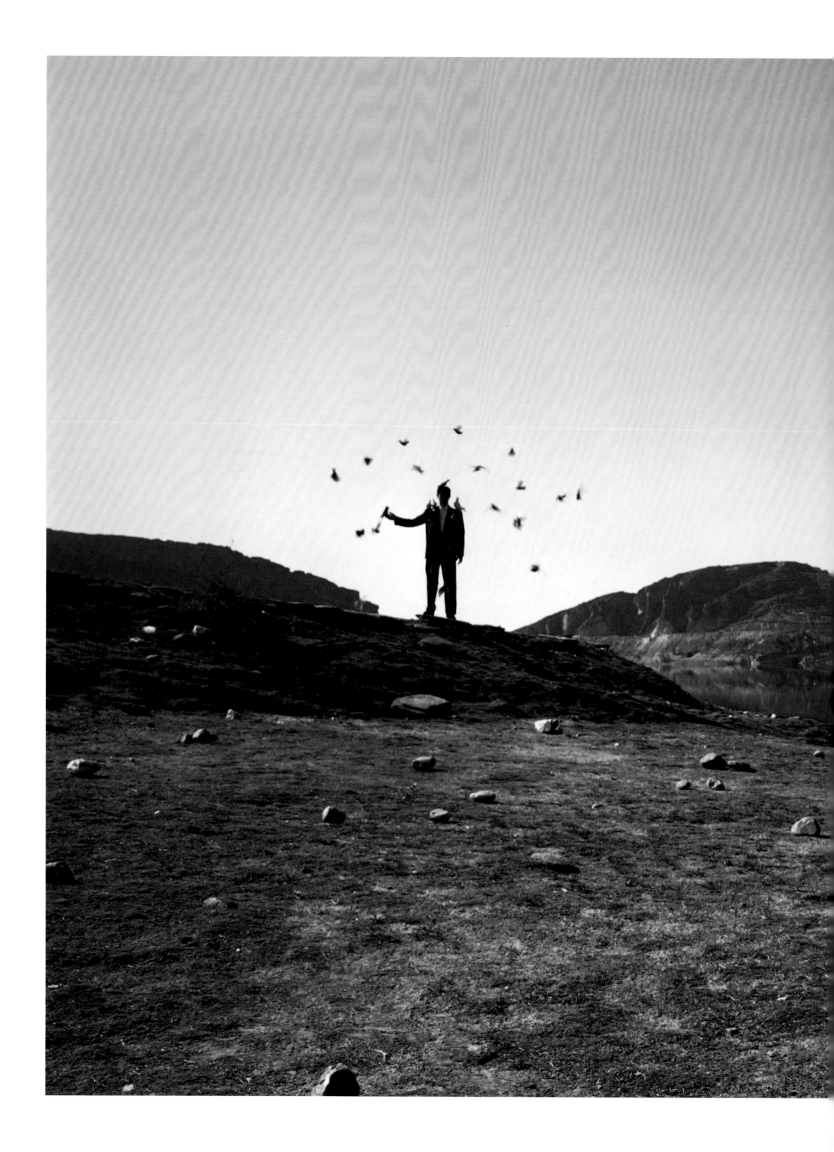

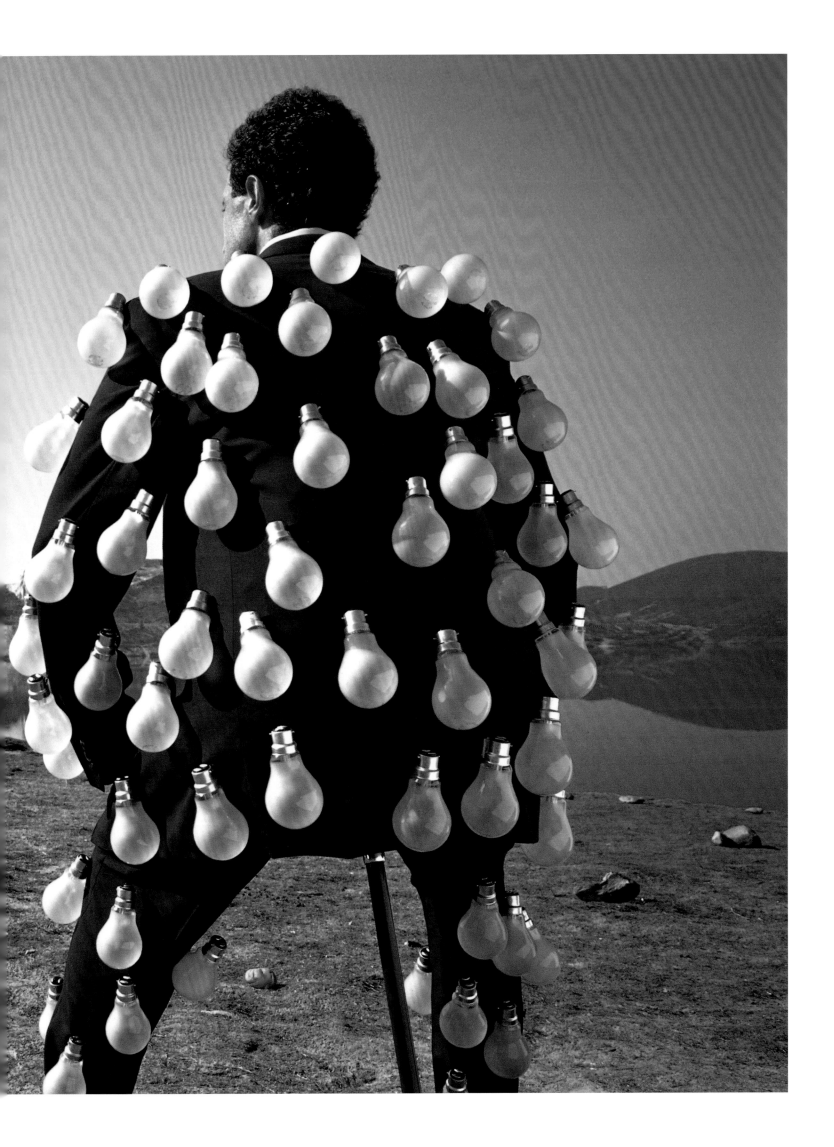

ONE of the most inventive people I have ever met is called Keith Breeden and he's a man who didn't mind getting his hands dirty. I asked him if he would like to make some sculptures out of motorbike parts and old gas boilers for the cover of **HOMELANDS** (pg 109) , which he did with great vigour. I think mostly I loved the teeth. These heads came to represent the 3 members of the band Ellis, Beggs & Howard. They were taken to Spain, near Alicante, and photographed with the mountains in the background. Three masks to mark the **HOMELANDS**, watching and protecting the territory.

I WENT to a live show of Pink Floyd in Detroit and it struck me they had the best light show and the best sound show ever, so, for their live album **DELICATE SOUND OF THUNDER** (pg 110/111) I thought of Mr. Sound and Mr. Light, the first surrounded by birds and the second wearing a suit covered with light bulbs, like Dali's wine glasses, and facing each other as if in a duel.

90s

TALKING FISH

Talking Fish consisted of
Peter Curzon, Tony May, Finlay Cowan, Jon Crossland
Sam Brooks, Rupert Truman and Storm Thorgerson

• • • •

THE nineties was a blur for me as in 1989 I uprooted myself from sunny California and moved east to New York, which involved quite a bit of physical and psychic juggling. I had no money to speak of, which meant selling all my guitars and amplifiers. This was fine as I had decided a year or two earlier to abandon my dreams of a music future to that of filmmaking – though it also meant leaving the bulk of my record collection in my old bedroom at my parents' house. Moving as light as possible meant the rock albums of my teenage years were boxed up and stored, and I traveled eastward with my punk LPs and 45's being as how I was one of those 'converted' to new music. Truth be told, by the time of the mid/late eighties, I had stopped frequenting record shops and given up on music as Punk had shifted to New Wave and other utterly banal post-punk offshoots. I no longer took elaborate day trips to used record shops with my friends, and I therefore lost what once was a major social and tribal ritual. It was all a bit disconcerting, as music had always been with me and all-encompassing and I have gone on record numerous times how music shaped my early identity, led me to art, and is still one of the foundations of my fucking existence here and now.

NEW YORK was still wallowing in the post Studio 54 mega-club scene though my new friends in the art world and I would frequent places a bit more off the beaten path like the Latin drag club La Esquelita (the 'little school' indeed), the after-hours Save The Robots, or the Amazon Hotel whose DJ's were mixing reggae and early rap music. It was great fun, but it lacked something I couldn't put my finger on. And then BANG...

MY close friend artist Michael Joo dragged me to a show of Bob Mould's band, Sugar, at the Roseland Ballroom in 1993. I had seen Bob Mould as a part of Hüsker Dü as a teenager, so I went out of curiosity, but the night ended with Michael and I thrashing in the pit in front of the stage, my shirt torn to pieces and me dripping with sweat. Nirvana had just been breaking into superstardom but this sealed the deal for me. I called a friend in Los Angeles who was working as a shipping clerk for an antiquarian book store and asked him to ship out the remainder of my record collection. I started combing the used record stores and CD shops in the West Village and St. Mark's Street. Occasionally I met friends but I was mostly solo. I would drift into shop after shop, reigniting a familiar obsession. New York became home.

AROUND this time other music-related trajectories would intersect – the rise of the compact disc and the consequent decline of the cassette tape format and beyond the explosion of grunge and its rock/metal aftershocks, the emergence of the Britpop and YBA (Young British Artists) movements in the UK. One should note that I am still some fifteen years away from meeting Mr. Storm Thorgerson, so part of this writing is pure speculation, but I can imagine that it must have been very exciting for Storm at this moment. Vinyl releases were still common, but a new music format had been invented, and now he had not one or two but three formats to design for! Rising groups like Catherine Wheel (meeting Rob Dickinson, he told me a precious story about having to negotiate with Storm over the release of the LP Chrome – "Well, Rob, I get to choose the vinyl and CD cover, and you can have the sleeve and inner sleeve of the cassette") then The Cranberries came calling, and Storm would hit his stride with some new iconic imagery for longtime associates Pink Floyd and Alan Parsons. In my own field, the first feature-length film cut on a digital editing platform was publicized in 1993, and the first version of Adobe Photoshop was released in 1990. The following plates of record covers from the decade of the nineties I believe reveal a refocusing of Storm's creative practice, and Storm would do some of the most dramatic 'real' stagings of what he was calling 'extallations' (his witty pun on outdoor installation): Pink Floyd's giant sculptures for the variations of *The Division Bell* cover and *Tree Of Half Life* – as well as experiments with the possibilities of computer manipulation (digital compositing and retouching rapidly replaced Exacto knife blade and rubber cement collaging techniques). Though Storm's budgets had yet to suffer major slashing, the rise of digital technology would have rapidly begun this decline. Unlike the eighties where the punk aesthetic of low-fi had some effect on Storm's image-making (and possibly even his and Po's move away from covers to music videos – their company Hipgnosis transforming to Green Back Films before disbanding), this particular change was more technologically driven – compare the different arcs of meaning from the punk chopped-up ransom note flyer making a new meaning from the letters of existing magazine or newspaper articles to Raygun Magazine's championed wanton illegibility in the early nineties. Record companies created in-house design teams while bands designed their own covers.

ONE wonders how concerned (or aloof) Storm was with all these new shifts in his terrain. Now knowing him on quite intimate terms, my conjecture would be not very much. He has always followed several conceptual strategies that are key to his approach to record cover design not to illustrate the music, lyrics or songs of the album, but to create a visual parallel. In essence this self-imposed hurdle put him immediately into another realm of creativity, one that is not driven by the tools or technology but rather by thought and ideas. Thus while his work may be affected by the

changes in dissemination (the size of a CD versus a vinyl LP for instance), the imagery resides and fluctuates in the back and forth of the music and the idea which often is surreal, hyperreal, unexplained, interrupted or obtuse. The prism for *The Dark Side Of The Moon*, one of the most iconic of Storm's designs, proves this beyond a shadow of a doubt. How many advertising executives would love the key to unlock the door of this one, eh? Some of Storm's designs from the nineties include body painting Pink Floyd covers on the backs of six women (*Back Catalogue*), hanging six well-dressed men upside down by ropes (*Try Anything Once*), a massive baby crib alongside the River Cam in Cambridge (*Happy Days*), dozens of photos of eyes staring back from a forest of white birch trees ('Gasoline') and a naked soul hiding from a massive eye (*Bury The Hatchet*). These show clearly that he still valued being in a real location with real characters or props and that this still was another underlying quality of his images – that is the confounding impulse of something unimaginable occurring in a real time and place. This characteristic of Storm's designs for me has been at the root of much of what I like about his work – not spectacle but play and humour, not impossible but rather beguiling, not fixed but hypnotic (hypgnotic?). And as usual, his 'ego the size of a small planet' (his words, not mine), shows through on many works from the period, revealing that he was still able to go after the jugular of the industry (The Cranberries' *Bury The Hatchet* features a CD cover and back devoid of title and barcode and is laid out to appear to have two front sides), and push the boundaries of what is possible in design (Pink Floyd's CD for

The Division Bell has the title printed in braille on the edge of the jewel case). Having to re-adjust his scale and attack must have been tricky going from the gatefold and liner bag to the CD booklet, but then again Storm always seems to like a challenge.

AND while in the nineties I once again began living with shelves of vinyl that contained numerous of Storm and Po's work from prior decades, I did in fact purchase some of Storm's new designs without consciously knowing it. While I no longer sat with my friends listening to albums and trading and borrowing, I did start spending time again in used record and CD shops talking with employees about new releases and what to check out. My vinyl collection began growing again and I caved in and got a CD player. No one could predict that the digital explosion would lead to a cliff that would entail the near erasure of the CD with such speed, and in 2010 when I asked Storm about this he matter-of-factly responded with a curt 'Can't do anything about it so I don't worry about it'. One could say this bravado might be a defense mechanism against the march of time but if it is, I'm implicated in it up to my neck. On the other hand, perhaps Storm's answer more realistically portrays where his imagination and energies really lie – in the encompassing, fun, exciting moment of the creation of images that will not only stand the test of time and technological advances but that will outlive us all in our collective consciousness.

. . . .

Roddy Bogawa

Alan Parsons, *On Air (1996)* →

↑ Catherine Wheel, *Happy Days (1995)* | Richard Wright, *Broken China (1996)* →

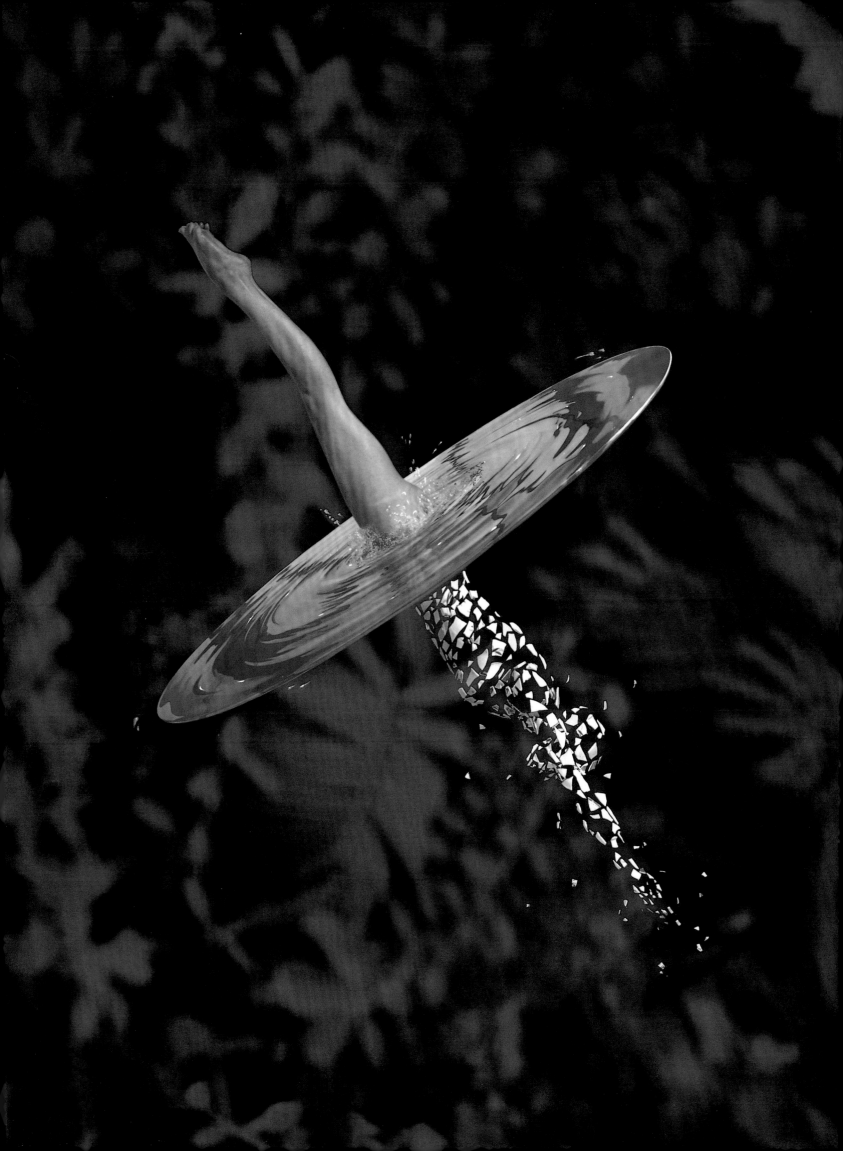

Pink Floyd, *Pulse (1995)*

Anthrax, *Stomp 442 (1995)*

Ragga And The Jack Magic Orchestra, *Ragga (1997)*

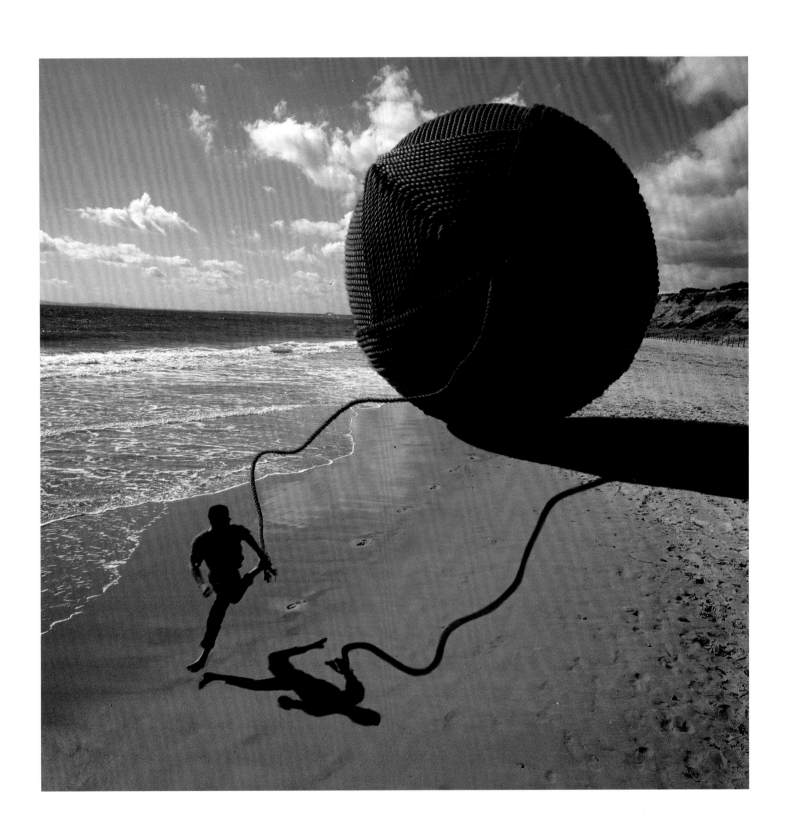

Phish, *Slip Stitch And Pass (1997)*

ON AIR IS A CONCEPT ALBUM BY ALAN PARSONS AS MUCH ABOUT THE THINKING OF BEING

airborne as about flying machines themselves, in effect it is about the world of air travel. It is about a thought and a deed, so I imagined a light bulb above a head, which often represents an idea, and made it as an air balloon and therefore a deed. The model air balloon (pg 117) is positioned over a hill like a light bulb over a head and, of course, the air balloon is shaped like a light bulb. As they say in a book shop, 'two for the price of one'.

HAPPY DAYS by Catherine Wheel (pg 118) involved the building of a large cot bed to house the baby Catherine Wheel. We found when we built the real thing that because the cot was oversized it made the adult seem more childlike, so that's why he's screaming – an adult trapped in a child's world.

I THINK BROKEN CHINA (pg 119) for Rick Wright is very unlike me as it is rather elegant and very pretty (due in part, I have just been reminded, to being derived from an idea by Peter). It is the story of a breakdown. The ring of water represents the trauma and the girl passing through the trauma is broken into pieces of china. The back cover shows the reverse – the girl emerges from the water whole and flesh and blood, they are all real bits composed together in Photoshop. Excuse my modesty but I think it is great.

THE FLOYD were always keen on technology and new developments in making sound, so the cover for their live album **PULSE** (pg 120) uses Photoshop extensively (the new technology). It is not often we do that. It is based on the reflection in the eye of a member of the audience at a live gig. All the elements, which are many and referential, are shot on purpose and then joined together in the ubiquitous computer.

ANTHRAX are a pared down hard rock band and, for **STOMP 442** (pg 121), nothing seemed harder and more pared down than a fucking great ball of metal, because it was only a sphere, although of course spheres have interesting properties. Are they hollow? Are they complete? Since the answer to these is that they can be, we only had to photograph a quarter ball and then stick it together, partially on site and partially on the computer. The location is Beckton in East London where Stanley Kubrick shot some of **Full Metal Jacket**.

ONE of the most tedious and difficult jobs ever. The man and woman in **RAGGA** (pg 122) were extremely picky, making life a misery step by step. I don't even think they liked the idea in the end and they didn't use it, which was pity because I like the 'shared' ears.

ON the other hand I was very impressed by Phish who didn't necessarily know what they were going to play exactly when they were on stage, so improvisation was the key and our man, on the cover of **SLIP, STITCH AND PASS** (pg 123) is running with a melody (the ball of wool), which will be unravelled. The ball is real and fucking heavy.

CHROME (opposite) was for Catherine Wheel who said, 'we don't want any of your "blues" i.e. sky'. However, due to the depth of water this picture came out very blue anyway, a marvellous blue, which in the end they loved. What's in a colour, hey? At first we used life savers in a swimming pool but they weren't terribly elegant so we replaced them with ballet dancers. It is unashamedly one of my favourites . . . but don't say it too loud!

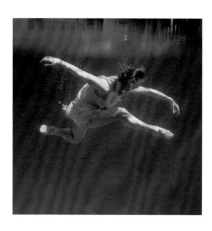
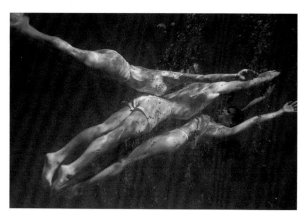
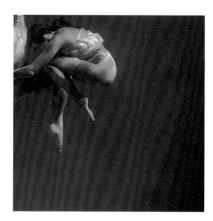

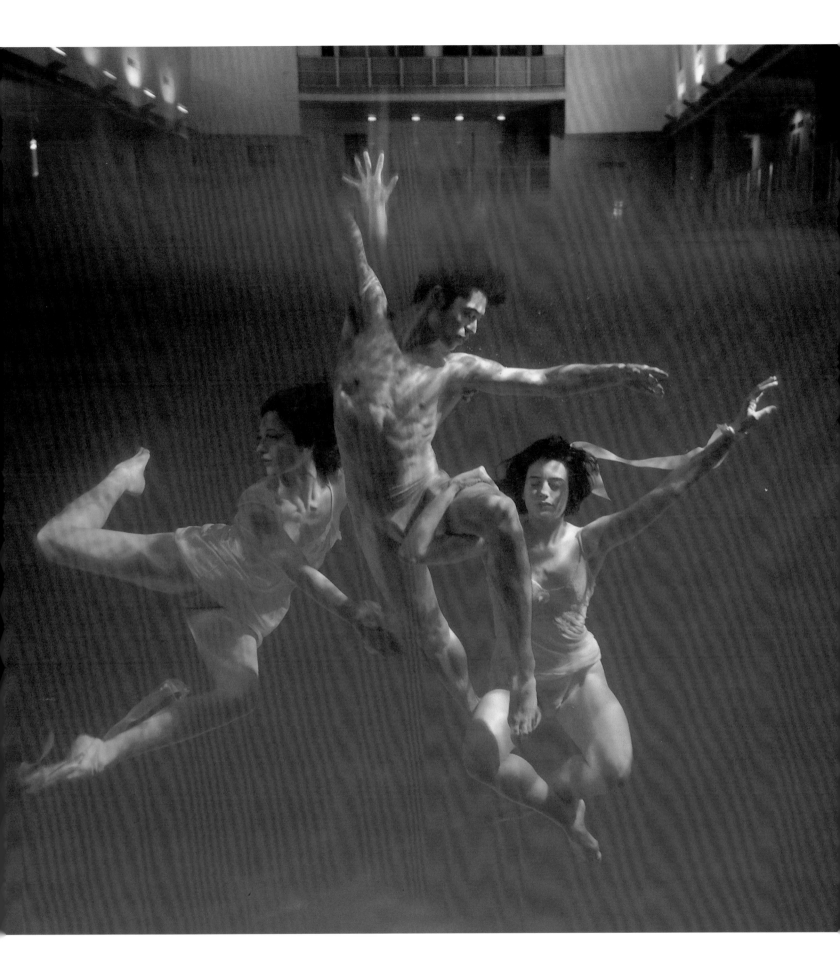

Catherine Wheel, *Chrome (1993)*

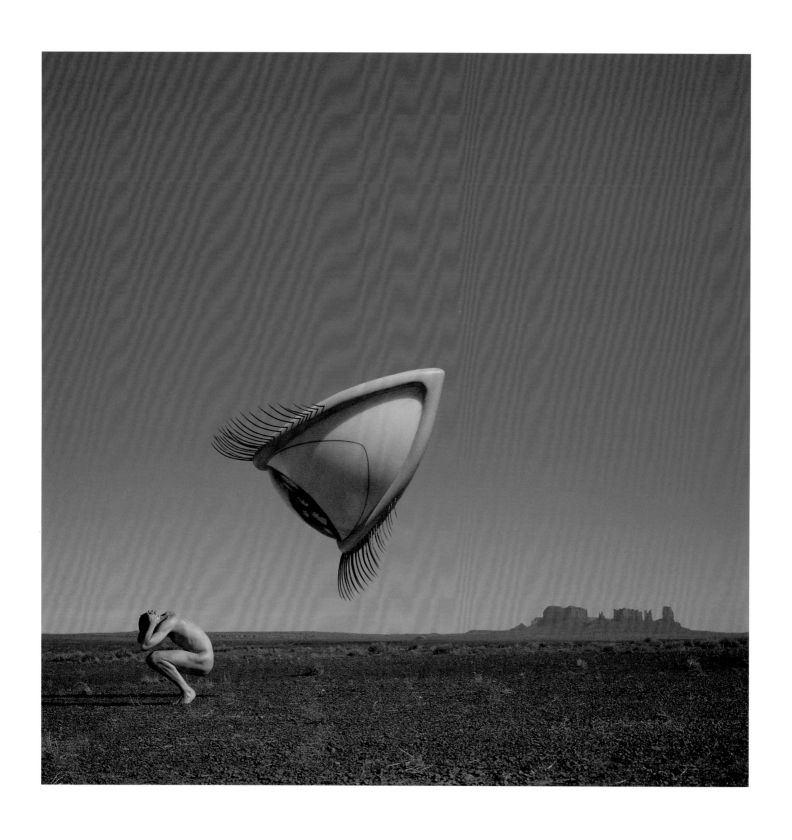

The Cranberries, *Bury The Hatchet (1999)*

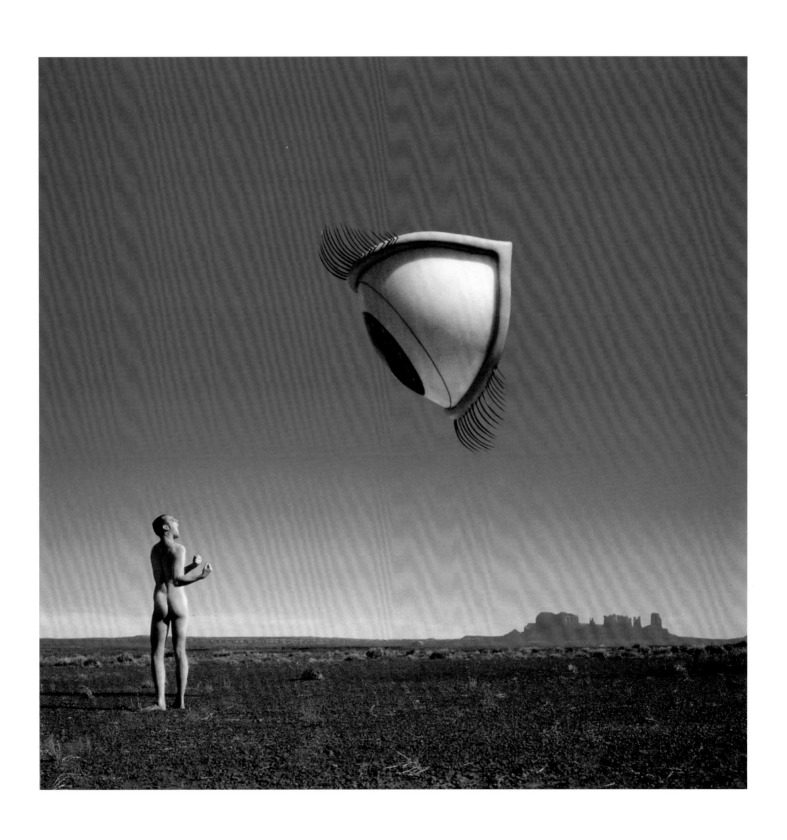

The Cranberries, *Bury The Hatchet,* Back cover *(1999)*

FOR **BURY THE HATCHET** (pg 126/127) we had this idea about surveillance, about Big Brother watching you, the all-seeing eye following you everywhere, even in the far, wild open spaces of Arizona. The red earth was something I particularly wanted, but I don't know why. When Jon the model was taking his clothes off, a big truck appeared out of nowhere and out of it came an Indian who confiscated all our equipment and then suddenly burst into laughter because it was a joke. We promptly swapped e-mail addresses. For the back cover Jon, who is no longer cowering, is telling the all-seeing eye to fuck off. It made a nice little diptych. I particularly like the eyelashes of the all-seeing eye at which Jon is shouting.

YOU are not of course allowed a favourite work when you are an artist, like you are not allowed to have a favourite child, but for me, **THE DIVISION BELL** (opposite and pg 130) got really close. I think it's a mixture of shape, meaning, power and elegance, care of Keith Breeden, and

it says a lot about the Floyd. The admitted luxury of working with a 'big' group is that, when they said that they liked both the stone head and the metal head, I suggested they do both and, of course, at great expense to the nation. It was photographed on location at Streatham near Ely, near Cambridge where the band come from. This was their suggestion. Available daylight was more than enough to make the heads look imposing, majestic – sentinels of a distant land.

NIGEL KENNEDY may be a great violinist but he is also a madcap. (That's a compliment!) He has a habit of waylaying you and berating you about drink and about Aston Villa Football Club. What is most significant is that he made a heavenly record, **KINDRED SPIRIT** (pg 131), for which this is the cover. It tells the tale of a famous violinist from the 20s called Kreisler who was attached and torn between his wife and his mother. I thought this is a great picture by Tony May but Nigel never liked it, what a twat! As Nigel would say . . .

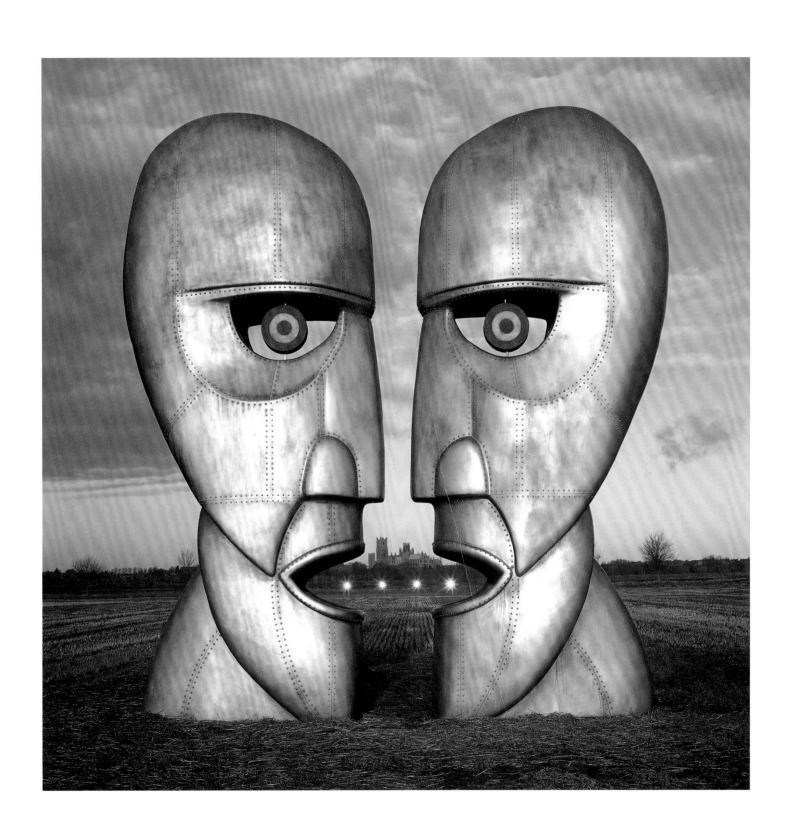

Pink Floyd, *The Division Bell - Metal Heads (1994)*

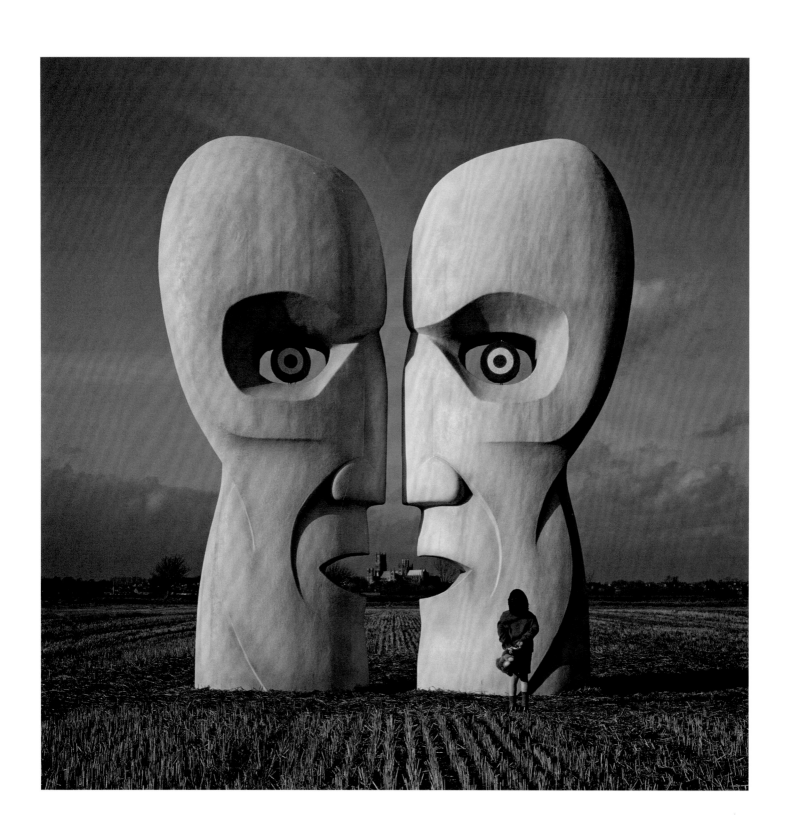

Pink Floyd, *The Division Bell - Stone Heads (1994)*

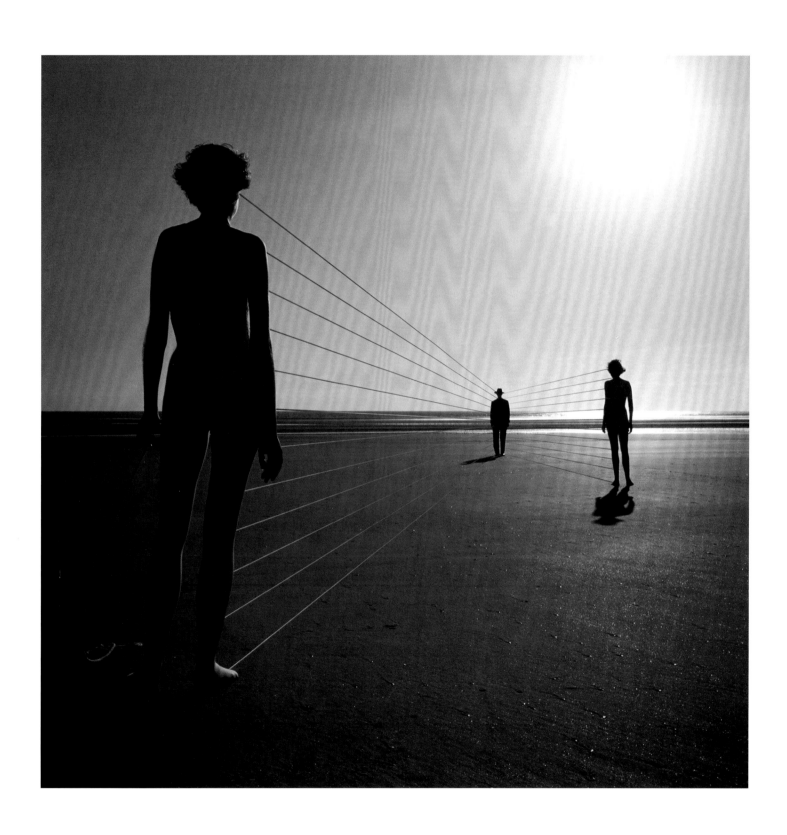

↑ Nigel Kennedy, *Kindred Spirit (1995)* | Pink Floyd, *Back Catalogue (1997)* →

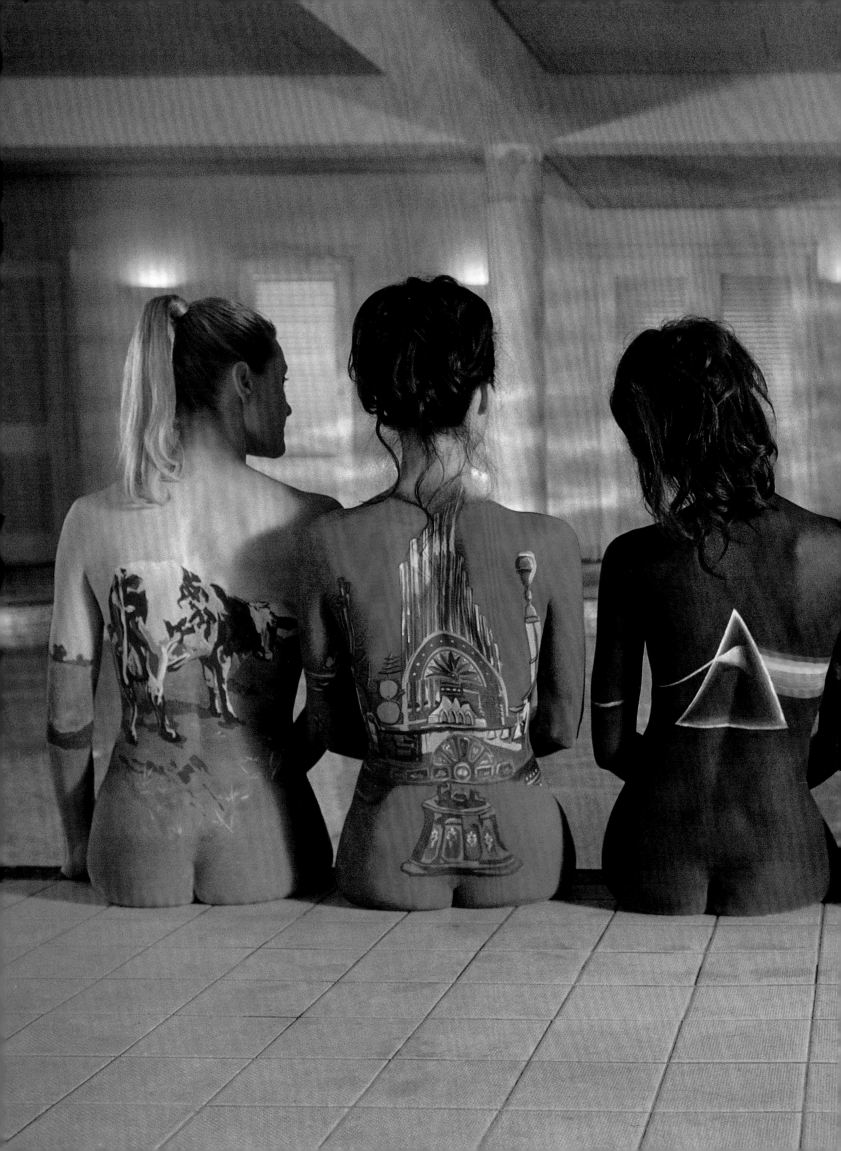

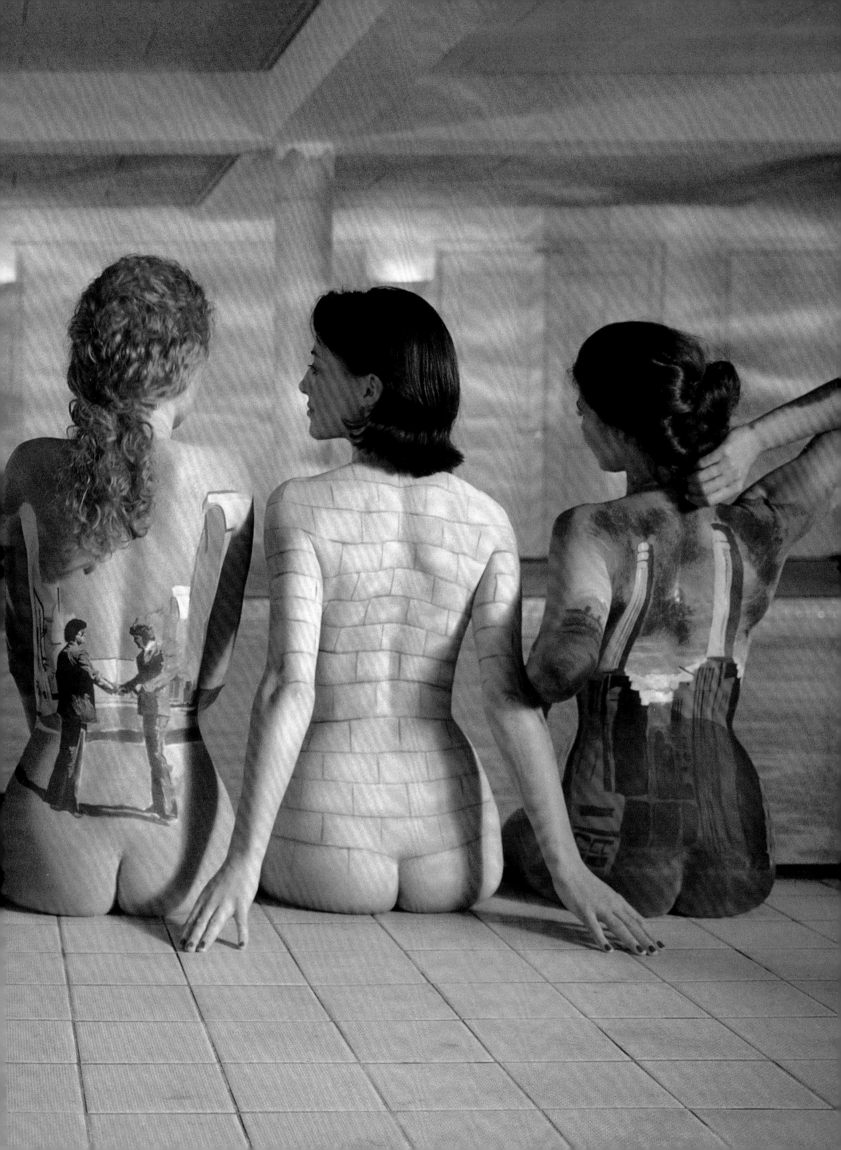

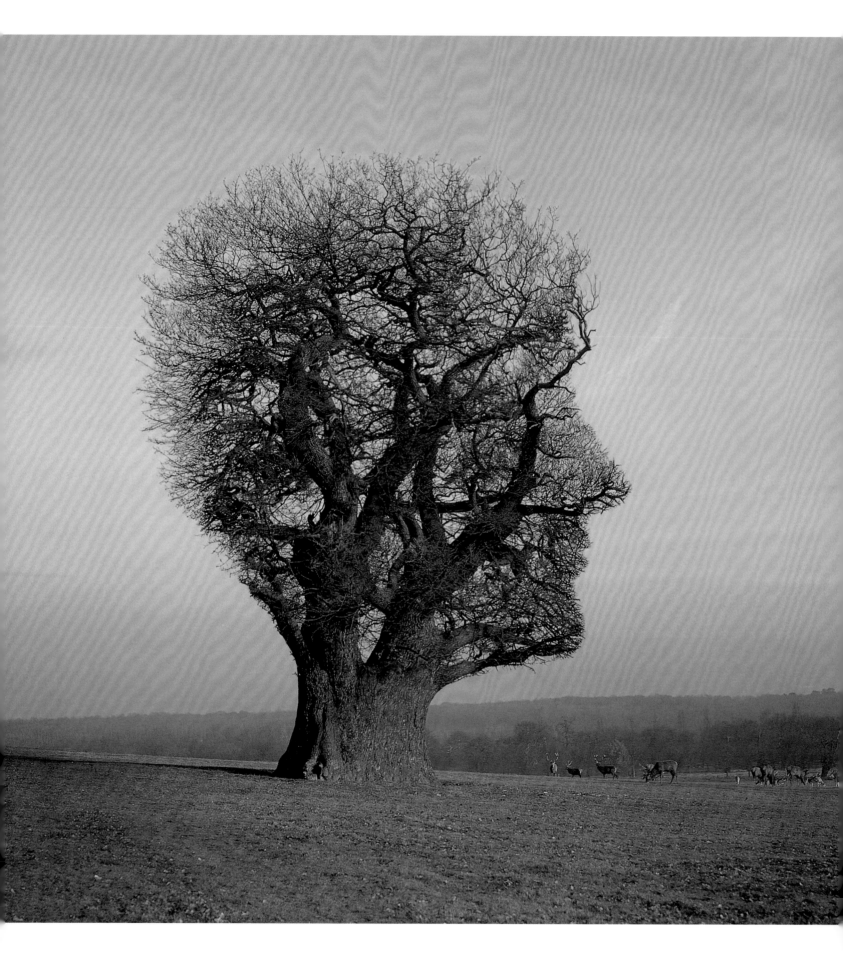

Pink Floyd, *Tree Of Half Life (1997)*

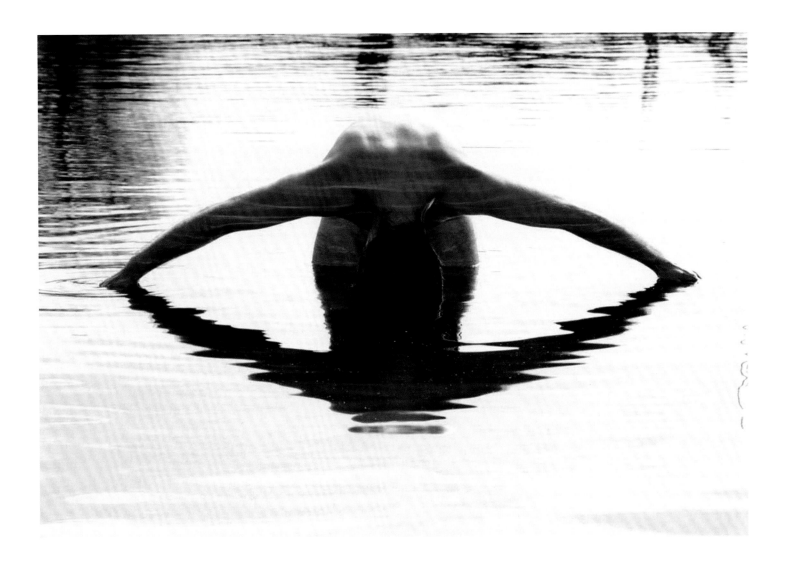

↑ *Eye 2 Eye (1999)*, used in 2010 by Alan Parsons │ Wishbone Ash, Twin Rivers (1999) →

PINK FLOYD'S **BACK CATALOGUE** painted on backs (pg 132/133) seemed such a silly idea in the mind but it was so much more delightful in the doing. This one, called simply **BACK CATALOGUE**, is the first of a series and it was a real pleasure, not for the obvious reason, but because the girls were lots of fun. The images were painted all in one go with versions of Pink Floyd album covers, and when the girls were ready they sat by the pool and we shot it. I always thought that it was the atmosphere of the picture that mattered.

THE image for **TREE OF HALF LIFE** (opposite) derived from a song not by Pink Floyd, but by Catherine Wheel, about a boy in a tree who won't come down, and it made me think of a tree like a house or a brain, because the branches look like dendrites; it became more associated with the latter for Floyd, being more their kind of thing. I already saw it as a communication between the tree and the viewer and the tree is saying hello by taking the shape, temporarily, of a profile. I have to say I love this picture because it doesn't feel like me, being a bit on the soft and gentle side.

EYE 2 EYE (above) is actually one person bending down in some water, whose reflection creates the shape of the eye. This was dreamed up by Sam and Fin and is a very clever and peaceful picture. I think it's very calming and charming.

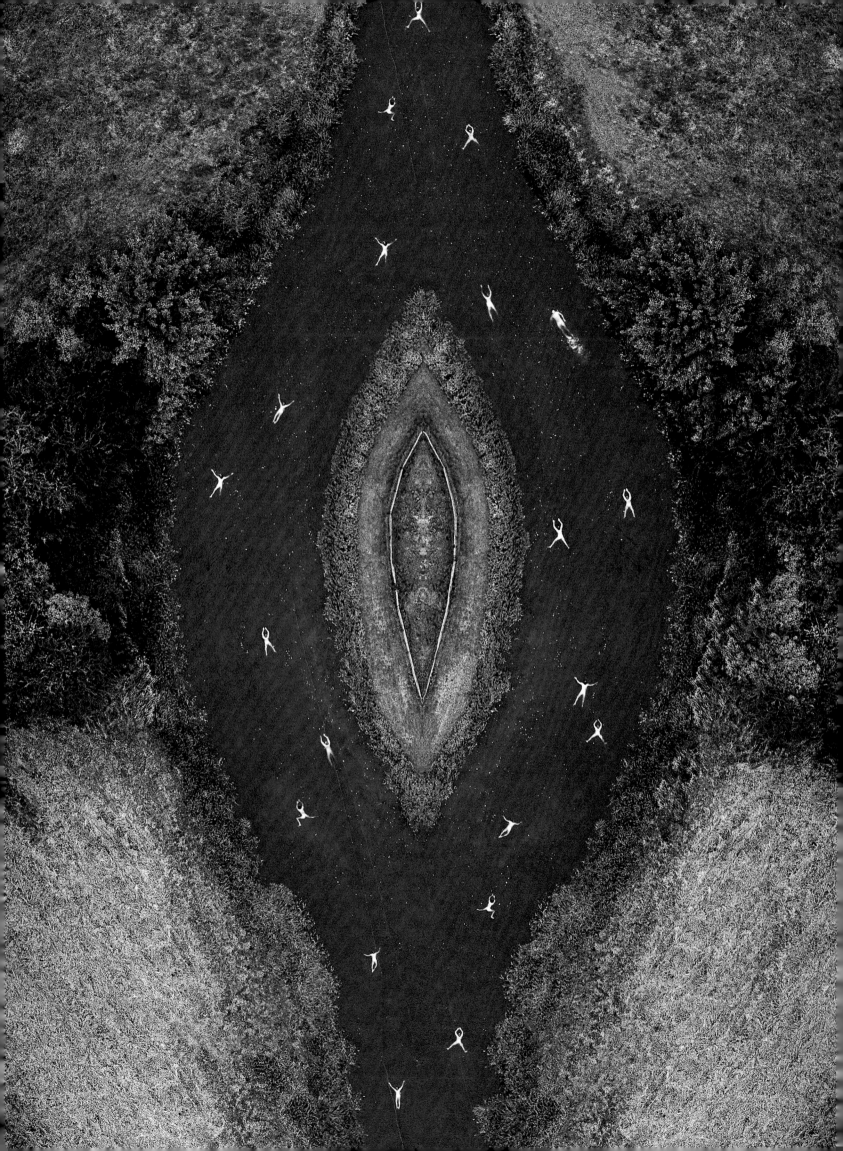

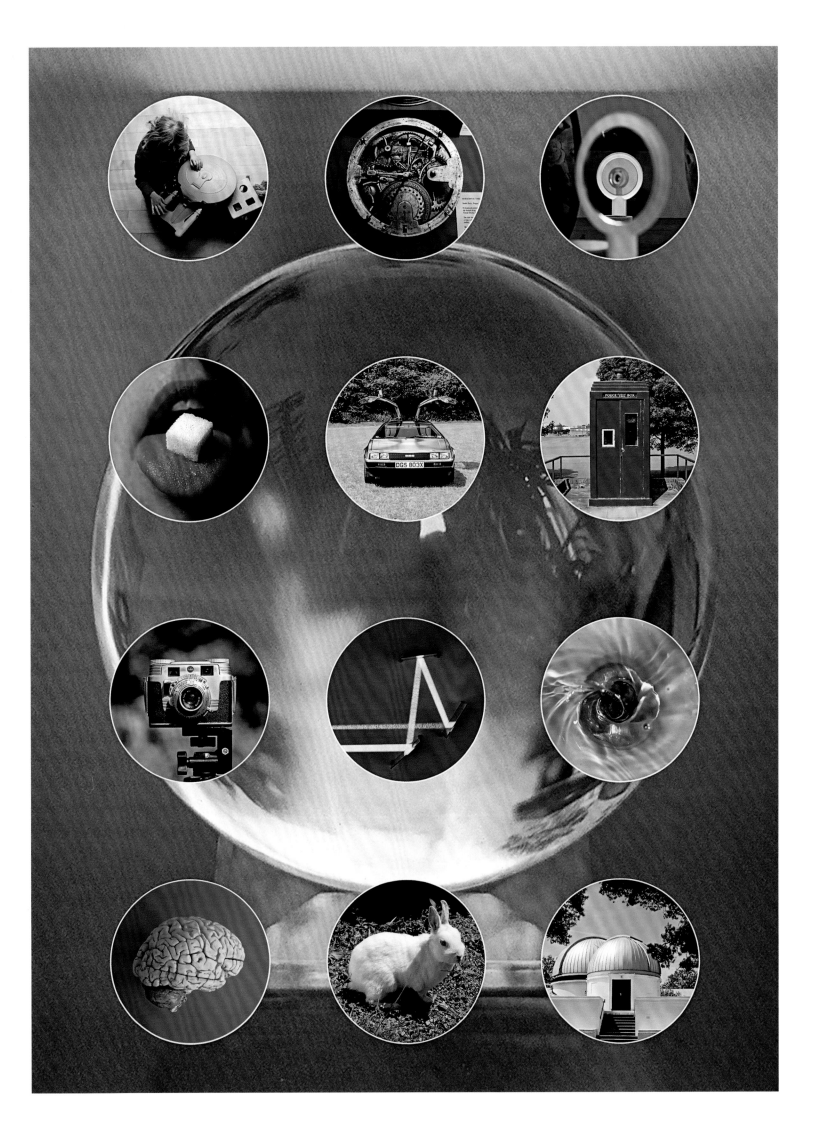

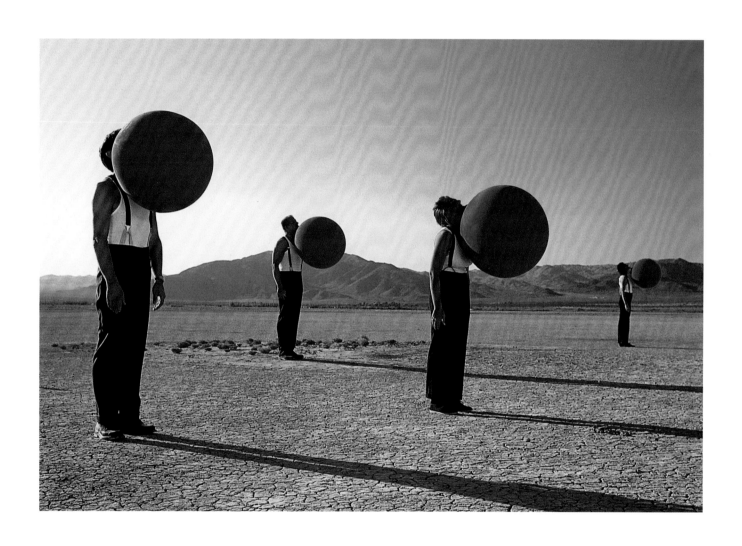

← Alan Parsons, *The Time Machine (1999)* | ↑ Alan Parsons, *'Luciferama' (1995)*

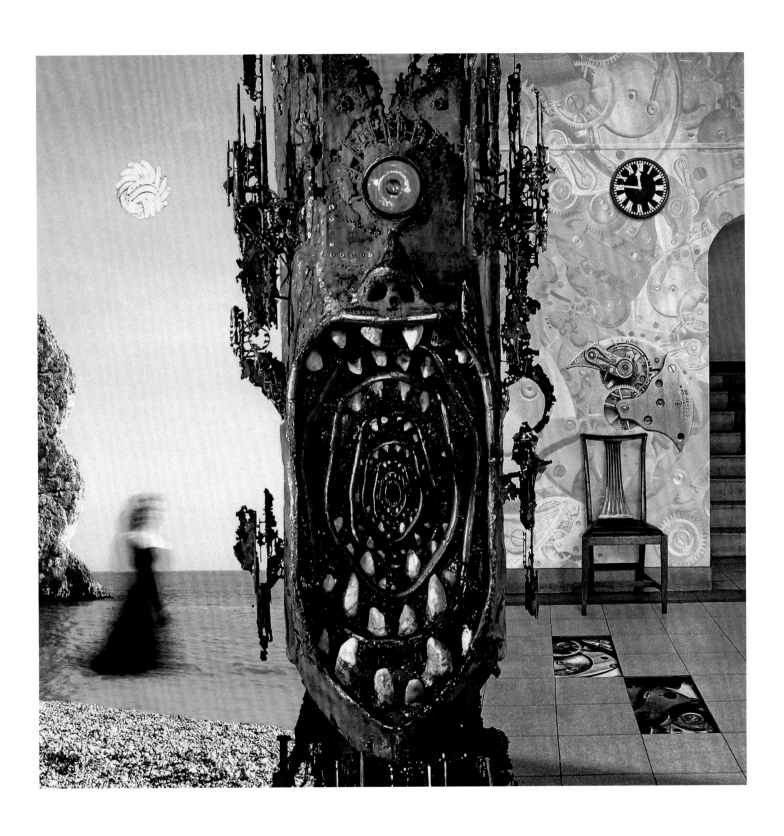

Thunder, *Laughing On Judgement Day (1992)*

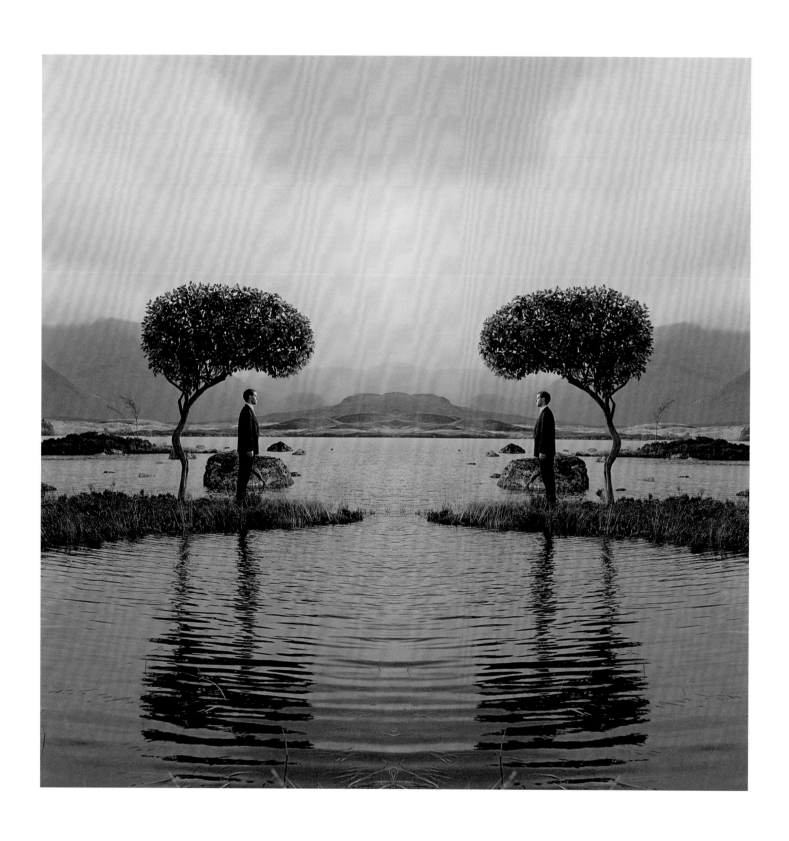

Bruce Dickinson, *Skunkworks (1996)*

TWIN RIVERS (pg 136) refers to the two guitars in Wishbone Ash, and was very difficult to shoot because it was taken from an helicopter. It was November and the swimmers nearly expired from hypothermia for it was bitterly cold, and even after much effort, it was turned down, because, apparently, the wife of the lead guitarist thought it was insulting to women, especially those with green pubic hair. We never understood what she was on about.

THERE are already several different types of **TIME MACHINE** (pg 137), from **Doctor Who** to a camera shutter, and I had no better idea than to arrange twelve time machines, representing the twelve hours of the day, against the crystal ball by which some people claim to divine the future. Though not Alan Parsons for sure . . .

THE picture for Alan Parsons' **'LUCIFERAMA'** (pg 138) was taken during a video shoot in Coyote Dry Lake, in California. Unlike the cloud heads, it doesn't mean a lot, it's just a picture of red balls, which came up again for The Cranberries (pg 158/159).

THIS is called **LAUGHING ON JUDGEMENT DAY** (pg 139) and I had just started working with Keith Breeden. This sculpture is based on a design I did for Syd Barrett 20 years earlier, of a mouth inside a mouth, inside a mouth. This version by Keith was a sculpture made of assorted debris and was considerably scarier.

THE word **SKUNKWORKS** (opposite) refers to secret R&D conducted by the American forces and technology companies to explore UFOs and copy their alien technology. I imagined that the people in **SKUNKWORKS** had very large brains, brains so large that the tree echoed their shape. It was a brain tree and what we did was to duplicate the picture and join it to itself which is something that I rarely do considering it a very easy way out. I think the atmosphere is very evocative, and everyone breaks rules now and then.

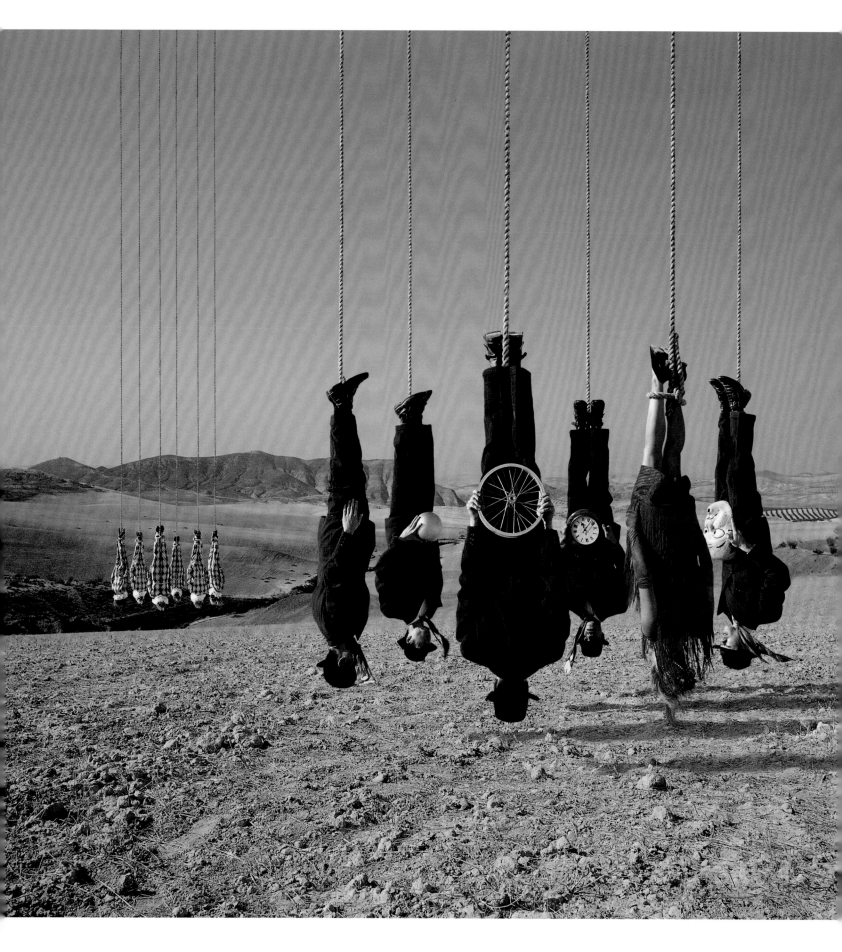

Alan Parsons, *Try Anything Once (1993)*

Alan Parsons, *'The Raven' (1995)*

The Almighty, *'Do You Understand'* (1996)

Thunder, *'A Better Man' (1993)*

THE cover for **TRY ANYTHING ONCE** by Alan Parsons (pg 142) is as silly as it sounds, with people hanging upside down from the clouds. The models are really up-side down, we just made the ropes longer, but it is one of the most beautiful locations I have ever been in, a valley be-tween two mountain ranges near Jaen in southern Spain.

WHEN we were making a video for Alan Parsons in Coyote Salt Lake, California we had this idea about people with their heads in the clouds as per the popular expression. So we decided to use it for **'THE RAVEN'** (pg 143) and we made an artificial cloud for each person and stood him or her above the horizon line so that the clouds looked like they were in the sky. It makes me smile a little.

ALMIGHTY suggested to me a couple of gangsters or at least a heavy, somebody threatening, and I thought what more threatening – not – than a goose who is sitting on the man's chest daring him to move or he'll peck his eyes out: **'DO YOU UNDERSTAND?'** (pg 144) says the goose. You may think, dear reader, that a goose is just a domestic farmyard animal, but they are far more frightening in real life. A goose is not to be argued with, take it from me.

THE way Thunder's **'A BETTER MAN'** (pg 145) was conceived it seemed to me like a fairytale but I don't know why, it's probably me being obtuse. I mean frogs have nothing to do with thunder and not much to do with rock and roll, but maybe if you kissed the frog it turns into a prince and thereby becomes a better man. Which is of course why the flowers in the background are tulips, two lips! As a 4-sheet poster it looked amazing and stood out as something different, even if I say so myself. Croak! Croak!

OOOs

STORMSTUDIOS

StormStudios is
Peter Curzon, Rupert Truman, Dan Abbott,
Lee Baker and Storm Thorgerson

• • • •

MUSIC used to be a thing you could touch. And sometimes it would touch you back. Music didn't come down a telephone line at all hours of the day, deposit itself in your 'Purchased' folder and cost you 99p a song. You had to wait for music. You had to go out hunting and gathering, to record stores, charity shops, music fairs – places where you could eye it up, fondle and touch it, coo over the sleeve and anticipate the sounds within. All of that ended – not with a bang but with a series of clicks – in the noughties.

IT HAPPENED almost immediately. In April 2000, it was announced that thrash metal leviathans Metallica were suing something called Napster. This Napster thing, it turned out, was taking CDs, turning the music into digital files and then making them freely available to anyone with a 56kps modem and a whole lot of time on their hands. Record company execs were understandably frustrated and annoyed. Mostly because they'd just spent hours waiting for a single picture of hot multi-racial lesbo action to download, but also because . . . Well, why hadn't they thought of this?

THEIR decade was about to get a lot worse. In October 2001 Apple's iPod was released. 'It's like carrying your entire record collection in your pocket,' said Apple. 'We'll take 350 million of 'em!' said the world. In 2003 a site called MySpace allowed artists to share music directly with their fans. Suddenly you didn't have to buy the album, you could just visit MySpace and play it over and over while chatting with fellow fans (smart move, artists). Between 2005 and early 2008, it became the most visited social networking site in the world. YouTube followed in February 2005, enabling everyone to look at and listen to pretty much any artist in the history of music for free. (And then write in txt spk underneath about how 'they is wack, bro'.) The switch from dial-up to broadband meant downloading, file-sharing and streaming music became quick and easy.

FACED with this free, continuous and on-demand music, the ways music was purchased and consumed changed radically. Radio became less relevant.

DAB seemed to offer specialist stations catered to everyone's tastes, but we were all playlisting our own personal radio shows. Why listen to a DJ playing tracks chosen by some faceless committee when you can hop from YouTube to MySpace, build playlists on iTunes, or swap DVDs full of MP3s with your friends? The BBC's baffled response to the new multi-channel, multi-platform world was to cancel Top Of The Pops in the summer 2006. It had already been displaced as the one mainstream music programme that the whole country sat down to together. In February 2002 some kid called Will Young won a thing called Pop Idol. This annual TV singing contest, later renamed The X Factor, was to dominate the charts and the airwaves for the foreseeable future. ('If you want a vision of the future,' George Orwell once wrote, 'imagine a boot stamping on a human face – forever'. He neglected to mention that shop assistants from Croydon would provide the soundtrack, warbling power ballads in the style of a hiccupping Whitney Houston.)

RECORD sales plummeted. Across the web, specialist music blogsites run by music fans – and cynical ad-hungry aggregators – shared albums old and new via file storage sites like Rapidshare and Megaupload. An application called Spotify was launched in October 2008. Music magazine sales dropped; some closed altogether. Retailers like Virgin Megastores, Tower Records, Zavvi, Fopp and Woolworths bit the dust.

IN March 2007 Paul McCartney signed a record deal with Starbucks on the rationale that 'if people aren't going to record shops anymore, we'll take the records to them!' In August that year Prince went one better, giving away three million copies of his latest album with the Mail On Sunday as promotion for a series of 21 nights at London's O2 Arena. Playing to 420,000 people, he makes a fortune on tickets and the publishing costs were paid by the Mail. Prince's previous album had sold just 80,000 copies in the UK. By giving it away for 'free', this deal may have earned him more than eight times as much.

THERE was a power shift from record companies to promoters and agents. In 2002 David Bowie announced that he was to perform his classic album Low in its entirety at London's Royal Festival Hall. ('Hang on,' double-checked a cynical audience: 'You're definitely not going to play any of your new album? Really? And none of that Tin Machine guff? Ok then, I'm in!') Acts with a similar pedigree who previously had thought that they had to release a new album in order to tour embraced a new nothing-but-the hits/ your-favourite-album-in-full touring model. Promoters, fed-up of losing small fortunes on hot, hyped young acts with no audience, smelled money. The new law: any band that can reform, will.

MP3 players took the focus from long-playing albums and put it on individual tracks. Why download an album padded with filler when you can just buy the tracks you like? Between 1999 to 2009, sales of full albums fell 55 %. Sales of individual digital tracks, meanwhile, went from nothing to 1.2 billion. By January 2012 US digital music sales accounted for 50.3 % of all music purchases, the first time that digital has overtaken physical musical sales.

SO where did all this leave Storm Thorgerson? As Storm himself put it: 'My work during the period didn't change much but everything else did'. I became Editor In Chief of Classic Rock magazine in 2004 and interviewed Storm in 2007 when the topic of conversation was most definitely, 'In a world without physical albums, where does that leave the album sleeve designer?'

AMID the insults and wind-ups I had to endure, Storm was philosophical: the whole issue, he said, 'raises a very good and complex question about the need for objects. That is, whether you live in a hut in Tanzania or a mansion in Malibu, there are common characteristics: mementos, objects, and possessions. It's a really deep issue (going back as) early as man had the first bone collection.' And he had already had an inkling of where things were going: 'Packaging might make a comeback," he said. "You can't get a virtual rendition of fancy packaging. We're about to do a special pack in remembrance of Syd Barrett, which will include a replica of a piece of original Syd artwork in the form of a little booklet, which he made. For those who love Syd, it'll be great to have in their hands. You can't get that down the wire. Maybe there are some things that won't be invalidated by downloading.'

IRONICALLY, the clue to the future (now present) could be found in a significant release that year from a band often dubbed 'the new Pink Floyd'. In October 2007 Radiohead offered their new album *In Rainbows* via their own website with a 'pay what you want' offer. Warner Chappell later revealed that most people who downloaded it from their website paid a grand total of . . . nothing. There is a 'but': pre-sales for the CD version were still more profitable than the band's previous album *Hail To The Thief*, aided by the promotion afforded the free release or perhaps as a result of their try-before-you-buy offer. More significantly, the band also created a limited edition 'discbox' packaged in a hardcover 'book' with slipcase, featuring the album on CD and two heavyweight 12" vinyl records, artwork, lyrics, a second enhanced CD

with eight extra tracks, digital photos and artwork. The package cost £40 and sold 100,000 copies. By October 2008, the album had sold 3 million copies across both paid-for physical and digital versions.

SOME people, it turned out, would still pay for a hard copy – for something more than just the music. The hardcore wanted something hard, a special, collectable edition that they could touch – and that might touch them back. For the serious fan, the desire to own and collect was reawakened. In a culture where you can have anything for free, paying extra for something you actually love makes sense. The years since have seen an array of lavish, limited edition box sets, the most ambitious being the 'Why Pink Floyd?' campaign that offered Floyd's back catalogue in a variety of ways – *The Immersion Editions* offered bonus discs of unreleased music, and a variety of exclusive, irresistible gifts: scarves, drinks coasters, replica backstage passes and tour tickets – and marbles, in case you had already lost yours.

SOMETHING else had started to happen. In 2011, SoundScan – them wot measure the sales of music – reported that sales of vinyl were at an all-time high: 3.9 million in the States, up over 1 million copies from 2010 and now accounting for 2% of the 228 million physical albums sold. In the UK, sales of vinyl increased 44% to 341,000. You might be tempted to think that these records were sold to people stuck in the past, Luddites who refuse to move with the times. In fact, SoundScan estimates that 9 out of every 10 new vinyl albums sold included a digital download code for the same album. That is, the people who bought them still wanted the music

in a form they could add to their iTunes playlists and stick on their phones – but they also wanted the artwork, the tangible thing, a little bit more immersion.

THROUGHOUT all of these changes, of course, Storm kept on working, defying bad economics just as he defies bad health. Storm's 21st century work was still instantly recognisable, even in cases where the album itself wasn't well known. (If you want to test this, trying viewing Megadeth album sleeves online. StormStudios designed only one – I guarantee you that among the skeletons, zombies and apocalyptic scenes of Megadeth's other sleeves you will easily be able to identify which one.) In the noughties StormStudios produced work for a diverse bunch of artists, from rock classicists, to electronic futurists and jazz-rockers. They're not all household names – O.A.R., Goose, Thornley, Powderfinger, Shpongle, YOURCODENAMEIS:MILO, Umphrey's McGee, Disco Biscuits – but they do have some traits in common. For all their variety, there's a lack of acoustic based roots music. Storm's lot are electric. Epic. They have big ideas, big sounds, big visions. They write songs with titles like 'Supermassive Black Holes' or 'Mountains'. Often they are a bit daft. Almost all of them are loners – bands that don't fit in any scene or movement. Single-minded dreamers. Mavericks.

AND apart from a few blockbusting acts – Muse, Biffy Clyro, Pendulum – few of them have enjoyed massive success. So the recent work of StormStudios is perhaps not as iconic or as recognisable as work from the 70s and 80s. It's not the art's fault, obviously: with iTunes, DAB, Spotify, SoundCloud, our own individ-

ual tastes are now indulged to such an extent that it's hard to imagine that we'll agree on any one collection of tracks from one artist ever again. It's tempting to say that this is reflected in Storm's work, to suggest that just as music has fragmented and we wave goodbye to the kind of consensus that brought us megabrands like Pink Floyd, Led Zeppelin and Genesis, so the artists that Storm works with now have become more niche, more obscure. But it's not as neat as that: for every Pink Floyd there was always a Public Foot, for every Led Zeppelin an Orange Bicycle. These days Storm's sleeves for Novalis, Hydra, Gravy Train, Strife or Quiver are better known than the music itself.

WHAT it means for the art itself needs a mightier mind than mine. The circumstances that turned the artwork for *The Dark Side Of The Moon* into a rock icon have changed. From where I'm standing, Storm Studios produced some of their greatest work in the noughties. Since yer asking, I like the Powderfinger sleeves, all The Mars Volta sleeves, Yumi Matsutoya's 'Setsugekka', Thornley's *Tiny Pictures*, Europe's *Secret Society*, and The Cranberries' *Wake Up And Smell The Coffee* – none of which are probably recognizable outside of the bands' fan bases. But does it matter? Is art to be judged on the amount of eyeballs that view it? If a tree falls in the woods, does it still make a noise?

I'M with Aristotle on this one: of course it fucking does.

• • • •

Scott Rowley

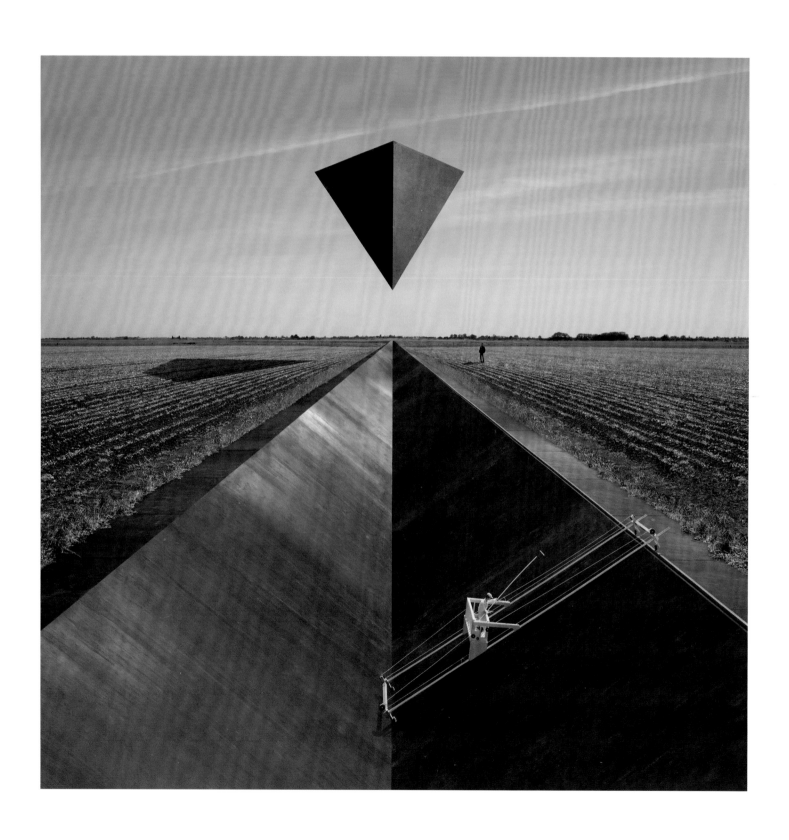

Goose, *Synrise (2010)*

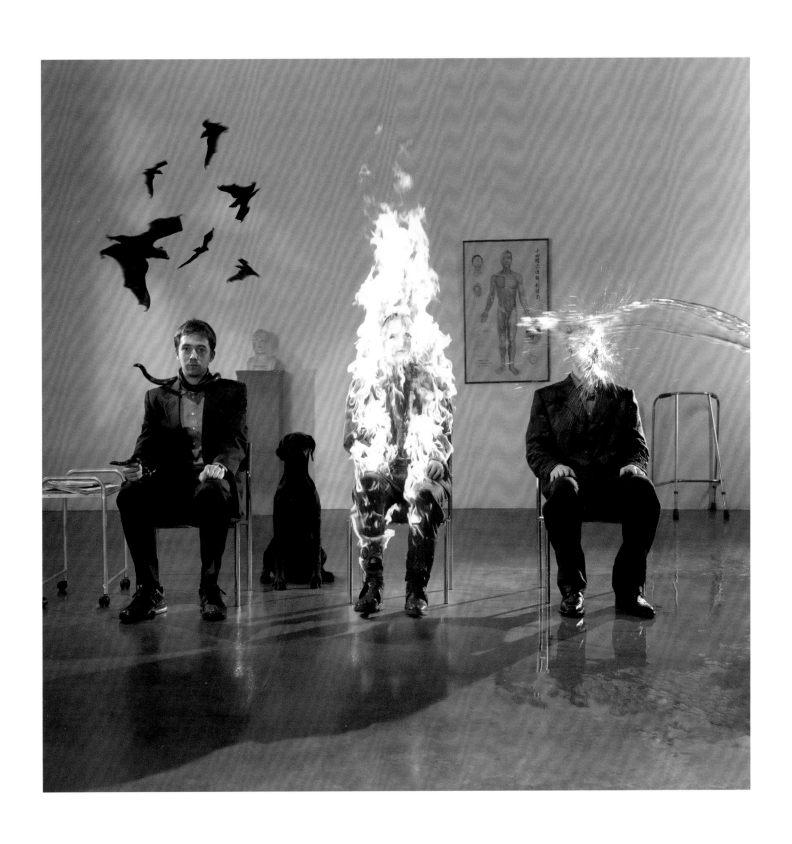

Biffy Clyro, *Saturday Superhouse (2007)*

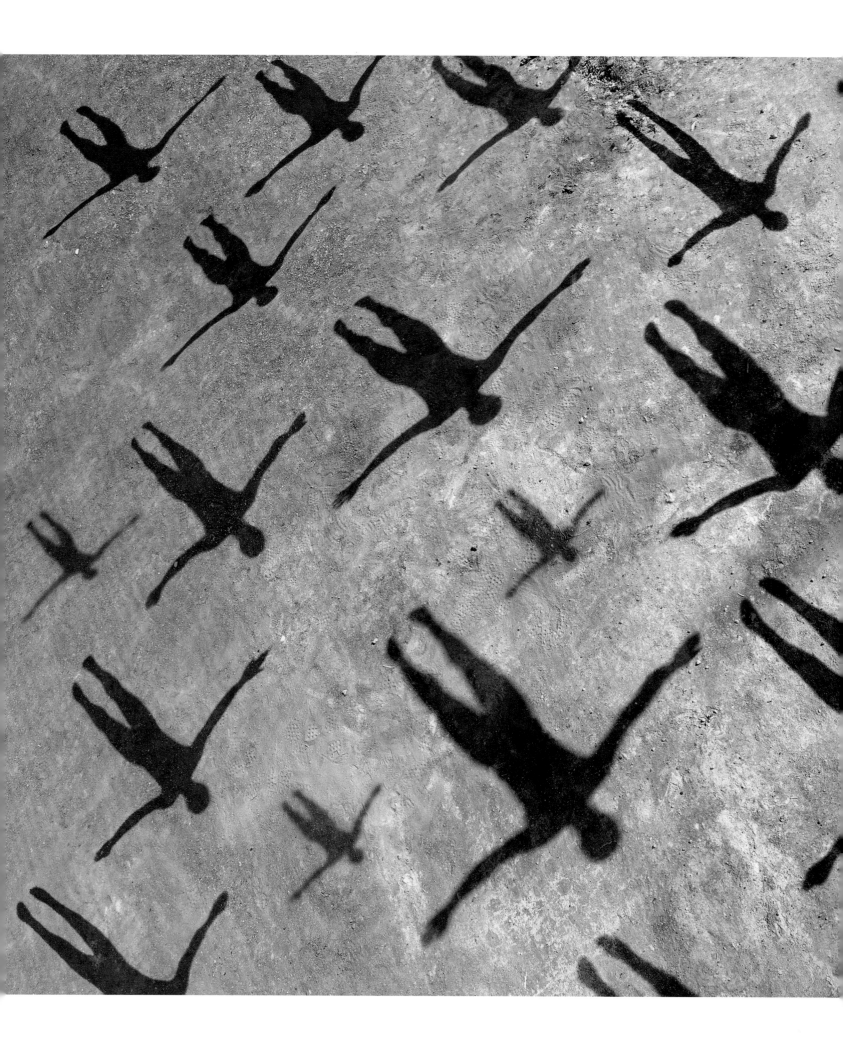

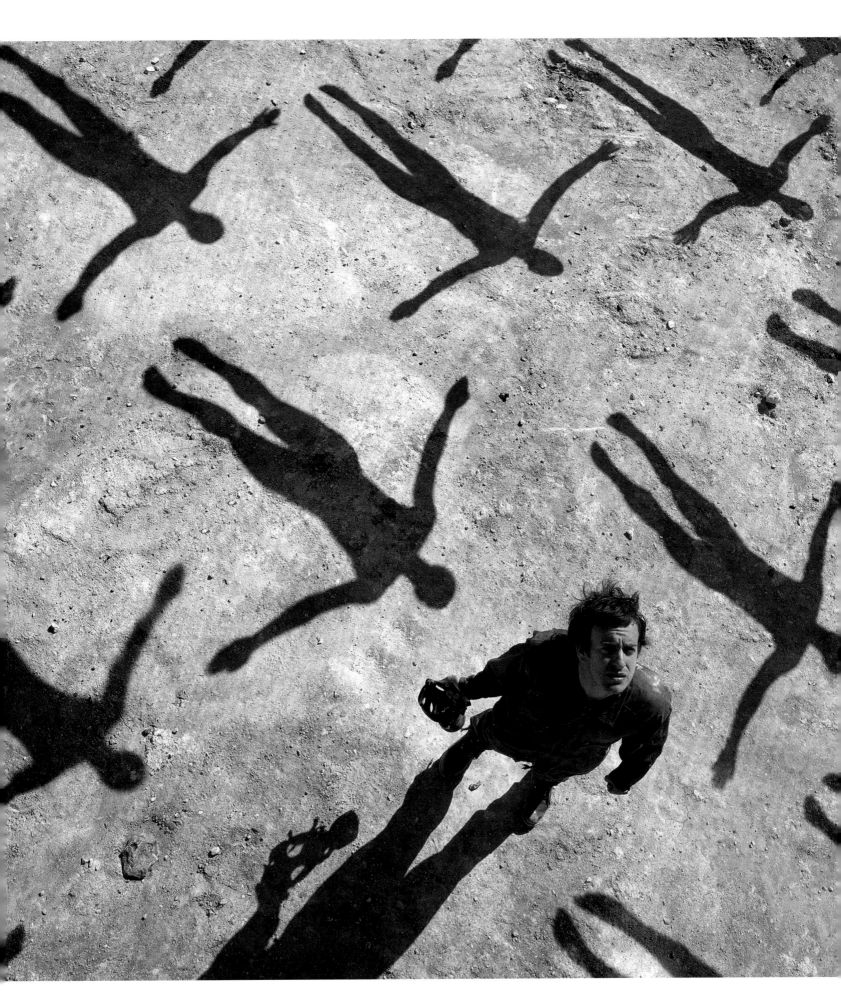

Muse, *Absolution (2003)*

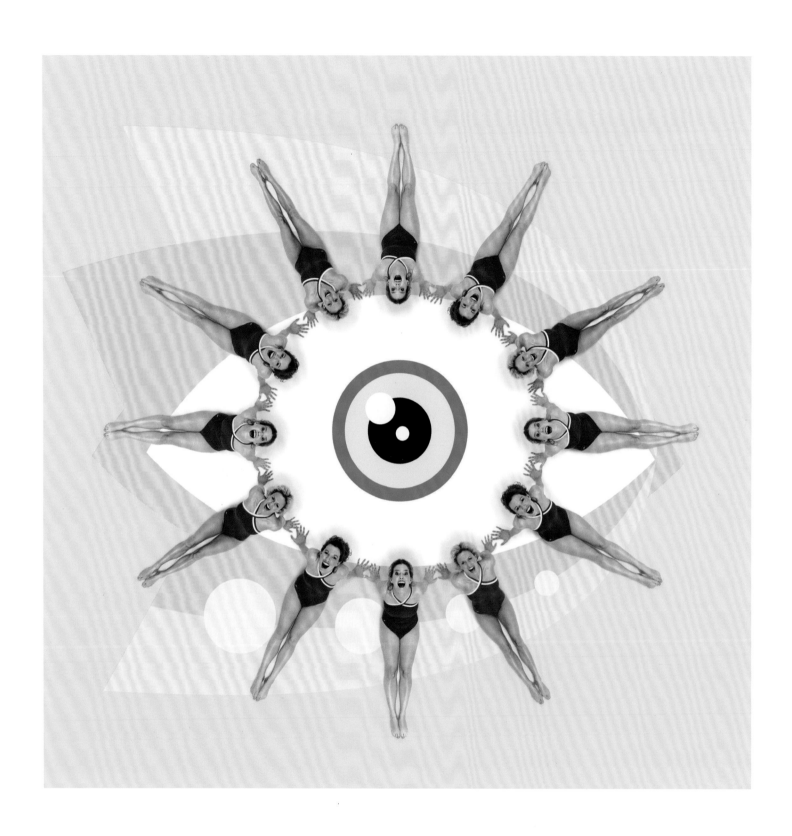

Muse, '*Supermassive Black Hole*' *(2006)*

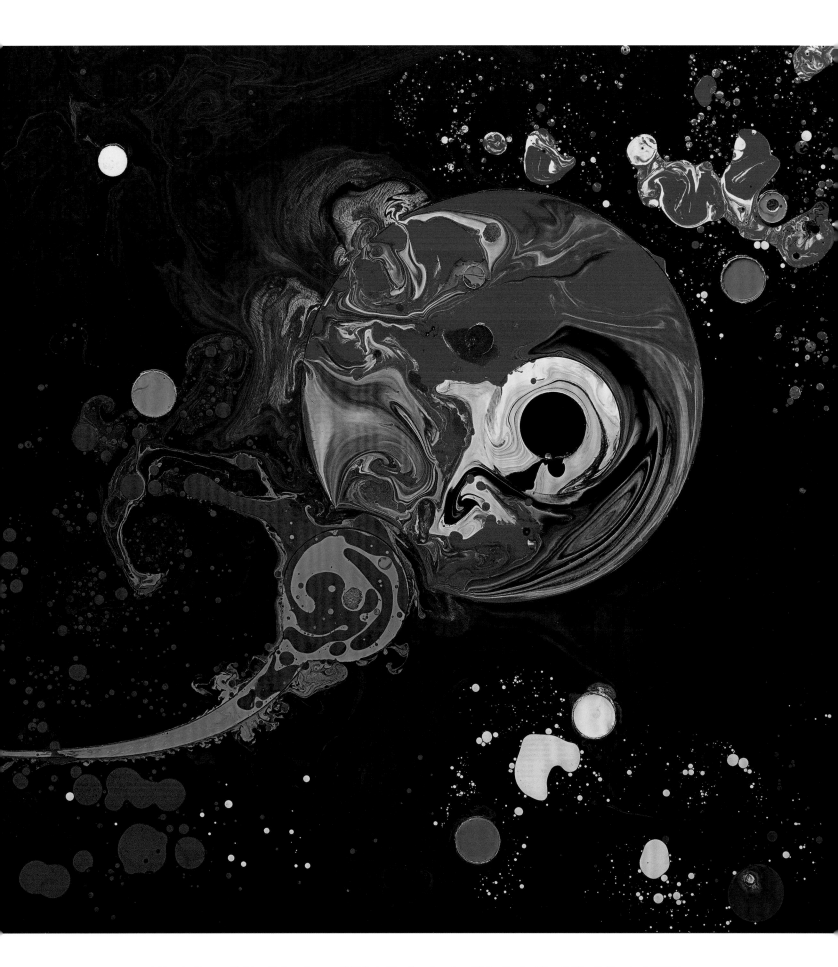

↑ Powderfinger, *Golden Rule – Sperm (2009)* | The Cranberries, *Wake Up And Smell The Coffee,* test *(2001)* →

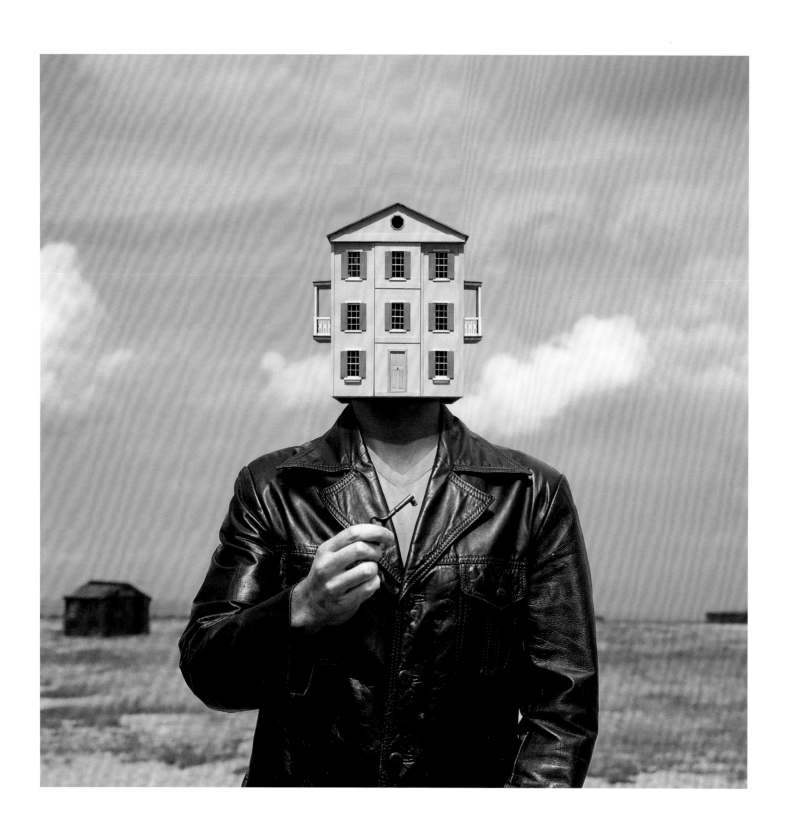

Ethnix, *Thirteen (2002)*

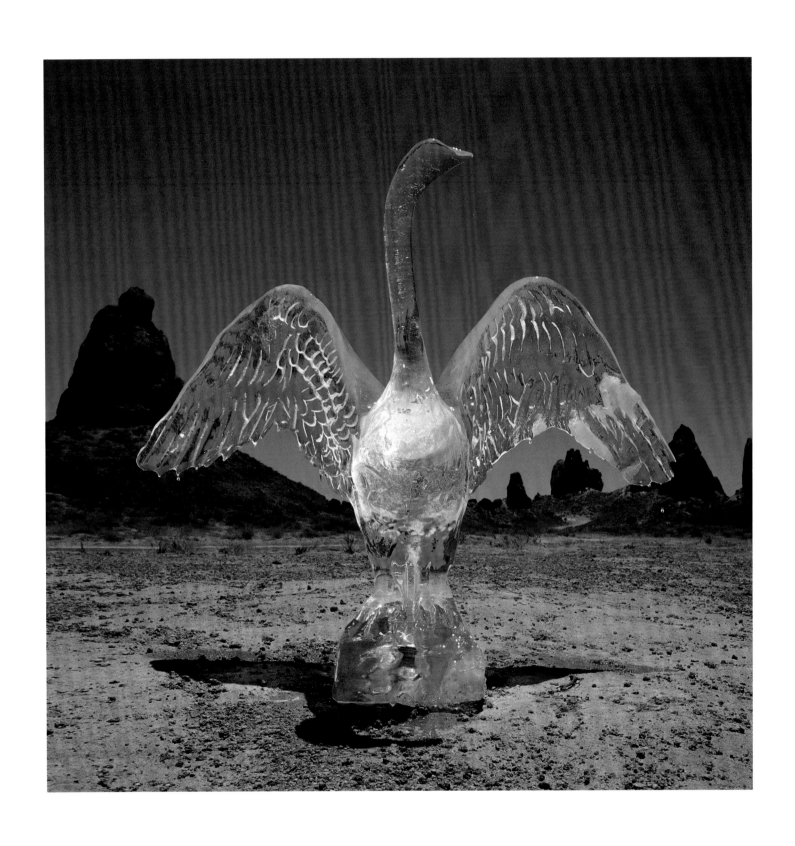

Blinker The Star, *August Everywhere (2001)*

I THOUGHT I WOULD TAKE GOOSE, AN ELECTRONIC OUTFIT FROM BELGIUM, TO my favourite Italian restaurant, which they enjoyed tremendously. But all this buttering up was kind of in vain since they had already decided what to use for the cover of SYNRISE (pg 152) from the roughs. So the long vinyl groove stretching across the countryside was the chosen design – it was hell to do, with heavy slabs of rubber grooves – no fun for the faint-hearted but a satisfying result or so I thought. But we didn't see band again until an opening night party for our exhibition in Ostend, where they told me they collected an award for our cover design that I didn't know about previously – should've left theirs out of the exhibition, but I didn't.

F OR the fantabulous Biffy single called 'SATURDAY SUPERHOUSE' (pg 153) I emailed the band and they replied with three little words – crying, anger, and sanity. Hence three guys (i.e. the band) in a waiting room as if attending some kind of ritual or examination, possibly medical. One demonstrates the ease with which one can be at with their demons (bats and snakes), one endures thrown water for tears, and lastly and most dramatic was the fire of anger – a plume of flame. It shot upwards in the studio when the 'figure' was set alight, quite impressive I'd say.

M USE'S album ABSOLUTION (pg 154/155) was a powerful affair – Muse's drummer Dom had seen our sketch of flying people but in a completely different context and asked if it could be adapted and interpreted more to their tastes. The image derives in part from **Where The Wild Things Are**. I think Dom felt they were the lost or even the last souls leaving a forsaken earth, and that witnessing such a magical event bestowed 'absolution' on the viewer– how I personally feel on seeing shooting stars.

'**S** UPERMASSIVE BLACK HOLE' by Muse (pg 156) was a thumping single, apparently concerning a woman in a bar rather than something astronomical, or maybe she was astronomical. We devised a cross between a 'thirties drawn eye and a set of circular ladies like Busby Berkley would do. We thought it was extremely attractive but they didn't give a shit. The problem of course with bands is that they are unaware that their audio cortex is already only one eighth of the size of the visual cortex, possibly already delimited by their chosen profession (in all fairness my old audio cortex is even worse off).

'**S** PERMY' is the unglamorous name we gave to a picture which was done for Powderfinger using the process of immiscible liquids (pg 157). Peter used as a template the fundamental act of creation, namely a sperm penetrating an egg, in reference to Powderfinger's own creativity. But I think they felt they had enough with the kookaburra and they didn't want to confuse things, however we do not have that problem, so here it is! Spermy Sperm in Technicolor.

W AKE UP AND SMELL THE COFFEE for The Cranberries (pg 158/159) is an outrageous temporary extallation which worked a treat. What you see here is the test but we prefer it in hindsight to the final... yes dear readers this is for real – approximately 200 red gym balls dropped from a tower, I kid you not. When we repeated it on a beach the balls bounced higher and further – Rupert and I were so amazed we, at first, forgot to take a picture.

E THNIX second album, THIRTEEN (pg 160) though concerned with war, was more preoccupied with the difficulties of returning home and trying to settle back into a civilian routine. At least this is what we thought they said, hence finding the key to their house or more likely finding a way back into their pre-war mindset.

A UGUST EVERYWHERE (pg 161) was initially called something else about 'heavenly', implying the transience of things, so when Jordon Zadorozny, aka Blinker The Star, changed his mind he still kept the cover design, which is a real event and extremely transient if not poignant because the desert sun melts the ice, which in effect kills the swan whose neck is the first to break.

• • • • •

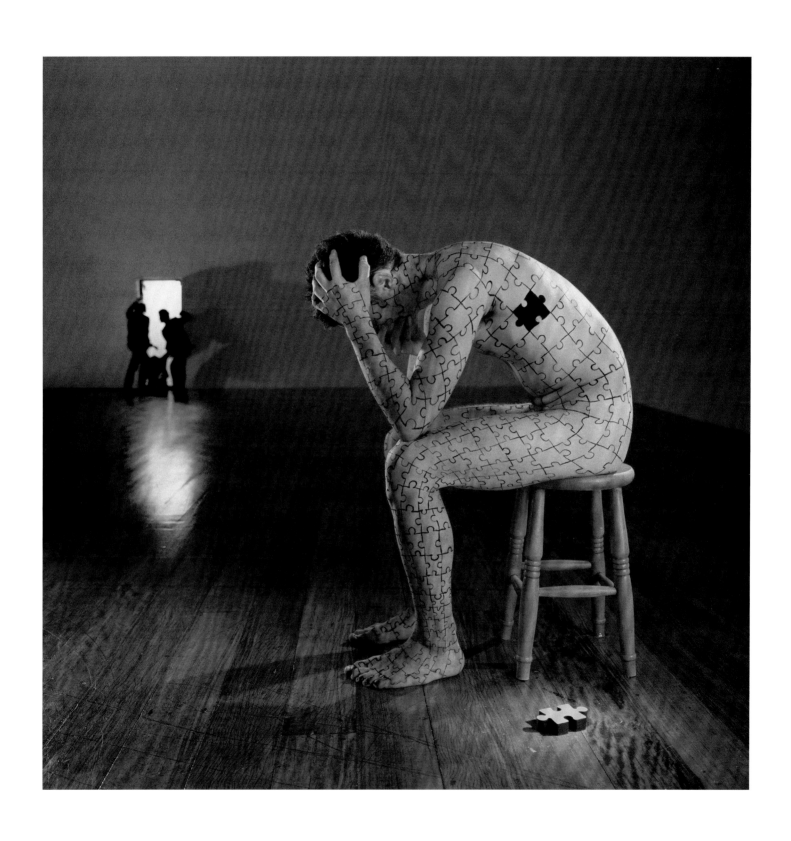

Biffy Clyro, *Puzzle (2007)*

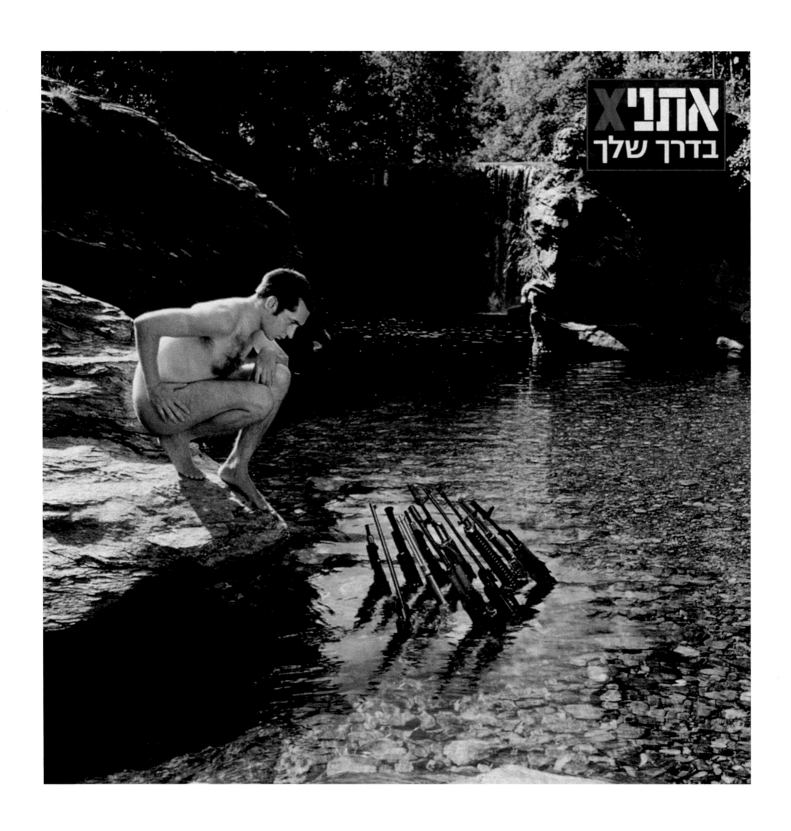

Ethnix, *Your Way (2001)*

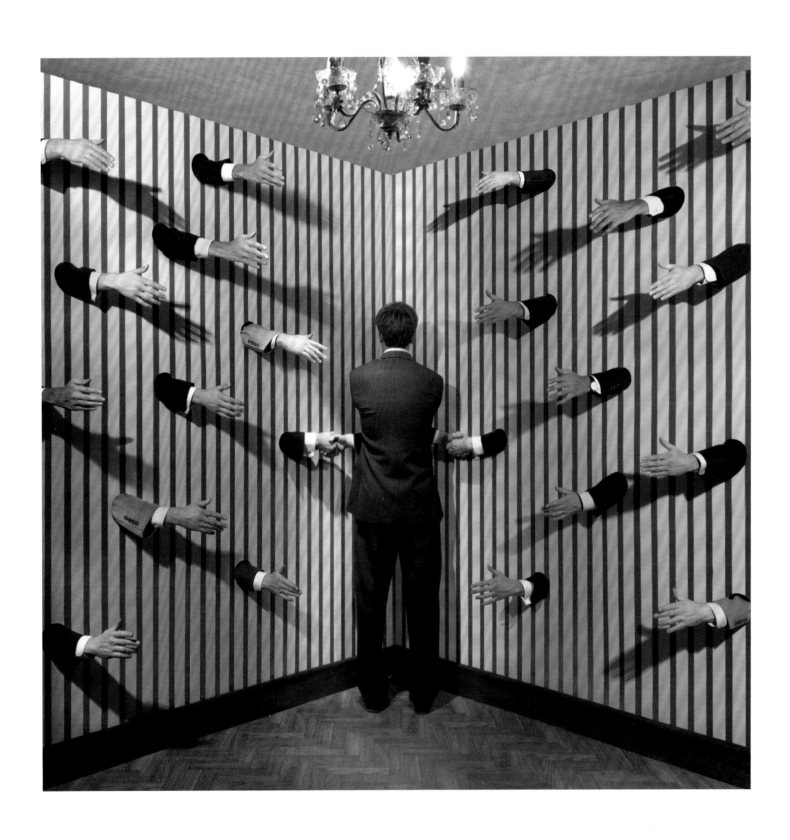

Europe, *Secret Society (2006)*

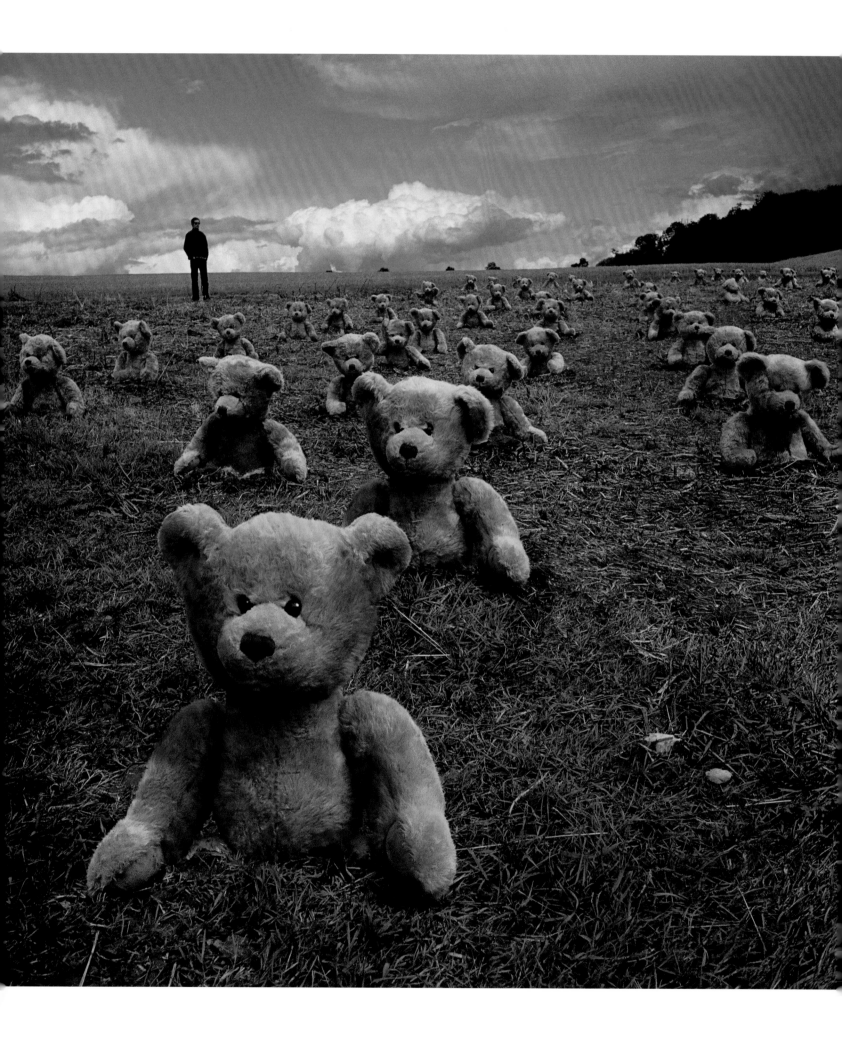

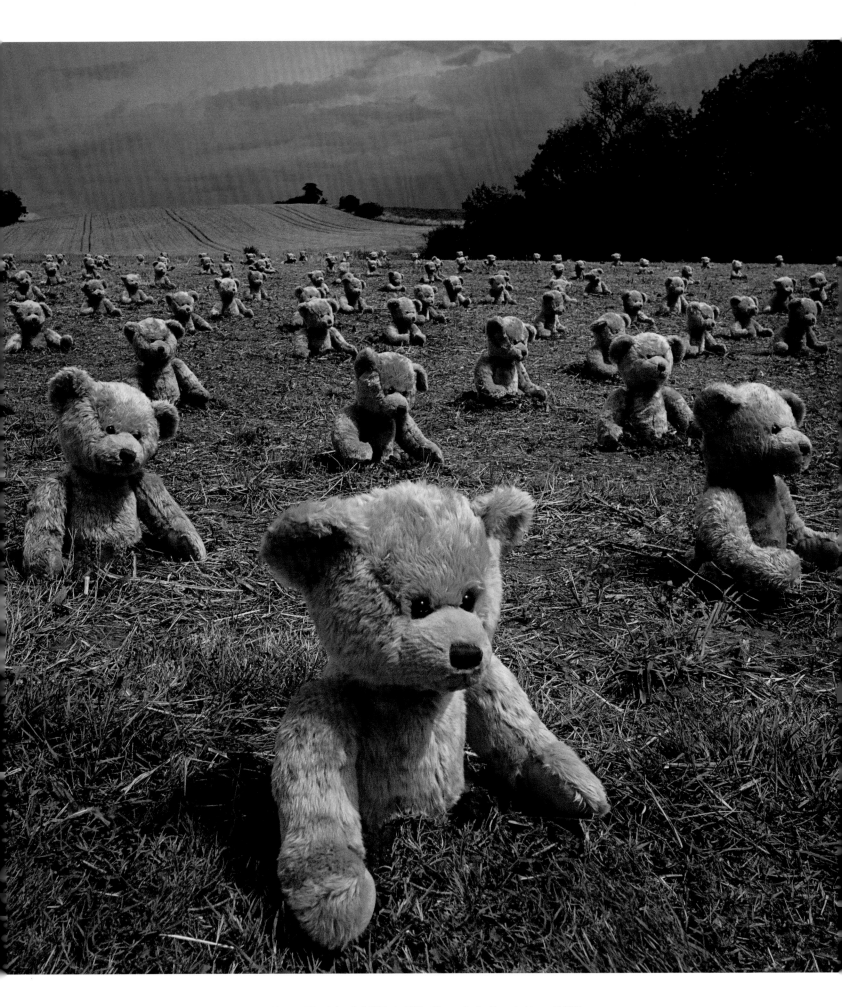

↑ Muse, *'Uprising' (2009)* | Biffy Clyro, *Only Revolutions (2009)* →

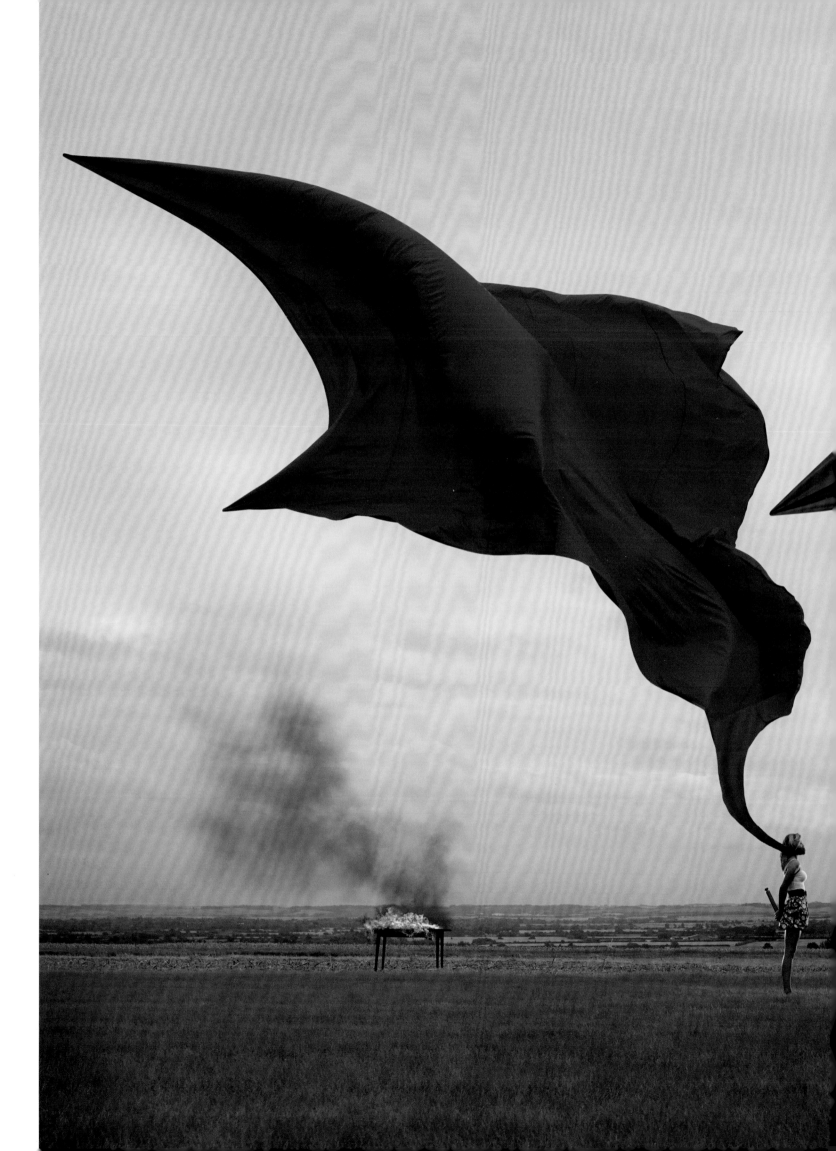

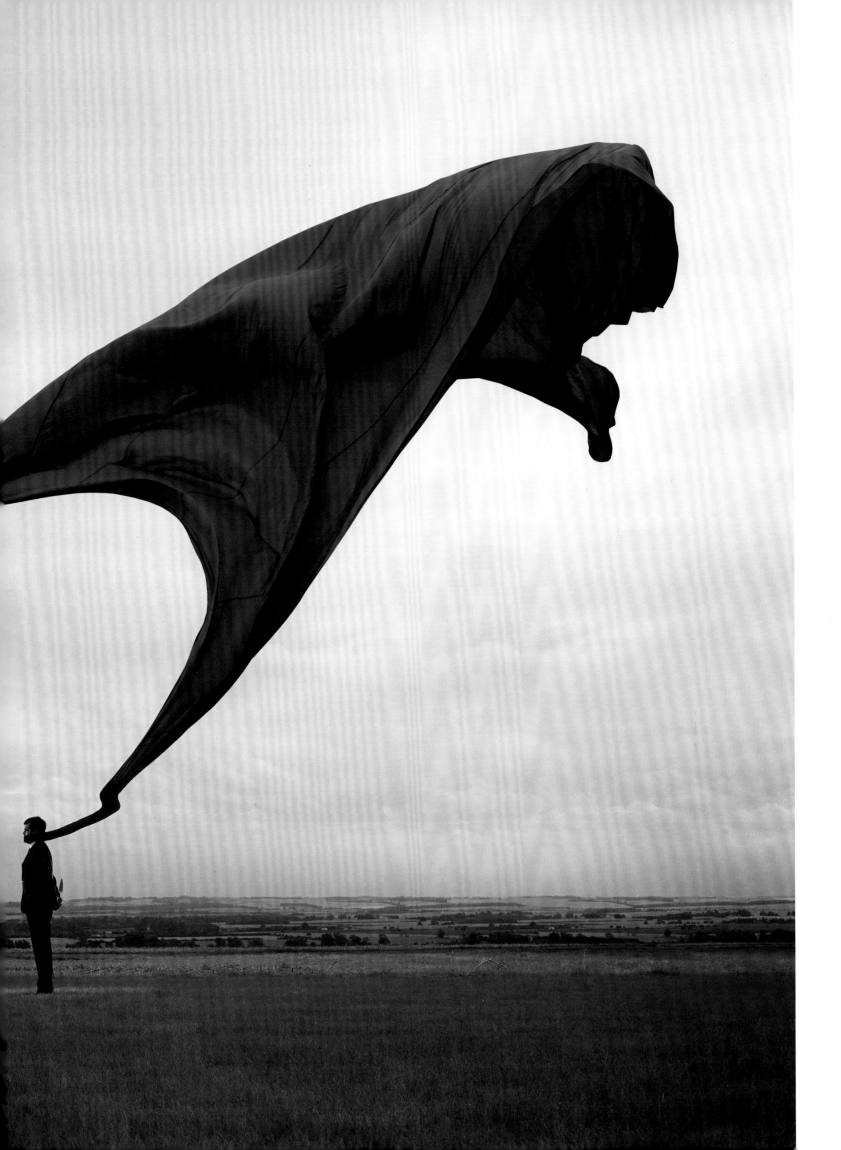

BIFFY CLYRO are a smouldering rock band from Scotland whose lyrics are sometimes very dark and edgy, and in my view a great band; PUZZLE (pg 163) referred to an emotional event about a death in the family and how to deal with the range of emotions which follow – grief, sadness, anger, guilt, and so on. I imagined some form of burial ritual common in all races – Japanese came to mind – a continuous pattern of puzzle shapes adorning a naked man sitting in 'grief posture', except there is a tromp l'oeil where one of the 2D pieces has fallen to the ground as if 3D. There is always a missing piece in the complexity of death, a hole in the heart.

ETHNIX were an Israeli band who wrote quite a lot about the morality or insufficiency of war and the difficulties of returning home. Since it is my view that wars are caused by narcissism, I had this idea for their album YOUR WAY (pg 164), where Narcissus was looking in a pool, like a mirror of reflection, not seeing himself, but a load of guns pointing back at him. Even to this day I find this image very unsettling. It is done for real.

EUROPE were not a band I'd expect to work for but it was most enjoyable (pg 165) . . . there was talk of secret societies, or at least secret hand shakes. We built a set with numerous holes for hands and what you see is what you get, but not what you may feel from a dodgy handshake.

'UPRISING' (pg 155). I guess all artists to one degree or another have their pet subjects. One of mine is teddy bears, some childhood trauma or gladness no doubt, I can't remember. In the case of 'Uprising' we see an army of teddies rising from the ground, emerging like zombies or half buried in the ground – teddies were being slowly submerged en masse. It is the viewer's discretion as to which. We buried by hand 150 teddies but Muse got cold feet and demoted it to a single and used a boring drawing instead for the album cover, I was most disappointed... It would have made a great billboard.

THERE was much talk about change and the battle of the sexes on ONLY REVOLUTIONS (pg 166/167). It actually came from a book where left hand pages were written from a girl's point of view and right hand from the man's, asking: does real change require extreme measures like a revolution? It is also applicable to a record going round. Revolutions stuck in my mind, where one of the prominent displays are flags. Dan said 'gags to flags' and both are big issues so I envisaged huge flags that came from gags. So 'huge is huge' but the sample flag was so big it went over the top of the studio and down the other side! Thus we took slightly smaller flags to a hilltop in Bedfordshire and tied one end to a scaffolding tower and let them blow naturally in the wind. It was fantastic! The shapes were phenomenal, undulating waves of material flapping, cascading, rippling, a joy to behold and all real, all natural. The protagonists hold weapons and the table they can no longer sit around burns in the background, and the flag shapes express what they cannot articulate. It is one of the most exhilarating thing I've ever done.

WE once designed a calendar for Pink Floyd, recreating **The Dark Side Of The Moon** with fruit, such is the depth of our humour. Dates could be the extensive background, whilst cranberries, blueberries, baby lemons etc. occupy the spectrum. This made me and Peter think simultaneously that liquids could be used to much greater effect.

We used the same 'tray' of compartments, thoroughly sealed, and poured colour paint into appropriately black water for the background, off white prism, and spectrum as normal and waited... the attempts to seal of compartments failed and colours leaked into each other in swirls and cloudy shapes, reminiscent of marbling but more vivid (see the front cover of this book).

It was fantastic to watch, we called it 'random control' and used the same procedure for Powderfinger's GOLDEN RULE (opposite) but incorporating a different motif obviously – the band were Australian, which was pertinent to a couple of the songs, so Peter suggested Australia's favourite bird, a kookaburra – the bird is easily discernible but with a little stirring and added oil droplets to help things along the patterns and swirls of contaminating colours worked their magic anyway. A wonder to watch, like a moving constellation.

Powderfinger, *Golden Rule - Vinyl cover (2009)*

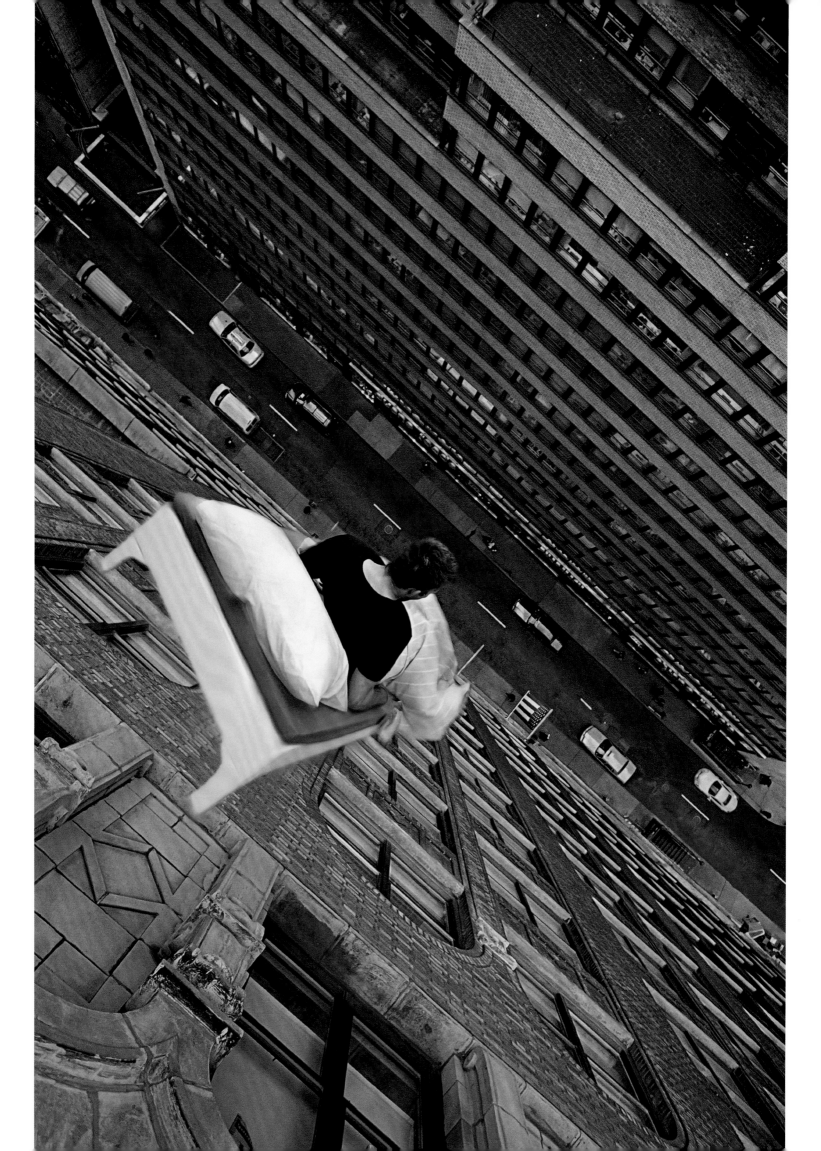

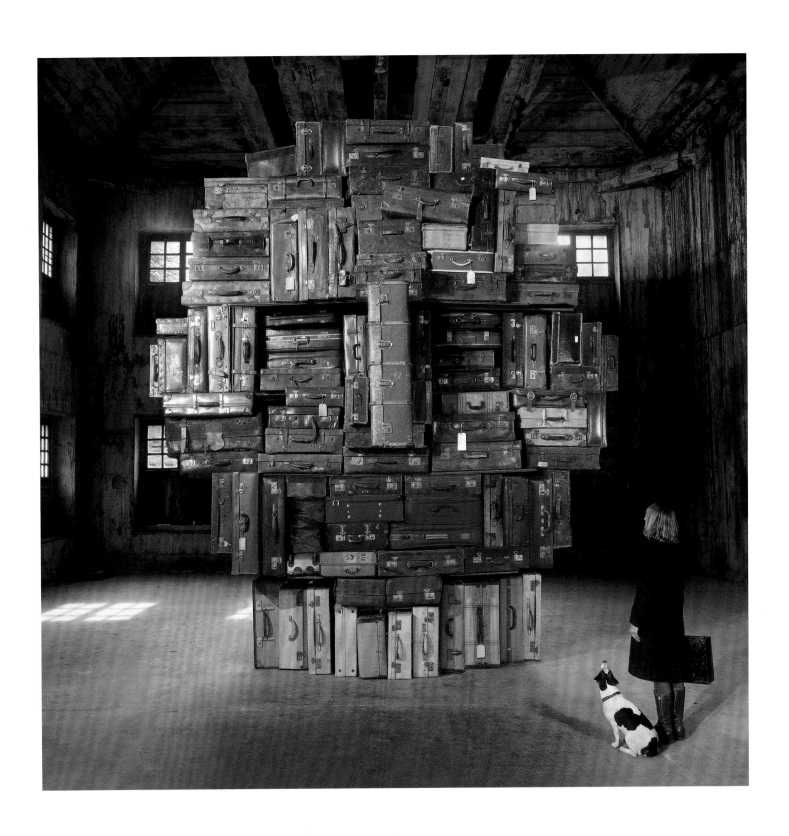

← Megadeth, *Rude Awakening (2001)* | ↑ Thornley, *Tiny Pictures (2009)*

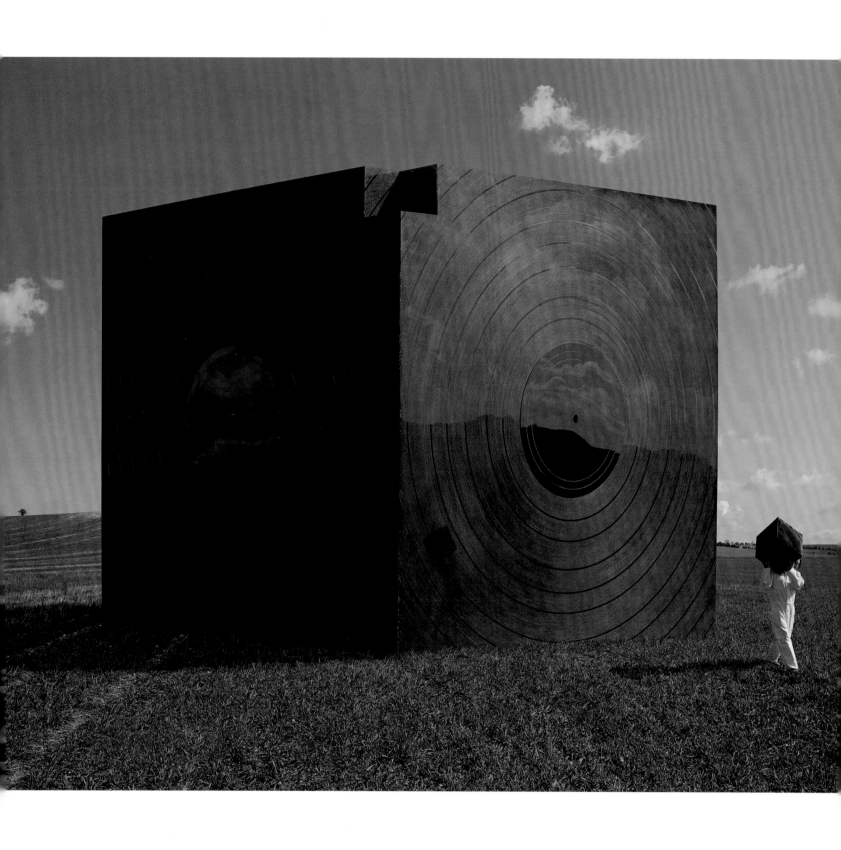

↑ Pink Floyd, *Chip Off The Old Block (2008)* | Pink Floyd, *Interstellar - Mirror Balls (2003)* →

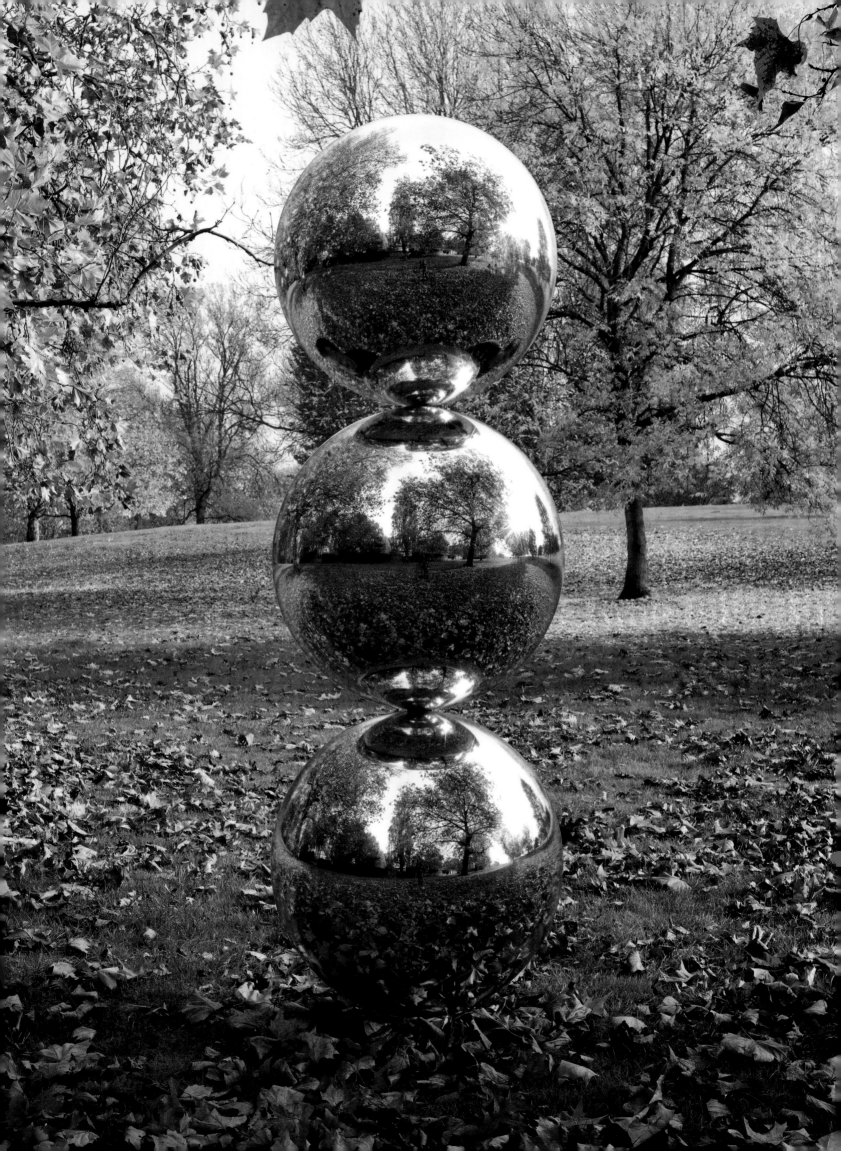

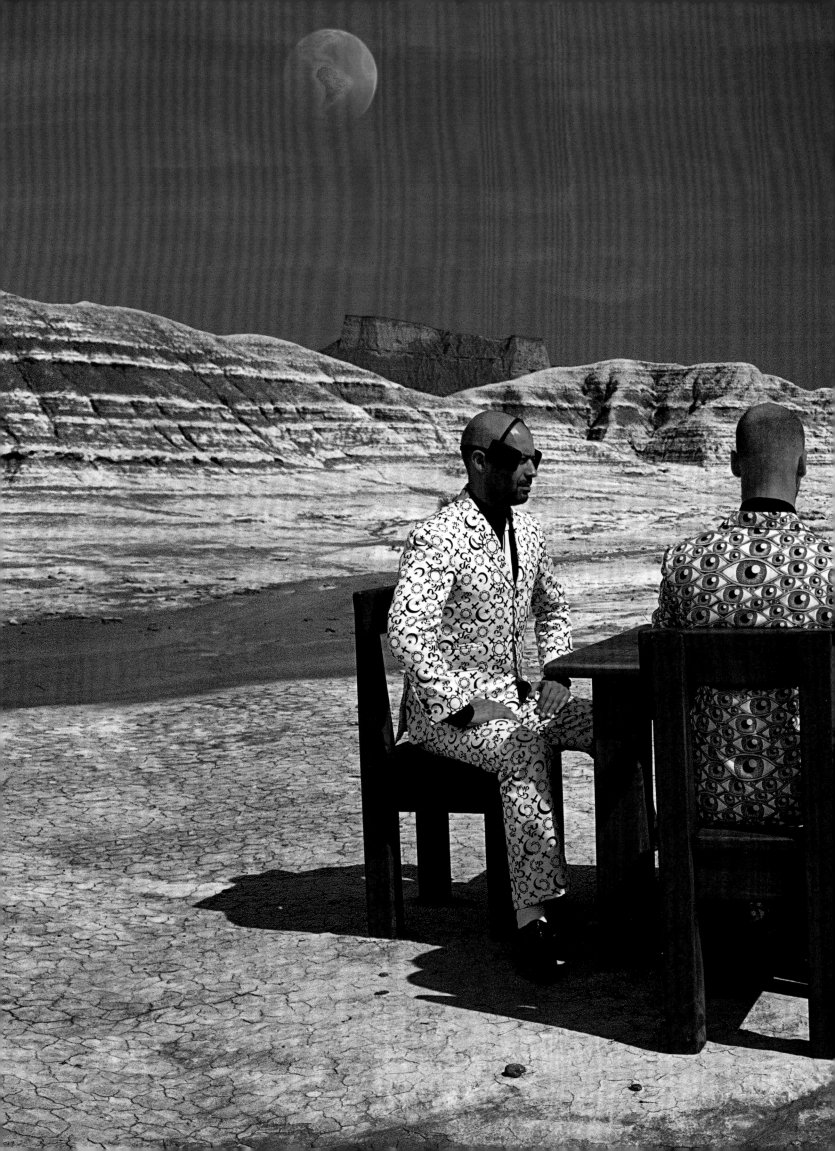

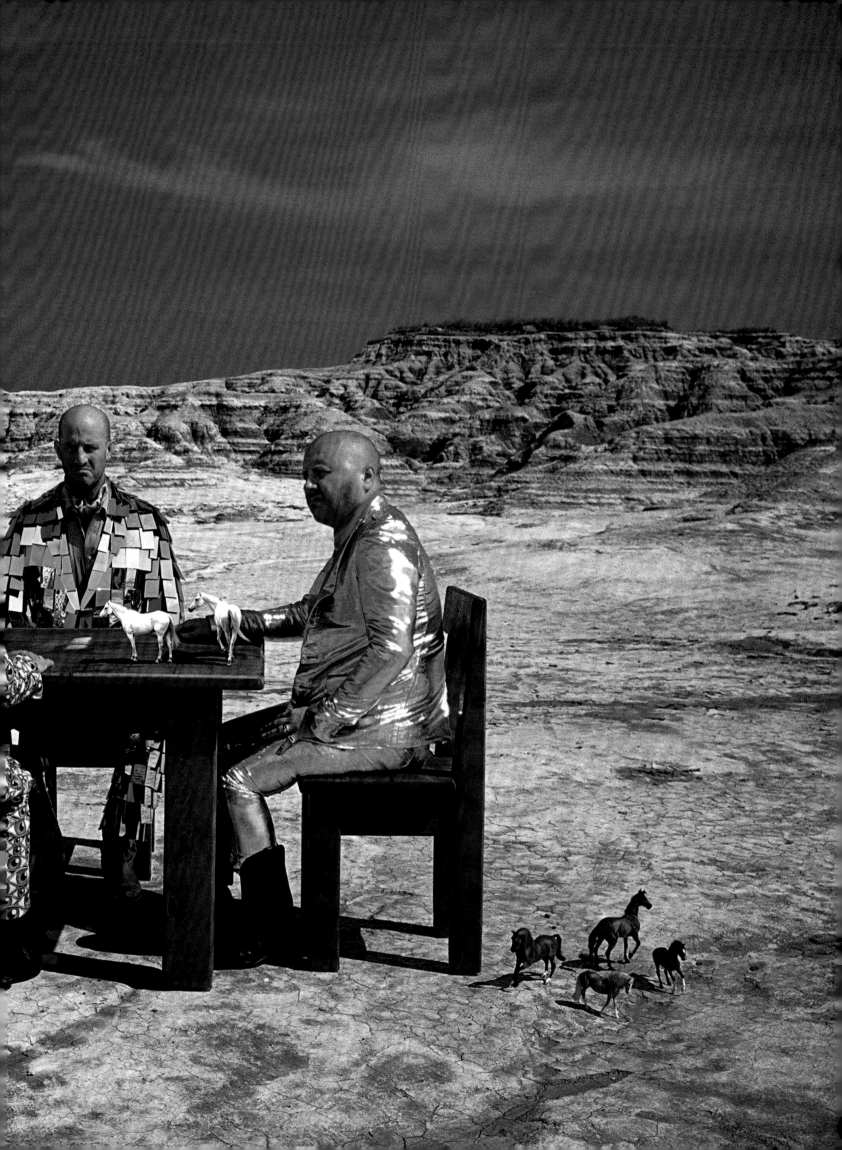

DAVE MUSTAINE of Megadeth had a nightmare about waking up as your hotel bed slips out the window and heads for the ground 20 floors below. Rather strangely Peter had the same idea, though viewed from a different angle. Since we'd had the same idea it seemed an appropriate design to execute for the cover of the live album RUDE AWAKENING (pg 172). Rupert suspended a camera from the 20th floor of a New York skyscraper on the end of a pole and took a snap. It scared the shit out of me, who, like Woody Allen, gets nervous just stepping off the kerb.

SOME jobs come through recommendation; some jobs come because they've seen something they like; some jobs come from old clients; very occasionally a job comes by finagling. The 'head case' (pg 173) was initially designed for the Floyd but they didn't like it. In the end it was done for two clients – one a rock band from Toronto called Thornley who used it for their album called TINY PICTURES, and one a private client who had an unhealthy respect for Pink Floyd. Through a mixture of desperation and strong belief, I always thought it as a subject worth doing. We collected 200 suitcases and arranged them in the shape of a head and installed them in a very large warehouse in Chatham Docks where they built the old galleons. The end result was like a left-luggage nightmare and slightly more menacing than I intended.

I GUESS all artists have preoccupations, things that they particularly like, obsessions; or maybe it's all the same. One of mine is a big black box, featureless and having no apparent function, sitting all by itself in the middle of wherever, doing very little. I have no explanation of this any more than Cezanne might, who painted his favourite hill 27 times, Hokusai painted his wave 96 times, and Van Gogh, his sunflowers 9 times. One returns, it seems to one's obsessions. I was at last able to do a big black box for the front of a Pink Floyd calendar about their singles, and thus the block was made of black vinyl as befits a rock band. The corner piece, which has been taken away, represents a single release; this is often the case in the record business that a single is taken from the album. It is not only the little chip taken from the corner but also the man carrying it is my son – hence 'CHIP OFF THE OLD BLOCK' (pg 174).

I THOUGHT this was a great way to show the colours of autumn (pg 175) and it was derived from the mirror balls used for the INTERSTELLAR poster at the Paris exhibition. These balls are electroplated with pure mirror. There is very little distortion and are exactly as you see them. In between each ball is a multiple set of reflections reflecting each other again and again and again which I, not the Floyd, think of as a simile for 'le secret' of Pink Floyd.

BLACK HOLES AND REVELATIONS is an album by Muse (pg 176/177). There was talk of the Four Horsemen of the Apocalypse. There were three songs featuring galloping horses and battles. Seeing something epic and biblical was called for, but not costumed oldies dressed up in rags and riches and armies of a million slaves, but rather an interpretation. And this interpretation meant that the four horsemen were dressed in clothes to represent the four great modern Evils of today – which in our infinite wisdom, we decided were Paranoia, who wears a suit of eyes, Mr. Prejudice (a suit of religious symbols), Mr. Narcissus who wears a suit of mirrors, and of course, the unalterable Mr. Greed who wears a suit of gold. They are debating an issue around a table in a far off planet. The Earth hangs in the sky; they are discussing the fate of the Earth or the price Mr. Greed wants for his horses. This is shot in Bardanas, northwestern Spain, where Terry Gilliam's ill-fated **Don Quixote** may have come to grief.

← Muse, *Black Holes And Revelations (2006)*

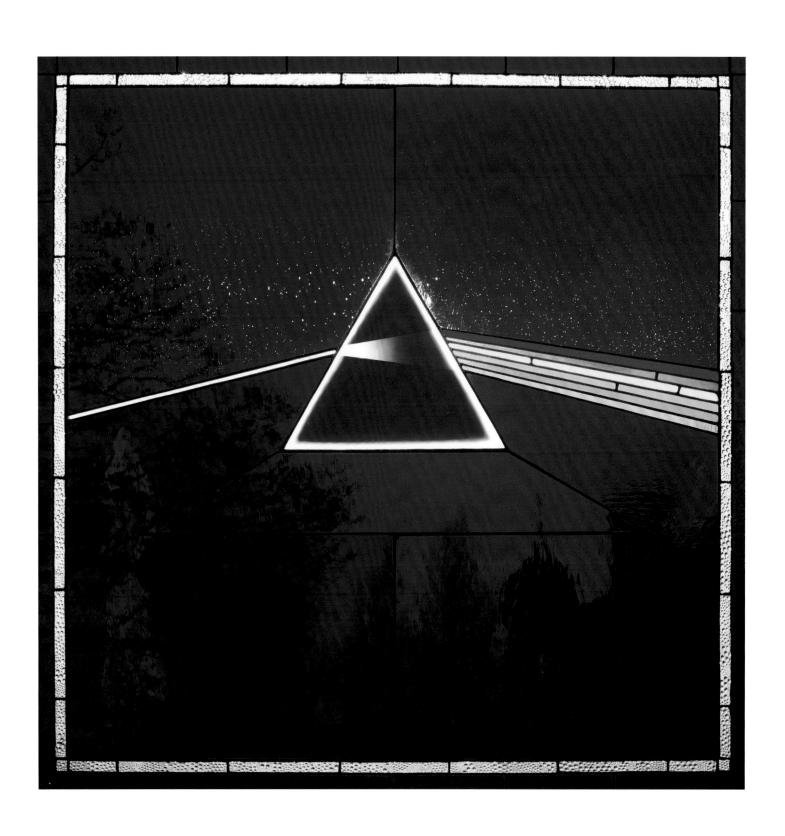

Pink Floyd, *The Dark Side Of The Moon 30th Anniversary* - Stained glass *(2003)*

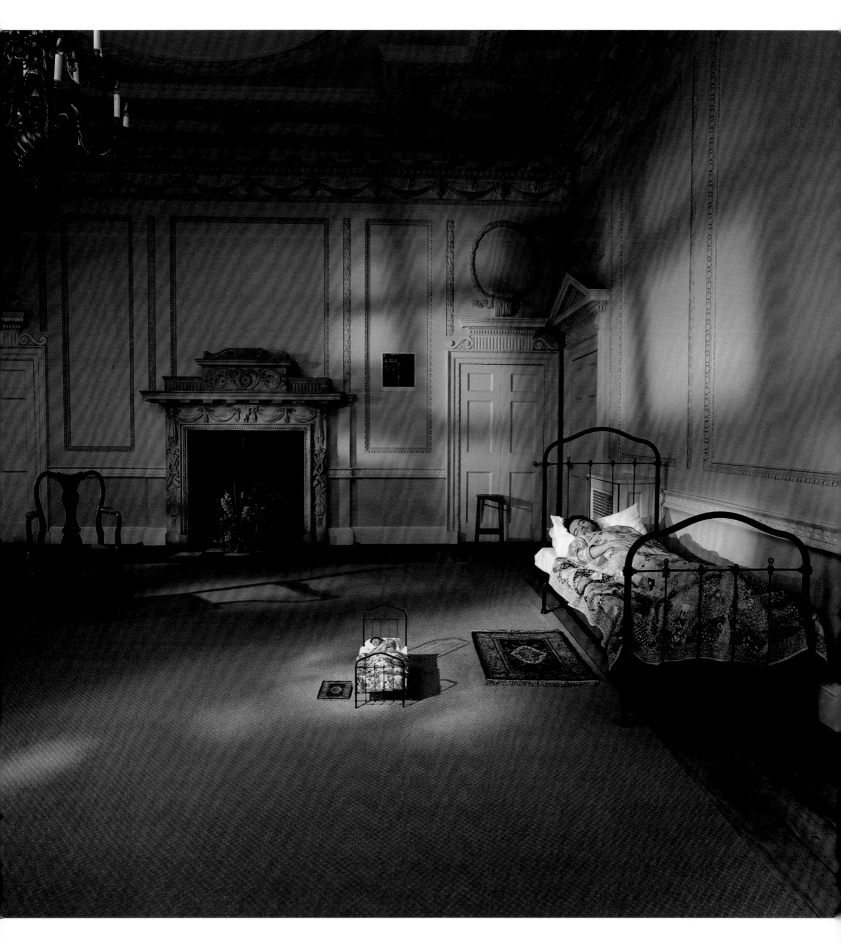

Silent Buddhas, *Virtual Lifers (2000)*

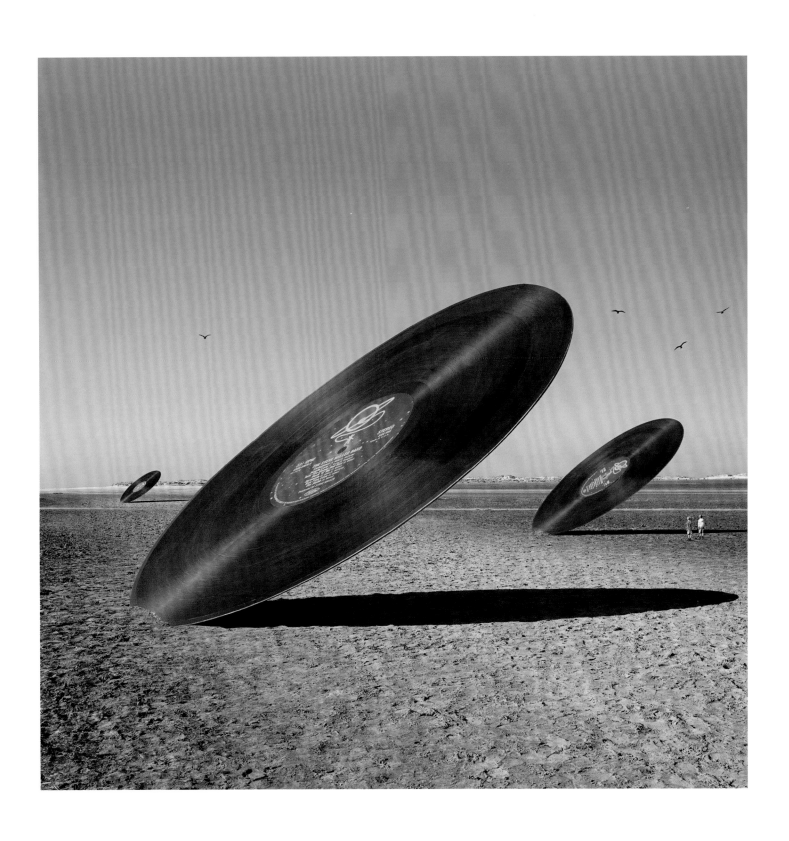

The Steve Miller Band, *Big Disks (2010)*

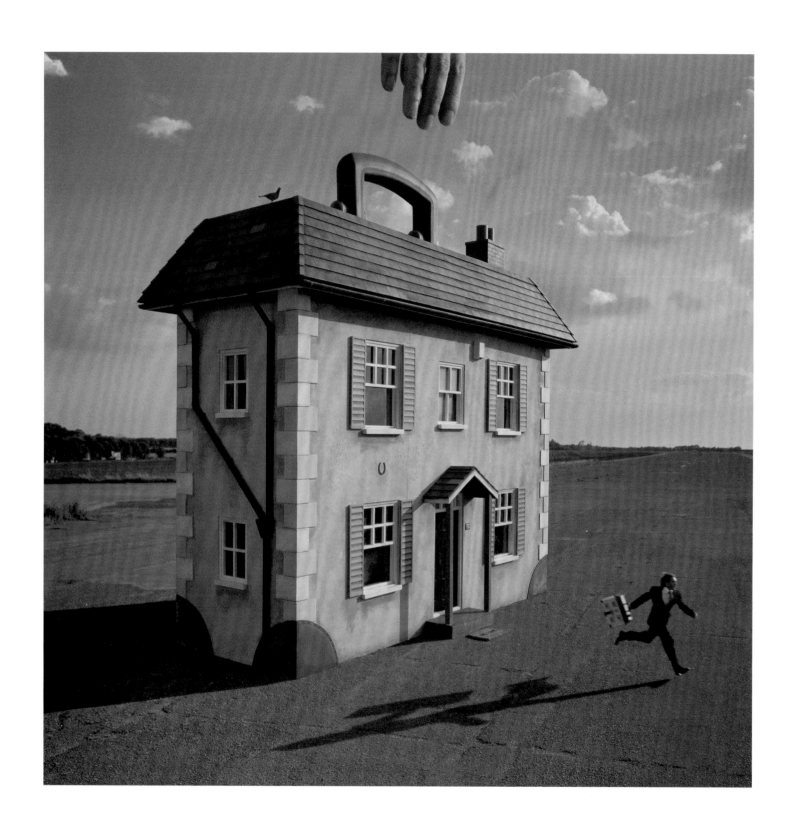

↑ O.A.R., *Stories Of A Stranger (2005)* | *Graphica Obscura,* Exhibition poster *(2002)* →

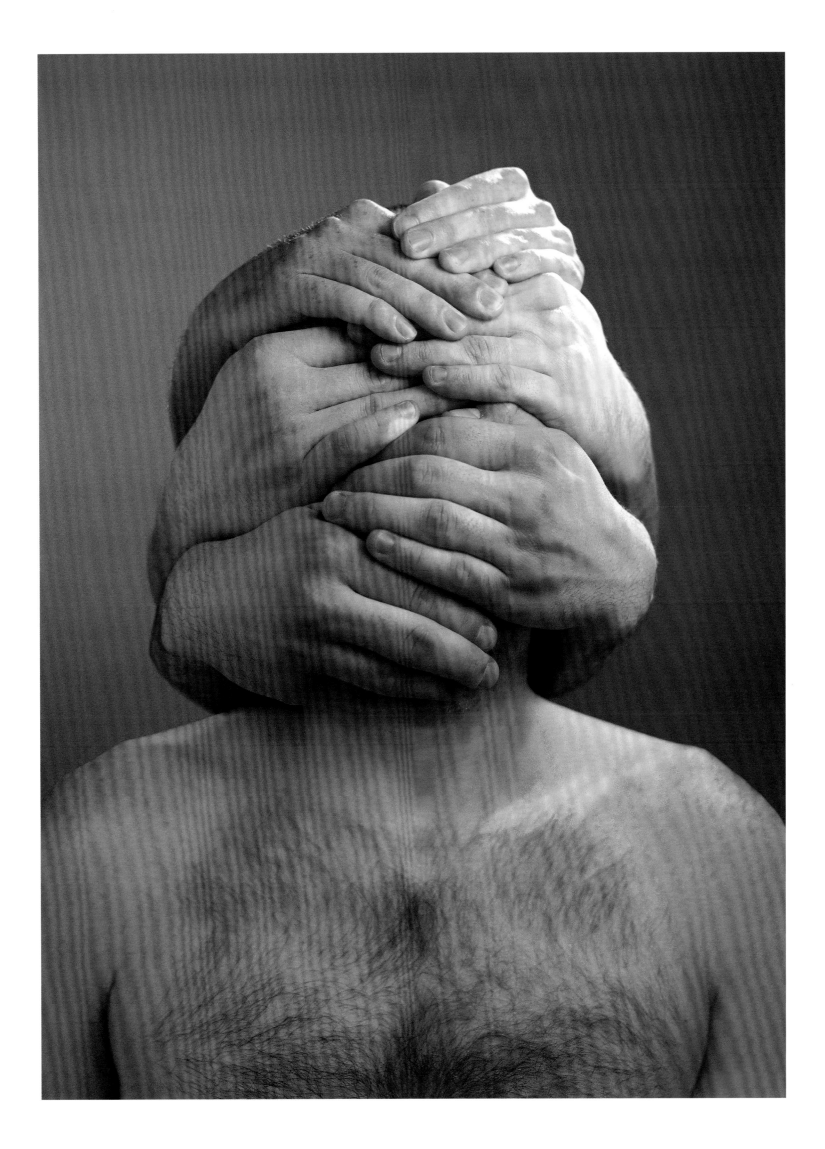

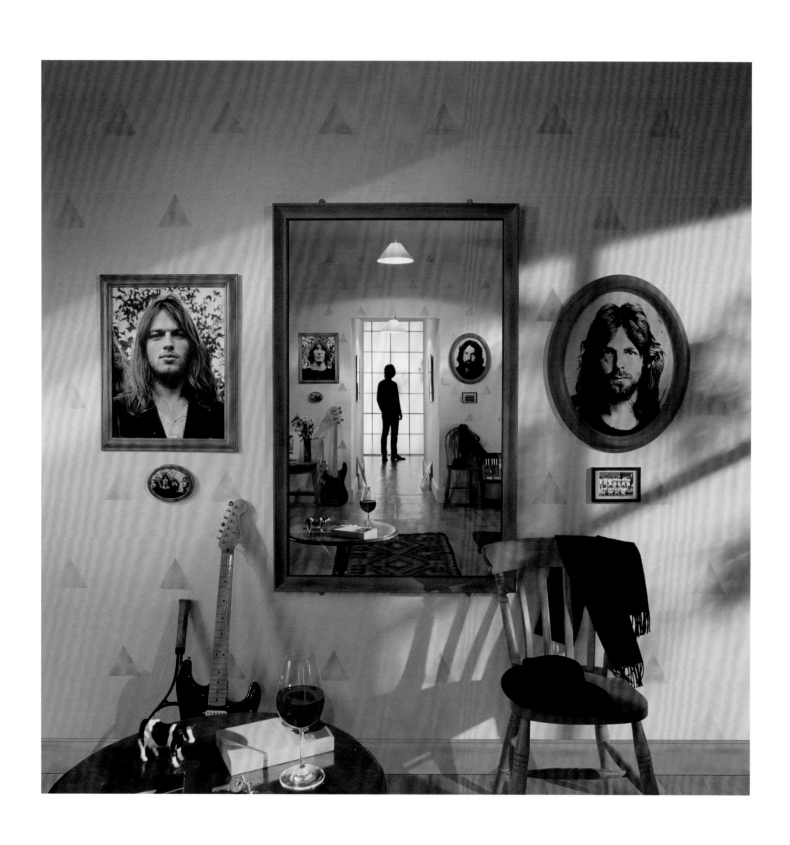

Pink Floyd, *Oh By The Way* - Cream *(2007)*

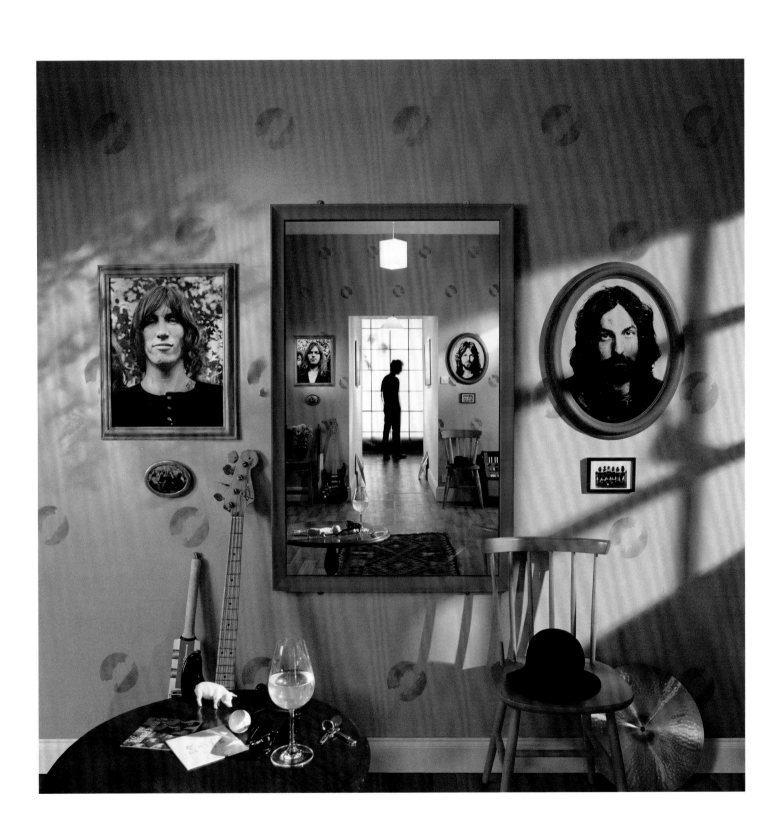

Pink Floyd, *Oh By The Way* - Lilac *(2007)*

A FAN in Canada sent me a circular piece of glass with a design upon it. I didn't like the design so much but I liked the thought of coloured glass. And Pete and I smiled at each other and said how cool it would be to do THE DARK SIDE OF THE MOON 30TH ANNIVERSARY cover (pg 179) as a window, in stained glass, since glass is a medium of light, and the prism is all about light. What could be more appropriate, more self-sufficient? We enlisted a man to build a stained glass window the same as one might find in a church, with leading and following the exact proportions and colours of DARK SIDE. The only change we made was with the background, because black would admit no light and defeat the purpose. We made it about a metre square, put it in the back of Nick Mason's garden and photographed it against the wintery sun – it was terrific! Instead of black we had Polish blue, we used a stipple border because it was customary for religious iconography and did not bother to reduce imperfections, which give the star burst, star cluster, like a galaxy which is what makes it so very groovy! We tried it in the studio as well, but it was strangely flat, although I took a nice little tidbit of the scene from Julius Caesar from behind the glass but have not used it. If you have your own church it is yours for 7/6.

A LITTLE known band from Essex called Silent Buddhas asked me to do the cover for VIRTUAL LIFERS (pg 180) when my head was full of Borges, especially the one about a dreamer who dreams a dreamer. In my version, the dream is dreamed by a little man rather than the other way round. The dreamer from the little bed has gone out for a moment but his dream of the big man remains. We made little replicas of the little bed to match the big bed. I wonder in my wildest fantasy whether Borges would have liked this picture.

BIG DISKS (page 181). This was an idea developed long ago from a frisbee with a hole in it. It can be easily thrown, and its circular shape is much improved when seen from an angle. A disc seen side on always appears to me more elegant, the circle being a bit of a blunt thing. As a homage to vinyl LPs, about which many people feel nostalgic, if not loving, we arranged a huge prop vinyl LP lodged in the sand, as if thrown by a giant, as the front of BIG DISKS, a box set for Steve Miller. We often thought it was an answer to an exam question: 'What is the meaning of the black object? Discuss'. The location is Holkham

Sands in Norfolk, England, where the film **Shakespeare In Love** ends. This shoot was a real bugger to do because the large vinyl props were extremely heavy and tended to be blown over in the wind, damaging small children and crabs.

THIS picture for the O.A.R. album STORIES OF A STRANGER (pg 182) is a narrative about a man who takes his work home and takes what little home he has, to work. We envisaged his briefcase as shaped like a house, which was built as a model but the same size as the briefcase. So when he has finished work he puts it on the ground, and it becomes a full-sized house, because he hasn't finished work at all. And when he comes out of the big house in the morning he is carrying an identical briefcase, which will become his workplace very shortly. A modern dilemma one might say, casting 'nasturtiums' in a magical rather than hard-nosed fashion.

WE once held an exhibition called GRAPHICA OBSCURA (pg 183) in Drammen – a little Norwegian town 40 miles from Oslo – partly because it was near Oslo, partly because Peter knew somebody there, but mostly because it is my family home town. There are more Thorgersons than you could shake a stick at, which was just as well as there would have been nobody at the opening if they hadn't all turned up. We designed a picture about not seeing what you should see, namely pictures in a gallery. I have a sneaking memory we adapted this from a sketch by Fin – I like the sense of a woman with towels round her head just emerging from the shower.

OH BY THE WAY (pg 184/185) is a diptych, which was used for both sides of a box set for Pink Floyd to represent the band equally. Both locations are Floyd rooms – one is lilac, and the other is cream. Not only are they supposed to mirror each other, but they are also supposed to make you wonder what's wrong. We place them opposite each other in exhibitions and visitors spend much time comparing them, trying to assess the differences, knowing something is wrong but not knowing what it is, invariably missing the point for there is nothing wrong with the rooms other than the absence of a camera in the mirror to record it. The rooms have genuine Floyd articles, guitars, sports-gear, etc. and beloved photos on the wall, which happen to be arranged similarly in reality and in the mirror, which of course is most annoying.

↑ yourcodenameis:milo, '*17*' *(2007)* | The Steve Miller Band, *Bingo! (2010)* →

↑ The Offspring, *Splinter (2003)* | The Mars Volta, *'The Widow' (2004)* →

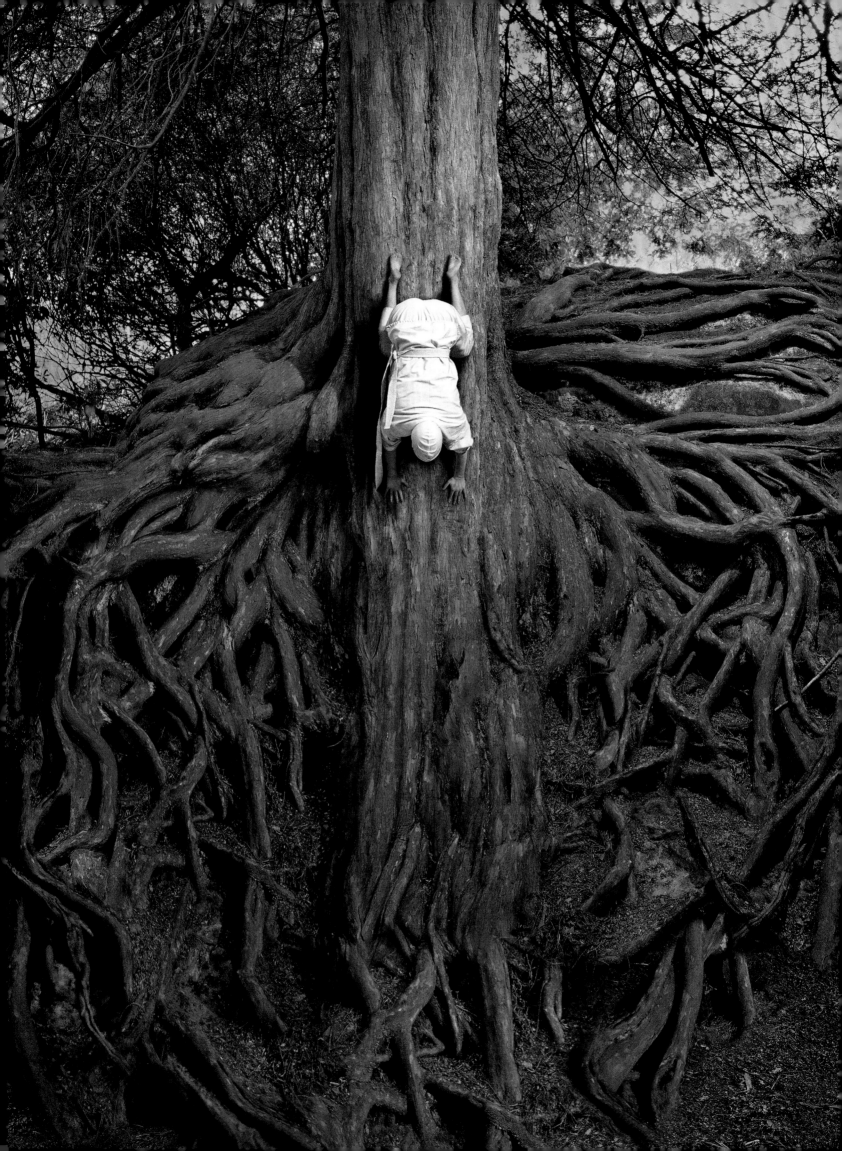

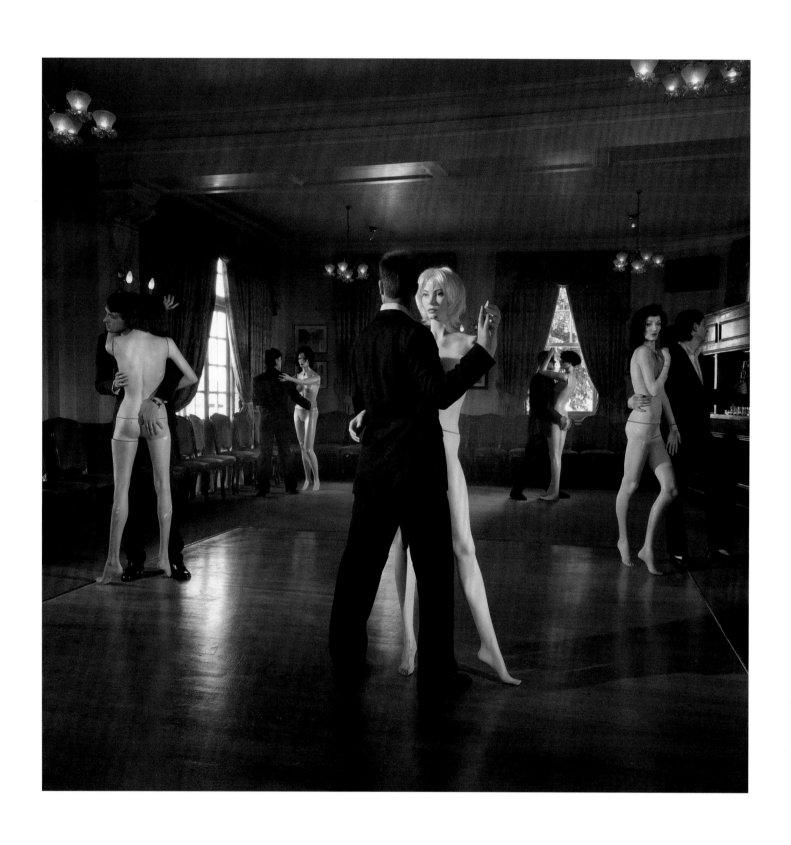

Program The Dead, *Program The Dead (2005)*

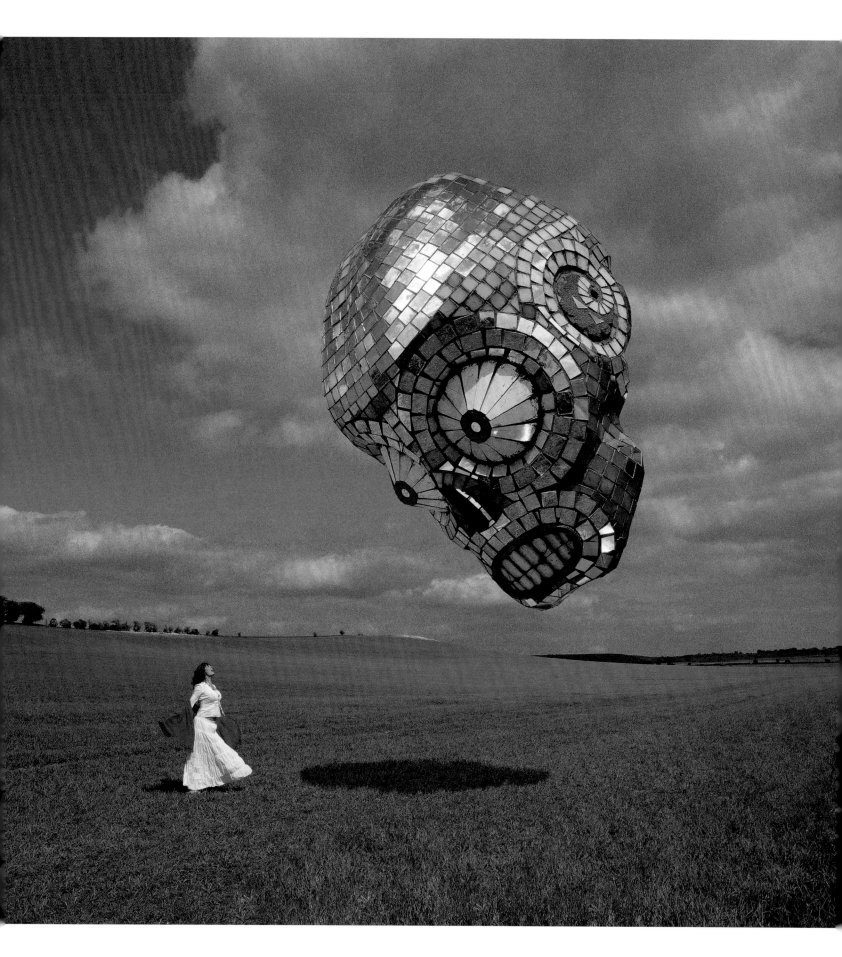

The Mars Volta, *Amputechture (2006)*

'**17**' BY yourcodenameis:milo (pg 187) is about a man struggling to get to a point while being held back by unknown forces. He runs, he sweats; he struggles against the restraining ropes but seems to get nowhere. The re-straining elements are too strong. It is a picture of frustration (the strings are also supposed to refer to those of a guitar).

IIMAGINED that twin guitar solos and vocal exchanges in a rock setting were a bit like a duel from a Western. Instead of exchanging bullets they were swapping notes, or variations of notes. One of the great things about the vocal exchange is rhyming. So, in **BINGO!** (pg 188/189) the objects being exchanged by the dueling cowboys are objects that rhyme verbally or spatially. So one is throwing chairs and pairs and bears, and the other is shooting circles. This image is shot in the same location as **A Fistful of Dollars** and I personally find it very peculiar. Like **Villainy** or the **Tree of Half Life** I don't understand it despite having designed it. They're done by me but they don't feel like me!

SPLINTER for The Offspring (pg 190) uses the sharp-ness of a scimitar moon to splinter a lover's heart. The moon is a symbol or vehicle of love. And the scimitar is in-credibly sharp. I happened to see it at the bottom of my street one night, with points as sharp as Sinbad's sword.

'**T**HE WIDOW' is a song by The Mars Volta (pg 191) , a wayward jazz-rock band from the most dangerous border town in existence, namely Juarez. They are a couple of sweeties and wrote an album that is like a film score but without a film. If I remember correctly an element of the story was about an orphan who was looking for his parentage, namely his roots, which is of course why he is going down the tree not up it! Instead of being taken in exotic Madagascar, this picture was shot near Gatwick airport, where the rain has washed away the earth around the yew tree roots that cling to a rock and become exposed, looking like something from a fairytale.

WE'VE always liked mannequins – not in any sexual way you understand – but for their deceptive appearance in shop windows; every so often one imagines them to be real. This image for **PROGRAM THE DEAD** (pg 192) is a spontaneous idea wherein the dead people (mannequins) are programmed to dance with real people. The men look so wooden, one imagines this to be the dance of the dead.

AGAIN The Mars Volta. For **AMPUTECHTURE** (pg 193) we thought a mask or totem of mirrors. In this instance, the mask, or Aztec Head as we call it, is pursuing a young girl who is not as frightened as she should be, because the head is a manifestation of her inner visions. This comes from a recent story that Mars Volta heard in modern day Poland of a heretical nun who was put to death by church authorities for claiming that her visions came from God. Sounds too primitive to be true, but still engendered this image.

WE once worked for northern English aspirants whose code name was Milo and, for their single '**RAPT. DEPT.**' (opposite) , we came up with the idea that the shadows of people don't necessarily do what the people do, in that inner feelings are not always the outer ones. So a couple argue and the woman turns away but the man thinks she is still there. It is like Healing Sixes (pg 211) in the sense of being a picture about what will be, not what is, nor was.

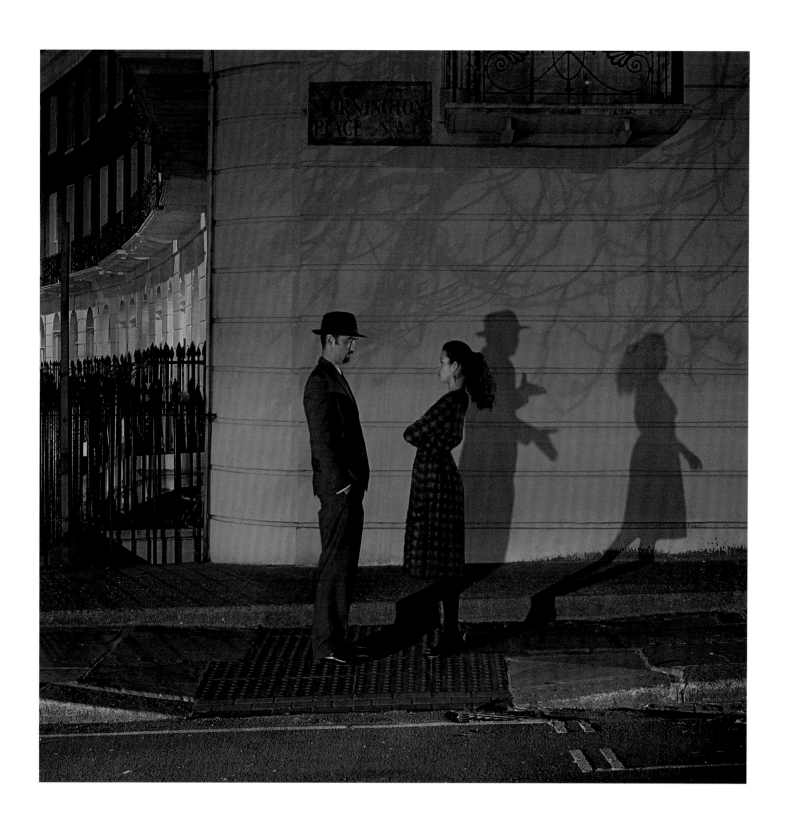

↑ yourcodenameis:*milo, 'Rapt. Dept'. (2005)* | Audioslave, *Audioslave (2002)* →

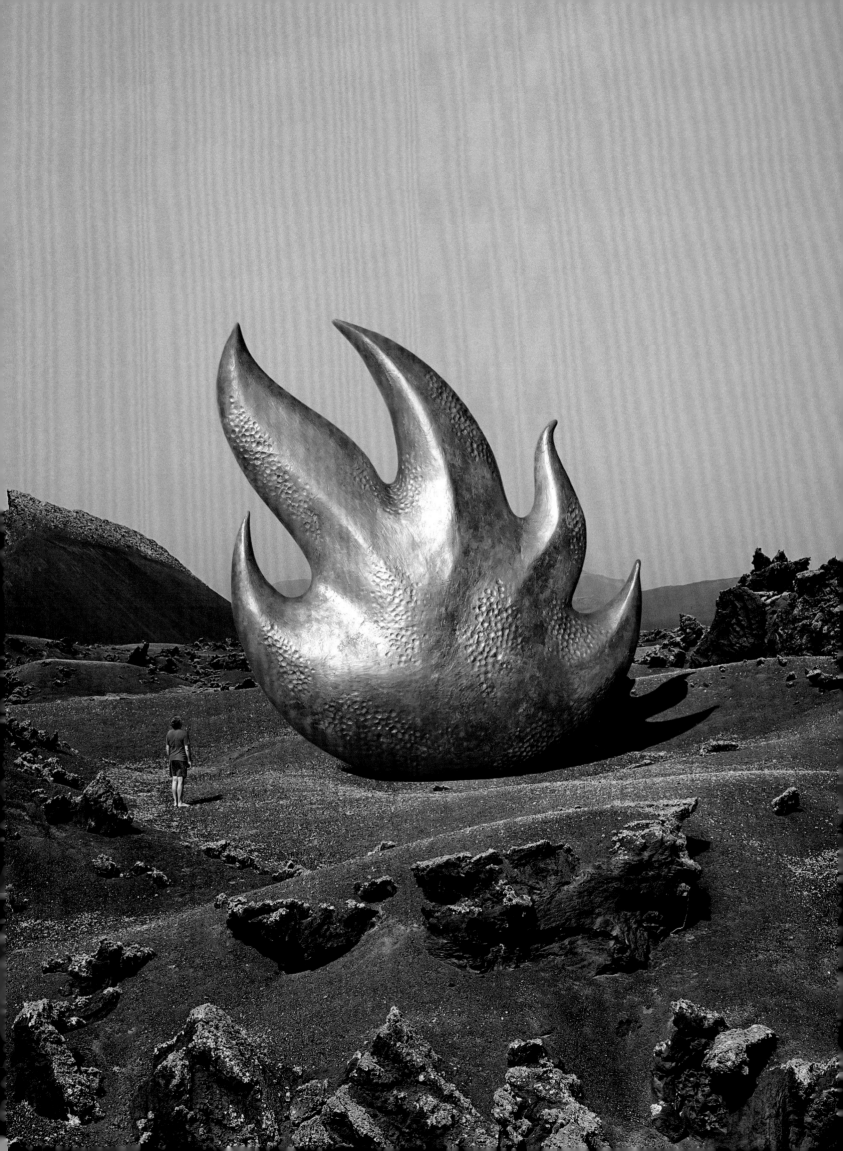

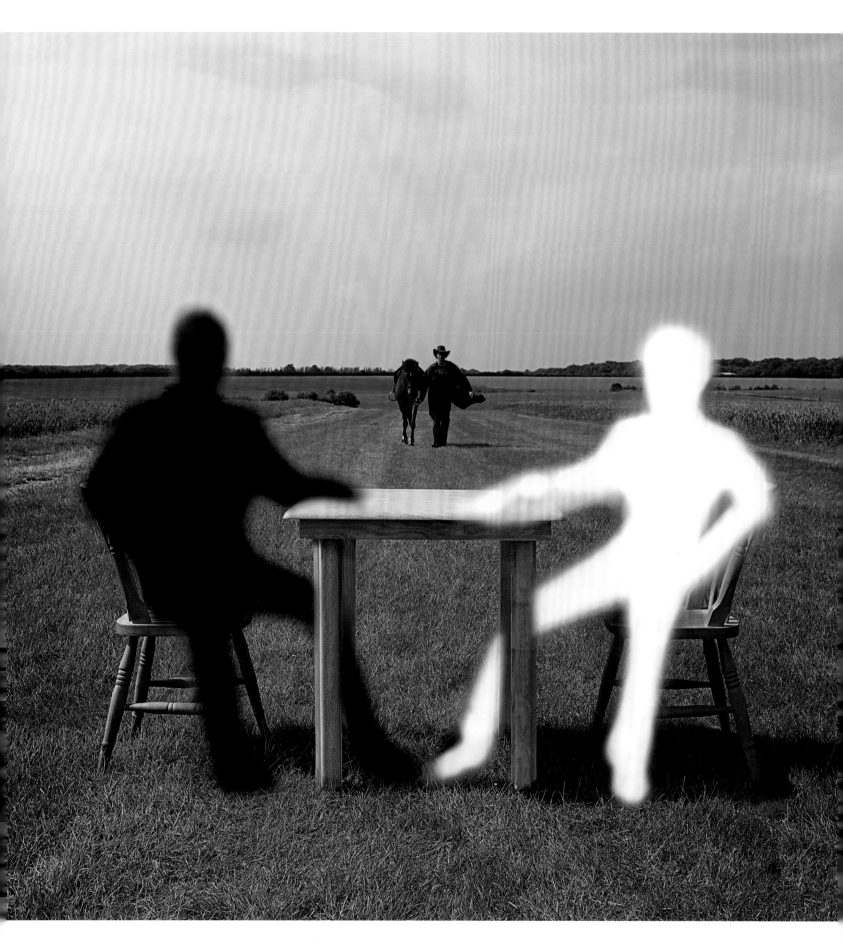

Biffy Clyro, *'God And Satan' (2010)*

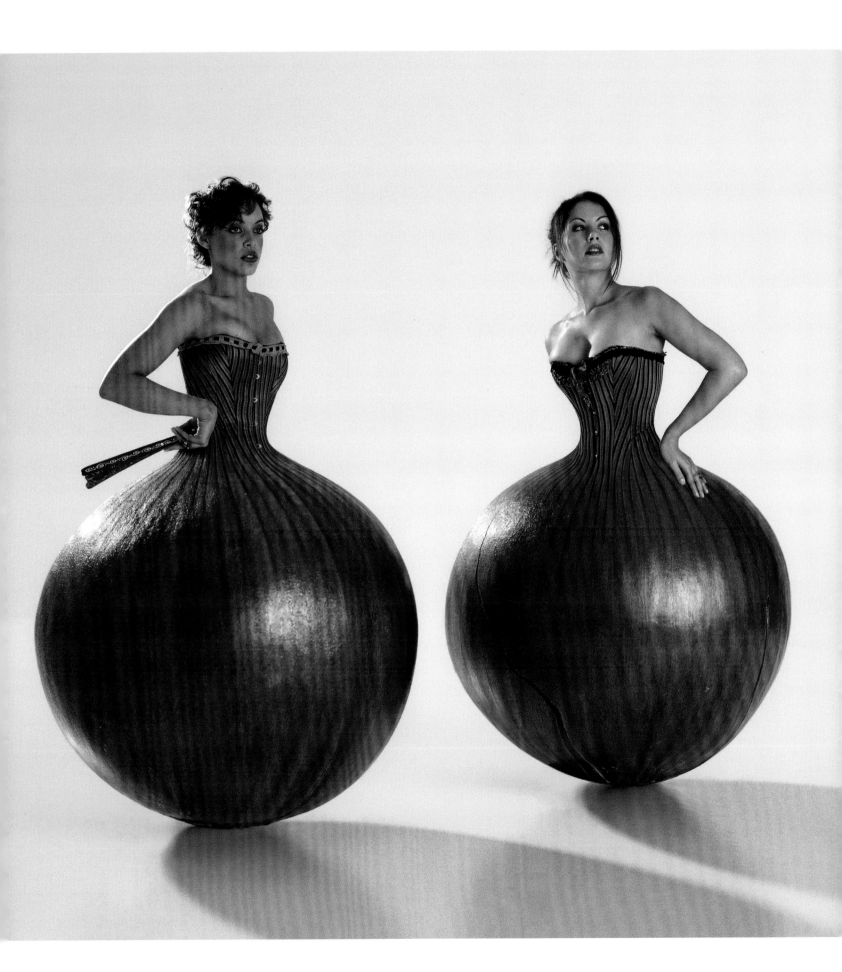

Umphrey's McGee, *The Bottom Half - Onion Ladies (2007)*

AUDIOSLAVE (pg 196/197) were a band temporarily formed by Soundgarden and Rage Against The Machine. They played very sultry music care of RATM's rhythm section and Chris Cornell's sonorous voice. It could be called American Hard Rock but was more than that. The brooding nature was overwhelming and spoke so clearly of volcanoes – so the overriding question for us was 'Where is the nearest volcano? And what should we add to that image to make it more interesting?', Lanzarote in the Canary Islands was selected, as being entirely volcanic (if you haven't been there, dear reader, I highly recommend it). Peter had also designed a graphic representation that was half flame, half hand, derived from the phoenix from the flames. I think we also saw it rather grandly as the flame of remembrance, of two bands, who were very good but transmuted. We did not on this occasion take the hand to Lanzarote but to Beckton Skip where a large coal slurry stood in for the black sand of Lanzarote. The emblem is like a sounding brass and can be beaten by pilgrims who travel far and wide, as any slave to audio should do.

THIS concerns a call from the singer to God and Satan to discuss an issue to help him resolve an impasse. So I imagined 'GOD AND SATAN' (pg 187) chatting, as they do, around a table, discussing the Godly and Satanic pros and cons. God is traditionally represented as a white figure and Satan as a black one, yet the table is neutral. This image becomes an experiment in the essence in photography, namely exposure. I didn't want to cut out anybody or composite by Photoshop – I wanted to use the extendability of the exposure inherent in the camera. Thus there are no hard edges. The figure in black is denied exposure by an umbrella; therefore underexposed, and the white figure has been flashed, therefore over exposed. The table background and rider are all receiving normal daylight.

WE don't often screw up and even if we do the client doesn't see it, because we do it over again until it's much better. In the case of THE BOTTOM HALF for Chicago band Umphrey's McGee the original idea for them was a whole mess. They were desperate to release their record. I wondered if they could possibly accept a substitute – namely the ONION LADIES (pg 188), whose previous client said, "What have onions got to do with it?" This image has an even longer tail since I first suggested it for Jane's Addiction, however I regarded this tawdry history as irrelevant to Umphrey's McGee, and simply sent them the picture. They love it, we love it, hope you love it! Onions make men cry. And women's vacillation can make men weep.

PART of the film score of FRANCES THE MUTE by The Mars Volta (opposite) concerned an addicted individual. Back in Juarez as kids, their mentor was heavily addicted and in a coma, coming in and out of consciousness. So in my mind's eye I saw a town in which everybody was addicted – it didn't matter to what, sex, drink, gambling – they were all characterized by one particular feature – that is that the addict thinks he is in control and knows where he is going, but he doesn't know shit. To symbolise this contradiction, all the drivers wore couture hoods.

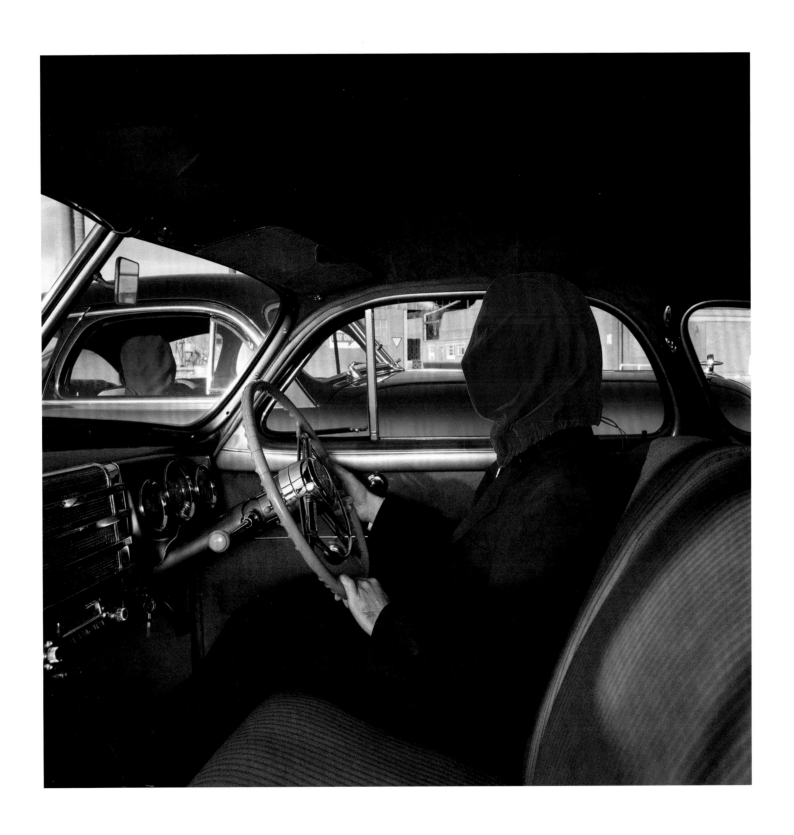

↑ The Mars Volta, *Frances The Mute (2004)* | Pink Floyd, *The Dark Side Of The Moon 30th Anniversary Poster (2003)* →

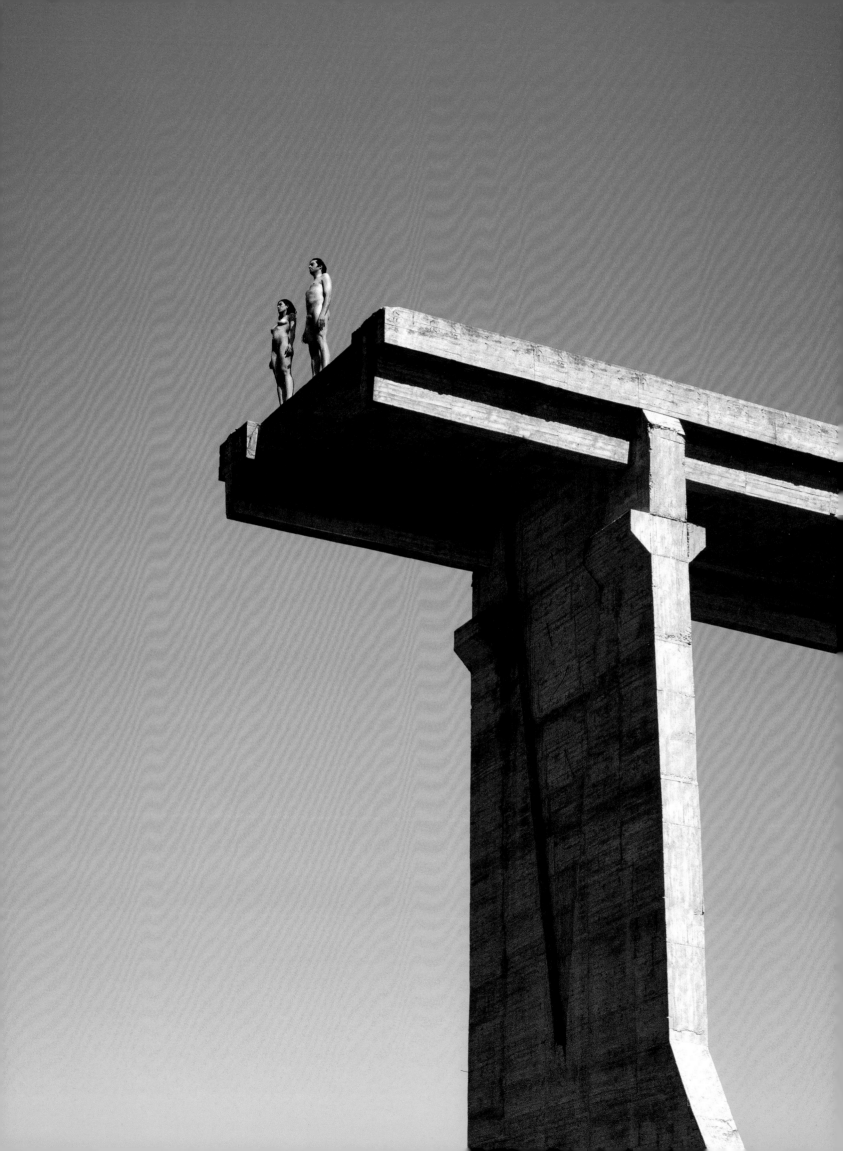

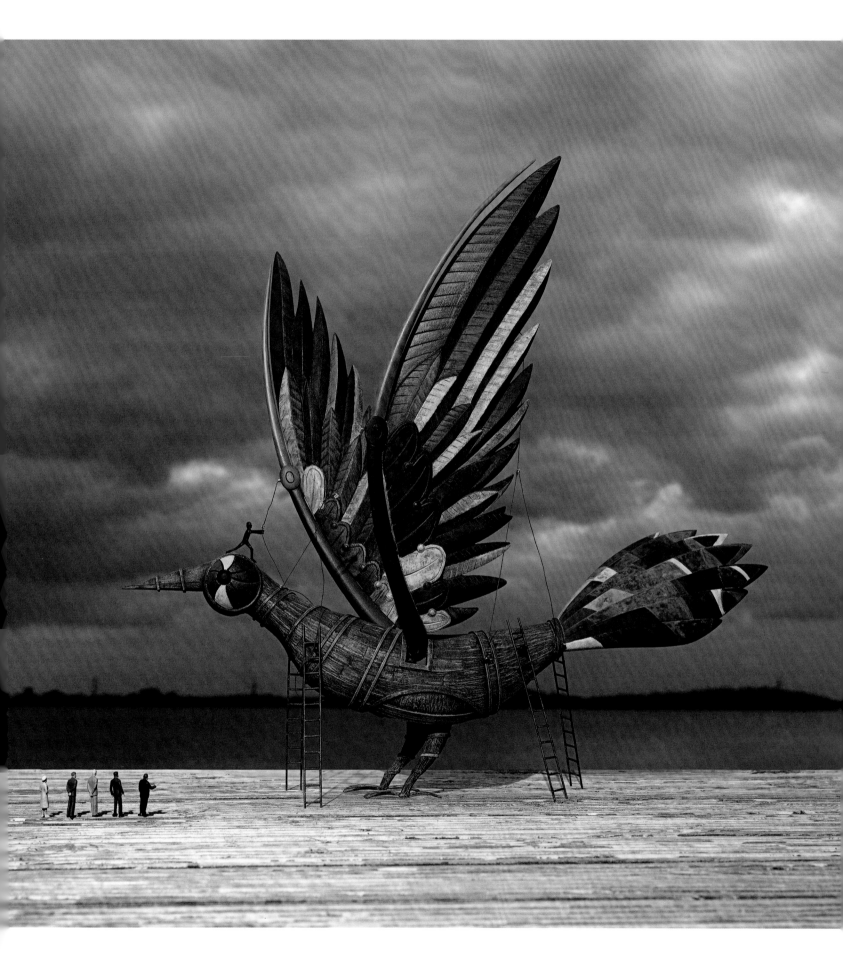

← Pink Floyd, *The End Of The Road (2003)* | ↑ Pendulum, *'The Island' (2010)*

The Cranberries, *'You And Me' (2000)*

IWAS on honeymoon with my wife in the Seychelles (lucky man!), which is one of the most beautiful places I have ever seen, and was idling away my time musing about the 30th anniversary of THE DARK SIDE OF THE MOON (pg 202). And drawing triangles in the sand I realised that 30 triangles filled a nice shape – so I set about composing a list of 30 triangles from life, because THE DARK SIDE OF THE MOON is ubiquitous. They varied greatly from a musical to a 3-cornered hat (as presumably worn by the governor of the Seychelles) also including a teepee, a samosa, and my favourite, the upturned glass vagina outside the Royal College of Obstetrics and Gynecology.

IT is an inclination of the left hemisphere of the brain to unlock the rational by sleight of hand, by jokes, inversion, reversal, aphorisms, spoonerisms, so this image made for INTERSTELLAR (pg 203) originates simply from an old saying that a marriage inevitably comes to the end of the road. So when the Floyd had come to the end there was a lot of trouble finding a road. It was in fact the end of an incomplete motorway in Madrid which in hindsight is no great surprise. I always wondered if certain nerds would get out magnifying equipment to explore the genitalia of the naked couple on the bridge, who were shot separately in order to avoid undue danger and vertigo.

WE call this the 'Airfix bird' after the Airfix airplane kits of the 1950s. Made for 'THE ISLAND' (opposite), a single by Pendulum, it was an attempt to suggest that the drum and bass outfit were trying to introduce more melody into their set. I don't know if this is true or false, but it allowed Dan to design and Hothouse to build an absolutely delightful model bird. A bird of the imagination – colourful, idiosyncratic and beautiful. No ordinary bird this, but a 'manned' bird, reminiscent of a sailing ship. It is parked ready for take-off on its maiden voyage, witnessed by several dignitaries under a threatening sky.

THE image of the two flamingos for 'YOU AND ME' (above) is from our lovey-dovey-lovey-dovey period when Jon Crossland imagined two canoodling flamingos and I added that they were melting due to their inextricable love. They are entwined and merge together forming an everlasting partnership. If I may be so bold, I think it is quite nice. Need a bit of romance, Jon, don't we, to ward off the electricity bill.

Yumi Matsutoya, *'Setsugekka'* *(2003)*

The Steve Miller Band, *Let Your Hair Down (2010)*

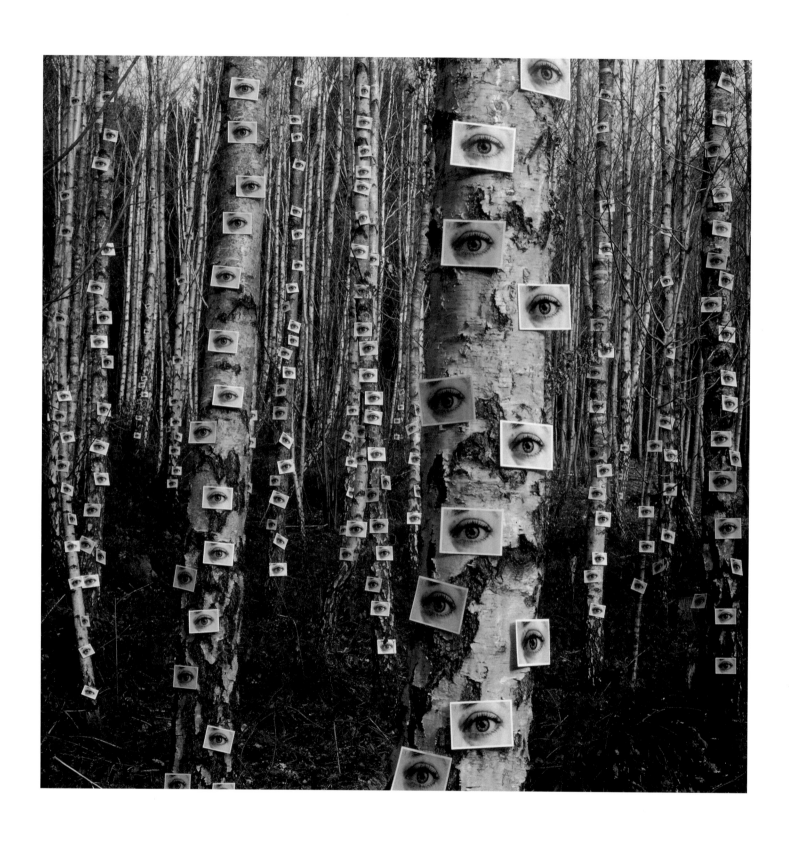

Catherine Wheel, 'Gasoline' *(2000)*

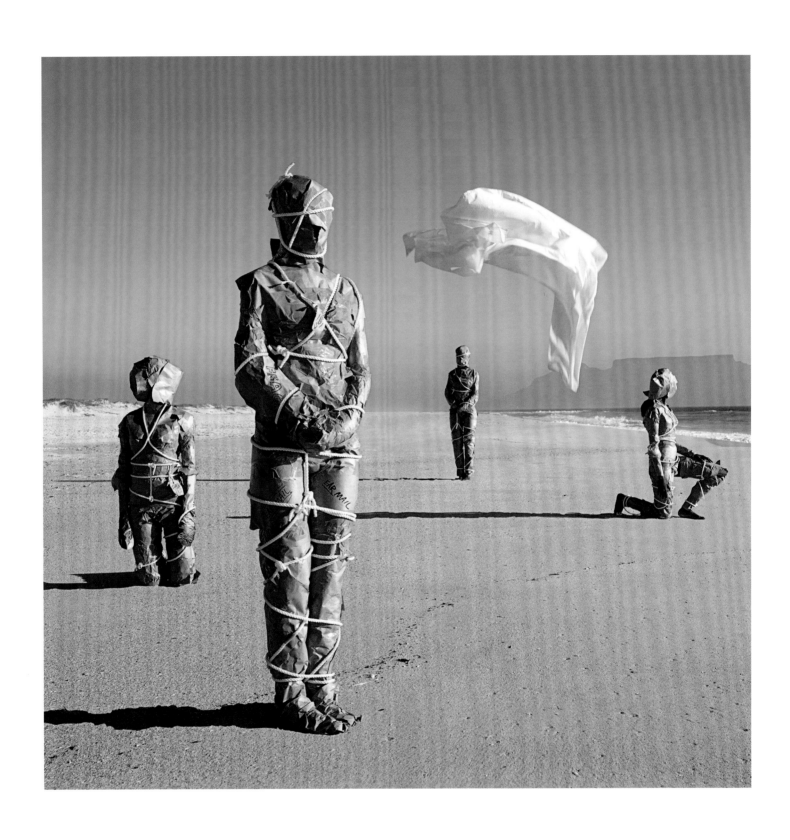

Disco Biscuits, *Planet Anthem (2009)*

'SETSUGEKKA' (pg 206) is a song by Yumi Matsutoya whose haunting refrains were underpinned by inscrutable lyrics (as you might expect). I think the song was about a memory of a lost love on a mountaintop but seemed to be more about the sadness of memory than about the lover, about how memories are drowned in time and how the loss of memory is in itself a sad thing. So I envisaged a Japanese woman drowning, pulled downwards by clocks. She is of course, wearing white, which shimmers in the murky water, and the clocks are metaphorical and therefore like school clocks, not watches. It's a sad and romantic image of which I am very fond. It was taken through the porthole of the diving pool in Hammersmith public baths, which was not quite so romantic.

WE met Steve "Guitar" Miller in New York through a mutual friend, Crazy Rob Roth, and agreed to do four designs for him. A month later we reappeared at a hotel in San Francisco and presented our sketches to Steve, who dispersed them across the floor of his hotel room and crawled amongst them, saying: 'I like this one, I'll have this one, I like this one, I'll have this one!' I said 'Don't be silly, you can't have them all!' and he said, 'I can if I want to. Have you got a problem?' He kept coming back to the hare on the head – eventually he said 'I don't understand this' so I said, 'what's your album about?' He said, 'about having a good time'. I was about to protest and he looked down at me and said 'do you know what a good time is, Storm?' Then he said, 'what is this rabbit doing on his head?' I said 'not a rabbit but a hare' he said, 'why does he need a ladder to get up?' I said 'he doesn't; he needs it to get down, as in LET YOUR HAIR DOWN (pg 207), as in having a good time' Steve burst into laughter and said 'I'll have that one. Start there'. So we did. Hares, of course, don't read scripts and so our marvellous retoucher Lee had to composite the hare from various positions, but it is still a hare, still on a head that is in need of hair. This is just a picture to make you smile and give you a good time, briefly.

THE image for 'GASOLINE' (pg 208) was a design done by Fin and Sam. I'm fond of it – it is clearly and simply about obsession. I think the aspen tree was chosen because it has eye shapes in it anyway. What you see is what you get – lots of photos pinned to aspen trees. It is a fine example of an exstallation.

DISCO BISCUITS is a jam band from Philadelphia. The spokesman Aaron said to me that they never knew precisely what they were going to play nor did the audience. But they knew approximately. They were jazzy in approach, like a wrapped present – you knew what it was likely to be but not exactly what it was. This made me think of virgins, by definition as yet unwrapped – but if you wrapped a woman in brown paper, you may not know what she looks like but you know damn well she's a woman. Our wrapped virgins look like presents or parcels to be sent to a foreign land and quite at ease in their wrapping. This shot for the album PLANET ANTHEM (pg 209), was taken in Cape Town – you can see Table Mountain in the background – and the quality of light was to die for. And what of the sheet? There is an elegant shape made by a thrown sheet which has particular significance in the context of medieval society – if the sheet was sullied she was a virgin; if it was clean she was not.

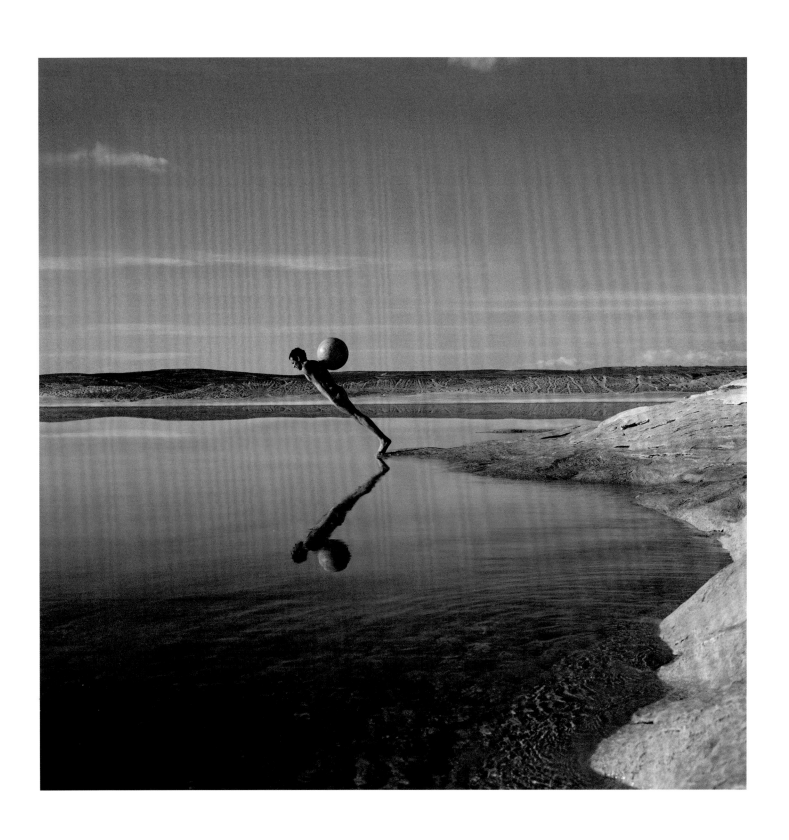

Healing Sixes, *Enormosound (2002)*

The Catherine Wheel, *Wishville (2000)*

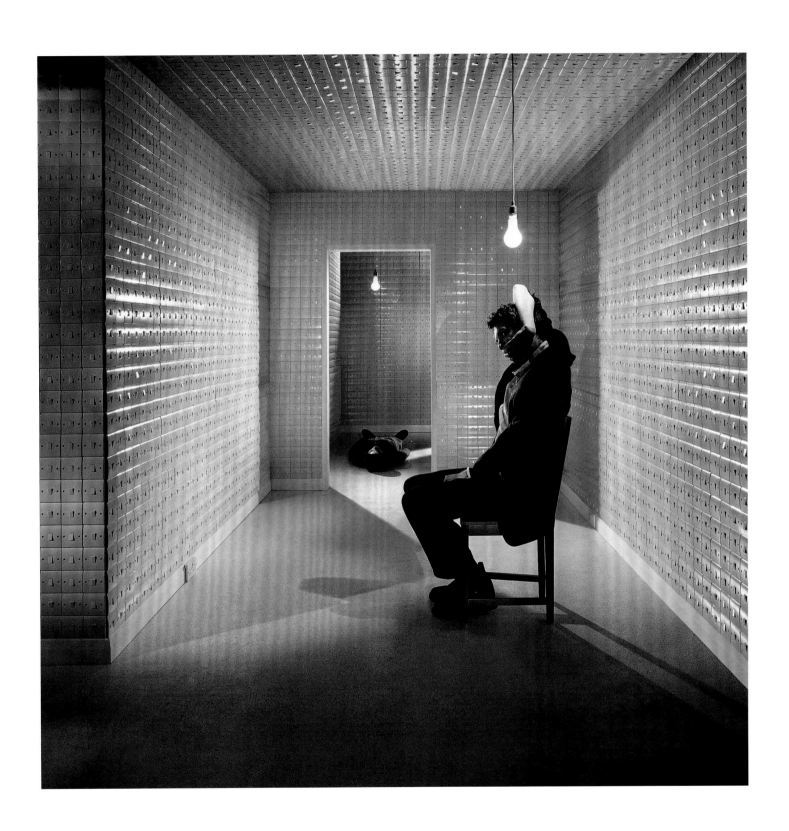

yourcodenameis:milo, *Ignoto (2005)*

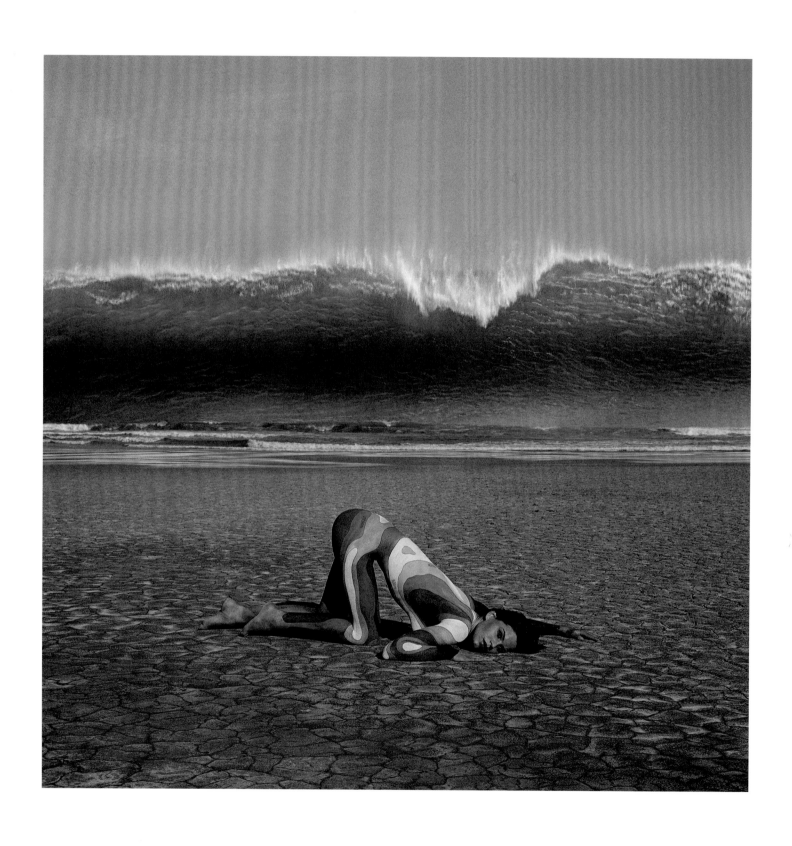

Deepest Blue, *Late September (2004)*

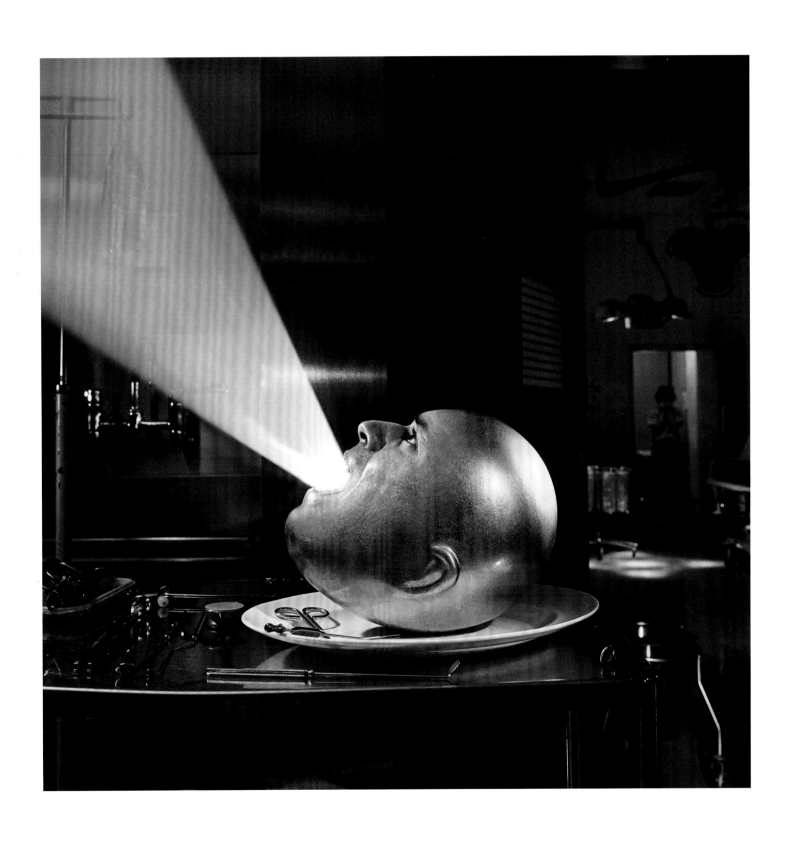

The Mars Volta, *De-Loused In The Comatorium (2003)*

MANY of the songs by the Healing Sixes were denigratory, not only criticising the singer but also his liaisons. I thought his self-dislike was possibly symptomatic of addiction. He didn't like his self-image and by falling into the water he would break it. This is not a picture of what is, but of what is to be. The picture for ENORMOSOUND (pg 211) was taken in Lake Powell Utah.

I WAS once at an exhibition in a museum, which had an empty square space between two structures. And I thought the gap in between was an exhibit, not a piece of real life. I began to think that even the plug on the skirting board could have a price attached. So for WISHVILLE (pg 212) I wanted to explore depth in different dimensions – one as an opening, one as a painting or photograph and one as a mirror. They are all the same size, but display depth in different ways – looking forwards, looking backwards and looking static. Any conclusions drawn from this exercise should be sent to your therapist.

CONFLICT and choice were two recurring themes in our conversation with yourcodenameis:milo. Peter devised this room (resembling a padded cell) made up almost entirely of switches, all designed to turn on/off the single light above the seated figure – the resulting conflict of so much choice drives the figure mad, so much so that he tries to gag himself. This image for IGNOTO (pg 213), is quite a sinister one not only because of its contents but also because the walls lack other features or colour. It's clean but oppressive. We built the set ourselves in a small studio and Rupert took a picture. On/off switches also have undertones of computers. Peter was obviously more forward thinking than he thought.

LATE SEPTEMBER (pg 214) was photographed in South Africa, for Deepest Blue. The contours painted on the girl represent depth contours as seen in maps of the sea. It is also, I guess, a picture about doing completely the wrong thing. She doesn't need to be listening with her ear to the ground to tell her what's coming – she'll bloody well hear it coming, as it's right behind her! I think the colours saved it from ignominy. The dry cracked earth was added as an obviously surreal element and as a soupçon of ambiguity, as it is rather near a very wet sea.

DE-LOUSED IN THE COMATORIUM (pg 215) is by those two loveable ruffians from scary Juarez on the border of El Paso (remember El Paso?) They had a good friend and mentor who was inclined to ingest too many deadly chemicals, which put him in and out of consciousness. He was likely to scream when awake, so I imagined a throbbing head sort of egg-shaped, allowing it to bob (in and out of consciousness). When it bobbed upwards a shaft of light emanated violently from its mouth. Its eyes were real. It is a bust, a golden bust. We made a model, which we still have today.

I READ about leaping Sadhus training in a small hut in Bedfordshire. And I wondered what they did for practice. Our Sadhu, on the cover of INEFFABLE MYSTERIES FROM SHPONGLELAND (opposite), is a young novice trying to traverse a lake by an Indian palace by yogic flying, but he keeps bouncing off the water and getting his loincloth wet. Through perseverance, he manages to cross the lake and to hover on the near side. Behind him is the lady of mystery whose scarf extends endlessly into the sky. Lady of Mystery plus Novice Sadhu = Shpongle, a well known ambient band usually featuring Mrs. Simon Posford and Raja Ram who is not a rajah at all but is inclined to behave like one.

THIS was photographed on location in Alwar, near Delhi in India as a sequence of pictures on an Indian theme, which adorned other Shpongle products, like the Escher staircase that follows (pg 218/219).

ONE of the ways to subvert the workings of the human mind is to invert the commonplace. So instead of counting sheep when a person is trying to fall asleep I imagined a sheep in the same position might be counting people. This sheep of course, comes from the title, SAFETY IN NUMBERS (pg 220), and we see him or her lying in bed next to a chest of drawers upon which is a framed picture of his favourite aunt. Outside the window across the rolling grassland are people on their knees in pajamas. Since an old adage of ours is to go for real if you can, there was quite a lot of traffic congestion on the road nearby. I still think it is the picture of the aunt that touches me most.

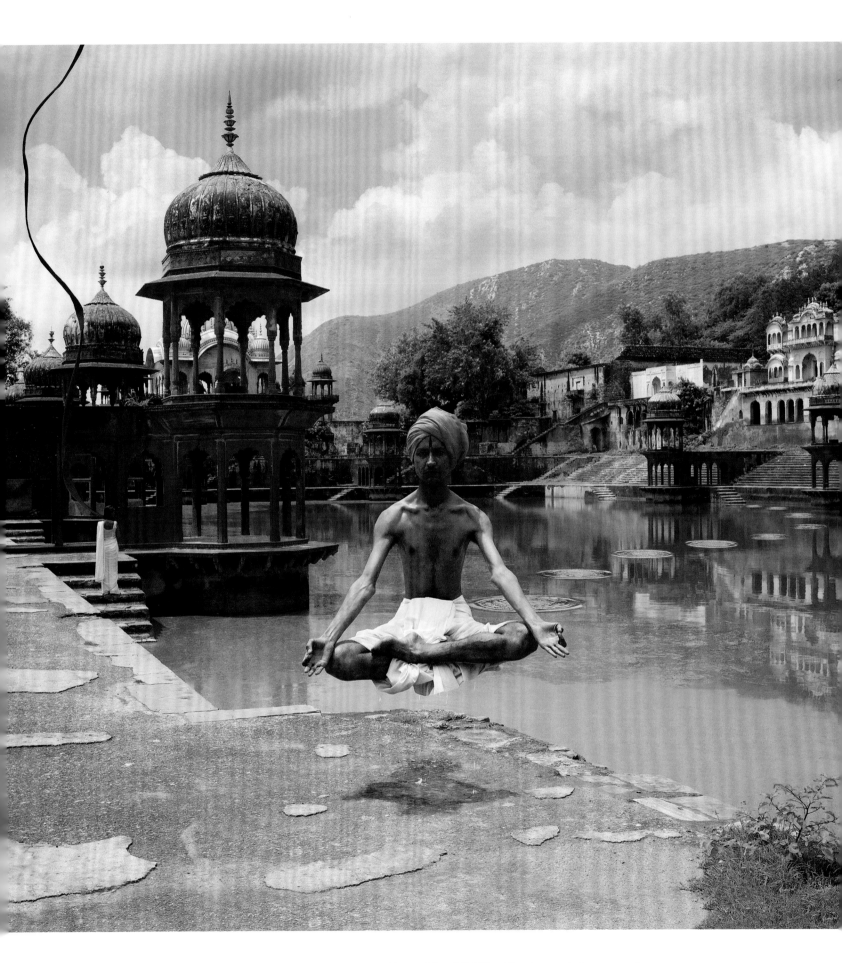

Shpongle, *Ineffable Mysteries From Shpongleland (2008):* ↑ Front cover | Inner spread →

Umphrey's McGee, *Safety In Numbers (2006)*

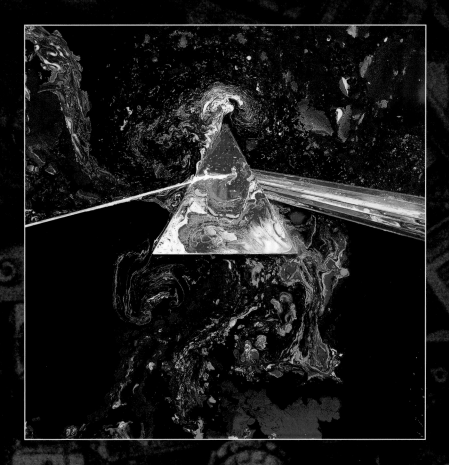

OutRo

It is clearly untenable to have several parts of a quartet unless of course you have, as I said before, the mindset of the late, beloved, Douglas Adams. Some pieces that were executed between 2010 and 2013 were greatly liked and became unbearable to omit.

· · · ·

Machineri, *Machineri (2011)*

Scrutiny — Unused *(2011)*

Goodbye Motel, *If (2012)*

Greg Friedman, *Can't Talk Now (2012)*

MACHINERI (pg 222) are a dirty blues band from Cape Town fronted by a woman so we body painted a woman with clock parts and had her perched like a boulder on real boulders and took a picture . . . in sunny Yorkshire, would you believe!

WHEN **SCRUTINY** (pg 223) was turned down as a drawing we were greatly distressed and decided we would do it anyway. As an image it's very much about retro, so the conglomerate machine of enormous, endless proportions is an exercise in retro. The other side of this image is Paranoia. On behalf of men who claim to be either mystified or frightened by womanhood, this machine probe is intended to help them divine the truth or uncover the secrets. We ourselves built the machine piece by piece, and shot it in a studio in West London. We still love it and can find no takers (it's yours for a tenner!)

THIS is an idea for Goodbye Motel's **IF** (pg 224), originally conceived by Fin as one of his well-known fantasy pieces. Executed as a photograph it becomes a little more ominous. A man is committing suicide by jumping off a very tall building and a flock of birds imitate his shape. Have they come to save him spiritually, or to mock him? They must be mocking birds.

GREG FRIEDMAN, a chap from sunny San Diego asked us for a cover design for his album **CAN'T TALK NOW** (pg 225) so we set him a test which he passed with flying colours. In 2012 we performed a piece of guerilla art, art on the run, in Cape Town main street and then rapidly dismantled it before arrest – also a result of like souls. I'd fancied a figure tied with bandages – to hinder or to assist – Angelique from the local University was equally into bandages. So she did the performance, we took a photo as you can see, she cleared up and we skedaddled.

• • • •

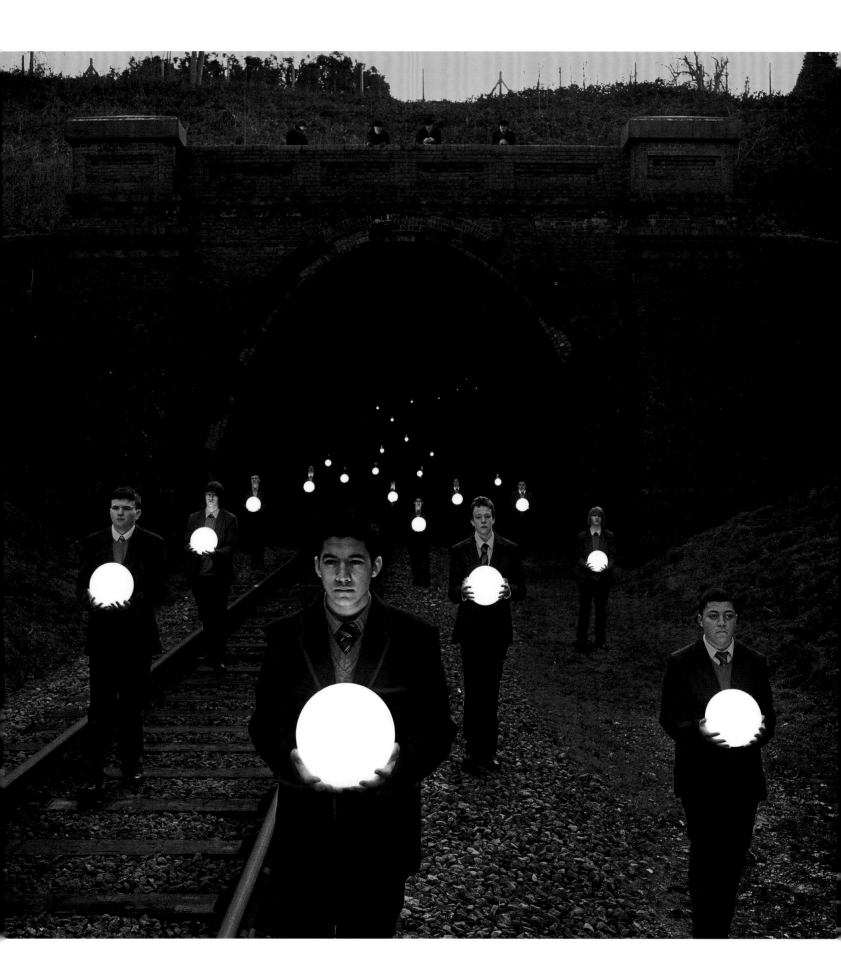

The Plea, *The Dreamers Stadium (2012):* ↑ Front cover | Inner spread →

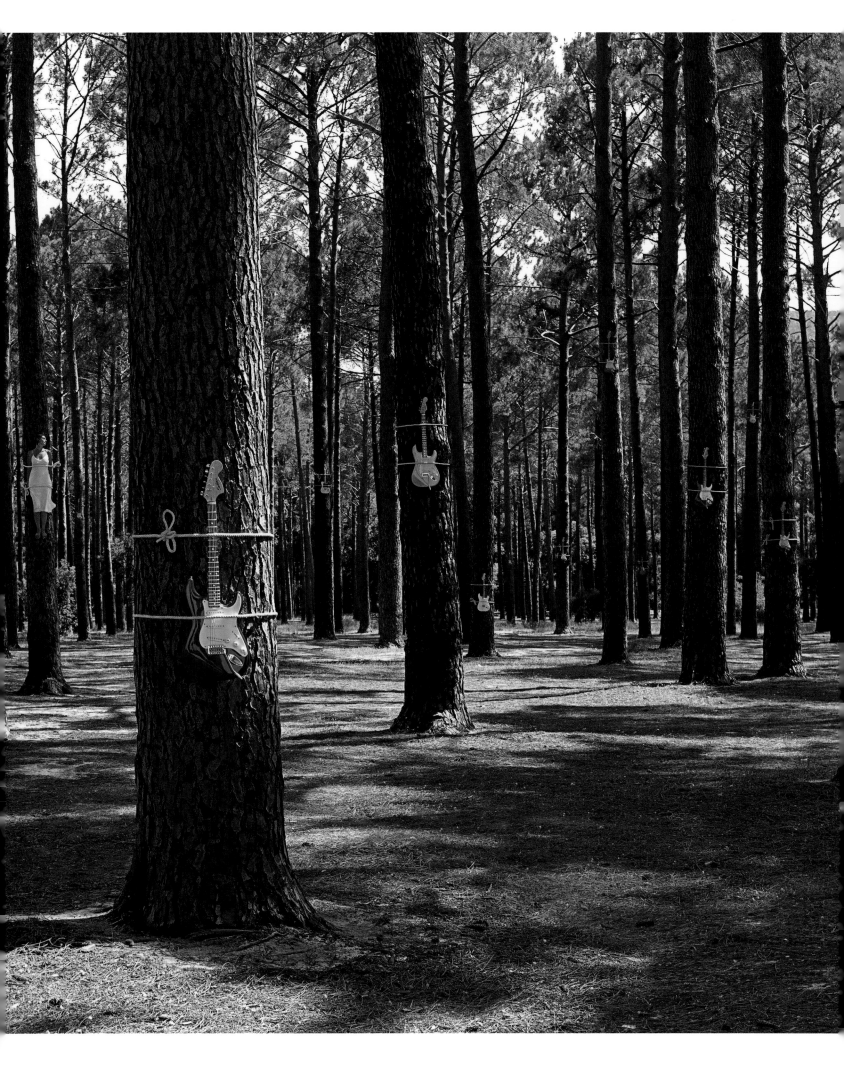

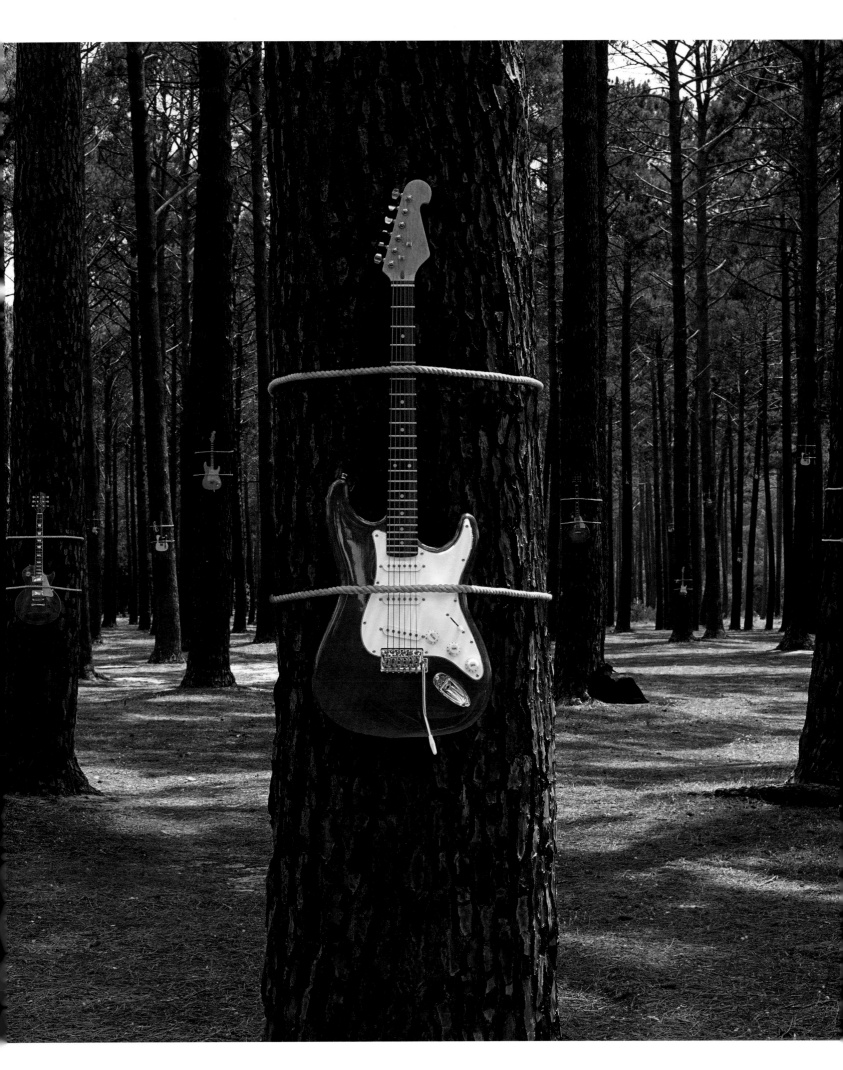

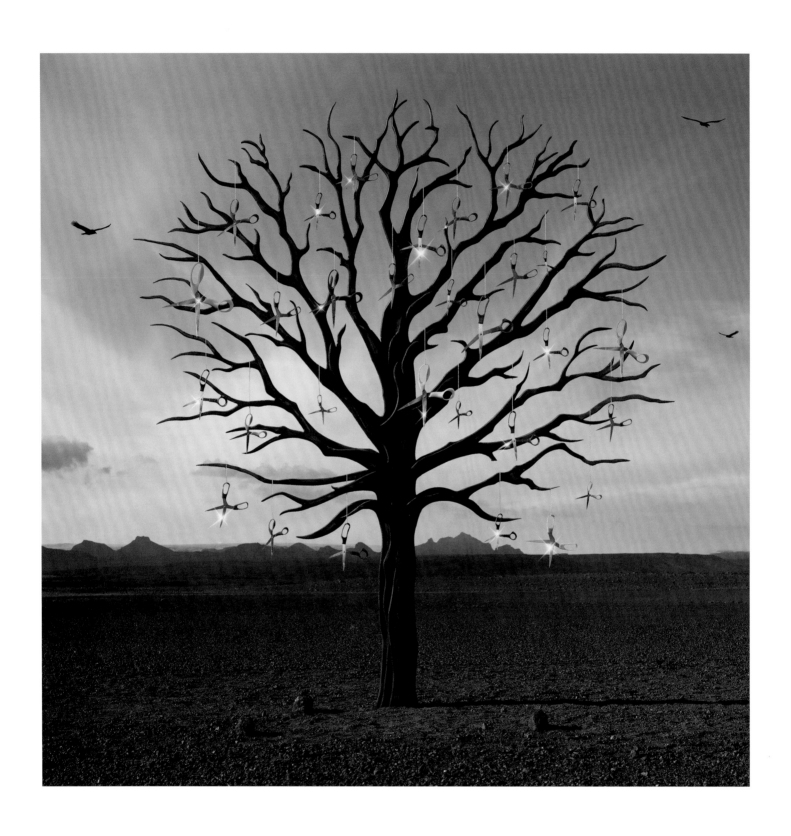

Biffy Clyro, *Opposites - The Sand At The Core Of Our Bones (2013)*

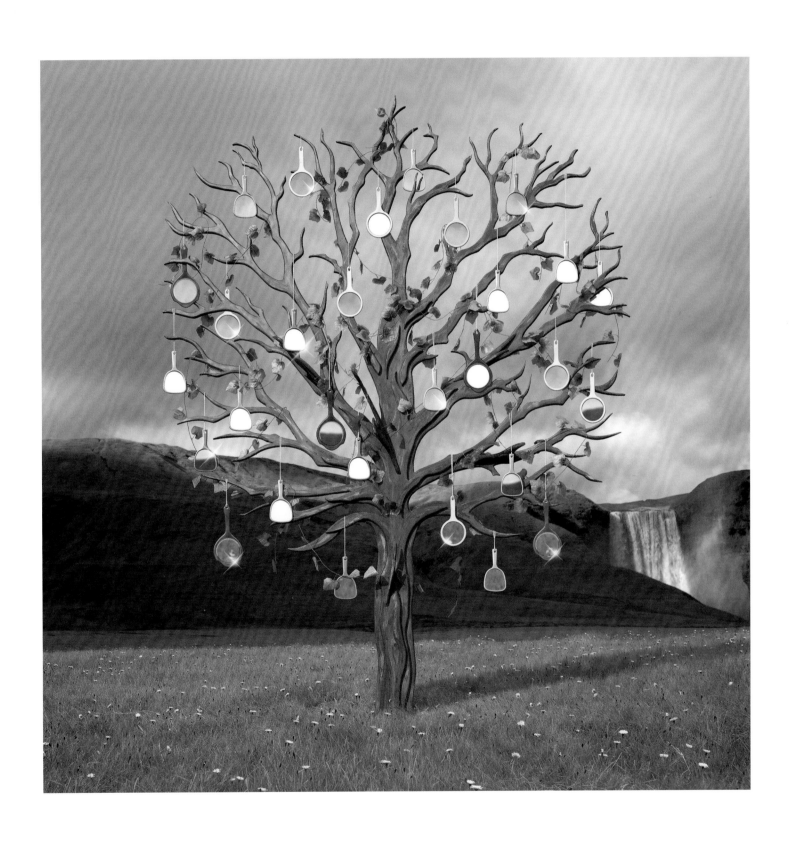

Biffy Clyro, *Opposites - The Land At The End Of Our Toes (2013)*

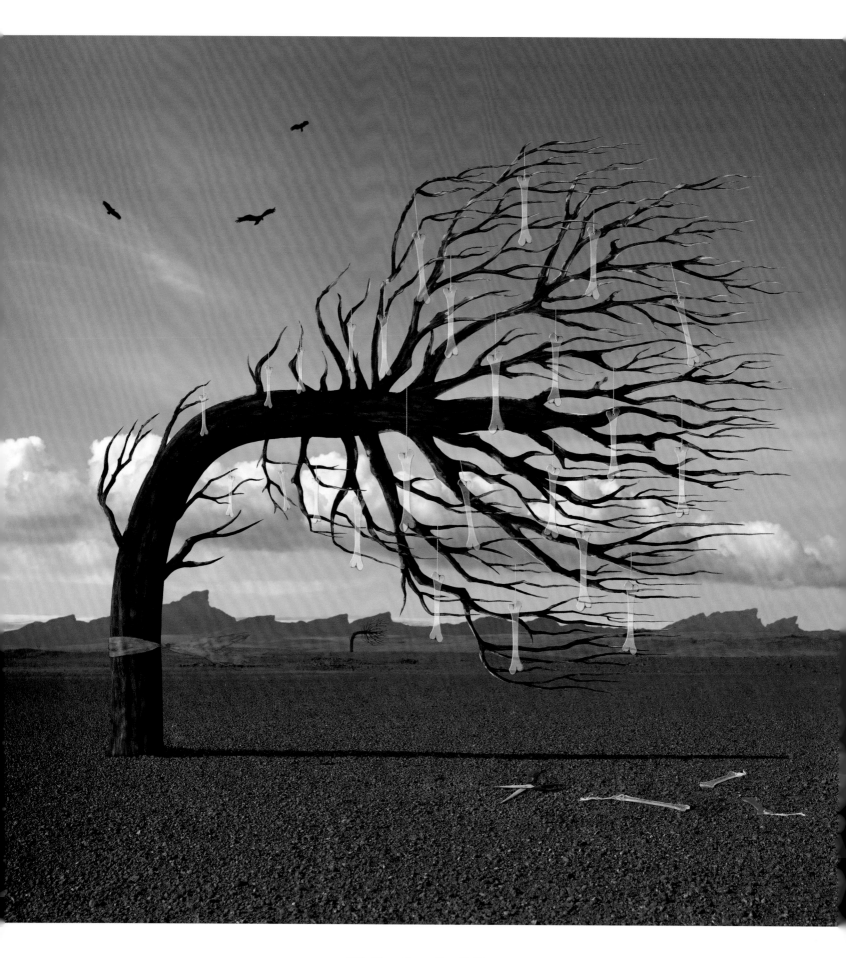

Biffy Clyro, *Opposites (2013)*

WE did these two images for The Plea's album **THE DREAMERS STADIUM** (pg 227, 228/229). As much as I enjoy the orbs of knowledge carried from the depths of the tunnel/ ignorance by the schoolboys, I prefer the guitars on trees. This is derived from an image we did of books tied to trees, as an homage to where the books originally came from. This image was in honour of Bob Dylan but of course his manager didn't like it. This variant had guitars – the icon of rock and roll – Strats and Les Pauls tied to trees in the sunny pinewood. I personally, without qualm or egocentricity (heh heh), really appreciate this picture. I think it is spiritually appropriate, pretty and interesting dialectically. Also, it possesses, at least in my mind, a ritualistic quality – this extallation is performed as a real event in a pinewood in Tokai near Cape Town.

AS we started designing **OPPOSITES** (pg 230, 231 and opposite), Simon Neil of Biffy Clyro said it would be a double album composed of 'before' and 'after' a time of oppression and negativity, and a time of recovery and positiveness. The first was called **'THE SAND AT THE CORE OF OUR BONES'** (pg 230) and the second **'THE LAND AT THE END OF OUR TOES'** (pg 231). And he said to me: 'I've had a vision of a tree, like a Tree Of Life'. I said: 'That's good, how about a Tree Of Life and a Tree Of Death.' He said: 'what's a tree of death? I like it.' I answered: 'I haven't got a fucking clue . . . yet!' The Tree Of Life is a common feature of many cultures and is primarily concerned with the interconnectedness of things. So obviously, the Tree Of Death is about disconnectedness. In all cases, these trees, known also as votive or wishing trees, have objects hung upon them; in Japan they hang notes, in Hungary they hang padlocks, in Scotland they wedge coins and in Australia they hang tyres. Native Americans used eagle feathers, but my idea was to use telephones and scissors. The band didn't like telephones and suggested glass bones and shards of mirror. They were happy with the location, Iceland, as a place full of appropriate scenery. Since there were two albums I wanted the tree to be the same. This meant we had to construct the tree and take it with us on the plane in a coffin-like box. The tree was erected near a waterfall on a green meadow with daisies and hand mirrors. Next we went to the desert and photographed the same tree, now with glass bones and scissors hanging from it. All seemed well, but then there was a long hiatus, because the band didn't like the tree, which was clearly hand-made not natural. This hiatus lasted interminably. The band claimed, although I suspect it was the record company as well, that they wanted a more 'powerful' tree, a more rock and roll tree . . . At this point I nearly shut down, since a bigger, older, leafier tree would undo itself and you wouldn't see the objects hanging there. I think neither the group nor the record company fully understood that it was the objects that were important, not the tree. In desperation, I bent the tree in the middle, due to thousands of years of prevailing winds. It was such a simple act it was stupefying! But the band said they loved it. This is a long piece of text because it was a long arduous job. But Biffy is a great band so God bless Ayrshire and bent trees!

Graham Gouldman, *Love And Work (2012)*

Vitalic, *'Stamina' (2012)*

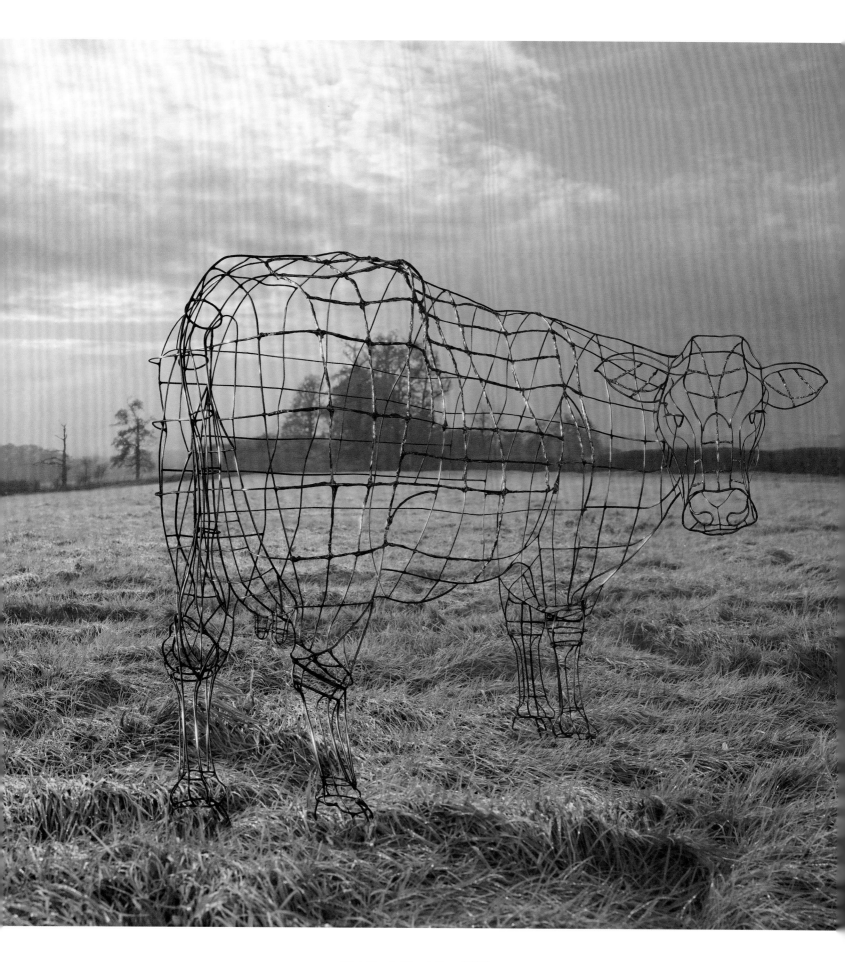

Pink Floyd, *Why A Cow (2010)*

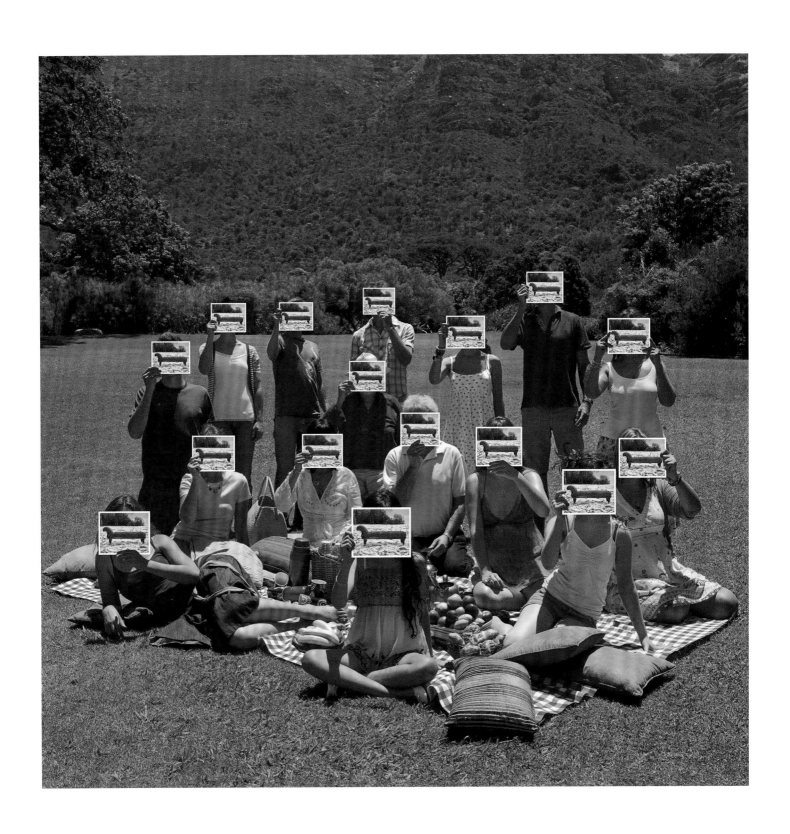

The Wombats, *This Modern Glitch (2011)*

LOVE AND WORK (pg 234) is an album by Graham Gouldman, a dear old friend from 10cc. This was all new material but performed by an old hand. It was like something brand new on an old nag so we put a baby on an antique rocking horse, which seemed to suit Graham to a tee; it also allowed us a pun on his initials (GG).

FOR Vitalic's '**STAMINA**' (pg 235) I asked Finlay to draw me a magic orb floating in the forest. He came back with a spectacular mirror ball, which reflected curved trees, etc., and Lee turned this with his magic retouching hand into a photographic version. The picture was taken locally on our beloved Hampstead Heath, one of the more extraordinary virtues of London.

A cow on **ATOM HEART MOTHER** (pg 20) by Pink Floyd is a mystery to me. Fortunately, it is to many others, too. To celebrate the **40TH ANNIVERSARY** of a real cow we thought, while driving past sheep in New Zealand, we'd make one of wire – Why a Cow – which we duly made and took back to the original location and reshot (pg 236). Since wire frames are so important in CSG it seemed only appropriate to make the sculpture of our new cow out of wire, not flesh and blood, or even polystyrene. We had a little trouble finding the location because it had grown in 40 years. The grass was longer and the hedges shorter, and it had one less tree. Such is the march of entropy.

WOMBATS is an Indie band from Liverpool, fronted by Murph, whom Peter and myself had the pleasure of meeting at Lime Street Station. This allowed us to gain some insights into the group's methodology and songwriting. We went away to design a cover for their second album **THIS MODERN GLITCH** (pg 237). They seemed to favour **Scrutiny**, but then accepted an idea about a picnic in a park, and completely changed it. I'm not sure I should have gone along with all these shenanigans but rock and roll is sometimes a bit like curry mixed with toffee pudding. Since the songs were often concerned with depression and people's problems, I had each one of the picnickers holding a photo of a shrink's couch in front of their faces so people couldn't see who they were. And lo and behold, they changed the cover again anyway, by having my ordinary picnickers replaced by their friends. I still quite like it. I guess it means that if the idea is strong enough it doesn't matter where or who or how you take it, perhaps.

VILLAINY is a well-organised rock band from New Zealand and in their album called **MODE.SET. CLEAR.** (opposite) it talked about the ups and downs of relationships, a common but fertile furrow. I imagined someone thinking about their past lovers, in this case a writer or authoress. The figures she imagined were not apparitions, but real. So a real person comes out of the wall, a real person comes up from the floor, but it is all in the mind, in the mind of the authoress.

One of the interesting things that surprises me is that like **Bingo** (pg 188/189) I don't really understand it . . . the image is mine but doesn't feel completely like me.

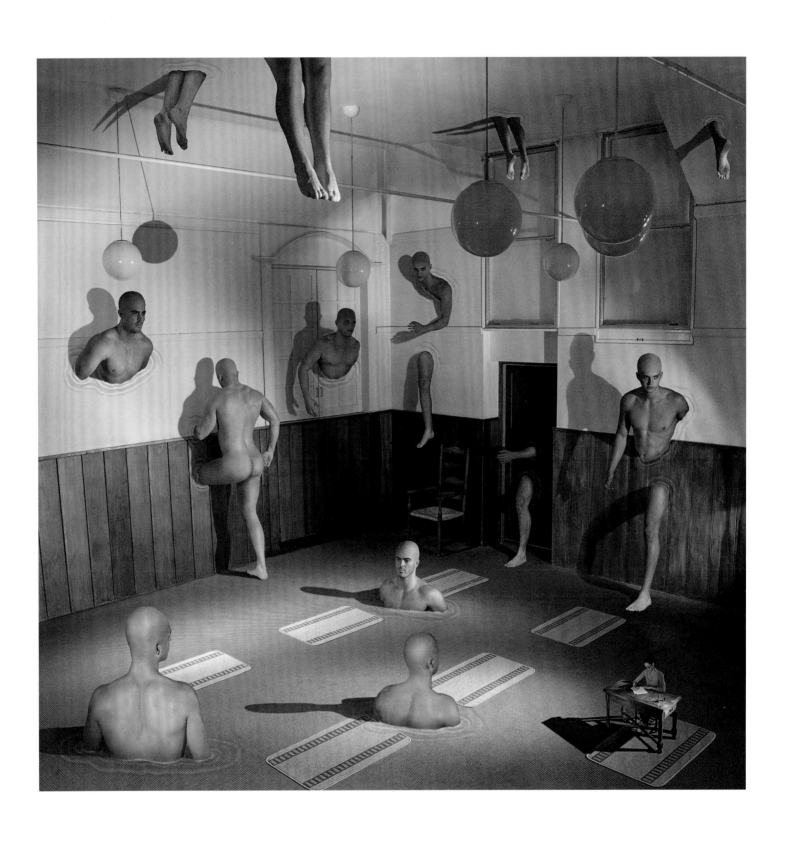

Villainy, *Mode.Set.Clear.* (2012)

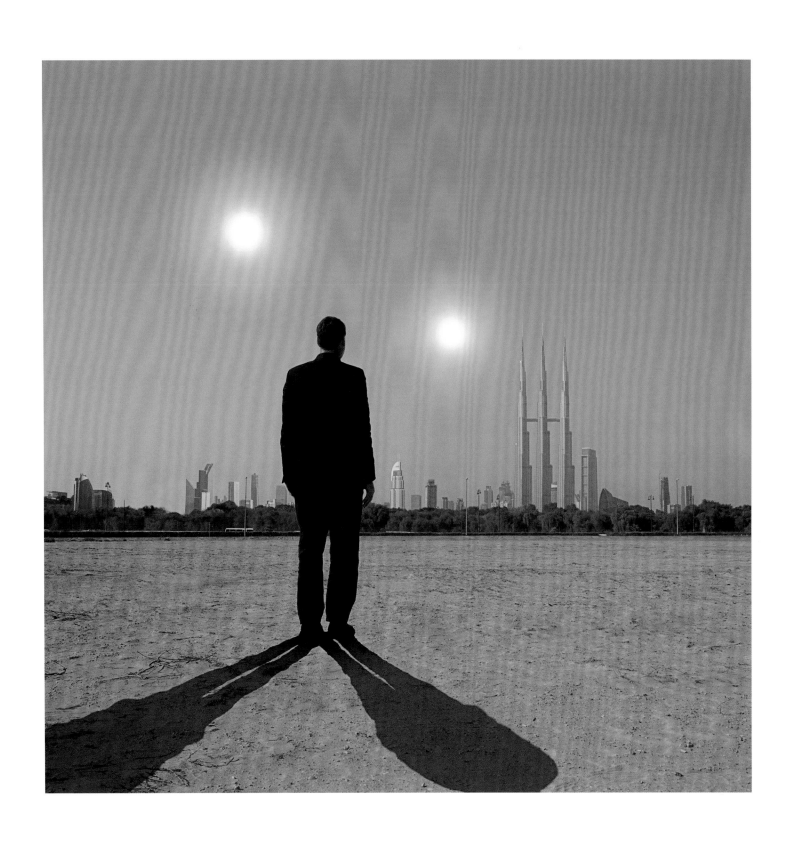

The Amplifetes, *Where Is The Light (2013)*

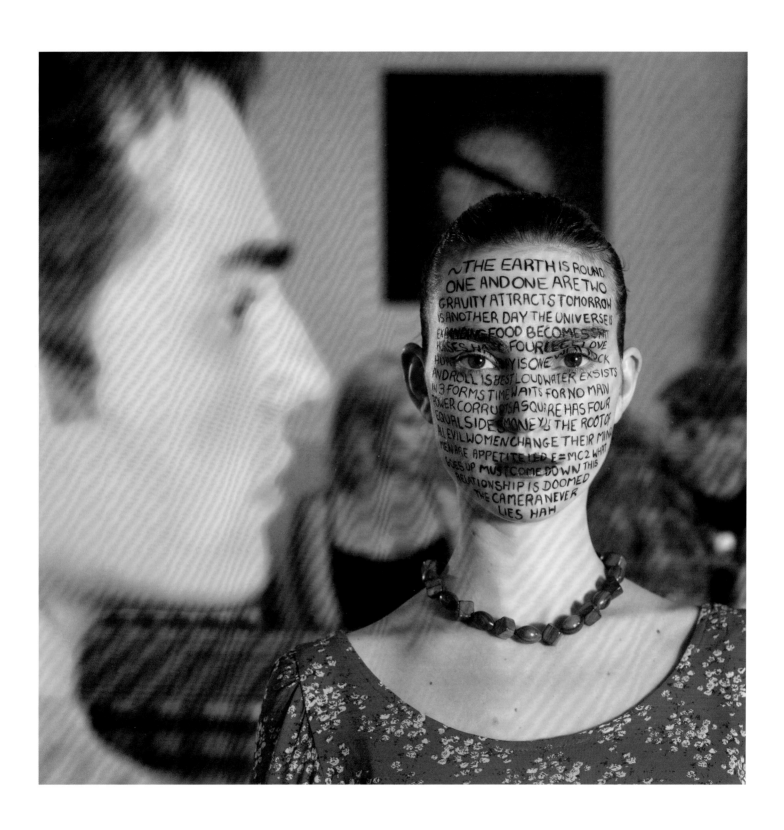

Octane OK, *Face The Facts (2013)*

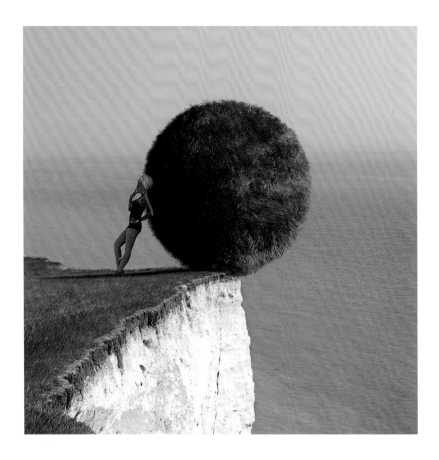

Voodoo Highway, *Show Down (2012)*

AN got us a job working for a Swedish band called Amplifetes whose album was called **WHERE IS THE LIGHT** (pg 240). In talking about their songs I could not escape from a sense of science fiction, particularly 50s fiction. Our visitor from the unknown stands before a city of the future, and in the sky are two suns, thus it cannot be earth (unless you know something I don't). The city is futuristic and the man simply stands there beholding, the purpose of his visit undeclared. It was photographed in Dubai in order to include a triple Burg Khalifa, the tallest building the world, which is truly remarkable!

I'VE always been interested in facial decoration, whether it be the flamboyant colouring of Native Americans or Africans, Xhosa white patterns, or punks in Stepney, not to mention tattoos, but have never indulged personally. I think I find more runic, ritualistic Japanese the most appealing – somehow more calligraphic, if not delicate. However, I wished to invest meaning in my marking so the facial decoration for Octane OK was words, so that the writing on the face became both decorative and informative. We liked the idea that in heterosexual relationships the man is seen to be reluctant to face issues squarely. The man is said not to **FACE THE FACTS** – so in our picture (pg 241) the man is turning away from a woman whose face is inscribed with facts, some of which are un-arguable, some aphoristic, and some contentious. I have to say that the model in our picture had a great presence, lending the inscription more weight and the picture a better atmosphere.

TRAFFIC COP (opposite) is a photo/graphic event – making particular use of the square of the album cover by bouncing off the corners. It is about a policeman who is holding up one line of traffic (words) to let another line of traffic (music) go through. This cover was executed for Younger Brother, who said music is more important than the words. Then promptly turned it down. (Don't you just love some people?)

AN Italian band from Modena is called Voodoo Highway (and you think we're weird!) whose first song of the album was called **This Is Rock 'n' Roll, Wankers!** I think the main thrust of the album, called **SHOW DOWN** (above), was coming of age so we designed a big hairy ball, parked on the edge of a cliff, being pushed over by a woman. The band were persistent, charming and broke. And when they asked what the hairy ball meant, I said 'I don't know . . . better it be a mystery! If anybody asks you say it is a mystery', to which they replied 'that is a great idea!'

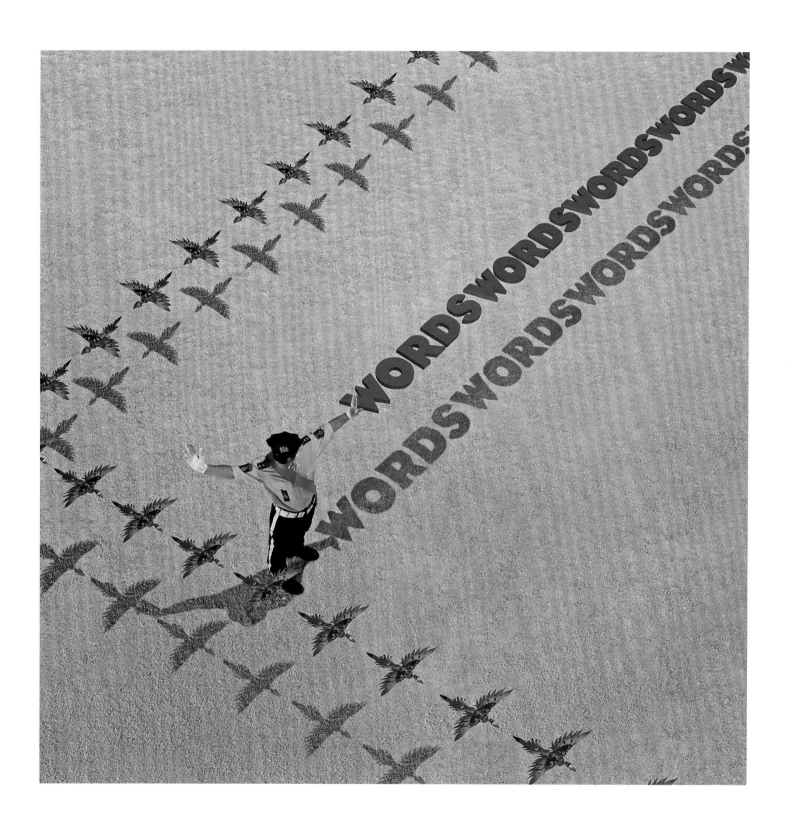

Traffic Cop (2011)

10cc, *Tenology (2012)*

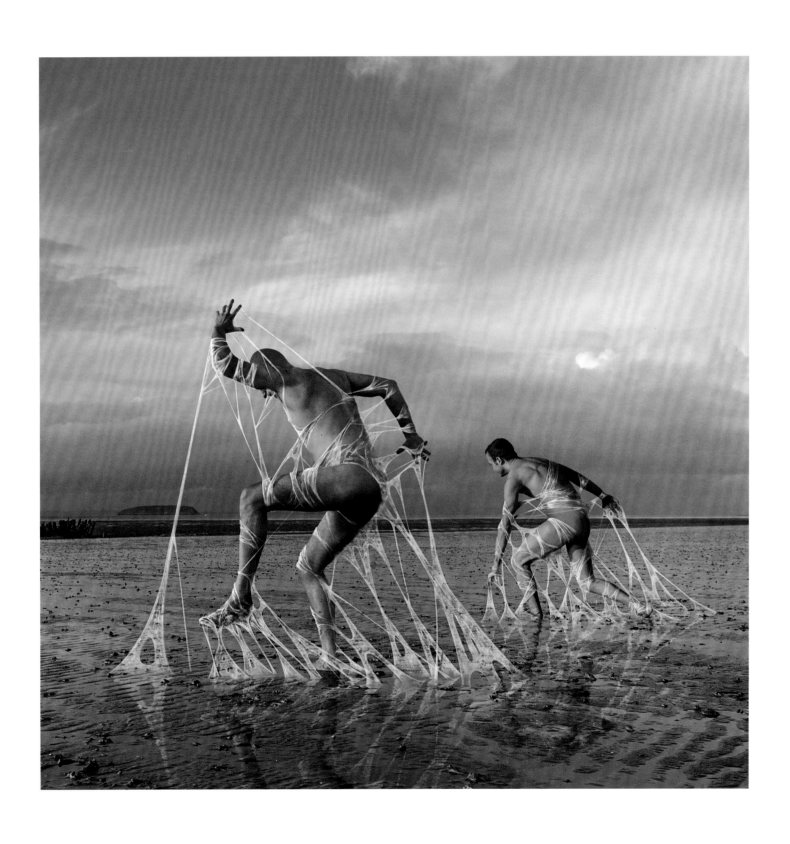

Slow Earth, *Latitude And 023 (2013)*

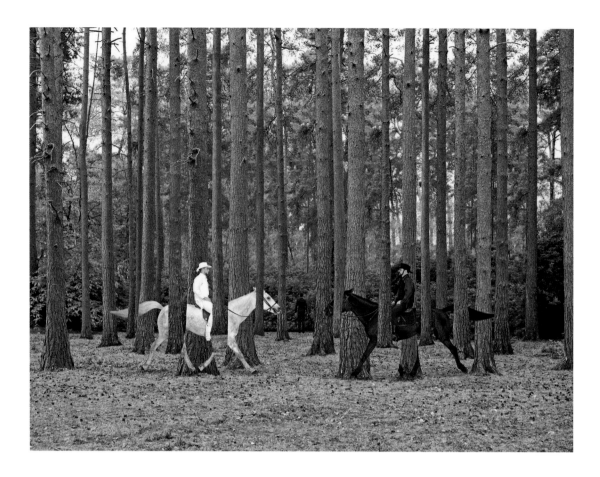

Whitley Heights, *Whitley Heights (2011)*

e were asked to do a box set for 10cc called **TENOLOGY** (pg 244) and I had an idea that since they were like cultured pop that we should use a phrenology head like the Victorians and inscribe the influences on the music in the compartments drawn on the porcelain bust. The references all come from the band themselves, and the head is a little bigger than a Victorian one. The crackling was added by the hand of Jerry and the very lovely Silvia. The head was taken to a canalside in recognition of the Manchester ship canal, which is where the band came from. A cricketer on the bridge reminds us of 'Dreadlock Holiday' and the dog with a bone reminds us that there are many telephone references in 10cc's music.

THIS image for the EP **LATITUDE AND 023** I find very compelling (pg 245). It derives mostly from Dan but the idea started with my son Bill who, having visited a giant redwood forest, Muir Woods in San Francisco, suggested that trees grow very slowly and people move very fast which is why we can see no change in the trees. Instead of slow earth, Dan imagined slow people, held back by sticky stuff, which made it difficult for them to keep going. I don't know what the sticky stuff is, but I don't think it matters; it's a metaphor, which I hope Slow Earth, who are from Ukraine, enjoy.

A LITTLE known but very friendly band called **WHITLEY HEIGHTS** (above) from Los Angeles came to see me in San Francisco. We chatted and I agreed to submit a questionnaire about their songs. Much to their surprise the gist of many of their songs was similar, namely much about opposites, life and death, love and hate, to run or stay, and so on. This gave rise to the two cowboys, one black and one white, trotting towards each other in a Magritte wood. I don't particularly like borrowing, but I always wanted to try this Magritte game as a photograph. I thought it might be more effective than his painting – a bit of a nerve, really . . . Anyway, Styx used this painting.

'BIBLICAL' (opposite). Biffy Clyro told me that the song was about a couple taking stock of their lives, but the singer didn't want them to change because their love was stronger than past misdemeanours. Taking stock reminded us of inventories or ledgers both of which are bookish, so we were going to use a pile of bibles from the song's title but decided that suitcases were more interesting and more representative of what is past – we are the baggage/luggage we bring with us – the pile of suitcases are very real and it was shot on an hilltop in Bedfordshire and it was freezing cold, the Italian girl model described it as, 'un cazzo di freddo!'.

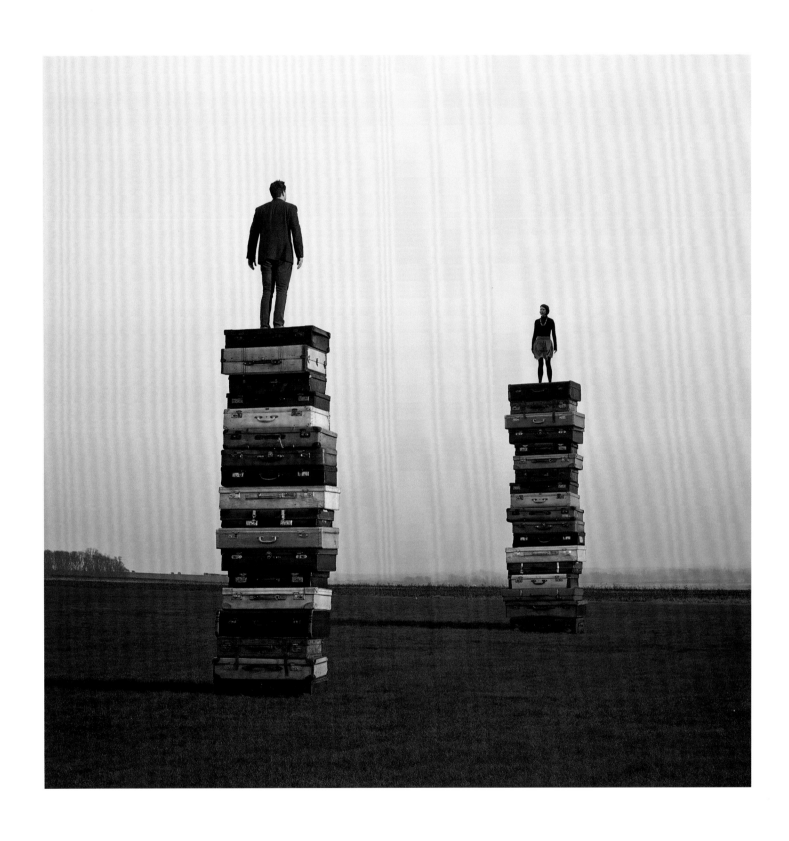

Biffy Clyro, *Biblical (2013)*

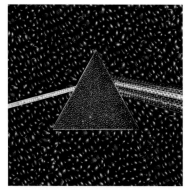

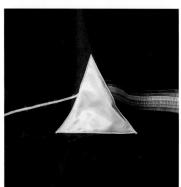

IT seems fitting to end with Pink Floyd, with whom I have been associated for a long time: forty years or more. It has, for the most part, been a very productive relationship. Since **Wish You Were Here**, **Burning Man** is one of my favourite images and **DARK SIDE** was so successful. **Atom Heart Mother** is so odd, **Animals** is majestic if not historical, I think we've done good, if you don't mind me saying so.

THIS entry is written in 2013, which is the 40th anniversary of **THE DARK SIDE OF THE MOON** so we proposed a poster/print of **40 DARK SIDES** which cleverly fit a square of 7x7 (opposite), leaving just the right number of spaces for Pink Floyd letters. We set about the mammoth task of doing twenty or so new **DARK SIDES** to go with the twenty we had already done so that it was all home grown as opposed to found (as in the **30th**). If you look hard enough, dear reader, you'll find an eye test, marbles, buttons, sweets, **LIQUID DARK SIDE**, stained glass, appliqué, and illustrations done in the style of Lichtenstein, Picasso, Miro, plus a few more.

THE whole conglomeration affords a suitable testament to one of the world's greatest records, or at least, that's what I intended. I always felt that the Pink Floyd were not easily categorised. They were called progressive rock but I always thought there was more to them – the breadth of their sonic landscapes allowed me to devise ambitious, occasionally silly or surreal, imagery.

*T*HE graphic simplicity of **DARK SIDE**, the semi-surreal complexity of **Wish You Were Here**, the madness of **A Momentary Lapse Of Reason**, all of this is a commemoration of **DARK SIDE**, not of **Wish You Were Here**, which may come later, but would be considerably more difficult. The advantage of **DARK SIDE** is that its iconography can be easily rendered in different media . . . and I am sure that there are some we haven't thought of. If you think of them, dear reader, keep them to yourself, there's a pal.

• • • •

Pink Floyd, *The Dark Side Of The Moon 40th Anniversary (2013)*

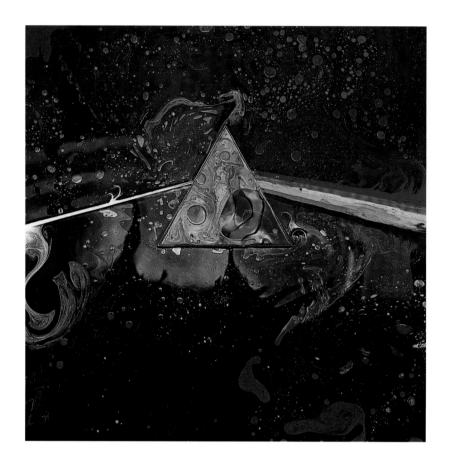

FOR this new edition, it saddens us to write this note about Storm's passing, following a lengthy illness, in April 2013. Storm spent the last few months of his life working hard to pull this book together, and in his final week he was able to view the first copy fresh from the printers and he gave it full approval. A smile, a thumbs up, another job done.

IT WAS Storm's wish that StormStudios continue and so, with Peter Curzon, Rupert Truman, and Dan Abbott at the helm, work has continued apace. There were a few unfinished jobs to complete and a flow of brand new ones to get our teeth into, some of which can be found in the following pages.

WE HOPE that Storm approves, of some of them at least.

• • • •

Pink Floyd, *'Liquid Dark Side - Idea Generation' (2010)*

Biffy Clyro, *'Opposite' (2013)*

The Answer, *New Horizon (2013)*

Six Inc., *Six Geese (2013)*

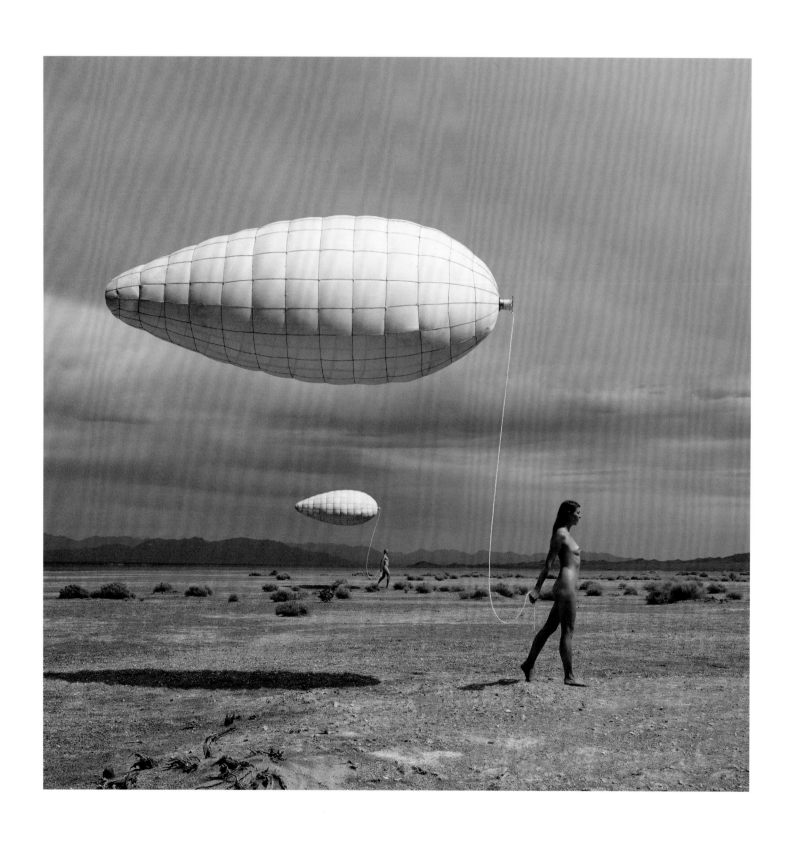

Leisure Cruise, *'Double Digit Love' (2014)*

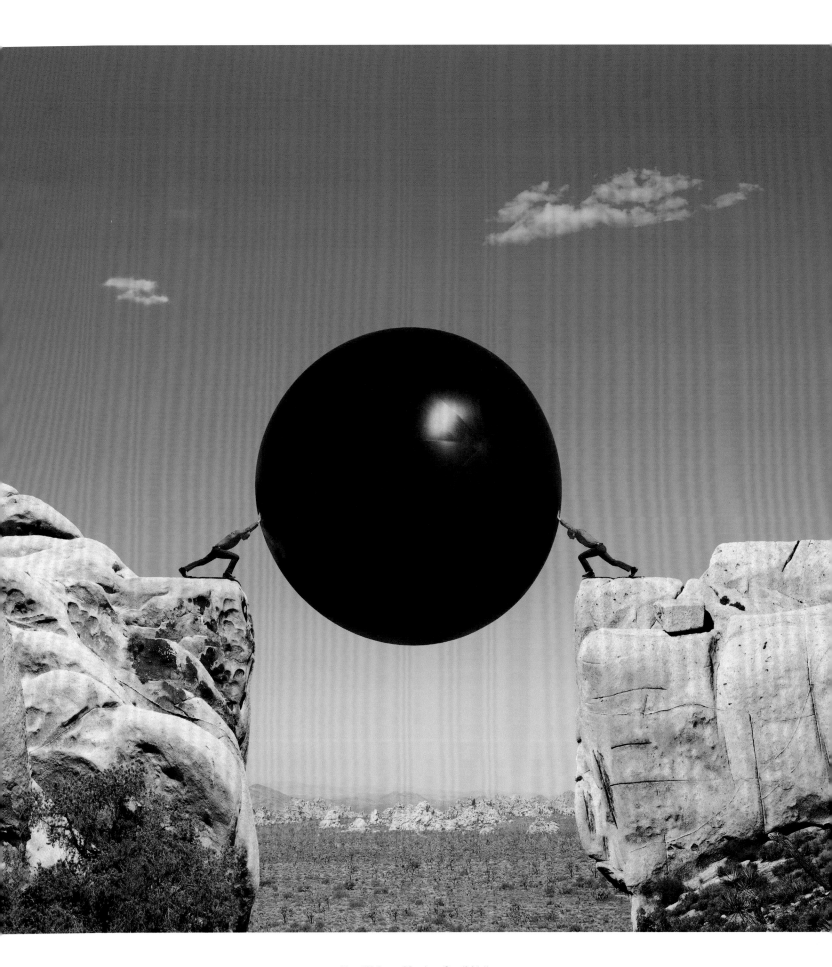

Kan Wakan, *Moving On (2014)*

WHEN is love not lovely? When it smothers you perhaps? We had been working with some rather fetching models, but somehow we always ended up covering up their faces – hopefully they didn't take it personally. For Biffy Clyro's single **'OPPOSITE'** (pg 251), we employed a large number of small red roses to obscure this lucky lady's face. To our amusement this also involved turning up at a famous London flower market at 2am, only to discover they didn't open until 4am. We stayed awake long enough to secure 400 of the blighters anyway.

THE ANSWER approached us with a question: could we design an album cover that reflected their new lease of life? The band were excited with their new album, **NEW HORIZON** (pg 252), recorded in a burst of fresh energy, with a no-frills, stripped down sound. They spoke of shedding dead musical weight and freeing themselves up.

Our response was 'the birdcage man', an idea that would involve employing the services of racing pigeons very early one summer's morn on the south coast. If you've ever tried to get pigeons to fly in a precise and particular direction you'll have some idea of the challenge that we faced.

We think our answer to The Answer's question turned out rather satisfyingly though, like a visual zen riddle, and well worth all the flapping around.

SIX GEESE (pg 253). In a change to the norm, newly formed Japanese creative agency Six Inc. approached us in early 2013 to design a logo for them. However, at the same time they requested an image and that we approach it as if it were an album cover. Brainstorming sessions with Storm resulted in ideas about connectedness and phrases containing 'six' bring rolled out, one of which being 'six geese-a-laying' from the Christmas Carol. Storm imagined the geese being the six founding members of the company, huddled together in a meeting at the office, debating, arguing or having a laugh, and who could then fly off to deliver the results of the meeting elsewhere. The office would of course be a farm, and we had discovered the somewhat idyllic location, with a great receding, curved path, on a previous shoot. So on a lovely summers day we headed there with the best looking geese we could find - not as easy as it sounds as geese are moulting in the summer and look very scruffy. Luckily ours were very professional models and behaved impeccably under the instruction of their herder. The whole day was a hoot. Or should that be honk!

NEW YORK–based Canadian Dave Hodge of Leisure Cruise e-mailed us shortly after Storm died requesting that we design a cover for his new band's first album, a central concept being . . . "What if we had to leave earth and colonize a new planet?" They imagined a final leisure cruise for the human race – and the fledgling musical project as a sort of soundtrack for it . . ."

When we presented the ideas to Dave in a restaurant in London's Soho he quickly picked out four, all of which involved couples in transit through barren landscapes to somewhere unknown with, as he saw it, our ark (pg 261) being their final destination, and the cover for the album. Furthermore, and music to our egos, he also requested that we go ahead and shoot the other three images to accompany different single releases. Given the central concept we couldn't very well shoot in a water-logged UK, and so a trip to the deserts of California ensued – the results of which can be seen in these pages. This one (pg 254), shot in the midday heat of Amboy, a deserted town with no fresh water, is for a single called, **'DOUBLE DIGIT LOVE'**. The blimp was ordered from the UK and collected when we arrived in LA, so it was a great relief to see it inflated without punctures, and even better once dressed by Charlie to give it a slight Victorian feel. In the week of the single's release Facebook closed down the band's page due to the supposed pornographic nature of the image!

WHEN grilled about their debut album **MOVING ON** (pg 255) Los Angeles based Kan Wakan implied that if there was a loose thread running through the songs it might be about disillusionment, struggle and the hope of transformation or transcendence. Throughout their short history, the band had also used a black circle/sphere as a recurring visual motif, and several of our ideas picked up that particular ball and rolled with it, as you can see in the final cover.

With bags packed and sandwiches made we headed for Joshua Tree in California, which is hot, alien and full of strange shaped rocks and trees, made stranger still with a 15 feet high black ball rolling around in it. Our final image clearly deals with a struggle of some kind, the gargantuan ball prevented from falling into a chasm of no return, by two (or is it one?) eternally struggling beings. Shades of Sisyphus perhaps? Maybe twin human scarabs hoisting a negative sun (the moon?) up to the heavens? The struggle was worth it, and if you'll pardon the pun, we had a ball!

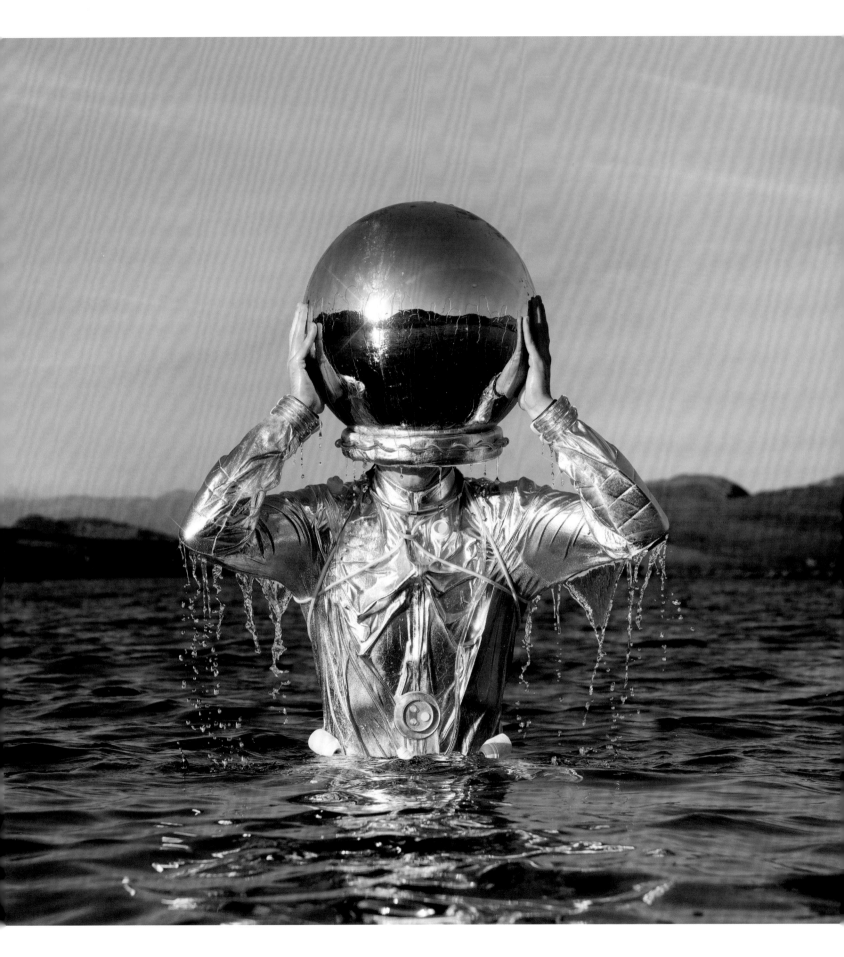

Korda Marshall, *Now We Breathe (2015)*

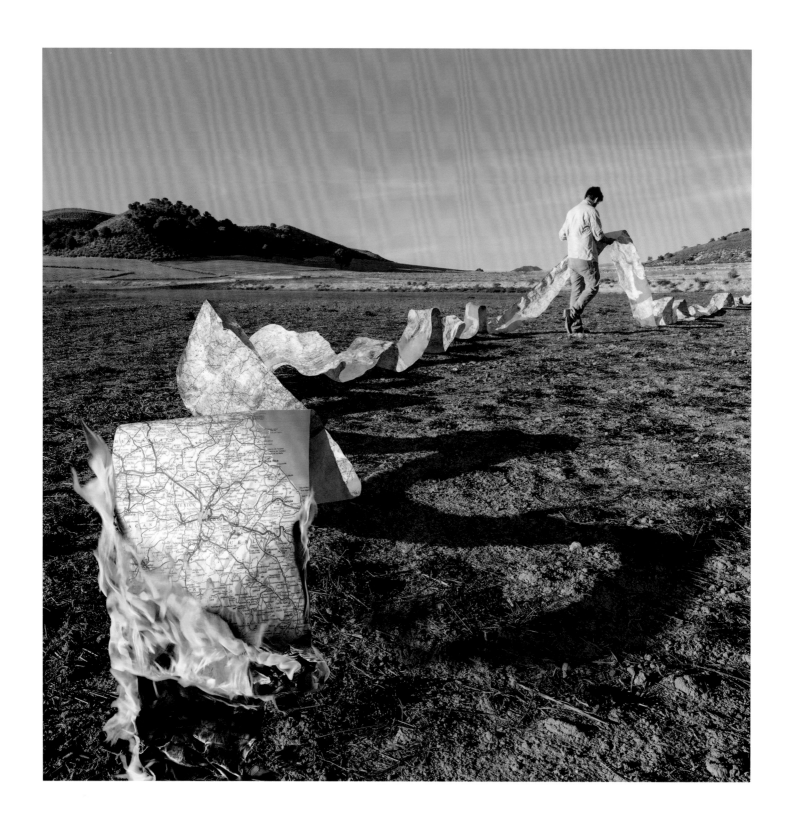

↑ Kim Churchill, *Silence/Win (2014)* | European Rock Fest Vol. 2, Poster *(2015)* →

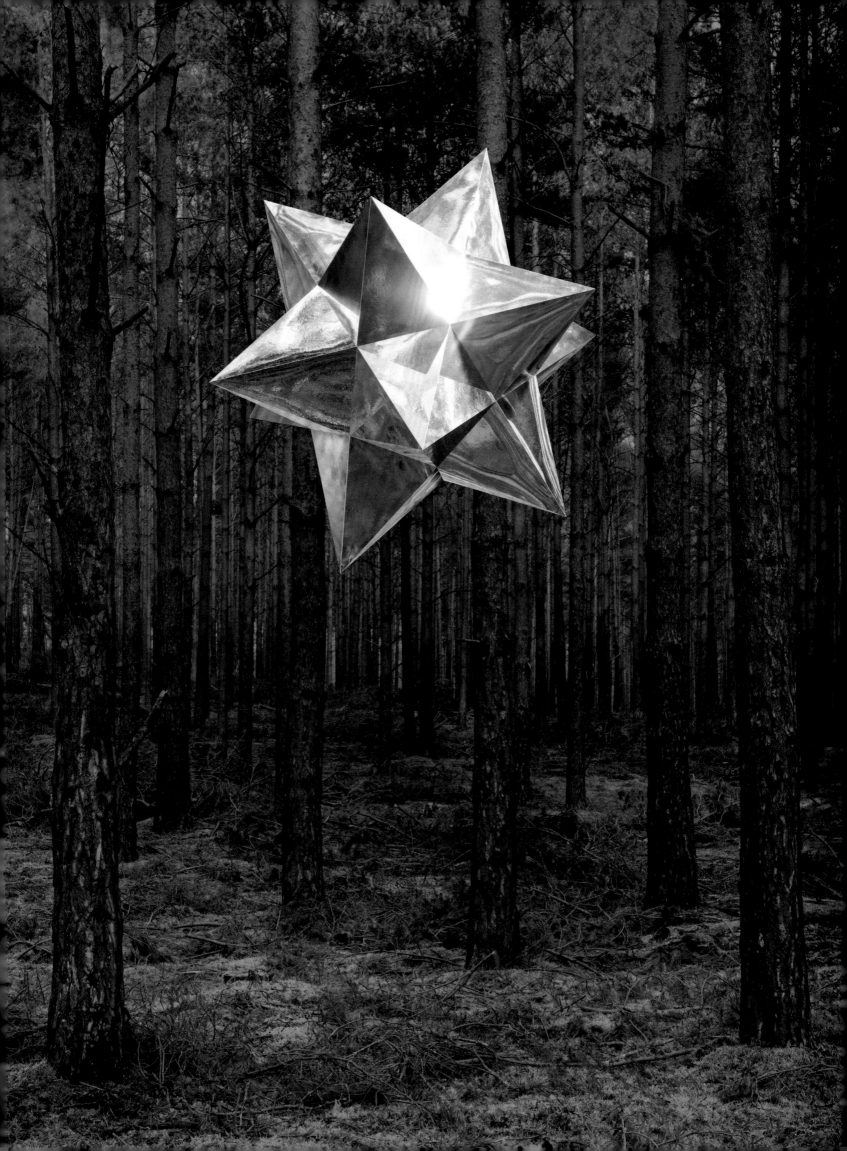

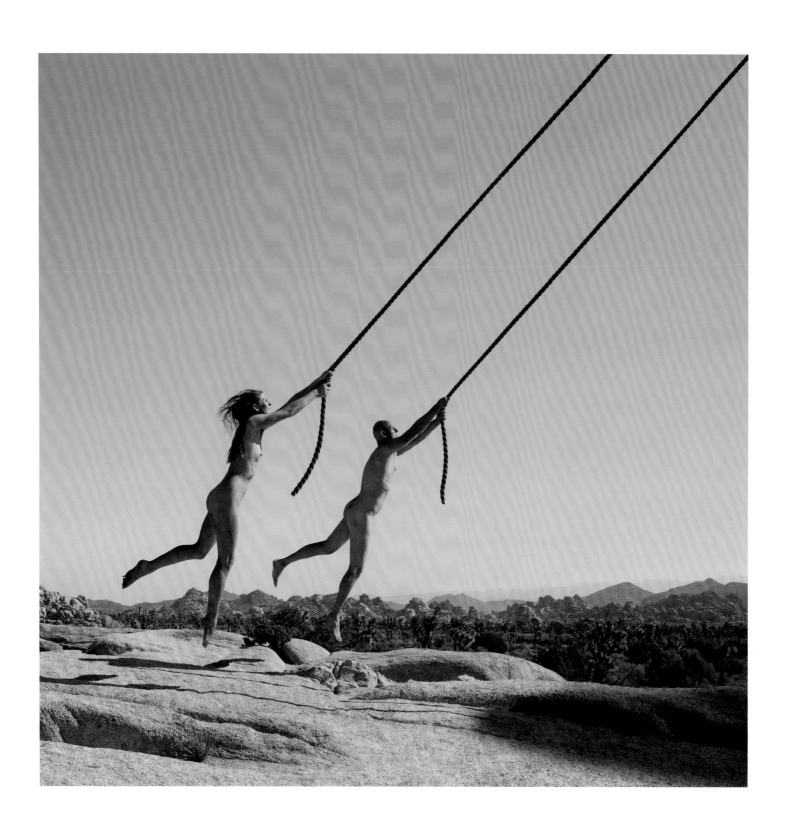

Leisure Cruise, *'Earthquake' (2014)*

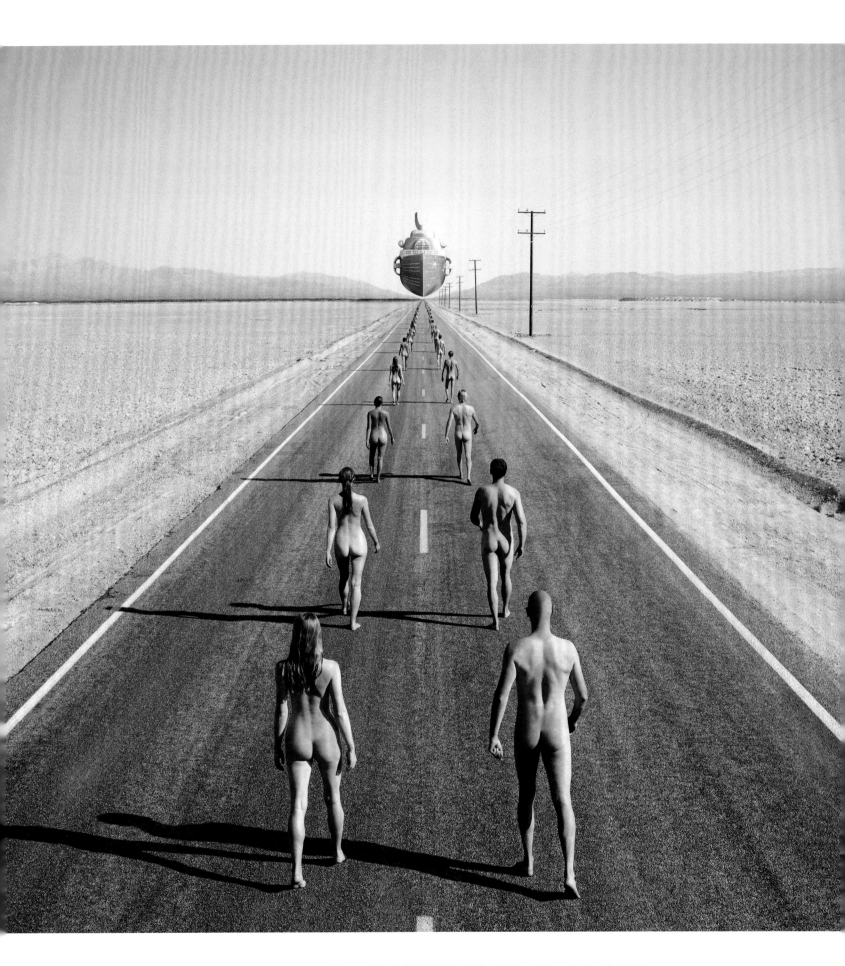

↑ Leisure Cruise, *Leisure Cruise (2014)* | Pink Floyd, *The Endless River*, Postcard *(2014)* →

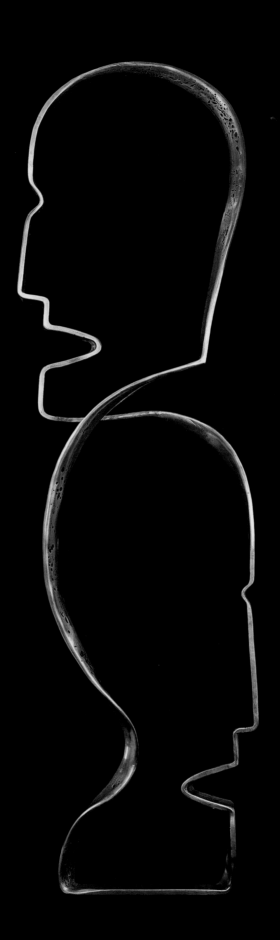

KORDA MARSHALL came to us in early 2013, shortly before Storm died. They said they were big fans (always a good start), but that they didn't have much money - and that they would really like us to do an album cover and three singles. After a brief discussion with Storm, and being intrigued by both their audacity and by their name (we had previously designed the Infectious Records logo for Korda Marshall the person) we agreed to do it. Sadly Storm passed away not long after we started work on the project, and so we set about designing one of our first covers without the big man's input. The design stems mostly from the title of the album, NOW WE BREATHE (pg 257), and as the notes from our meeting with the band tell us, 'it refers to the fact that the band had been gigging, recording, writing, fretting, plotting for two years, and that they finally feel ready to go - they're coming to life. They're ready to breathe.' Those notes however were made two years prior to the album's release in spring 2015, so that two years is now four, and we can only presume that they must be positively gasping with relief and delight now that it has finally come out.

AUSTRALIAN singer songwriter Kim Churchill came to us requesting a design for his fourth album, interestingly titled SILENCE/WIN (pg 258). We were beguiled by the album's twelve songs, varying from gentle orchestrated folk fingerpicking to full-tilt widescreen rock, and lyrics that dealt with philosophical concerns rather than the usual boy-girl problems. Kim relayed his thoughts on following a natural creative flow – the paradox of trying hard to do something but it only happens when you let it go. And about 'letting go' of control and about how global guitar-in-hand touring had affected his outlook.

These clues led us to an image of a man following an endless map and due to it being about the only dry place in Europe during an extremely wet winter, we found ourselves in Almeria, Spain, to shoot it. We tried a variety of locations before chancing upon this eerily silent field with just an hour of sunlight left (the quiet was deafening). Going with the flow, or away from the flow of rain, seemed to pay off.

EUROPEAN ROCK FEST (pg 259) is the name of a Japanese festival organised by some of our friends in Tokyo, which showcases the talents of acts old and new who specialise in the magical art of Prog Rock. When asked to make a poster, we were given the briefest of briefs: "organic, forest, fantasy, prog" – but then again those four words said it all – prog! We chose a very linear forest for graphic purposes, to both compliment a vertical poster shape and because we thought the trees resembled

a standing audience. The hovering mirrored polyhedron (is that a band name?) is a musical satellite that's travelled from the other side of the globe, its reflective facets being a metaphor for a sonic kaleidoscope of exotic music.

THE images for the eponymous album by LEISURE CRUISE (pg 261) and their single 'EARTHQUAKE' (pg 260) stem from the themes mentioned on page 256, namely that of humans having used up Earth's natural resources. We have the couple holding on to some rope dangling from a mysterious aircraft, desperate to get in the queue with the other couples to board the 'Ark' and setting off in to space to find a new home. While this might sound somewhat convoluted we are very happy with the results, and they were great fun to shoot. Our models Charlie and Oskar were great, delivering a mesmerizing display of rope-catching skills. Likewise shooting the people (photographically) from the top of a car in the middle of a long straight road in Amboy, all the while looking out for approaching cars. We got the timing of this down to a fine art – about two minutes from first sight of a vehicle to the models rushing to cover themselves and our car having to be moved from the middle of the road, sometimes with the photographic department still on it.

FOR Pink Floyd's final studio album THE ENDLESS RIVER (opposite) we designed an elegant sculpure based on a combination of the infinity symbol and Storm and Keith Breeden's original 1994 Division Bell heads (pg 129/130) – because most of the album was originally recorded at the time the band were making that album. Watching the team at Artem make the sculpture was great, as they beat, twisted, forged and welded the heavy steel bars into shape. Unfortunately it didn't make it to the front cover, but it did appear as a post card in a box set - which was good as it meant there was a little piece of Storm in there.

ONE FINE DAY (pg 264) was the début album by South Korean singer Jung Yong Hwa. A thread of sadness ran throughout the album's songs, a recurring theme of loneliness and melancholic memories of happier days. Our initial idea was to use a shot of a girl's eye but our client convinced us to feature the eye of Jung Yong Hwa himself. We agreed after deciding that such an intimate close up would make a paradoxically anonymous portrait shot. It's a simple image, a broken hearted man's dreamy rainbow-tinted (as opposed to rose-tinted) gaze back to better times, his love falling ever further into the past; was it all just a dream? But the camera never lies, and they do say the eyes are the windows to the Seoul.

Jung Yong Hwa, *One Fine Day (2015)*

iNdex

LED ZEPPELIN PINK FLOYD
PETER GABRIEL STYX THE MARS VOLTA THE
CRANBERRIES 10CC THE WOMBATS CAPABILITY
BROWN GENESIS AMFIBIS THE NICE
GOODBYE MOTEL BIFFY CLYRO Disco Biscuits
GRAHAM GOULDMAN BRAND X FOREIGNER
YOURCODENAMEIS:MILO CATHERINE WHEEL
XTC HEALING SIXES THUNDER THE CORTINAS
VOODOO HIGHWAY VILLAINY ANTHRAX ETHNIX
WISHBONE ASH THE FABULOUS POODLES
ASHRA VITALIC KANSAS GENTLEMEN
WITHOUT WEAPONS QUARTERMASS GODLEY AND CREME
THE OFFSPRING RICHARD WRIGHT BLINKER
THE STAR THE ALMIGHTY BE-BOP DELUXE
OCTANE OK GO RAFF THE
STEVE MILLER SCORPIONS
PRETTY THINGS DEEPEST BLUE GRAVY TRAIN
GREG FRIEDMAN SYD BARRETT G.A.T.
STRING DRIVEN THING RAGGA AND THE JACK
MAGIC ORCHESTRA AL STEWART SILENT BUDDHAS
THE WINKIES THORNLEY UMPHREY McGEE
TOE FAT YUMI MATSUTOYA STRAWBS GOOSE
YES ELLIS BEGGS & HOWARD RAINBOW PENDULUM
AUDIOSLAVE BLACK SABBATH SLOW EARTH
BRUCE DICKINSON POWDERFINGER
NIGEL KENNEDY BILLY KARLOFF AND THE EXTREMES
MACHINERI THE PLEA TREES
MIKE RUTHERFORD SHPONGLE MEGADETH
PROGRAM THE DEAD WHITLEY HEIGHTS
JOHN McLAUGHLIN MARVIN, WELCH AND FARRAR UNCLE

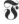

acknowledgements & credits

Hipgnosis was Aubrey Powell, Storm Thorgerson
and Peter Christopherson. Richard Draper, Colin Chambers,
Richard Evans, Richard Manning, George Hardie amongst others.

STD-Icon was Andrew Ellis, Colin Chambers and Storm Thorgerson.

Talking Fish consisted Peter Curzon, Tony May,
Finlay Cowan, Jon Crossland and Storm Thorgerson.
Rupert Truman, Sam Brooks, Julien Mills, Jessica Chaney and Hannah Evans.

StormStudios is Peter Curzon, Rupert Truman, Dan Abbott and Storm Thorgerson.
Lee Baker, Laura Truman,

• • • •

Thanks to props at Hot House I Wants Gets, Model Solutions and Aden Hynes.
Bayeux Lab (Terry and Robin), Brad Faine, Stuart Nicholls,
Tony May, Andy Earl, Colin Elgie, Peter Edney, Robert Lands

DER THE CORTINAS Healing Sixes THE FABULOUS P
BONE ASH Voodoo Highway ASHRA
LEMEN WITHOUT WEAPONS GODLEY AND CREME KANSA
NE WHEEL UNO BE BOP DELUXE YES WHITLE
G POWDERFINGER LEISURE CRUISE SCORPIONS
VY TRAIN SYD BARRETT STRING DRIVI
ORCHESTRA AL STEWART TREES SILENT
ITALIC STYX EUROPE Nigel Kennedy YUMI MAT
JUNG YONG-HWA BLACK SABBATH BRUCE I
VE MACHINERI THE STEVE MILLER BAND SHPO
GHLIN KAN WAKAN MARVIN, WELCH A
ETER GABRIEL THE MARS VOLTA 10cc THE
NESIS GOODBYE MOTEL AMPLIFETES THE NI
ENAMEIS:MILO Disco Biscuits XTC THUNDER THE CO
AND THE EXTREMES ETHNIX WISHBONE ASH
A MARSHALL QUATERMASS GENTLEMEN WITHOUT
THE STAR slow earth CATHERINE WHEEL UN
SE THE ALMIGHTY THE OFFSPRING POWDERFIN
OW PROGRAM THE DEAD O.A.R. GRAVY TRAIN
AN RAGGA AND THE JACK MAGIC ORCHESTRA
ORNLEY UMPHREY'S McGEE TOE FAT VITALI
TRAWBS GOOSE PENDULUM DEEPEST
KINSON PRETTY THINGS MIKE RUTHERFOF
NGLE MEGADETH THE PLEA RICHARD WRI
AND FARRAR MUSE LED ZEPPELIN alan par
WOMBATS KIM CHURCHILL THE CRANBERI
E BIFFY CLYRO GRAHAM GOULDMAN FO
E CORTINAS Healing Sixes THE FABULOUS POODLE
ONE ASH Voodoo Highway ASHRA CA